WALL-TO-WALL
AMERICA

A Cultural History of Post-Office Murals
in the Great Depression

Published with assistance
from the Margaret S. Harding Memorial Endowment
honoring the first director
of the University of Minnesota Press.

Wall-to-Wall America

A Cultural History of Post-Office Murals
in the Great Depression

Karal Ann Marling

UNIVERSITY OF MINNESOTA PRESS
MINNEAPOLIS

For Helen, Tim, Gary, M. Sue, Anedith, Erika, and Sue.

Copyright © 1982 by the University of Minnesota
All rights reserved.
Published by the University of Minnesota Press,
2037 University Avenue Southeast, Minneapolis MN 55414
Printed in the United States of America

Library of Congress Cataloging in Publication Data

Marling, Karal Ann.
Wall to wall America.
Bibliography: p.
Includes index.
1. Mural painting and decoration, American.
2. Mural painting and decoration — 20th century —
United States. 3. United States in art. 4. Postal
service — United States — Buildings. I. Title.
ND 2608.M3 751.7'3'0973 82-2622
ISBN 0-8166-1116-5 AACR2
ISBN 0-8166-1117-3 (pbk.)

The University of Minnesota is an
equal-opportunity educator and employer.

Acknowledgments

I am grateful to the University of Minnesota for supplying the basic ingredients of this study: money, time, and a reason to need both. A Research Grant from the Graduate School paid for my fieldwork in lots of post offices and for a long, hot spell at the National Archives. A leave from the College of Liberal Arts let me fret about murals, not courses about murals. My graduate students in the Departments of Art History and American Studies thought the murals so screamingly terrible that I was forced to stick with the topic to salvage my credibility.

And my friends remained tactfully oblivious to the murals and to my bouts of whining and moaning about them. On that score, I owe an awesome debt of gratitude to Rick Asher and Fred Cooper.

Preface

Writing this book has been something like painting a mural for a New Deal post office. It has involved making a picture by effecting a compromise between competing aesthetic and institutional claims. It has also been a search for a middle ground where a clear picture of the visual culture of the Depression years might emerge from the shadow of opposed and partial visions of federal art patronage. And that has been my goal—to paint a picture of the shape of American popular culture during the presidency of Franklin Delano Roosevelt.

The conceptual form of the picture comes from the history of social and governmental institutions; the conceptual content comes from the history of art. In the '30s, paradoxically, the analogy worked the other way around: the bureaucracy charged with the task of public patronage concerned itself largely with the content of wall painting and, within stated but fluid limits, left formal considerations to the artists commissioned to paint the murals. The murals, at any rate, responded to both aesthetic and socio-political stimuli. Perhaps because of this dual origin, the murals have remained impervious to the analytical methodologies of historians and art historians alike.

Scholarly literature about New Deal art in general and the group of post-office and courthouse murals I have chosen to discuss has grown exceedingly rich during the past decade. Francis O'Connor's documentary anthologies created interest in the subject. Yet those of us who began our work on the '30s under his tutelage have been induced by the sheer difficulty of juggling the form of the mural pic-

ture against its content, to paint ourselves into corners at the edges of Depression America's pictorial panorama.

Those who have begun to study the history of the New Deal programs which created public art have, by and large, done just that—they studied the history, not the art itself. Thanks to Richard McKinzie and Belisario Contreras, we know a lot about how murals came to appear on the walls of public buildings during the '30s, but very little about the ways in which patronage affected the perceptual character of murals. Those who have begun to study the history of the art created under federal programs have just as scrupulously stuck to considering only the art, isolating the object from the bureaucratic and social pressures that came to bear on the genesis of murals. Thanks to a series of excellent catalog monographs on regional aspects of New Deal art, we know a lot about the appearance of the '30s murals, but very little about the ways in which art and ideology intersected.

Historians look at patrons and painters, and then ask this question: why and how was this art made? Art historians look at paintings and ask a different question: what does this art look like? I have tried to address these important issues in the following pages. But I have also tried to frame and to answer yet another question: given the fact that these murals were painted and were painted as they were, what are they all about? What did they mean to the people of the '30s who watched them being painted on the walls of their hometown post offices, told painters and federal patrons what ought to appear above their postmaster's door, and let Washington know when the complex process of social visualization went awry?

I have tried to tell the story of public art from the perspective of a public that screamed in protest, smiled in satisfaction, or merely yawned when they saw these New Deal stories in paint. Although I have taken lengthy sidelong glances at the painters who made murals for the people and the bureaucratic patrons who sent them into the people's arena, my focus is on the confrontation between the mural and the people, between art and Depression culture, between the picture and American society. Mine is, in short, an iconological approach to the story of Mural America during the Great Depression.

This book is not, therefore, an orthodox history of federal patronage, of the Treasury Department art programs of the New Deal epoch, or of the pervasive governmental itch to paint public walls in the '30s. It follows no chronological order and does not claim to be inclusive.

I have left out the Federal Art Project, for example, even though that WPA relief program sponsored twice as many murals as the Section of Fine Arts, the agency responsible for the murals I have considered here. My decision to stick to Section murals was dictated by several factors.

Although most of the Section's commissioned artists were needy, of course, the Section officially ignored destitution, and the financial plight of the American painter is not my primary interest here. Neither are the workings of a bureaucracy, which is the topic of most remaining FAP records. By contrast, records in the National Archives provide a day-by-day chronicle of what transpired when a mural was painted under Section auspices. As my own research on federal art in Cleveland, Ohio, has demonstrated, that kind of intimate profile can sometimes be pieced together from scattered bits of evidence about FAP murals; but, more often than not, parts of the portrait have been lost beyond recovery. The Section, however, has left us its entire history. The people, the painters, and the patron all speak out, and I have taken the existence of that multifaceted documentary portrait as a significant indicator of how the New Deal wished posterity to remember and to reconsider the post-office pictures of the era.

This book is not, however, an orthodox art history of Section murals. Although I have told my story through examination of those works of art and their themes and styles, the reader in search of a comprehensive view of the aesthetic problems of the Depression decade must await O'Connor's promised account of the American mural movement. I have used historical form and art historical content—along with the concerns of needy artists and the plans of the bureaucrats—to get at questions that fall within the purview of the people.

What did it feel like to stand in the newly painted lobby of a post office in the '30s? What did the people of Mural America hope to find in the picture on the post-office wall? What did America look like to American eyes during the Great Depression?

Writing this book has been like painting a mural for a New Deal post office in yet another way: the preliminary sketches and the finished work look very different. I discovered that once the people's tastes, tolerance, and demands were placed at the heart of the enterprise, the picture I had planned changed in surprising ways. My original outline was rigidly structured. Using the output of the Section as my

data base, I intended to classify recurring mural themes into appropriate groups, to count the examples in each category, to trace the character of each distinct iconographic type in several case studies, and thus to arrive at a series of crisp surmises which might add up to a definitive statement about the incidence and significance of imagery in the public art of the Depression epoch. To a degree, that schema is still implicit in the following pages.

The more closely I studied the data, however, the more obvious it became that the routine scholarly form and the minutely precalculated content chosen could only do violence to the artistic and social phenomena under consideration. The loose narrative format and the plain prose of my text, for instance, evolved as I struggled to integrate telling quotations from artists, administrators, and citizens into an analytical scenario punctuated with "whereases" and filled with academic argumentation and technical phraseology. The risk of presenting myself as a heedless iconoclast or, worse, an inept student of the several disciplines involved seemed well worth running when the alternative was leaving the false impression that my cast consisted of silly twits whose ideas were as crude and inconsequential as their habitual modes of literary expression.

In retrospect, I have come to believe that my peers in academia and I have taken an unnatural interest in writing about public art from an institutional or "official" vantage point because we can too readily understand the language of New Deal administrators. They wrote the way we do. It also became obvious as I struggled to find the right literary tone for this endeavor that language caused many, if not most, of the catastrophic misunderstandings between '30s project administrators and artists, between artists and their audience, and between the public and the Washington bureaucracy. By giving each constituency its own voice (and by amplifying the weakest voices so they can be heard), I have tried to allow this communication gap to reveal itself.

The danger in doing so is obvious: since my cast includes lots of artists and many more ordinary citizens but only a handful of administrators, the casual reader might conclude that I am contemptuous of that brave band of bureaucratic planners and shapers. Starchy prose would have made the artists and the townspeople look bad, and my informal prose could now, I suppose, be construed as a slap at their superiors. But I am not contemptuous of anybody, as I trust the careful reader will perceive.

The decision to write a story—an interlocking group of stories, in fact—came from my growing appreciation of the conceptual barriers thrown up by traditional modes of expression. Those of us engaged in interdisciplinary scholarship and teaching realize sooner or later that we spend too much energy in translating terms, merging discrete theoretical structures, and clearing out a neutral field of action in the midst of the styles and goals unique to writing about film history, intellectual history, social history, art history, and so on. Precise terminology about one's subject is not meaningless jargon; still, those of us who aspire to contribute to the holistic enterprise called American Studies are frequently driven to despair by the hermetic lexicon of terms and the idiosyncratic order of argumentation adopted, in all good faith, by our worthy colleagues in disciplines that we, alas, are dying to loot. The narrative framework and informal prose used here represent an attempt to step into that neutral field and to give those who wish to follow immediate, painless access to my terrain.

I am an art historian by training. The methodology and the language of my discipline provide finely tuned instruments with which to probe the meaning of the work of art in its temporal and social context. The work of art itself, nevertheless, rightly remains the primary focus. Yet the work of art and its social dimensions must eventually, I think, find a place in broader cultural studies. American Studies needs the work of art and cannot limp forward much farther on ancient crutches labeled "American Lit" and "Social Sciences." Art can and must help to answer questions that are not, strictly speaking, art historical. Because these questions are not of intrinsic concern to the discipline, it is pointless to excoriate art historians for failing to provide the means of answering them, just as it is churlish to accuse art history of elitism because its practitioners have performed their proper task of exercising qualitative judgment with enormous rigor, skill, and conviction.

At the same time, there are occasions—doing American Studies could be one of them and discussing art that has a major popular component is surely another—on which it becomes important to know how to cope with art of less than self-evident quality and art to which quantitative rather than qualitative standards might better be applied. On such an occasion, cannibalizing orthodox art-historical methodology most often does little more than cast a pejorative pall over the proceedings. Most popular art, in its relationship to high culture and mass culture, has suffered, I know, because the scholars

who could best explain its formal and iconographic properties have habitually regarded the popular arts as a minor source for art of greater value and interest.

That state of affairs was driven home to me with special force over the past couple of years as I tried to puzzle out the persistent appeal of two very well-known paintings of the late 1920s: Charles Demuth's *My Egypt* and Thomas Hart Benton's *Boomtown*. Both works drew upon ideas current among the painterly avant-garde of New York; both also used popular themes and styles of visual organization. In a real sense, then, the works of Demuth and Benton are equally germane to the creation and definition of a pervasive, shadowy aesthetic tendency of the '30s which I have associated with true Regionalism, a concept to which I return time and time again in the course of delineating the boundaries of Mural America.

Now, Demuth is a very fine painter indeed. His admixture of elite and popular conventions has never debarred him from ready inclusion in the rollcall of great American artists. Demuth did not make a fetish of his popular interests, and although it is engaging to learn of his fascination with billboards and the like, popular culture remains a source—a starting point—which neither detracts from nor enhances his high standing among American Cubists of the '20s. Benton's is a different case, because that great painter insisted on the absolute primacy of the popular component of his art. Demuth was content to exhibit his work in art galleries; Benton, as time went by and the '30s approached, became rabid in his rhetorical attacks on the institutions that were the traditional custodians of elite culture and sought out mural commissions so that his popular leanings could be evaluated in the popular arena whence they derived. Benton's work, therefore, demands sensitivity to popular art per se, and sensitivity to the distance he tried to put between art and *his* art. What did Benton find there on the hustings that engaged his imagination so deeply, that he could not find among his peers? Benton's work also demands a sensitivity to his new, self-selected audience, a group very unlike Demuth's circle of cognoscenti, of which latter-day art historians are surely a part. Because Benton elevated popular sources and the opinion of a popular audience to a position of primacy in his art, he has proven maddeningly elusive to art historians and me. We write his biography and leave out his art. We write about his Cubist technique and leave out his street-wise themes. We falsify Benton despite ourselves.

A vast mural program with one foot planted in the popular domain and the other resting in the camp of elitism multiplies these problems exponentially. Added to my difficulties, for which the discipline of art history provided little hope of easy resolution, were the related burdens of keeping many murals of a widely varying range of quality on the stage simultaneously; of trying to assess the validity of cooking up yet another theoretical hybrid called "quasi-popular art"; and, ultimately, of applying that semi-popular, not-too-great art to the solution of cultural problems altogether external to the objects in question. A narrative format was particularly useful in contending with chaos. It did not oblige me to tackle a complicated tangle of issues whole by arranging them into a tidy hierarchy ruled by the principles of great art. It did not force me into prejudgments before I was ready to make any tentative judgments at all. It did not burden me with a covert art-historical agenda I could never follow. Bluntly stated, meandering through a story has let me crash about in the bushes, stumbling into and sometimes out of a variety of cul-de-sacs and pathways; the latter I can now confidently deem pertinent to studying American culture in the '30s. Although I would have preferred to have written a definitive, Olympian tract, I am stuck with an essay in trial and error.

At the same time that I recognized the messy shape of the task before me and grudgingly began to accept structural untidiness as a plausible strategy for contending with it, I started to read *Winterthur Portfolio*. Until recently, that admirable publication concentrated on the decorative arts, especially furniture. Although the editors are not responsible for my misinterpretation of their accomplishments, it did seem to me that studies of furniture offered some assistance to an art historian about to leap into the terra incognita of American Studies, which looked less and less like a neutral field of interdisciplinary endeavor and more and more like an intellectual minefield. Students of the decorative arts were not unduly burdened with the authority of the masterpiece, for instance: some chairs may be better than others, but there is no "definitive" chair. Furthermore, a given furniture type was liable to be traced—often via meandering and charming narrative—through all its manifestations, ranging from an exceptional example by a master craftsman, through a piece of hackwork from a factory, to a garbled stylistic echo of the type buried in some pocket of folk culture. And finally, *Winterthur*'s writers seemed remarkably willing to use insights gleaned from impeccable analyses

of patronage, usage patterns, and style in the service of generalizations about the state of American culture in a given period.

Treating chairs as documents of material culture which might or might not also be works of art yielded, I thought, some remarkably cogent and novel insights into both the meaning of objects and the character of American life. Extrapolating from that methodology resolved many of my doubts about how to present Section murals. My own modified art-historical methodology here leans on material culture theory, tolerant of pluralism, chary of hard-and-fast value judgments, and directed at defining a culture of which the object is one among many manifestations.

One unexpected bonus of treating popular mural art as a subspecies of material culture was a giddy sense of liberation; that led, in turn, to my rediscovery of the awful and useful word *picture*. When I was a sophomore art-history major, I knew that Poussin's *Et In Arcadia Ego* and Picasso's *Guernica* were terrific pictures. I walked into the places they showed me and stayed there, enchanted, scared, and deeply moved, for days on end. Sometime around the middle of my years in graduate school, I finally learned that I was supposed to stay *outside* the picture plane; if I strayed inside, against all advice, I had better keep the news of the trip quiet. *Picture*, in the trade, was a self-deprecating synonym for *painting*, a professional's affectionate understatement, reserved for exceedingly distinguished iconographers. Used under other circumstances, *picture* was the war cry of the philistine. Yet seen en masse, the thousand-odd post-office and courthouse murals which form the basis for this study have one thing in common. Whatever else they may be—and they are sometimes paintings, too— they are pictures. Together they make up a vast, intricate, startling, and fascinating mural picture of the Great Depression.

Contents

WALL-TO-WALL
AMERICA

A Cultural History of Post-Office Murals
in the Great Depression

Introduction

This book is about taste in the Depression decade. I have proceeded on the assumption that popular taste can be understood through the medium of murals painted for a mass audience, by artists charged with consulting the preferences of the people, under the auspices of a New Deal program which earnestly solicited public opinion about the wall paintings it caused to be hung in post offices all across America in the years 1934 through 1943. Occasionally, in fact, when prodded by the goad of popular taste, that agency caused offensive murals to disappear from view and highly regarded murals to sprout satellites and appendages.

Given this assumption, it becomes important to establish how the mural program in question worked, how it accommodated public opinion, and how it measured and responded to popular taste. Armed with these facts, it then becomes possible to suggest why people reacted as they did to the style and content of the murals they scrutinized, thereby expressing their sense of what American culture ought to be like. When the people discussed here do give an idea a ringing endorsement or react with pleasure to the sentiment conveyed by the style through which a pictorial idea is manifested, I have taken that expression of taste as a popular vote for the vision of America embodied in the mural—a pleasing image of an operative cultural myth that made life seem more beautiful. And I have pressed on to explore both the origins of that vision and the rationale governing its public acceptance. When the people register a strong

3

negative opinion on a theme or the manner in which it is presented, I have taken that expression of taste as an indicator of a problematic issue—a sign of tensions which made it harder to stagger through life's daily grind. And I have pressed on to explore why some visions of America were particularly repugnant to the '30s.

My compound chapter titles emphasize the two distinct aspects of this approach to mural painting in the Great Depression: what happened and what these events might signify in the broadest possible cultural terms. In each instance, the chapter subtitle charts the terrain of Mural America in the '30s: a mosaic of unique places and their people, one that spread across the national map "From Iowa to Missouri," "From Kansas to Maine," and "From Maryland to Idaho." These places constitute the vast and heterogeneous public arena in which the New Deal mural operated, exerted the force of its form and content, and, ultimately, succeeded or failed in the court of public opinion. These geographic subtitles thus articulate a corollary to my major premise: namely, that whatever other standards were or can be applied to these murals, considered as works of fine art in the aesthetic context of their epoch, they were also appraised in the '30s on a local basis, as works of popular art, responsive or indifferent to the tastes and so to the social and spiritual needs of the several unique communities in which they came to reside, and can justly be reappraised in those same popular terms today. Such local, popular appraisals of public art are key factors in the life of the New Deal mural. Popular verdicts on murals are therefore reported and probed with some care here, and form the historical basis for my analysis of popular taste and its cultural implications.

The case studies of local murals grouped under these geographic subtitles—each chapter centers upon one or two detailed presentations and peripherally sketches a few analogous situations—comprise the factual evidence. The case studies describe how the federal program that launched a mural renaissance in 1934—the Treasury Section of Painting and Sculpture (renamed the Treasury Section of Fine Arts in 1938 and renamed once more, in 1940, the Section of Fine Arts of the Public Buildings Administration of the Federal Works Agency)—went about placing a mural among the people of Aiken, South Carolina, or New London, Ohio.

In a limited sense, then, this book can be read as a factual compendium, a detailed narrative telling how one New Deal agency sponsored mural art in the Depression years; where murals were painted

and under what circumstances; and what, in the end, people in various places thought about them. Although that story is not set forth in chronological order—the book purposely opens and closes with case studies of atypical murals, commissioned during the heyday of the program—each stage in the life cycle of the Section, from its prehistory in the '20s, through its genesis in the heady first months of Franklin D. Roosevelt's first term, to its rapid decline with the outbreak of World War II, is given ample consideration, and evolutionary changes in policy and procedure over that span of time are duly noted. Indeed, the text begins with a brief account of how the Section was founded and leaves off with a glance at the resurgent wave of abstraction which all but obliterated memory of popular mural art within a decade after the demise of the Section. In common parlance, all '30s murals henceforth became "WPA art," a term soon considered pejorative.

Presenting these facts about murals, in their temporal and geographic variety, might be construed as a worthy objective in its own right. It no doubt is, but that was not my goal. I have dealt so extensively with the "facts" to lay the foundations for a study of taste and New Deal cultural history. Published studies on Depression art patronage have generally aimed at describing all the New Deal agencies involved, comparing them, and distinguishing their sundry goals and structures. The attention devoted to any given program has been of necessity limited, and so all '30s murals have remained specimens of "WPA art." More important, neither the scholar nor the general reader emerges from the available literature with any clear sense of the nuts-and-bolts working of the mechanisms whereby a Section artist was commissioned for service; betook him or herself to Anyplace, USA; mingled with the natives; and painted a mural that local tastemakers deemed satisfactory, abhorrent, or ignorable.

Looking at the give-and-take on the nuts-and-bolts level is extremely interesting. By extracting that grassroots data from exceedingly rich archival sources and setting it down in terms of what happened first, in the case of a mural in Corning, Iowa, for instance, and what happened next and what happened after that, I can at the very least solidify the historical record. Political historians draw conclusions about the legislative programs of the New Deal only after establishing what happened and in what order events took place. Cultural historians of all stripes have not been similarly attentive to

hard facts about New Deal murals. Or, rather, armed with archival data, they have failed—dismally and repeatedly—to inform the rest of us about the facts from which their extrapolations arise. Whatever else a Section mural was, it was a fact, an event in the social life of the community, a particular, documented event with antecedents and consequences. Thus every mural occupies center stage in a historical scenario of more than formal interest.

Each of my case studies marshals the salient historical facts in their order of occurrence. I have provided a quantity of such case studies for three reasons: first, to underscore the scope and importance of local variables; second, to demonstrate that the range of local variables does not preclude cautious isolation of a broadly based climate of opinion diagnostic of American popular taste in the '30s; and third, to undercut any premature temptation on the part of myself or my reader to mistake a given set of facts for a paradigm, a microcosm standing for a complex aesthetic and art-historical macrocosm whose outline these clusters of facts can only begin to trace. By locating these clusters of fact, my geographic subtitles map a metaphorical journey across Mural America, the historical ground upon which my analysis of popular taste rests.

My chapter titles proper, and their order of presentation, allude to my own sense of what that journey means in terms of American taste and the dominant drives of American culture in the Depression decade. The truisms and the '30s catchphrases given each chapter title characterize the various and contradictory meanings attached to the exercise of taste, as revealed in the images chosen by the people of the Great Depression. With hindsight and some caution, we can gauge public opinion about art and life from the various reactions to these murals and can reach some general conclusions about public taste. Taste was a product of local prejudices and vanishing regional folkways. It mirrored a cultural consensus about the nature of American society and the ongoing role of art in American life. It was an unpremeditated response to the terrors of the moment, a fever chart of Depression-bred fears and hopes. It was a moral judgment on social evils. It was an aesthetic decision. In fact, study of public taste shows just how artificial are academic efforts to separate moral judgment rigidly from aesthetic decision.

In the '30s, taste was a matter open to rational negotiation among the triumvirate of interest groups party to a mural's creation: "The Patron, the Painter, and the Public." Taste was an ineffable regional

mystery, beyond the pale of reasonable discourse: "De Gustibus Non Est Disputandum." Taste was a self-evident proposition, for prevailing standards of decorum had already mandated those traits of style and content suitable for "Murals As Murals Should Be." Taste was "An Article of Faith," a means of dreaming in paint of a better future for America. Taste was "The Naked Truth," a manifesto in paint of those moral and political values to be preserved and protected during the nation's hour of crisis. And taste was a query about "That Abstract Art Stuff" and its place in modern American culture.

Chapter One, "The Patron, the Painter and the Public," introduces the particular difficulty in creating a social art, one destined to be viewed by a new, pluralistic art audience—the great American public. The process of creating mural art in the 1930s was fundamentally at odds with cultural traditions governing the genesis of easel painting and the fine arts in general, especially since those traditions had been reshaped by the rise of the avant-garde and the concomitant decline of church and state patronage in the nineteenth century. According to the avant-garde model, artists had become free agents, painting whatever they deemed desirable, in whatever manner they saw fit. The art object was therefore socially autonomous: the painting was "art for art's sake." An audience was not necessarily party to the creative process; rather, if an audience was taken into account, it was an elite composed of aesthetically educated disciples of modernism.

Propensities for hacking off an ear, starving in a garret, and exhibiting assorted forms of antisocial behavior characterized popular stereotypes about "modern" artists. Quite apart from their woeful basis in reality, such stereotypes expressed a feeling that the painter was alienated from the sensibilities and interests of the general public. The public perceived the painter as a social alien. This is not the place to fix blame for that state of affairs, or to applaud the liberation of the artist-seer from the stranglehold of middle-class values, although both views were defended and debated among art theorists of the '30s. It should be noted, however, that alienation or the perception of alienation had produced one especially baleful effect upon artists newly freed from societal constraints: the majority of American painters were so bad off in the 1920s that the Great Depression scarcely reduced their meager incomes. Their plight was that severe.

From a purely economic standpoint, a reassessment of the adversary relationship between the painter and the public was overdue,

at least for the artist, even before the Crash of '29. Whether the overt aim of a given New Deal agency was to supply necessary economic relief for artists or to commission works of art for a public audience under economic circumstances that induced artists to accept public employment, federal patronage provided the forum wherein painterly alienation and the concept of the avant-garde would be intensely scrutinized by painters, art experts, and a new artistic audience of ordinary people. Chapter Six summarizes the results of that public examination of modernism during the '30s.

America, to be sure, was not overrun with antisocial bohemians fixated on the promulgation of autonomous "isms." But neither did America have a sustained tradition of official public patronage of the fine arts. Non-elite, social art was the preserve of the popular mass media when a mural revival suddenly took hold in the commercial sector in the boom of the '20s, only to peter out in the bleak early years of the Depression. That shortlived mural movement, supported by the profit motives that had always generated popular art, became a crucial prelude to public patronage under the New Deal, and a knowledge of it is therefore fundamental to understanding the eternal triangle that bedeviled the Section program in the form of an uneasy partnership between the federal patron, the mural painter, and the American public.

The corporate and institutional patrons of the '20s had a vested interest in using art to attract visitors to the facility being adorned with murals. Repellent art was not acceptable, regardless of its independent aesthetic merit. To fulfill the economic demands of the patron, the artist had to agree, tacitly if not publicly, to curtail his or her choice of both style and subject matter. At the very least, the corporate muralist needed to temper private views by awareness of the new audience, to feel the public pulse directly and empathetically, or to accept the patron's assessment of the taste and tolerance of the clientele. As for the public, no hard evidence suggests that citizens boycotted movie houses and department stores tricked out with murals. Although the joint efforts of corporate patrons and painters to achieve appealing results can be observed and analyzed with some confidence against the backdrop of the noncommercial art world outside this mural boomlet, what the public thought—if anything—is a good deal harder to ascertain.

The work of artists who turned their hands to murals with apparent success—that is, without setting off a public furor—supplies

some clues about the range of public taste and tolerance in the 1920s. Private-sector commissions carried out by James Daugherty, Boardman Robinson, and Thomas Hart Benton help to define both public preferences and widespread painterly and corporate perceptions about public preferences. As the '20s faded into the '30s, the work of artists who succeeded in enraging the public gives cogent negative evidence on the same point. Diego Rivera's infamous Rockefeller Center commission helps to define public and corporate antipathies. Considered as a group, these works of the '20s and '30s also demonstrate that having a specific subject matter—a readable image of something—was considered essential to the successful popular mural. Also essential was imagery devoid of disputable, controversial overtones. Historical subject matter, recreating real or imagined events safely closed to public debate, was an important thematic discovery of the muralists of the '20s.

If the enforced choice of "safe" topics is construed as a negative artistic feature of painting historical pageants, the positive social worth of such cycles, once the Depression began, was considerable. By showing long chains of events leading up to the present, historical cycles calmed public apprehensions of imminent catastrophe, the terrors of which I explore in detail in Chapters Three and Five. History could be social therapy, and this belief, as Chapter Four argues, made the mural "An Article of Faith." Past and present took their places in a visual continuum that covertly promised hope for the future, as history chugged along placidly and predictably toward tomorrow.

Acceptable mural content was also derived from popular visual sources such as the tabloid press and the movies, which the public had already endorsed with their pocketbooks; Chapter Two develops this theme in the context of the Regionalist style of '30s painting. But whether a mural's content was history or Hollywood, style was a telling part of that content. The dominant style-content that bound together this family of proto-New Deal murals was the kind of avantgarde art called Cubism. Degrees of Cubist influence were marked in the planar flattening and faceting of imagery, in the emphasis on a two-dimensional pictorial surface coextensive with that of the wall, and, to a lesser extent, in a tendency to adjust the scale of objects freely according to narrative or compositional preferences rather than the canons of reportorial accuracy. In no instance did Cubism inhibit ready public identification of the objects depicted or the

stories told. But in all instances, Cubism branded the mural and its iconography as contemporary and modern.

The newness of the urban buildings hung with private-sector murals might be thought to justify a modernistic "look" were it not for the Cubistic wall painting adorning new structures, like movie theaters, that masqueraded as palaces of yore. A Cubist look, however debased from avant-garde purity of form and regardless of the content or location of the mural, conveyed something in and of itself. The look was up-to-date, jazzy, moderne, and urban; it was corporate, technological, and industrial. Cubism, as symbolic decor, was part and parcel of the iconography of any mural employing it. Cubism's function as a symbol of the modern world thus accounts for one noteworthy peculiarity in public assessments of murals in the '30s: the widespread belief, articulated most forcefully by small-town audiences like the one in South Carolina described in Chapter One, that planes, facets, and bright modernistic colors might signal an attack on traditional local values. The modern look per se often meant an incursion of alien, urban ideas. It represented, to some, an irksome intrusion of national problems, which the local consciousness could otherwise have regarded as somebody else's. It represented an elite mockery of ordinary perceptions.

Thomas Hart Benton's private-sector murals of the early '30s attacked the senses with a brash Cubist dynamism redolent of modern America. His work so aggressively demanded attention that subsequent public resistance to modern style becomes easier to comprehend. Yet, paradoxically, Benton was also the commercial muralist who exhibited the greatest sensitivity to those popular stylistic elements, plucked bodily from the contemporary mass media, with which a mass audience might reasonably have been expected to feel at home. The popular motifs and visual styles Benton used in his Cubist mural format, along with the meaning those motifs and techniques originally possessed in the popular media, pointed toward a plausible strategy for creating a popular mural art under federal auspices. Benton's version of social art was a populist Regionalism: the Regionalist mural was grounded in a form and a content already accepted by a pluralistic audience strewn from Aiken, South Carolina, to New London, Ohio. Benton attempted a daring merger of fine art with popular culture.

Chapter One thus introduces the iconological possibilities explored by mural painters in the '20s and the early '30s, and the principal

issues of taste upon which the text will focus. It describes the experimental legacy inherited by the Section when the federal government became the mural patron of record in 1934. Federal patronage, because it was federal, brought issues latent in the mural genre out into the open. Given the political climate of the New Deal, the federal patron was newly responsible to the taxpaying public in ways that the captain of industry was not. Besides being burdened with public accountability, the new federal patron was also given a wider range of options: government could accommodate public taste, as the commercial patron had done; government could strive to educate public taste by fiat, on the basis of aesthetic conviction; or government could, like Thomas Hart Benton, try to do both. In a manner directly parallel to President Roosevelt's own modus operandi, the Section decided not to limit itself by choosing any one course of action.

The ongoing struggle to keep all these options open eloquently reflected the humane pluralism of the New Deal, but it left the government in the difficult position of setting up a system which would result in many murals being installed in varied places with amicable dispatch, without unduly offending any of the three parties witness to the creation of a Section mural: the patron, the painter, and the public. The regulations whereby murals were created defined the relationships between the three parties but did not, unfortunately, delineate their spheres of influence; nor did the rules anticipate or accommodate the infinite permutations of the three groups' overlapping and often antithetical responses to the planning, execution, and installation of a mural. Instead the rules loosely projected an ideal circle of mutual, non-overlapping interests: the patron enlisted the painter; the painter dealt with the public; and the public reported its judgment to the patron.

In practice, however, the interests of all the parties, at various times and in various places, did overlap and conflict. Insofar as the Section was an agency staffed by experts in the fine arts, the patron had a collective notion of what constituted "good" mural art—good, that is, for the progress of American art and the improvement of American taste. The Section had aesthetic biases as, of course, did painters and the public. Insofar as the Section was a purchasing agent for the American people, it was an employment bureau representing the American painter and the stylistic diversity of American art, as well as a conduit for transmitting the often inchoate preferences of the public to the painter. Insofar as the Section was a government

agency, it represented the New Deal both in the character and content of its mural output and in the nature of its transactions with painters and people. Similarly, the painter working in the public arena assumed the conflicting duties of representing Washington and articulating the views of the people, leaving aside for the moment his or her self-defined artistic responsibilities. Finally, the public always remained the implicit patron, entitled to make aesthetic demands and capable of rendering vociferous objections to the form and content of mural art.

All these overlapping concerns, responsibilities, and interests came into conflict in Aiken, South Carolina, in 1937, 1938, and 1939. The complicated story of the Aiken mural is therefore a useful starting point for considering popular taste in the context of the Section program. The story of the Aiken mural, and its procedural predecessors among early Section commissions, exposes the complex welter of ideological, aesthetic, local, political, and perceptual aspects of taste that generated a crisis of some sort in Washington every time a mural was painted. And it is no adverse reflection on the motives of the federal patron or on the deliberate pluralism courted by the bureaucracy to highlight such moments of extreme crisis. The pluralism was well motivated, but those good intentions did not preserve the mural endeavor from controversy. The Aiken story and the other case studies that follow examine times and places at which the delicate balance between interest groups and their varied perceptions of muralmaking fell out of kilter. Such episodes are indeed of exceptional interest. Moments of crisis demonstrate that the patron's intentional ambiguity of purpose—the art-politics of pluralism—made for a procedural chaos vesting ultimate power in public taste and tending thereby to negate the value of those aesthetic criteria customarily regarded by the avant-garde of the '30s and by today's critics as paramount in artistic production and evaluation. Section murals became a species of popular art, a social art whose primary function was to be liked by the American public.

In the Aiken case, the loose structure of procedures whereby Washington was to pick the artist, the artist was to take the pulse of public opinion, and the finished mural was to take its place in the life of the community broke down completely. At any rate, rules governing the activities of patron, painter, and public did not mesh and failed to produce any semblance of a partnership of interests among the three groups. When that sense of communality—that balance of in-

terests—was disturbed, nonaesthetic values assigned to the Aiken mural undermined its status as a work of art. The painter confessed to covert political goals. The patron had selected the painter for aesthetic reasons but began to support him on different ideological grounds, against local protests. The public took vehement exception to a pictorial content perceived to be at odds with prevailing social customs and to a disturbing modernistic form at variance with the doctrine of states' rights. As the dispute wore on, the Aiken mural became a manifesto of modernism, an inflammatory illustration, and a federal symbol. It ceased to be an aesthetic entity, insulated from the popular realm of ordinary perceptions, and became a social document. As a social statement, the mural was defined differently by everyone to whom its existence mattered. Everyone seems to have been shortchanged in Aiken, too, by a governmental process prone to misadventure because its inherent fuzziness and flexibility accurately reflected a disinclination to impose a single definition of art or its meaning upon the government, the artist, or the American people.

Alternatives to a policy of pluralism were not hard to find in the '30s. State patronage in Nazi Germany, Fascist Italy, and Soviet Russia, for instance, turned art into a blunt instrument of repression. When content was the calculated propaganda of a totalitarian regime and form was the most expedient method of driving the message home, orderly rules governing the creation of public art were easy to frame. Ends justified and mandated the means. Although the art programs of the New Deal sorely lacked political clout, it is sobering to view moments of chaos in the Section program against this invidiously tidy background, with a large "what if?" firmly in mind. What if those art experts in Washington who were, by and large, sympathetic to the pictorially legible American Cubism in vogue in the late '20s had chosen to exclude other formal possibilities? What if they had harbored political aims and enforced graphic expression thereof?

I raise these questions because federal officials did have their own set of iconographic, stylistic, and ideological objectives and were equipped with the means of attaining them. And the Aiken story suggests that Section officials pushed their ideas hard. Yet whatever the experts' personal hobbyhorses, the implicit partnership of interests between patron, painter, and public favored compromise rather than control and negated the private ambitions of public ser-

vants. The patron shaped the mural to the extent that Washington chose the painter and supervised his or her progress. The painter shaped the mural, but did so under the guidance of varying degrees of pressure from the Section experts and the general public. Then the people spoke. Even if the people played no part in the process until the eleventh hour, their judgment determined whether the mural would enjoy a vital existence in the life of the community. Few Section murals were ripped off the walls of public buildings, but when the public refused to look at a mural, it was banished to the metaphysical shadows. A work of art existed; a work of social art, resonating in a new popular arena, did not.

If mural art could not be defined according to the wishes of experts and artists, if the public was to be given a decisive voice in determining the fate of the mural, and if a balance of sorts among these three distinct groups was imperative, then the "democratic" compromise eventually struck in Aiken in a vain attempt to reconstitute the ideal circle of interests seems less paradoxical. The work of art was painted, paid for, and doomed to invisibility. Balance was restored at the expense of the art object, which simply vanished from the center of the circle of interests, and that disappearance in itself is an excellent reason for beginning this study in Aiken.

In the court of public opinion, under the rules of democratic compromise, the autonomy of the mural as an art object broke down completely during the '30s. The mural remained a painting, but it was a painting last; first, it was a depiction of objects and scenes, a picture, a symbol, an event. The mural was an aesthetic entity last; first, it was a forum for discussion of national issues, a window on times past and times to come, a mirror of current anxieties and aspirations. A mural might serve all these ends, some of them, or occasionally other purposes altogether. Hence the '30s mural is not a work of art with which the critic or historian of the 1980s can assume easy familiarity. None of the parties most intimately involved with a Section mural agreed to any given proposition concerning it (let alone a definition of its aesthetic status) with any predictable regularity. Thanks to official recognition of the finality of the public verdict, nobody had to agree so long as the work of art contrived to present a passable picture of an acceptable theme. Compromise was always possible and indeed desirable when the ultimate question was not one of art but one of popular taste: what stories and shapes and colors the American people would like or hate or tolerate.

Aikenites argued successfully that the mural which made a fleeting appearance in their hometown did not conform to local taste and specifically to the Southern conception of art. Accordingly, in Chapter Two, I have explored regionalism and the underpinnings of popular taste in the '30s, returning for that purpose to the work of Thomas Hart Benton and the so-called Regionalist painters of the period. The Section acknowledged the validity of a regional approach to art. To ensure that a mural would have some appeal to viewers in the geographic sector where it was placed, the agency routinely insisted on factual content derived from the local scene. Recording the appearance of the locale was one way to achieve regional credibility, but a blanket policy calling for reportorial accuracy recognized neither the feelings and values the public associated with seemingly neutral facts nor people's inclinations to see what they wanted to see when gazing upon their own hometowns. Although the canonical Midwestern Regionalists played a minor role in the federal mural campaign, I believe their art provides the benchmark against which the Section's attempt to accommodate regionalism through a "return to the facts" must be evaluated. Their paintings and sensationalized doings were also, of course, familiar to many artists who did receive post-office commissions, especially those from Missouri, Kansas, and Iowa.

Benton of Missouri, Curry of Kansas, and Wood of Iowa, as their numerous detractors realized, did not premise their bond of affection with the people of the Midwest upon observed fact. Instead, they directed their attention to the attitudes of their audience. The rural stereotypes purveyed by movies, cartoons, fiction, drama, photographs, and the press provided important cultural clues to the Regionalist: the themes that turned up repeatedly across a range of media and the stock images and figures that were generally understood to convey a fixed meaning gave Benton and Wood, in particular, a feel for the texture of contemporary, popular perceptions. Whether a given cultural stereotype of the day—a ragged sharecropper or a prim farm matron—could be corroborated by a given factual example was beside the point. What was relevant was the capacity of the operative stereotype—the Ozark shanty or the white clapboard farmhouse—to communicate shared and current ideas in familiar terms to a small-town audience which, thanks to the media, was a participant in a new, mass culture.

The centrality of the Regionalist stereotype in shaping and comprehending popular taste is illustrated by two murals painted for

rural communities. One of these murals spoke about rural America in a vocabulary of cheery, positive stereotypes. The people of Corning, Iowa, were gratified to discover, as they contemplated those stereotypes, a warm and optimistic portrait of themselves and their neighborly town. The second mural began as a grim sketch taken from actual facts of life in Arkansas and was quickly altered through the intervention of townspeople because the facts it depicted reflected a negative stereotype which the New South business community of Paris, Arkansas, was eager to shed. The rejected sketch, to be sure, showed a real sharecropper before his crumbling shack. That particular unappealing fact had, however, been chosen from a plethora of other facts about Paris. The gradual industrialization of the community—a fact verified by the warehouses and smokestacks shown in another artist's mural sketch of Paris—was the positive, progressive self-image preferred by those citizens who deemed the mural important enough to warrant scrutiny. If Corning, Iowa, saw its mural as a flattering mirror image confirming local self-esteem, Paris, Arkansas, saw its mural as an advertising billboard proclaiming the existence of an up-to-date, modern enclave, or perhaps as a window on a future state of technological grace achieved through scientific management of those rundown farms which symbolized a rejected, rustic past.

Taste—local and regional—was not primarily expressed through a gasp of aesthetic delight, although people could be smitten en masse with an idiosyncratic fondness for garish hues and right angles. The exercise of taste transcended the private joys of connoisseurship and the collective pleasures of fashion. The stakes were a great deal higher, and the rewards more tangible. Taste was the naked admission of a compelling affinity between picture and viewer, between image and self-image, between a meaningful complex of cultural symbols and a culture desperate for some hard, external validation of its worth in the face of economic collapse and social disorder. Taste was a confession of dissatisfaction with the status quo, a well-placed scratch on the itch to begin anew. Taste offered a choice between now and someday: it meant gazing into a rose-colored mirror to see a well-scrubbed version of the present or peering through a magical window to see the future.

If taste had been a matter of acknowledging simple delight in the beautiful, it could be argued that modern art never had a chance in Aiken, regardless of the subject treated in a modern manner. Despite

all the rhetoric, "the Southern conception of art" boils down to nothing more than a yearning for the comfortable, conventional prettiness of calendar illustration. But prettiness and aesthetic pleasure ultimately seem to have as little to do with popular taste in the '30s as the mysterious attraction of blueness or clusters of parallel lines, except insofar as those formal elements contributed to and reinforced the meaning of picture-making. In social art, the character of the picture determined the attractiveness of the painting. Modernism of shape and tone, for instance, was not reprehensible per se to those towns of the Midwest and the South that were fully prepared to embrace other aspects of modernity.

Judging by the numbers of streamlined pictures of machinery painted in bright colors in enthusiastic rural communities, many localities—fired up by a collective vision of prosperity attained through technology—embraced the idea of depicting modern machines and welcomed them into their pastoral gardens without so much as a quibble over the relative merits of abstract form or the absence of calendar prettiness. The shiny, red streamlined tractor was, in its own way, a comprehensible stereotype, trotted out at county fairs and the great World's Fairs of the '30s as a romantic panacea for all the problems bedeviling the American farmer. Stereotypes—like campaign promises, the Section's particularized facts, and a farmer's dreams—need not be true to be potent and symbolically useful. What makes the technological optimism exuded by many rural murals, including those in Paris, Arkansas, and Jackson, Missouri, so fascinating is not the reportorial truth of the imagery or the angularity of the style. Fascinating, rather, is the people's relish for those cultural stereotypes that proclaim a hungry faith in the power of a machine-oriented, modern society to extricate itself from the dilemma of the present and to zoom miraculously away from the burden of hardship and failure imposed by its own past.

In Chapter Three, I have examined the significance of machine imagery in the '30s, with particular emphasis on depictions of vehicular technology. Transport machinery nearly dominated mural iconography through 1939—the New York World's Fair of that year paid lavish tribute to zooming Fords and Chevies—and is itself a complex cultural metaphor. Zipping airplanes and thundering stagecoaches alike proposed a dynamic, impatient alternative to Depression stagnation. Conestogas and steam engines coursing westward revived the frontier option and linked national progress to motion, machin-

ery, and turning wheels. Motion invited escape from troubled times. Projected upon the American past, motion constituted a model for renewed activity in the present, but more especially, a magic carpet to tomorrow. The mural saga of transportation across America was an object lesson to the '30s, a pictorial genre with an enormous public appeal which recognized no regional boundaries.

The theme did, however, succumb to temporal exhaustion in 1939, as the citizen outcry against the transportation cycle in Towson, Maryland, demonstrates. There the machine stereotype was doomed by its popularity and familiarity. Stereotypes have a kind of effective half-life: when a roaring train roars so loud and so long that it elicits a yawn rather than a jolt of fresh insight, the typology has worn out. Regionalist art always ran the risk of becoming trite and stale by using media stereotypes to achieve contemporaneity and to tap shared feelings. The Towson case pinpoints several of the unique problems posed by mechanical stereotypes. Local taste rejected the artist's streamliners and wagon trains because people readily identified that imagery with the movies and other forms of antic mass entertainment. They expected something more from a mural permanently ensconced in a public building—something more than a dimestore souvenir of the fleeting fashions of the moment. In fact, they expected stability. "Murals as Murals Should Be," they opined, ought to deal with fixed historical realities and enduring truths. Implicit in this demand was a major cultural question of the period: was the industrial system that failed to be trusted again? Was social stability compatible with technological progress and constant change? Were the glittering promises of a mechanized utopia of the future to be believed?

In 1939 the people of Westerly, Rhode Island, asked these same questions in the course of repudiating a proposed mural picturing the ubiquitous streamlined locomotive. The machine was not dismissed as a false idol. Rather, discussion of the mechanical stereotype redirected attention to the implications of the machine image—the painful issue of work in an era of joblessness. The machinery that worked in the '30s often did so in robot fashion: machines performed tasks and skittled off, out of the picture, while people merely looked on. The kind of mural the citizens of Westerly thought most suitable for their town had two important ingredients missing from the popular technological archetype of the day: humanity and fixity. Work was something people did, whether the worker did his

birds

green r

came

gu

b

job with the help of modern, mechanized marvels or with his own two hands. And hard-working people defined Westerly. Home was not a place to escape from in some sleek metaphorical conveyance. Home was a workplace, the working-man's environment, ennobled by the labor of his forebears. Human labor was the communal hallmark of home, the operative value system of Westerly in its productive past, in the jobless year of 1939, and in the future, when work in the quarries would surely resume.

The intimate connection between home, work, and communal identity accounts for the bitter dispute that erupted in Kellogg, Idaho, in 1939 when an artist submitted a mural design showing a fatal accident in a local lead mine. The pictorial equation of work with catastrophe was intolerable to the public. On one level, work and the opportunity to work were subject to calamity on a daily basis. Jobs were hard to come by and easy to lose, yet the mural promised to recall the specter of imminent joblessness forever. On another level, accidents were a fact of life in the mines, as the Section was quick to note. But an irrevocable merger of the local workplace with pain, death, and tragedy presented a negative portrait of home, a critical statement incompatible with the self-protective attitudes of those who lived and worked in Kellogg.

Work in local industries was a very popular mural theme throughout the '30s. The industrial murals that aroused the most ardent local enthusiasm, however, strike the modern eye as the most boring and uneventful of all Depression images. Indeed, the best-loved work murals scrupulously avoided any suggestion of drama, tragic or otherwise, and illustrated with deadpan earnestness the mundane rituals of making a living as a steel-puddler or a cheese-tester. In a sense, by excising abnormalities from factories and mines and by stressing the absolute, unheroic ordinariness of productive labor, work murals became talismanic objects or fetishes. They gave tangible form to hopes for a future in which going to work would be the most routine of human activities.

When Kellogg, Idaho, opted for a mural recreating a legendary scene out of local history, its citizens (like their counterparts in Towson and Westerly) were making a declaration of considerable interest. They were choosing a stable, immutable image of home, insulated by time from the accidents of the present. Historical themes were the popular alternative to the restless, futuristic motion of the technological mural; the choice of history bespoke a commitment to one's

roots, to coping with the problems of the '30s on one's home ground, rather than fleeing toward some chimerical new frontier. Apart from work fetishes and the occasional landscape, mural iconography of the Depression seldom contended directly with the unpleasant facts of the present, save through the language of metaphor. "Now" is not to be found. The center is missing. Around that missing center, imagery polarized sharply into wishful projections of a wondrous tomorrow and wishful reminiscences of a serene yesterday.

The vast corpus of historical murals analyzed in Chapter Four falls into two distinct groups as well. The first and slightly smaller category of history paintings is composed of distinctly queer pictures of what, for want of a better term, might be called "American Stuff," the idiosyncratic local lore often dispensed in the WPA tourguides to America's backroads. The second category is made up of costume pieces reconstructing the moment at which a town was founded. These "American Genesis" pictures constituted the largest single imagistic type painted under Section auspices; foundation pictures were popular throughout the period and were sought after by citizen groups in every part of the nation. The historical mural is, therefore, the surest index of American taste in the '30s.

The American Stuff heading includes depictions of strange events, dubious "firsts," peculiar doings, and the humble origins of heroes who attained national fame elsewhere. The diverse, often zany topics defy classification, but guidebook themes do share several traits. Their specific themes are defiantly provincial and deliberately obscure: in that sense, American Stuff murals are local ripostes to the cultural homogeneity enforced by media America. They are expressions of a stubborn grassroots regionalism of local fact, very much at odds with the stereotypical universality and mass orientation of Regionalist painting. Indeed, without an official Section report on the subject matter in hand, most American Stuff murals are pictorially incomprehensible to motoring gadabouts who did not have the good fortune to have been initiated into oddball regional folkways at birth. These are homeloving, homebound murals. By creating a new local folklore—a new regional mythology—and by cannily maintaining that the nice little boys who left their towns and villages to achieve historical notoriety would have been much better off at home, this brand of fairytale Americana emphasized stability and provided a stay-at-home citizenry with ample cause for self-congratulation. The rude past, frequently made ruder still in painted form,

provided a benchmark in time against which the contemporary situation, never visible, could be judged. The past became a source of pride and comfort at a disturbing point in ongoing history, when both were welcome anodynes to hard times.

American Genesis pictures, highlighted in Chapter Four, are seldom arcane or amusing. Like work murals, they seem, apart from a quaint detail here and there, exceedingly dull. Foundation images, however, provide the key to the metaphorical code in force in New Deal murals. These scenes are related to work pictures inasmuch as they show the productive human activity that launched the town where the mural hangs. People worked together in the American past, and they accomplished something the onlooker can observe for himself in the nonaesthetic realm, outside the world of the picture: the existence of the '30s town verifies the pictorial statement. Mural history is usable history, therefore, inculcating a palpable sense of stability by demonstrating temporal persistence. Historical continuity also serves a second function. The past, redeemed for the present generation by communal work, possesses a fixed set of iconographic attributes: people work, communities strive harmoniously together, and effort is always rewarded with signs of material abundance, prosperity, and order. Murals in Granville, Ohio, and Rome, New York, for example, recompense local pioneers with lush vegetation, ample foodstuffs, and tidy homes. They are further rewarded by spiritual serenity, by protection against all disruptive external forces. In the Granville mural, an interlocking network of formal design knits the pioneer band together and seals it off from any intrusive entity foreign to the self-referential infrastructure of the painting. In other Genesis images, the edenic past is protected by the very fixity of the painted image on the post-office wall. The mural itself freezes and enshrines the idyllic pioneer past forever.

Although the missing center of New Deal cultural history—the calamitous present—is not portrayed on the post-office wall, the values and especially the hopes of the '30s reside in the pictorial contents of these historical tableaus. Working, building, and achieving; snug houses and good things to eat; an orderly life; protection from catastrophe and disaster emanating from outside the community: these are the topics addressed in American Genesis murals. Because the past serves as a repository for the dreams of the present-day generation, and because the historical moment depicted stands in an implicit causal relationship to the present-day town, Genesis

murals also constitute "An Article of Faith" in the future of the community. They are psychic bridges, anchored at one end in the local past and vaulting over the present into tomorrow: historical continuity invokes and guarantees a future of dreams come true for those who believe in work and home and neighborly cooperation.

The enormity of townspeople's spiritual investment in historical pageants and the anxieties grounded in them were not always apparent to artists or federal officials. Salina, Kansas, and Safford, Arizona, were the settings for particularly acrimonious disputes over the way history ought to be painted. In part, these disputes dragged on interminably because local taste was construed by art experts as a matter of formal preference rather than an urgent expression of psychological needs. To the people of Salina, depiction of real-enough natural catastrophes such as droughts and tornadoes blighted the hopeful, future-oriented content of a series of panels tracing the history of Kansas. To the people of Safford, the presence of painted Indians in a history of the Gila Valley evoked feelings of crisis antithetical to the supposed function of mural decor. Indians had posed a threat to Safford within living memory of townspeople now threatened by economic calamity; unleashing the Apache on the post-office wall ruptured the serene insularity of history and colored it with a pervasive sense of vague menace which seemed to jeopardize the past, the present, and so the future of Safford. People understood, even if art experts did not, that history painting was a rite of community exorcism, allaying self-doubts and healing psychic wounds as neighbors gathered before the Parcel Post window.

Because murals, regardless of their ostensible subject matter, embodied and defended a system of values and because they protected an image of the ideal America and the ideal home ground, the public was apt to read clusters of ideas into paintings—ideas that may or may not have been there. Apprehension played as vital a role in the exercise of popular taste as did positive choice. Fixated by the vision of their own hopes and beliefs hovering over the mural, viewers were inclined to suspect that creative strangers—artists and officials they neither knew nor trusted—may also have deposited a layer of offensive, critical content into the ether. Chapter Five examines this phenomenon through consideration of figural works, with special emphasis upon a miniscule group of murals depicting a subject that never failed to engender suspicion and controversy: the nude.

Institutionalizing social art within a federal mural program did not

automatically erase lay hostility toward the presumptive strangeness of artists nor, for that matter, did it make all artists receptive to the opinions of people who "didn't know anything about art but knew what they liked." Thus a second campaign of protest directed against the painted figures enacting the historical pageant in Salina, Kansas, arose from local resentment at the appointment of painters from distant New York City. Opposition was stiffened by an underlying skepticism about the ability of strangers to treat folks and folks' hometowns as folks perceived them, particularly when the strangers were well-known professional artists. Local chauvinism eventually triggered an attack on art, an attack that reveals the true meaning of those recurrent invocations of "the regional conception of art" in the '30s. Art created by artists—that is, strangers to Salina and to workaday American life, strangers who made art for a living—was perceived as representing feelings and attitudes endemic only to artists. Art therefore was pitted against ordinary people's reality: art was a filtered distortion of the truth. And since the truth was nothing less than the local way of life in America—the value system of the people—then art, until proven otherwise, was fated to be dishonest, elitist, unseemly, indecorous, and potentially immoral. Immorality became the popular, working definition of modernism, a label affixed willy-nilly to all sorts of contemporary painters who enjoyed some measure of critical approbation within the art establishment.

The implication of this folkish link between aliens, art, immorality, and modernism is plain enough: "murals as murals should be" need not be works of art. Nor was it really necessary to look at paintings to discern their merits and defects. It was not, in fact, necessary to look at pictures in post offices either, since "good" murals were always concealed in a sociable miasma of emotion emanating directly from the observing public. The cloud of belief floating over the post-office wall was the evanescent mirror in which the self-image of the public was truly reflected.

The few unclad or semiclad figures painted during the '30s offer deeper insight into the anti-artistic tenor of popular taste. The nude was closely associated with time-honored conventions of art; furthermore, the nude in '30s America was hardly an ordinary fact: live nudes were not apt to turn up in the local post office to verify the painted data. Looking at nudes, therefore, necessitated playing the art game: regarding the object as a work of art and setting aside

one's personal, everyday agenda for the moment of aesthetic truth. Finally, the topic of nudity, like holding a job or securing a community in the midst of economic and social chaos, was fraught with incredible suppressed peril. The nude in effect stripped its audience naked if the viewer declined to regard an undraped body as a specimen of art. If he or she persisted in equating that body with ordinary experience, then personal morality, sexual mores and memories, and all manner of disconcerting feelings intruded themselves into the lobby of the post office. And since those feelings were not the sort of stuff discussed in polite company or in public, public murals containing nudes did not provide socially acceptable mechanisms for venting the private conflicts they created. Emotions were trapped within; viewers sizzled uncomfortably.

During its first major skirmish with the nudity issue, the Section repeatedly described several undraped women exposed in a Washington, D. C., post-office mural as "impersonal" and "almost abstract" nudes. This argument clearly aimed at cajoling the public into drawing a distinction between the perceptions appropriate to assessing a work of art and the perceptions appropriate to assessing pictures drawn from real life. The ploy backfired. The lasting result of the much-publicized scandal in the District post office and the Section's defense of "almost abstract" nudity was the creation in the public mind of an iron link between fine art, nudity, immoral ideas, antisocial tendencies, and—ultimately—modernism. Whatever his or her style, however feeble the artist's claim to standing among the avant-garde, the slightest hint of anatomical revelation thereafter set off dark editorial mutterings about "the contemporary manner," "modern art," and the "abstract" spirit. As the term was bandied about in popular accounts of murals painted in Kennebunk, Maine, and Richmond, Virginia, "modern art" was a dirty word. "Modernism" was a catchall expletive condemning any picture or circumstances related to mural painting that failed to please. Calling someone a modernist was tantamount to calling him a communist: the Kennebunk mural was yanked off the wall on the grounds that it was un-American, modern, "Red," and stuffed with "naked hussies"—a strange, nonvisual description of a cluster of middle-aged ladies in one-piece bathing suits.

Because popular taste admitted of a tangential connection at best between art and the mural, between fine art and social picture-making, avant-garde painting was virtually absent from the Section

program. Chapter Six takes up the story of the only abstract mural, so designated, to grace a New Deal post office and thus returns to the nature of the democratic alliance between the patron, painter, and public and its effect upon the aesthetic orientation of the mural renaissance. Public opinion tended to regard "That Abstract Art Stuff" in one of two ways. On the one hand, modern art—regardless of what specific experimental works looked like—connoted either a quasi-political attack on the moral fiber of America or an elite denigration of popular culture. Modernism was bad and it was snotty. On the other hand, modern conventions of style oozed their way into murals almost unnoticed when the pictures at issue were imagistically legible or when those images corresponded to a progressive, communal self-image.

It is important to realize that the popular reaction to modernism, pro or con, was not premised upon visual evidence or the affinities for shape and color generally associated with taste decisions. Modernism was a formless bugbear. The experts at the Section, however, had a precise visual conception of what was reprehensible about the art of the avant-garde. Washington officialdom had no quarrel with the historical sequence of "isms" stretching, roughly, from Renoir to Cezanne; what I have called Cubist tendencies in the art of the late '20s and early '30s did not bother them either, since American Cubists, like Cezanne before them, were realists. However much they dissected and rearranged the components of the pictorial image, they nonetheless retained it intact. When the Section fulminated against modernism, the bureaucrats meant a second sequence of "isms," beginning with Matisse and Picasso; independent colorism, analytic Cubism, synthetic Cubism, and nonobjectivity of all sorts were the targets of opprobrium because the image was abstracted, compromised, or dispensed with altogether. Hence nascent Surrealism and contemporary "experimental" tendencies in general were greeted with suspicion because images were liable to serve as mere components in a design whose ultimate goal was, in some fashion, extraneous to that image. In short, the Section based the aesthetic criteria governing the mural program upon the social criteria of judgment in force in the public arena. It is my central and surely controversial contention, therefore, that questions of art have very little bearing on mural painting in the '30s. The Section was not an art program. It was, in the final analysis, a social program that employed artists.

This hypothesis, of course, raises serious questions about the sta-

tus of the painter sandwiched between a public and a patron who, from vastly divergent perspectives, arrived at a working consensus about what and how he or she should create, and had the means to enforce that decision. If art was beside the point, what about the artist? The artist was an instrument in the creation of a social dialectic; in that respect, his or her relative unimportance to the mural renaissance approximated the marginal significance of the work as art. Although this brutal fact has been skirted by present-day critics, it has been intimated often enough that the radical avant-garde fared especially badly under federal patronage. The flowering of Abstract Expressionism in the post-war era has been viewed as a pointed reaction against official suppression of experimental art.

If, as I believe, art and artists were among the least of the preoccupations of those concerned with the mural enterprise, it becomes difficult to sustain a case for the deliberate suppression of anyone: art was the neglected proposition. Yet just as the iconography of social non-art was ultimately defined on a kind of quantitative basis, by polling the taste of the many, so the broad stylistic midground staked out by the mural movement was delineated on a quantitative basis, too. Academic art, being right of center, received little encouragement, because a wholehearted commitment to the past excluded the academic from full participation in the problems of the day, although his or her art often met the social criterion of legibility. Few academic artists applied for Section jobs. Experimentalists who were left of center received little encouragement, because a commitment to the future supposedly excluded the modernist from contemporary problems. There were, however, few committed modernists seeking work with the Section.

Whereas popular mural imagery was characterized by a missing center, hemmed in by pictorial flights toward the historical past and the anticipated future, the underlying content of the mural was always grimly contemporary. The social dialectic was firmly mired in the Depression epoch, in the troubled present, in that missing pictorial center. The iconographic center was where America lived. It was home. The stylistic center, or so the weight of evidence suggests, was the contemporary home of the American artist. A stylistic midground of pictorial legibility, tempered by admixtures of formal experimentation, was home ground to the vast majority of American painters. The majority occupied this center point, and the flanks were held by

two exceedingly small minorities for whom questions of art were more important than questions of national identity and national destiny. Most people and most artists occupied the social center, the gathering place of an embattled democracy. The federal patron watched over the painter and the public as they met there to dream and hope and reminisce together. That place, of course, was the post office, in the heart of Mural America.

1

The Patron, the Painter, and the Public
Beginning at Aiken, South Carolina

Aiken lies on the west-central border of South Carolina, a stone's throw from Augusta, Georgia. In 1938 Aiken was, to all appearances, just another sleepy Southern town ravaged by the Great Depression. Aiken was, or seemed to be, a most unlikely setting for a nationally publicized battle over aesthetic preferences, federal art patronage, and the cultural aspirations of the New Deal.

Of course, an alert field agent from the Section of Fine Arts, had such missionaries of beauty been abroad in South Carolina in 1938, might have detected signs that the mood of the South was a more elusive proposition than the magnolia-scented somnolence of legend and that the mood of Aiken was positively testy. The Depression had brought rapid change to South Carolina. Visible scars of the Crash were perhaps difficult to find in such a sluggish, agrarian economy, but obtrusive symbols of Washington's response to national trauma were not. Public-works projects, designed to create jobs and stimulate the flow of cash, were beginning to blanket the state in 1938. Eleven federal buildings were on the drawing board or under construction; three had already been completed. Walterboro and Winnsboro had brand-new post offices. Aiken had a brand-new courthouse.

In Walterboro, Colleton County folks were pleasantly stunned by the unaccustomed ministrations of their government. The local innkeeper recalled that "when the Post Office was being built . . . the townspeople stood around in the street watching the process. It was

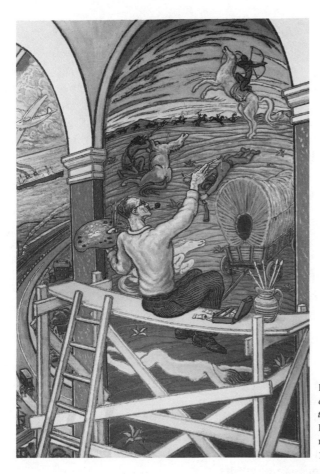

Harold Weston, detail, *Procurement Division Activities*, Procurement Division Building (Treasury Department), Washington, D.C. 1938. National Archives.

. . . the first new building that they had had in their lifetime[s]."[1] In Aiken, the appearance of "WPA" work crews elicited a different response. The fancy courthouse was scheduled to be open for judicial session exactly five days each year; when crowds gathered in the street bordering the work site, it was to swap escalating rumors about the cost of this federal folly. Uncle Sam was spending a lot of scarce dollars on the Aiken Court House; people asked, "What for?"[2]

By the time the U.S. Judge from Charleston arrived that fall to convene his circuit court in Aiken's white elephant, people were in a decidedly hostile frame of mind. Annoyed that the courthouse had been built in the first place and stung by the presumption of whatever alien bureaucracy had foisted it off on Aiken, the citizenry had made the edifice a focal point of their disgust with crackbrained New Deal schemes to coddle shovel-leaners and boondogglers at the taxpayers' expense. The courthouse was a rankling symbol of everything

that was wrong with the world in September of 1938—namely, "the WPA" and its pushy minions from Washington, D.C., who could sneak into the sovereign state of South Carolina and put up a useless courthouse without so much as a how-de-do to the natives of Aiken.

Meanwhile, in a studio in far-off Bennington, Vermont, and in total ignorance of the rancor brewing in South Carolina, Stefan Hirsch was painting a mural for the new Aiken Court House. And Hirsch was having problems of his own with Washington bureaucrats, albeit not with officials of the WPA. Hirsch was under contract to the Section of Fine Arts, a division of the Treasury Department charged with securing "art of the best quality available for the embellishment of public buildings."[3] Although the popular imagination of the '30s never quite grasped the distinction between the Section and the WPA's Federal Art Project, the differences were vast and hinged upon the New Deal's chronically bifurcated vision of the Great Depression. Given the dismal facts of wholesale unemployment and social disruption, it was still possible in the months following the inauguration of Franklin Delano Roosevelt to view catastrophe pragmatically or idealistically. Economic collapse posed problems for which immediate, short-run solutions were desperately needed; the work-relief programs of the WPA ultimately answered those needs. But disaster also created unprecedented opportunities for a sweeping reform of American life. The Section mural that was bedeviling a Vermont painter and would soon enrage a South Carolina town was a byproduct of this messianic impulse.

One of the more curious features of '30s history is the attention paid to murals and painters by New Dealers engaged in the ideological dialectic between reform and relief. To the man in the street, art was, at best, a marginal luxury, an acquired taste. Even Holger Cahill, an arts partisan and director of the WPA's FAP, was forced to concede that modern American painting spoke "to a very limited number of people" and that "an understanding of its self-communicated mysteries was . . . limited to a few initiates."[4] Despite Cahill's justifiable pessimism, circumstances bred by the Depression prompted other observers to detect a healthy erosion of artistic elitism, already in progress; with federal intervention, they argued, an American Renaissance was surely in the offing. The promise of cultural rebirth from the ashes of despair—the promise of a democratic, public, people's art of mural painting—glimmered before the eyes of painter George Biddle in May of 1933, when he sat down to write

a remarkable letter to the President of the United States. Biddle seized upon a nodding acquaintance with FDR to propose a revolutionary partnership between artist and government. His letter marks the genesis of New Deal patronage.

"There is a matter which I have long considered and which some day might interest your administration," Biddle began:

The Mexican artists have produced the greatest national school of mural painting since the Italian Renaissance. Diego Rivera tells me that it was only possible because Obregon allowed Mexican artists to work at plumber's wages in order to express on the walls of the government buildings the social ideals of the Mexican revolution. The younger artists of America are conscious as they never have been of the social revolution that our country and civilization are going through; and they would be very eager to express these ideals in a permanent art form if they were given the government's cooperation. They would be contributing to and expressing in living monuments the social ideals that you are struggling to achieve. And I am convinced that our mural art with a little impetus can soon result, for the first time in our history, in a vital national expression.[5]

The Roosevelt administration was cautiously interested, although Biddle's obvious enthusiasm for the Mexican mural Syndicate might well have disuaded the faint-hearted. Beginning in 1920, the regime of Alvaro Obregon had subsidized murals depicting a Marxian reading of contemporary events and the Mexican past in a folk-flavored style.[6] Young Americans, Biddle among them, flocked south to serve as mural apprentices, learn the fresco technique, and marvel at the spectacle of art miraculously transformed into a popular and vital component of national life.[7] When the Mexicans came north, however, their murals occasioned scandal and shock.

On May 9, 1933, the very day Biddle wrote his letter in praise of the Mexican example, John D. Rockefeller, Jr. ordered Diego Rivera's mural in the new Rockefeller Center covered and expunged because a prominent portrait of Lenin "guiding the exploited masses toward a new social order based on the suppression of classes . . . in contrast to the war, unemployment, starvation, and denigration of capitalist disorder" struck that capitalist as an inappropriate guardian angel for the portals of his monument to American business enterprise.[8] As Nelson Rockefeller gently reminded Rivera, the "piece is beautifully painted, but it seems to me that the portrait appearing in this mural might seriously offend a great many people. If it were in a private house, it would be one thing, but this mural is in a public building and the situation, therefore, is quite different."[9]

The Rivera debacle—he called it "the Battle of Rockefeller Center"

—became a cause celebre: the startling propaganda power of mural art, unleashed in a public arena, forced painters, critics, and ordinary citizens to weigh the principle of freedom of expression against the countervailing rights of a majority that did not share Rivera's communistic faith.[10] The debate seemed especially crucial in the wake of a controversial mural exhibition mounted by the Museum of Modern Art in 1932 to open its headquarters on West 53rd Street, a gallery backed by Rockefeller money. The catalog accompanying "Murals by American Painters and Photographers" admitted that the show had been "stimulated in part by Mexican achievement," yet the mural sketches destined to receive the lion's share of attention were blatant copies of Syndicate models glorifying the *Class Struggle in America Since the War*, exposing *The Last Defenses of Capitalism*, and heralding *The Triumph of Lenin*.[11]

Did the promised American Renaissance mean the face of Lenin, glowering down from the walls of the Justice Department?[12] Would federal art patronage presage the revolution of the clenched fist, the hammer and sickle?

If Biddle's letter made Franklin Roosevelt pause to consider these troublesome possibilities in the spring of 1933, the President might have taken comfort from the few domestic alternatives to the Mexican canon. And the alternatives were not numerous. The United States lacked a strong tradition of mural painting. Forbes Watson, former editor of *The Arts* magazine, who served as adviser to the chief of the Section and was resident apologist for that program, explained the deficiency succinctly in his foreword to a compilation of early Treasury designs: "Back of all great mural painting is a belief."[13] The mural is, by nature, a social art form; historically, mural painting had flourished under the institutional protection of church or state and expressed beliefs shared by patron and audience. In a pluralistic democracy, which guaranteed freedom of religious and political conscience to each citizen, what belief, except perhaps that of commitment to the rights of the individual, could official art embody without impinging on those same constitutional liberties?

Content was a major stumbling block to the democratic mural, but style presented equally thorny problems in a climate of multiple "isms." Should the state-sponsored mural skirt the Scylla of controversial content, it might still founder on the Charybdis of personal preference. There is no accounting for taste. One American's dream of beauty is another's nightmare of ugliness. At those rare junctures

when Congress, with due trepidation, ventured to commission murals for national monuments, the results were predictably disappointing. Constantino Brumidi's decorations in the U.S. Capitol, completed after the Civil War, are a case in point.[14] An art that aims to please everybody and offend nobody is not the great art Watson equated with ardent belief. Brumidi's visual pablum offered feeble inspiration to the fledgling muralists of the 1920s who were struggling to build an American tradition under commercial auspices.

The commercial boom of the '20s touched off a construction boom, for corporate architecture was advertising on a grand scale. Tastefully appointed public amenities served to solidify the company image, lure the consumer, and boost the civic pride ballyhooed by the go-getters of the Chamber of Commerce. It is ironic that mural art in America was proving to be a staunch ally in the capitalist crusade at the moment when Rivera, in the frescoed courtyard of Mexico City's Ministry of Education, was foretelling the demise of the free-enterprise system with a savage lampoon of John D. Rockefeller, portrayed as a senile old ruin dining on ticker tape washed down with a tumbler of illicit gin.[15] As a high-toned form of interior decor, wall painting was uniquely suited to the heavily trafficked halls of American trade. Murals were immune to the ravages of the few poor pilferers among the prosperous crowds and lent otherwise mundane shops and offices a Medicean luster. Murals made movie theaters the palaces of the '20s and department stores cathedrals of capitalism.

Even before the advent of the talkies, theater decor had proven as crucial to the box-office take as the current Mary Pickford hit. For the price of admission, fans could bask in the splendor of the Pharoahs—and the more splendid the lobbies and lounges, the more often people paid to live vicariously in the luxury of make-believe. Grauman's Chinese Theatre in Hollywood transported patrons to the exotic Orient for the cost of a matinee ticket; Loew's State in Cleveland aimed for the gilded grandeur of a Palladian villa adorned by a latter-day Tiepolo.[16] The State was among the first theaters equipped with murals in the heat of the glamor competition between moviehouse magnates "Roxy" Rothafel and Marcus Loew. Flanking ersatz marble staircases that swept from popcorn stand to loge was an elaborate treatment of "The Four Continents" by James H. Daugherty, completed in 1920.

The American continent was represented by *The Spirit of Cinema America*: a director in regulation knickers, a boy scout, and a little

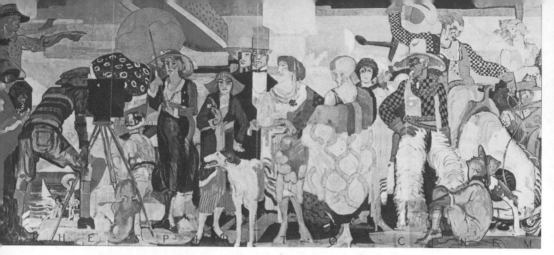

James H. Daugherty, *The Spirit of Cinema America from The Four Continents*, Loew's State Theatre, Cleveland, Ohio. 1920. Playhouse Square Foundation, Cleveland, Ohio.

girl admired assorted cowboys, bathing beauties, vamps, and Injuns from Central Casting. Daugherty's style was tentative, eclectic, and frankly decorative. Unlike his Mexican counterparts, who were prone to score didactic points by making big heroes unduly big or stuffing the abused "masses" into impossibly oppressive cubbyholes, Daugherty lined up his smiling actors in a neat, even row, facing their public. All inhabit the same shallow stage. The frieze arrangement harked back to the turn of the century. The enlarged magazine cover by Maxfield Parrish that passed for a mural in the Girls' Dining Room of the Curtis Publishing Company in Philadelphia marshaled pseudo-Renaissance courtiers in parallel ranks and dressed them in costumes ablaze with contrasting patterns.[17] Daugherty borrowed the spatial frieze, along with the checkerboarded, curlicued, polka-dotted, and striped clothing, in a half-hearted attempt to harmonize his painting with the surface of the wall. In the same cause, Daugherty ironed out the sky or backdrop tucked away behind the file of movie extras, where he also abandoned the illustrator's bag of tricks for a daring excursion into Cubism. Long, irregular rectangles of mauve, cerise, and gold picture nothing in particular. But they do echo the fashionable colors of the actors' costumes and lend the scene both a theatrical unreality and a piquant flavor of modernity, à la Picasso.

The Loew's State murals fulfilled their commercial function admirably. Bright color made the lobby cheerful and gay. A surfeit of jangling pattern struck the eye as rich and very smart. The parade of Hollywood types in gorgeous regalia aimed only to charm and amuse. Daugherty's art, in other words, could pass for elegant wallpaper. A vital national tradition was not to be created overnight,

however, and ten years passed before American muralists and their nervous patrons were ready to abandon "the pretty posture and the tactfully empty space" of handpainted corporate wallpaper.[18] In 1930 that moment arrived with the unveiling of two large and influential mural cycles that signaled the emergence of a mature native movement. One was Boardman Robinson's *History of Trade*, a ten-panel ensemble for the mezzanine of the Kaufmann Department Store in Pittsburgh. The other was Thomas Hart Benton's nine-part panorama of *America Today* at the New School for Social Research in New York City.

Begun just before the Crash of '29 and finished just after the Wall Street fiasco that so cheered the Mexicans, *The History of Trade* is the apogee of the evanescent boom in commercial wall painting. Robinson tinted his enterprising Carthaginians, Venetians, and Yankee traders with autobody paints from Detroit. Like the Loew's State pictures, then, the Kaufmann murals were loud in tone and celebrated a moderne present through the impact of clear industrial primaries. With the force of a roadside billboard, shiny patches of pure red and blue and yellow and green telegraphed the presence of this hymn to commerce across the cluttered counters of the shopping floor and proclaimed the largesse of the astute corporate patron of the finer things. Modern, too, was Robinson's

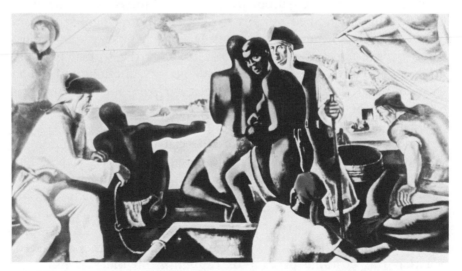

Boardman Robinson, detail from *The History of Trade*, Kaufmann Department Store, Pittsburgh, Pennsylvania. 1930. (Photo: the author)

Thomas Hart Benton, *America Today*, New School for Social Research, New York City. 1930-1. The New School for Social Research, New York. (Photo: Helen A. Harrison).

insistent stress on the planes and edges of forms, especially evident in the scraps of scenery that added historical authenticity to each separate tableau. Had Cezanne or Picasso ventured to immortalize the activities of *Dutch Traders in the Baltic*, they would have unerringly hit upon the cutout facades and faceted sailboats with which Robinson fleshed out his story. The thoroughgoing Cubism of the Kaufmann murals transcends Daugherty's jazzy quotations. Robinson's Cubism is a sober effort to solve the formal problem of painting three-dimensional reality on an architectural plane without negating the structural integrity of the building, and this high degree of aesthetic seriousness lends a complementary mood of dignity and gravity to the episodes pictured.

Under Robinson's brush, the commercial mural lost its brash insouciance. Despite factory-fresh colors and streamlined shapes, *The History of Trade* possesses the monumental solemnity of a fresco by Piero della Francesca, as the saga of commerce slowly unfolds from primitive origins to a triumphant culmination in a Pittsburgh still heedless of the perils of prosperity in the waning '20s. Despite cubistic simplifications and compressions of form, the characters enacting this costume pageant of capitalism on the march are instantly recognizable human beings. Accurately rendered props and accessories distinguish the Englishman in Canton from the slave

trader in Africa, while gestures and poses make the narrative import of their appearance plain. Albeit modernistic, semi-abstract, and — by some operative standards of the day—radical, degenerate, and ugly, style does not impede appreciation of story line, the historical epic which was Robinson's principal contribution to the gathering American Renaissance.[19]

Robinson taught the new American mural of the '30s to tell a story, and a kind of story uniquely suited to the public arena. Ideologically blameless—save perhaps, to a rabid Marxist—*The History of Trade* retreated into the fixed, incontrovertible domain of the past. In 1930 Americans might not have agreed with Herbert Hoover's belief that "the worst effects of the crash upon unemployment will have been passed during the next sixty days," nor would *Literary Digest* polls have disclosed unanimity of opinion on the merits of Garbo's performance in *Anna Christie*, or Sinclair Lewis's chances for winning the Nobel Prize, or the probable outcome of the Army-Navy game (Army won, 6-0).[20] Belief and opinion were mercurial, individual passions. But history was a matter of cold, hard fact. Ancient traders had plied routes to the Indies. Although Charles Beard could have questioned the motivations and consequences of their treks, Robinson's innocuous treatment of the theme invited no such speculation on the part of the casual shopper. Stolid figures, all of them executed in an identical palette of red and blue and yellow and green, pose serenely, the group on the right always echoed by the group on the left, pantomiming what becomes a secular ritual of exchange when the same symbolic arrangement occurs again and again and again.

Boredom is not quite the right word to describe the cumulative effect of this repetitive ritual. Chromatic intensity saves *The History of Trade* from that fate, and compositional regularity also sets up a lively decorative rhythm across the wall. Yet the Kaufmann murals are emphatically deficient in the passionate fire that would soon make Rivera's work controversial. The history of commerce, of course, does not offer the same dramatic possibilities as, say, the history of warfare or a skewed history of "capitalist disorder," nor would Kaufmann executives have sanctioned the kind of pictorial diatribe the Rockefellers rejected. At the same time, however, Robinson's placid sequence of imaginary views of times long past seems calculated to elicit little more than a "ho-hum" from the viewer. Precisely because it is dead and gone and disengaged from the tur-

moil of the present moment, history is a safe theme for the public mural. Events like those pictured probably did occur; in any event, few would care enough about Carthaginian traders to dispute the matter. Old-fasioned dress and faraway landscapes and quaint details are all interesting, too. They hold the mild fascination of the plates in picture encyclopedias, but they are scarcely the stuff of which mass outrage is made.

Historical reconstructions—detractors labeled the genre "American-history-in-costume"—became the favorite subject matter of artists commissioned to paint post-office and courthouse murals by the Section of Fine Arts, once New Deal patronage assumed definitive bureaucratic form in 1934.[21] And many painters followed Boardman Robinson's prudent lead into the pages of history out of self-defense, in order to spare themselves and the government the embarrassment of coping with unforeseen citizen objections to interpretations of timely, hence debatable, topics. History painting was something more than an exericise in expedience, however, as the Kaufmann murals showed. *The History of Trade* moved, with the monotonous drive of inevitability, from a distant, foreign past to a contemporary American present. Whether the cycle is read from the vantage point of the painter, shaping his message in the final days of the frenetic '20s, or the shopper, seeing the results in the opening days of the chastened '30s, the plodding continuum of history links a modern American experience with the saga of time itself. History validates the present and lays its uncertainties to rest; contemporary commerce takes its place in a smooth, unbroken flow of events. Whatever the problems of Pittsburgh and its business community in 1930, the emotional weight of nine virtually interchangeable glimpses of trade as a historical constant serves not only to enshrine the tenth instance of buying and selling at the pinnacle of a hallowed progression but also suggests that the sequence can and will continue ad infinitum, in much the same fashion.[22]

Robinson's brand of history is therapeutic, a "usable," useful past that cushions the shocks of a confusing, topsy-turvy now.[23] "Driven by a pressing need to find answers to the riddles of today," novelist John Dos Passos also found his antidote to the unsettling world of the Great Depression in history. "We need to know," he concluded, "what kind of firm ground other men, belonging to generations before us, have found to stand on."[24] The soothing generalities of the

Kaufmann murals failed to supply crisp answers to the riddle of economic collapse, but *The History of Trade* did map out the pictorial ground upon which the American muralists of the '30s could take their stand, with a legible presentation of facts divorced from the disputations of the day and redolent with confidence that time's passage would mold the future in the stable image of an imagined past.

By 1930 Thomas Hart Benton had had his fill of stability and history. After laboring for seven years over a group of uncommissioned and never-to-be-installed mural panels collectively entitled *The American Historical Epic*, he found himself eager to confront the present, the "energy and rush and confusion" of everyday life in the United States.[25] Along with his friend and apologist, critic Thomas Craven, Benton was attracted by the prospect of a "usable" mural art, although he did not equate utility with a particular choice of subject. Rather, painting a mural was a useful act, in and of itself.[26] When he abandoned the privacy of the studio to work under the spotlight of public scrutiny, the artist made a social statement. He tacitly renounced elitism—the option to concern himself with "art for art's sake" or art for the connoisseur alone—in favor of a collective expression, a middle ground between the professional's legitimate interest in aesthetic verities and the nonaesthetic preoccupations of the man in the street. The mural was "usable," therefore, in two distinct ways: it pulled the artist back into the social mainstream and provided the pictorial forum for mutual consideration of national problems. Benton countered Robinson's "usable past" with his own commitment to a usable present—to murals grounded in contemporary life, stylistically and iconographically "arguable in the language of the street."[27]

The *America Today* cycle in the New School for Social Research addressed the usable present.[28] The diversity of *City Activities* dominates two bustling panels: people go to the movies, the prize fights, and the burlesque show. They dance in speakeasies, check the broker's stock ticker, congregate in soda fountains, ride the subway, preach in the Bowery, and neck on park benches. Benton and Craven comment on this portion of the action when they appear beneath a circus scene, drinking a toast to "the recognition of things as they were and are."[29] In the country beyond Manhattan Island, the tenor of life grows more serious. Steel is forged, mines are sunk, timber

felled, and grain harvested. *The Changing West* buries a cowboy past beneath a forest of oil derricks and cracking towers. *The South* replaces slave labor with the mechanical cotton picker.

The seven segments of the New School decoration which deal with agriculture and industry betray a lingering attention to history insofar as old work habits are juxtaposed with the new technology, but Benton's chief object is recognition and acknowledgment of "things as they are" in 1930. Reality includes the modern machine and popular entertainment and more than a touch of urban iniquity. These are only aspects of contemporary life, however; the salient characteristic that binds discrete incidents into a coherent whole is the dynamic energy of the ordinary American, who works and plays with a ferocious, titanic gusto.

The figures, drawn like animated cartoon characters, defy orthodox anatomy. Double- or triple-jointed, their lanky bodies twitch at more angles than nature intended. Arms akimbo and fingers tapping, Benton's farmers and floozies diagram kinetic energy poised for release. Elimination of a middle distance in the New School murals makes the observing eye twitch in syncopation with this irrepressible vigor. Large-scale forms stand very close to the picture plane and small ones cower on a distant horizon. Air itself is energized as the viewer finds himself alternately jerked deep into space and catapulted abruptly out of it. And because the mural surface is segmented by strips of applied molding, a dizzying array of vignettes can coexist side by side in the same picture: a park gives way to a mission and a mission becomes a subway car at rush hour. Attention jolts nervously from one focal point to the next. Discontinuity mirrors the lively confusion of Everyman's America.

Juxtaposing episodes that do not have a common depth or topic or scale recalls cinematic montage, the popular realm to which the impossibly flexible bodies of Benton's heroes belong. In practice, Benton lifted the technique from the tabloid section of the daily newspaper, where an assortment of photographic images, cropped in decorative shapes and framed by geometric borders, spilled willy-nilly across rotogravure pages.[30] In movies and newspapers, montage heightened the impression of simultaneity, of contemporary action and incident appreciable in their own right and set down without explanation or judgment. This is Benton's aim: the profusion and variety of experience pour across the walls of the New School. The murals are "arguable in the language of the street" because the visual

vocabulary of *America Today* comes from the popular media. The man in the street can recognize sights he has seen and things he has done. He can also recognize the fact that this message is for him, because its pictorial conventions are those of everyday life. Benton has renounced the rarefied language of the studio to speak the argot of 42nd Street.

The Kaufmann murals were dominated by historical plot. Story line binds together and sustains the covert meaning of the cycle: yesterday provides a blueprint for tomorrow and nurtures renewed confidence in today. *America Today* is essentially plotless but achieves a comparable unity through Benton's forceful contention that energy is the hallmark of American life. As the Depression deepened, the dynamism of the New School murals promised that this powerful race of doers could find a way out. The change, confusion, and turmoil of the day were incidental by-products of an American itch to act. The plain man and women, objectified and glorified in *America Today*, constituted Benton's apolitical, ahistorical solution to the problems of 1930. His artistic act of faith in America was premised on their creative force.

The New School murals gave Section painters an alternative to renditions of *Lincoln as Postmaster in New Salem*, *Experimenting with the First Model of the Cotton Gin*, and *Episodes in the Life of John Brown*.[31] The working people of America—and the industries, occupations, and pastimes they pursued—became an important theme for the federal mural in the jobless '30s, in the face of critical and ideological reservations about Benton's seminal excursion into the contingent present. By choosing to look at the positive, colorful side of the national picture, while ignoring the negative and controversial, Benton alienated the political left. "The radicals," he reported, "were mad because I didn't put in Nikolai Lenin as an American prophet."[32] The Director of the New School, for example, adopted Rivera's perspective when he bewailed the fact that *America Today* showed the "gigantic, inhuman machinery of industrialism with never a pathetic note for the wage slave operating it."[33] Alma Reed, Benton's own dealer, yoked aesthetics to ideology in her invidious comparison between *America Today* and the Mexican protest mural. Whereas the latter attained a timeless validity by appeal to what she deemed transcendent ethical values, Benton's temporal specificity— his populist delineations of the contemporary minutia of the bootleg still, the current fashion, and the brand-new tractor—threatened

to date his pictures within months of completion.[34] Without Lenin, Benton's usable present was an egregious fantasy, another specimen of artistic preciosity, rightly doomed to the inertia of the museum artifact, Reed implied.

Thanks to Rivera, Lenin figured prominently in Washington discussions of George Biddle's proposal to put muralists on the federal payroll "at plumber's wages." Roosevelt told Biddle that he was interested in patronage—"the expression of modern art through mural paintings"—and referred his letter to the Procurement Division of the Treasury Department, which supervised construction and embellishment of public buildings.[35] But even as he did so, the President must have had misgivings about the political wisdom of supporting art for its own sake in the throes of a Depression.[36] Biddle, who rapidly enlisted Benton and Robinson to lobby for a mural program, was primarily interested in art patronage. He envisioned formation of a subsidized consortium of "a few . . . creative artists of the first rank . . . experienced in mural painting."[37] Harry Hopkins, Roosevelt's relief czar, saw government support as a means to alleviate the plight of needy artists, experienced or not, good, bad, or indifferent. "Hell!" he growled. "They've got to eat just like other people."[38] Roosevelt did know that he wanted no part of a plan to foster art for the sake of leftist ideology; he did not relish the prospect of "a lot of young enthusiasts painting Lenin's head on the Justice Building."[39]

In December of 1933, when a meeting was called to hammer out the details of the first New Deal art program, the Public Works of Art Project, these issues were still unresolved. Others, such as questions of style raised by Biddle's ad hoc alliance with Benton, the populist, and Robinson, the Cubist, had yet to be recognized as issues. Presidential confidante Rexford Tugwell sounded more than half-serious when he proposed to handle all contingencies this way: hire as many artists as possible, give them complete freedom of expression, keep the good work, and whitewash all the rest.[40]

The mural emphasis of Biddle's letter made the Treasury Department, custodian of the nation's walls, the locus of strategic planning for detente between government and art, although the PWAP, as its mission came to be defined, was not exclusively or chiefly concerned with wall painting. Funded by a grant to the Treasury from Hopkins's Civil Works Administration in the winter of 1933, the PWAP was nominally a work-relief program. Destitute artists were to explore as-

pects of "the American Scene" and tax-supported institutions were to become repositories for works commissioned from the public purse. In actuality, the PWAP was the kind of catch-all experiment Tugwell outlined. The pay scale established by the CWA for unemployed industrial craftsmen prevailed: "Group One" artists got $40 a week and "Group Two" artists got $25. "Experience and financial need" ostensibly determined the categories.[41] Means tests were never applied to the 3,749 men and women hired, however. In fact, nearly half of those who served with the agency were not eligible for relief on the basis of economic hardship. Artists with recognized talents were courted and elevated to the peak of the wage scale. To accommodate all comers, a broadly based assistance program needed a cadre of experts equipped to give technical guidance in pulling a print, priming a wall, and the like. But Washington was also eager to justify expenditures by pointing to works of outstanding quality and clients of proven reputation.

During the seven-month lifespan of the PWAP, murals of merit were executed by well-known painters: Grant Wood's decorations in the Iowa State College Library at Ames won national praise.[42] To the public eye, the mural accomplishments of the project looked more spectacular than the fifteen thousand smaller prints and easel pictures and statues finally inventoried. Most people thought that the mural was the sole artistic interest of the New Deal, and PWAP officials were forced to issue disclaimers.[43] That four hundred mural ensembles were undertaken, in the face of severe constraints of time and budget, testifies to a powerful source of support for this, the chosen vehicle of cultural renewal. In any case, the popular equation between federal sponsorship and the mural was not entirely fallacious. The quirk of fate which had delivered art into the hands of the Treasury Department assigned leadership of the PWAP to a Treasury lawyer who was a vociferous prophet of the American mural Renaissance.

Edward Bruce was a man of many parts—executive, economist, corporation counsel, semi-professional painter and muralist, public servant. He was, as well, a seasoned bureaucrat who understood the ways of Washington, and it was to Bruce that the Treasury turned when faced with the Biddle plan. Unlike Biddle, Bruce did not perceive an intrinsic connection between the subject content of public art, the social philosophy of the New Deal, and the prospect of a second, Depression-bred American Revolution. Yet his views on the

potential relationship between art, society, and government in an epoch of crisis were, in their way, as opportunistic as Biddle's. The young American nation, he maintained in a letter to Eleanor Roosevelt, had devoted all its energies to conquering physical frontiers, at the expense of the artistic development associated with states which "have left the world richer because they have lived."[44] The Depression showed that the United States had reached the limits of material conquest. A spiritual frontier now beckoned. As Italian and French commerce burgeoned because of cultural riches, so renascence on the home scene offered tangible rewards. "No great artistic or spiritual movement has ever developed without a patron," however, he maintained, and under current conditions, government alone had the power to set artists to work on the task of diverting social energies from the closed frontiers of old. In sum, Bruce believed in federal patronage of art of an enduring quality. He was never comfortable with the relief provisions that survived his efforts to make the PWAP a patron of "Group One" masterpieces.

Proponents of comprehensive art relief held to "the principle that it is not the solitary genius but a sound general movement which maintains art as a vital, functioning part of any cultural scheme."[45] Tugwell was willing to "whitewash a lot of walls . . . to salvage good things that are made."[46] Holger Cahill of the FAP later insisted that "art is not a matter of rare, occasional masterpieces."[47] To Bruce, a laissez-faire approach—simple trust that a large quantity of artistic output would cast up something of quality—was philosophic heresy, and in 1933 he had also identified two stylistic heresies against which he felt constrained to do battle, using the mechanisms of official patronage as his weapon. One was academic art, the nymph-ridden nostalgia purveyed by the National Academy of Design. The other was the modernism of the School of Paris, imported and promulgated by the Museum of Modern Art. He condemned avant-garde and rearguard alike on grounds that members of both camps ignored American reality. The modernist invented form. The academic manufactured content. Neither, therefore, created art that reflected the visible truths of modern life, the factual compass of the PWAP's recommendation that "the American Scene should be regarded as a general field for subject matter" in public art.[48]

The effect of the seemingly innocent American Scene proviso was to harness public patronage, from the outset, to a nebulous species of realism, defined by the extremes Bruce chose to shun. Painting the

American Scene excluded radical types of abstract art because the artist, in effect, was required to limit his or her creative activity to matching up some visible element of the environment with a picture that recapitulated the same. Abstractionist Byron Browne put his finger on this covert standard of official excellence and revealed the penalty for deviation from it when he complained that "as my work contains little or no emphasis on subject matter, I was ignored for a long time after the PWAP began to function and then cut off after a period of four weeks."[49] Painting the American Scene excluded academic expression for similar reasons. Gilbert White, commissioned to decorate the Agriculture Building in the last days of the Hoover regime, painted a classical allegory ridiculed by Bruce for "showing a group of ladies [garlanded] in sheaves of wheat and sitting on pumpkins to represent American agriculture."[50] Bruce wanted 1934 model tractors. Gilbert, on the other hand, said that he had tried to conjure up "a work of timelessness, one without locality, a work that will be appreciated 100 years from now."[51] Official realism left little room for timeless dreams and inner visions. Reality meant things, facts, the facts of life in the grueling winter of 1933-34. Or did it?

To achieve nationwide relief coverage quickly, the PWAP relied upon a jerry-rigged administrative structure: the map was divided into sixteen regions, each headed by a local art authority, most often a museum director who knew area artists and had an institutional base of operations from which to conduct project business. Regional chairpersons in turn assembled advisory committees of prominent citizens and officials whose main function was to find tax-supported facilities amenable to receiving PWAP artwork.[52] In theory, regional headquarters disbursed paychecks and implemented Bruce's directives. In practice, decentralization encouraged autonomous developments at the grassroots level that faraway Washington was ill-equipped to anticipate, much less check. The Coit Tower controversy of 1934 exposed the dangers of decentralization. It also spelled out the full implications of the American Scene proviso.

The new Coit Tower on Telegraph Hill was a memorial to the volunteer firemen of San Francisco. The Region 15 committee negotiated with the city Art Commission and obtained permission for a team of twenty-five PWAP artists to paint murals in the stairwells and lobbies of the monument. Project technical adviser Victor Arnautoff, who was himself executing one of the largest of the Coit

Tower decorations—a fresco called *City Life*—was supposed to take a look at his colleagues' sketches as work progressed. Otherwise, Chairman Walter Heil and the regional committee seem to have left the group to proceed on their own recognizance. At any rate, Heil was stunned to discover, several weeks before the Mayor was due to cut the opening ribbon, that the murals were awash in Red symbolism. His wire to Washington conveyed a barely suppressed hysteria:

Certain difficulties concerning Coit Tower. Some artists have at last minute incorporated in their murals details such as newspaper headlines and certain symbols which might be interpreted as communistic propaganda. These things not visible when design approved. Tower not open to public yet but through reporter's knowledge . . . these things have come to editors of influential newspapers who have warned us that they would take hostile attitude toward the whole project unless these details be removed. Trying our best to settle matters tactfully and peacefully . . . However what are we to do if they refuse making changes. Please advise immediately.[53]

The three artists accused of sabotage were not immediately responsive to tactful persuasion. Clifford Wight had painted a sequence of three panels showing *Rugged Individualism*, *The New Deal*, and *Communism*. Whereas the point of his triptych was dubious political prognostication—like Rivera at Rockefeller Center, he used interpretations of past and present as foils against which to project the glories of a collectivized future—Wight was prepared to defend his work from censorship by invoking the American Scene rule. The Coit Tower muralists, he stated, "were asked to depict the contemporary American Scene. The paramount issue today is social change—not industrial or agricultural or scientific development"; hence, his choice of symbols of the change from capitalism (a golden chain) to New Dealism (the blue eagle of the NRA) to the hammer and sickle of "Communism, another alternative which exists in the current 'American scene.' "[54]

Bernard Zakheim's *Library* also smacked of Rivera in the crudely drawn readers pouring over newspaper headlines which featured, in prescient proximity, creation of the PWAP mural program at Coit Tower and local reaction to the destruction of Rivera's New York fresco. At issue in Zakheim's case were the sorts of literature available in his painted library: a tract by Karl Marx with a bright red cover, novels by Erskine Caldwell and the proletarians, and a paper bearing the logo of the *Western Worker*, a Communist Party weekly.[55] Arnautoff's *City Life* used the compact Mexican figure type rather

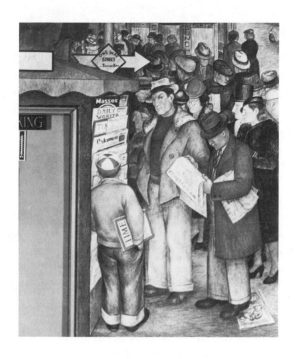

Victor Arnautoff, detail,
City Life, Coit Tower, San
Francisco, California. 1934.
(Photo: University of
Minnesota, Photo Archive)

than the rangy fidgeter of the New School to stand for the average
San Franciscan, but his catholic portrayal of the variousness of the
urban scene, with wholesome and unsavory details given equal weight,
stemmed from Benton. The cavils of the pious press were not direct-
ed at his holdup men or bleeding accident victims, however. What
enraged civic patriots was a newsstand where the *Daily Worker* and
the *Masses* overshadowed a lone copy of *Time*.

Edward Bruce was furious with all concerned. He fired off an omi-
nous telegram to Heil putting every artist in Region 15 on notice
that "propaganda of this kind is hurtful to the best interests of Amer-
ican art and is likely to discourage further government patronage."[56]
Wight's reading of the American Scene proviso was lunacy. The pick-
et line thrown up in support of the spoilers' freedom of expression
by the San Francisco Artists' and Writers' Union was lunatic impu-
dence: "They're welcome to all the propaganda they want but I
don't see why they should do it on our money."[57] Privately, Bruce
wished that somebody—anybody—would "wipe the damned paint-
ing[s] out of the Tower."[58] In the end, the great Coit Tower brou-
haha petered out. In October of 1934 the monument opened to the
public without further mention of Zakheim's *Western Worker* or
Arnautoff's *Daily Worker*, although neither mural had been "correct-

ed."[59] Sometime in September, Wight's Soviet hammer and sickle simply disappeared, without a word of explanation or protest.[60]

The subsequent history of the New Deal projects is peppered with sporadic appearances of the hammer and sickle and paranoid visions thereof. Philip Guston, for instance, was accused of sneaking that Russian insignia into a playtime scene at New York's Queensbridge Houses: the arc of a puppy dog's tail crossed a toddler's ankle at an angle suggestive of the Red emblem, and work on the mural was suspended while WPA troubleshooters peered skeptically at the detail. In one corner of an immense mural ensemble at Brooklyn's Samuel Tilden High School, shadows cast by the tines of a spading fork were said to form the numerals 441, the call numbers of the Communist Party local. A big red star in Arshile Gorky's Newark Airport cycle was hastily repainted in blue. The airport manager feared that the red star could be construed as a free ad for Texaco products. Art administrators feared the worst.[61] These were all FAP murals, however. By 1934 it had already become obvious that no program with which Edward Bruce was associated would tolerate the slack supervisory procedures that courted such dismaying surprises.

The Coit Tower mess taught the Treasury negative lessons it was not likely to forget. The troubled marriage between art relief and art patronage was dissolved upon expiration of the PWAP mandate, leaving Bruce at liberty to pursue the chimera of enduring quality in American public art.[62] Yet from the beginning, that quest proceeded along an exceedingly constricted path of action. The strategy of avoidance shaped regulatory tactics to nip controversy in the bud and to stifle adverse publicity. The Treasury Section—for some four years, the agency was known as the Section of Painting and Sculpture—was formally established on October 14, 1934, by executive order of Secretary Morgenthau.[63] Decentralization promptly gave way to a rigid system of aesthetic watchdogging under which Bruce and his operational deputy, Edward Rowan, set up a schedule of graduated stages for the conception, refinement, and completion of a mural, and personally scrutinized designs at every step for iconographic and stylistic deviations from quality standards. The summer of 1934 found Rowan already reshuffling the old PWAP client file into three stacks marked "good," "medium," and "bums."[64] Although the need for art relief had not abated, Rowan's labors showed that "bums" need not apply; competitive procedures for securing Section commissions let Treasury officials weed out Mexican parti-

sans, abstractionists, academics, and other extremists. The winnowing process, along with punctilious control of work in progress, helped to insulate the Section from public relations gaffes of the Coit Tower kind. Prudence barred the Soviet stars, shadows, and tails which did, in fact, whet Congressional zeal to harass and finally to dismember the WPA/FAP.

Relief programs funded at the pleasure of Congress had every incentive to steer clear of trouble. The Section, however, did not need to submit an unblemished record of good conduct to the people's representatives at regular intervals. Traditionally, one percent of the moneys appropriated for construction of public buildings was set aside for artistic enrichment. By a formalized gentlemen's agreement, arrived at wholly within the Treasury hierarchy, funds once spent on decorative radiator covers and chandeliers were diverted to the new mural program. Control and disposition of the reserved percentage passed from the architect to Bruce and his Section.[65] Hence neither creation nor operation of the Section hinged upon legislative approval, yet it was the vulnerable relief cause which laundered its linen in public and the impervious reform campaign which wrapped itself in a cloak of obscurity. From 1935 until the virtual destruction of the WPA creative arts units in 1939, the FAP courted publicity with quixotic abandon. While Holger Cahill struggled to tell reporters just how his New York City supervisor had come to be besieged in her office by unionized strikers, in a violent incident that sent a dozen painters and police to the hospital and resulted in 219 arrests, the Section usually made the papers in the form of single-column, back-page retractions, correcting previous announcements that the home-town post office had been gussied up by the WPA.[66] Bruce and his staff cultivated, and largely achieved, anonymity; Cahill's name was a household word.

The paradox is difficult to resolve. Until his death in 1943—the Section died with him—Bruce did harbor ambitions to convert the Treasury program into a permanent federal bureau. Judicious tact can account in part, then, for the low profile his agency studiously maintained. But it is hard to avoid the conclusion that the aura of Byzantine secrecy which muffled the day-to-day workings of the Section was a calculated (perhaps a miscalculated) response to the problems of making public art in a troubled democracy. Anonymity was the silent partner of aesthetic reform, Bruce's secret weapon in the crusade to forge an American mural Renaissance under the ban-

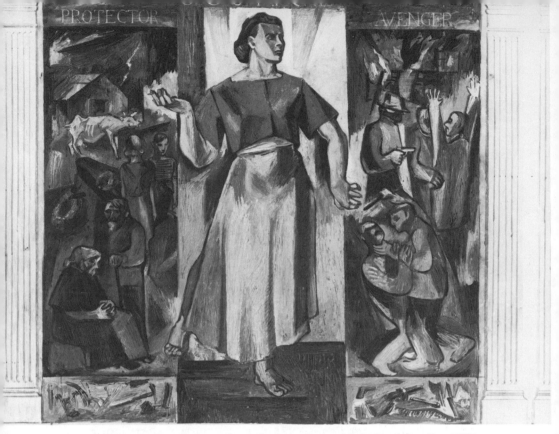

Stefan Hirsch, preliminary sketch for Court House, Aiken, South Carolina. 1937.
National Archives.

ner of enduring quality. The story of the Aiken Court House shows how
and why and where the battle lines of federal patronage were drawn.

In March of 1937, Stefan Hirsch was invited by letter to submit
preliminary sketches for a mural to be installed behind the judge's
bench in the Aiken, South Carolina, Court House. The designated
spot on the courtroom wall, he learned, was a rectangle that measured
about four feet on a side. When his designs were approved, Hirsch
was further informed, he could expect to receive a contract for
services in the amount of $2,200. Judged by prevailing levels of com-
pensation, the Aiken commission was a real plum. Mural painters em-
ployed by the FAP at weekly relief wages could hope to clear $1.80
per square foot. The Section regarded $20 a foot as an optimal fee
for "quality" muralists, but the actual total of reserved funds avail-
able for a given site meant that most awards fell short of the ideal.[67]
The Aiken job would pay better than ten times the going rate. And
$2,200 was a princely sum in 1937, when the best dress suits Sears
and Roebuck had to offer sold for $15.45.[68]

Hirsch was not destined to find a fat government check for $2,200 in his mailbox along with his contract, although as a newcomer to Section procedures he might have imagined himself instantly rich. Payment schedules varied slightly over the years; a pattern of carrot-and-stick inducements to good conduct persisted. Contracts were prepared and issued only after the artist had undertaken research into feasible themes for use in a local community and had worked out convincing pictorial renderings of the topic in color. Greetings from the Section, therefore, did not put cash in hand. Instead, the letter of invitation signaled the start of a demanding correspondence course in what to paint for public consumption and how to paint it.

The visual culture of the decade delimited topic, across an admittedly broad spectrum of contemporary options: there was history, thanks to Robinson; everyday life, courtesy of Benton; and for the adventurous or the angry, the purified future foreseen by Biddle and the social-protest school. Washington confirmed that range of possibilities, in part. When the Section held regional competitions for the decoration of important buildings, artists were provided with a general statement on topic selection. The formal announcement of the 1935 contest for the Barnesville, Ohio, post-office commission is typical: "The subject matter should have some relation either to the post, local history, past or present, local industry or pursuits. This may be interpreted freely." In 1936, after post-office juries had grown weary of "the more obvious symbols of airplanes, trains, packet-ships, etc.," competition publicity added that "the Post Office . . . functions importantly in the human structure of the community. As distinguished and vital a conception as possible along such lines is desired."[69] According to hints like these, a distinguished conception—an acceptable approach—would most readily be found in the usable past or the usable, nonpoliticized present, but the emphasis on the community and the locale introduced a crucial variable.

Public art involved three constituencies: the painter, the commissioning agency, and the people. The Section, to be sure, had convictions about the nature of content tolerable in works of art subsidized with federal money. The artist, presumably, had ideas of his or her own about subject matter, although a commission depended on the degree of willingness to adapt one's beliefs to the collective wisdom of the Section. What was the role of the public in this process of compromise? In the dialogue between the aspiring muralist and

the federal bureaucracy, who spoke for the beliefs and preferences of the people?

Official pronouncements about the mural program waxed rhapsodic over community involvement and yet contrived to leave the question of who represented the public interest exceedingly vague:

The Section stresses primarily the creation of vital design, but it recognizes that a work of art carries more meaning for the people for whom it is intended when it deals with familiar subject matter and reflects their local interests, aspirations, and activities. For this reason, each artist is urged whenever possible to visit the community for which his mural . . . is commissioned. There he talks with the townspeople, gathers their tales of folklore and history, visits the chief industries, and acquaints himself with the architecture and landscape peculiar to that region. From this material, he selects subject matter which typifies that community and which he feels will lend itself to the creation of a vital design. While the aesthetic quality of each completed design rests upon the personal interpretation and ability of the artist, the content is determined by the community for which he is working.[70]

This last, idealistic sentence corresponds in no particular to the way things generally worked during the heyday of the Section of Fine Arts. Bruce's antipathy for abstract and academic manners guaranteed that decisions affecting "personal interpretation"—style— would not rest with the artist alone. Because the initial installment of the painter's fee was withheld until preliminary drawings—the locus of content—had been finished and reviewed, artists were reluctant or frankly unable to travel to remote points for consultation with John Q. Public in the depths of a Depression. A Manhattanite assigned to the Agriculture Building in Dardanelle, Arkansas, did his field research in the photo files of the New York Public Library. "I should like to go out there to do some study," he assured Rowan, "but, unfortunately, I haven't the money for the train fare."[71]

Exploratory travels amounted to speculative ventures in the '30s, and Hirsch, for one, refused to gamble. He never set foot in South Carolina until his iconographic program had been completed, and his arrival came as a shock to the people of Aiken who heard nothing of plans to hang a mural in the courthouse until the deed was virtually done.[72] Artists who tried to do research by long distance discovered that postmasters were not always arbiters of local taste; artists who dutifully presented themselves in places far from home found nobody to confer with or fell into the clutches of the town eccentric, the monomaniacal village historian, or a neighborhood faction. Despite a rhetorical commitment to the principle that "con-

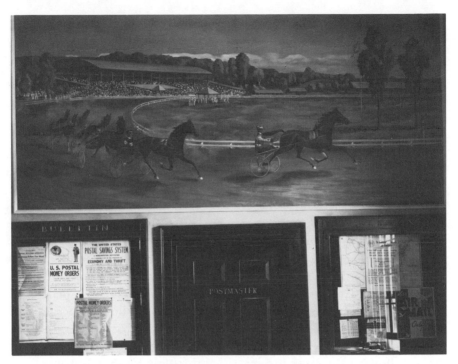

Georgina Klitgaard, *The Running of the Hambletonian Stake*, USPO, Goshen, New York. 1937. National Archives.

tent is determined by the community," the Section neglected to develop routine channels of communication between the artist, the government, and the people. The majority of commissions were doled out to runners-up in regional competitions; outside the site-specific competitive process, however, no formal mechanism existed to establish citizen advisory committees, notify communities of the opportunity to contact the artist-designate, or poll local opinion.

When painters took independent measures to give the community a say in subject choice, the Section's response to local enthusiasm was sometimes perplexing. In 1936 Georgina Klitgaard received an invitation to submit designs for the Goshen, New York, post office. The letter included the stock paragraph on theme, urging her to visit Goshen, if she could, to ascertain what aspects of the town's history or current occupations might best appear in the mural. Klitgaard went straight to Goshen, talked to everybody, and speedily ferreted out the consuming passion of the community:

After my visit . . . there remained no doubt as to what the subject matter . . . should be. The whole-hearted pride and interest of the town—the business,

too—centers about horseracing, the "harness horse," preparing for and bringing off the summer Hambletonian, a racing meet which has taken place since before the Civil War.[73]

Ed Rowan was aghast. Low-life racing topics were not considered proper for the adornment of public buildings, whatever Goshenites said. Only after the postmaster personally intervened, confirming the fact that horses were the most important element in the past and present history of Goshen and restating citizen preference to have horses in the mural, did the Section agree to entertain the proposal.

According to Rowan, however, by acceding to the quirks of community preference, Klitgaard incurred a special obligation "to have the drawing of the horses exceedingly well done and all the details as to the trappings, buggies, and the like correct. You can understand why such an attitude is necessary in relation to this community."[74] And so, for seventeen long months, Klitgaard and the people of Goshen wrangled with the Section over facts Goshen knew best and Washington presumed to know better. For her part, the artist was eager to take expert advice from the assistant postmaster, "who has been following the races for years," and from a Mr. Sanders, manager of the Good Time Track and collector of equestrian paintings, who supplied photographs and design criticism. She put her color sketch on exhibit in the post office, where it received unqualified approval from the townsfolk and from the Damon Runyon set. Yet members of the Section, reviewing the same sketch, voted to withhold authorization for partial payment on her $500 contract because of supposed factual errors. The Section judged the racecourse "crooked," the hindquarters of the trotters too small, and their flying tails "offensive" to good taste. Couldn't Klitgaard give up horses and settle for a nice landscape? No matter that Goshen wanted horses and liked Klitgaard's horses: "What they said in Goshen doesn't matter much," she wistfully and correctly surmised.[75]

The Running of the Hambletonian Stake was finally affixed to the wall of the Goshen post office, offensive tails and all, and, much to the chagrin of the Section, letters of appreciation began to pour in. A high postal official who stopped there in the summer of 1938 pronounced the mural "splendid" and spearheaded a local drive to have Klitgaard paint a second panel for the opposite flank of the lobby. This may have been some consolation to the artist. Her Section commission had thrown her relief eligibility into question, and she lost her $77-a-month job with the FAP although, in fact, Klitgaard

earned something less than $30 a month during the protracted tussle over the Goshen mural.[76]

Working for the Section could be as expensive as it was frustrating. That, at any rate, was the conclusion of the artist's husband, Kaj Klitgaard, who included a thinly disguised account of Georgina's trials in his book on American art of the '30s, *Through the American Landscape*.[77] The major premise of the disgruntled muralist voicing the Klitgaards' complaints was that only millionaires could afford to accept Section commissions. He enumerated the expenditures involved in traveling to the specified locality for research on thematic material and for installation of the finished mural. Over and above these costs —and the purchase price of canvas, paint, varnish, and adhesive—the artist had to pay for local services which made him or her the prey of greedy businessmen charging what the traffic would bear. Before a Section contract was discharged, a paperhanger had to be hired to glue the picture to the wall. A professional photographer had to be called in to record the work in situ. All the sketches, cartoons, and snapshots the Section required as verification of progress were shipped to and from Washington at the muralist's expense. Color sketches to scale, which might have been salvaged for sale to a prominent local art lover, became the property of the U. S. Government.

This litany of woes was accurate. More irksome than the financial burden of the Section contract, however, was irrepressible, carping criticism of the work. Kaj Klitgaard's anonymous informant dubbed Rowan and his associates "little schoolmarm Hitlers." They would "paint the picture for you down there" in Washington unless the object of their spleen defended his or her judgments and the opinions of the local constituency tooth and nail. Even a good defense was risky because the ultimate weapon belonged to the bureaucrats. At the sketch stage, the cartoon stage, the halfway point in execution, and the installation stage, the Section had the option of suspending payment until the recalcitrant offender came to heel.

How an angry community might be forced to comply was a different question altogether. The Goshen incident seemed to indicate that neither the American Renaissance nor reform of American culture had much to do with popular opinion. The rhetoric of community determination notwithstanding, practice suggested a covert policy of benign indifference to the people's preferences, save in those instances when locals caught wind of mural schemes afoot. Then, Washington unilaterally averred, what the people really wanted was

fact. But there was more than a touch of disingenuousness in the fuzzy argument Forbes Watson advanced to explain what he christened "The Return to the Facts." Analyzing the first crop of Section murals, which "have every detail right," Watson represented Washington as a mere conduit for communion between artist and public. He attributed the quest for verisimilitude to painters, whose social sensibilities rejected modernism and "befuddled" academism, whose delight was to ascertain "that this is right or that is right, meaning that in the Post Office they actually do so and so, or in the prison, or in the courtroom, or in the factory":

All this . . . is not by request or direction of the Government. The idea comes from the artists themselves. As much as anything else it seems to me to indicate on their part the consciousness of a larger, a broader, and a more human public than the precious one to which the concatenations of the theorists appealed. . . . I don't want to infer that such changes are the result of the nation-wide encouragement induced by the permanent section of the Government which Edward Bruce . . . organized. These changes have been encouraged by it, but they had already taken place in the artists' minds. They are the inevitable result of the pendulum-swing. The pendulum swung too far toward purely intellectual painting. It always swings back. This time it has swung back to the facts.[78]

A less partisan observer would surely have noticed that the stylistic pendulum was being nudged by the Section and that a carefully orchestrated "return to the facts" began with the National Competition of 1935-36, from which the commissions of Klitgaard and Stefan Hirsch stemmed. The Postal and Justice Department buildings, under construction on Federal Triangle, were the first New Deal additions to the architecture of the capital and were potential showcases for the Section's maiden excursion into patronage. Secretary Morgenthau's executive order setting forth the duties of the Section called for "competitions wherever practicable." But the symbolic importance of these buildings demanded invocation of Morgenthau's qualification to that statement: he had added that some artists, because of their recognized talent, should be appointed without benefit of jury. In the spring of 1935, an Advisory Committee handpicked by the Section thus asked eleven famous painters to accept mural commissions, the remaining slots—seven in the Post Office and three in the Justice building—to be awarded on the basis of a closed competition among 244 invited artists also selected by virtue of their presumptive excellence. The list of appointees included Biddle, Benton, and Robinson, and so disposed of the original Biddle consortium.

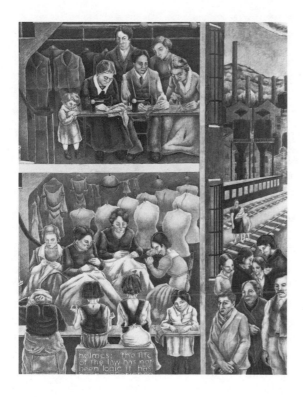

George Biddle, study for *Society Freed Through Justice*, Department of Justice Building, Washington, D.C. 1935. The University of Maryland Art Gallery.

Appointee and invitee alike, however, were set firmly on the path that returned to the facts.

Biddle chose a predictive theme for his Justice Department panels: "The sweatshop of yesterday can be the life ordered with justice tomorrow." The listless starvelings imprisoned in the pigeonholes of his tenements were vintage Rivera, in style and import. Although the Section felt obligated to circumvent their rejection of the Biddle schema, the venerable Commission of Fine Arts, chartered by Congress in 1910 to advise the government on art-related matters, advised the Treasury of his alien leanings. The Justice murals and contemporary social realism in general were, in the judgment of the commissioners, "intrinsically un-American and ill-adapted to express American ideas and ideals."[79] And despite the fact that Rowan— not Lenin—occupied the place of honor in *Society Freed through Justice*, some members of the Section concurred in the negative verdict. Watson wanted Biddle's check held up until figural distortions were rectified, Rowan thought the drawing needed "correction" throughout, and correspondence repeatedly admonished the artist to make his liberated family look a lot happier.[80]

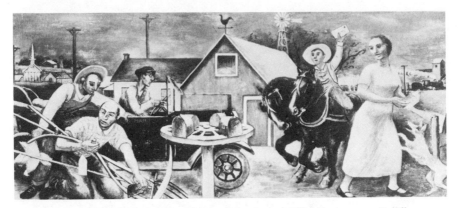

Doris Lee, preliminary sketch for *Country Post*, Post Office Department Building, Washington, D.C. 1935. National Archives.

Social realism made social statements through a selective, and selectively exaggerated, treatment of reality. The poor were physically warped by oppression, and Biddle's political conscience did not allow him to pretend that tomorrow had already come—that two years of New Deal leadership had ushered them all, grinning and beaming, into a secular Nirvana. But hyperbole, in whatever cause, was not fact, especially when the fact at issue jangled sensitive political nerves. Biddle's social realism of the sweatshop was not what Watson had in mind when he extolled the compulsion to get "every detail right . . . in the prison, or in the courtroom, or in the factory."

Competitors began to sense the importance of "the return to the facts" the moment their invitations to submit entries arrived. Form letters said that artists were free to use their own discretion in matters of subject, style, color, and composition. However, the Section required murals destined for the Postal Department to treat one of seven themes, all of which were historical or reportorial in nature. Topic #5, for example, was "The Effect of Mail on the Development of the Far West and the Southwest"; #6 was "The Development of the Post in the Country."[81] Justice Department themes, concerned "with some phase of the administration of justice in relation to contemporary American life," demanded attention to the histories of the labor movement, women's suffrage, and the juvenile courts.[82] Hence the painter who entered the National Competition was limited from the outset by the intrinsic demands of the recommended topics. To convey the subject content of a work purporting to describe the colonial period or the frontier, he or she was virtually unable to avoid the use of a representational style. And the Section

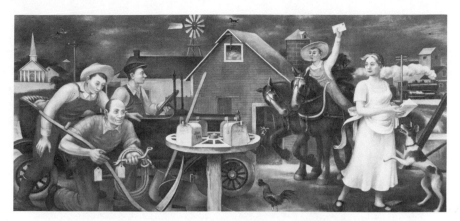

Doris Lee, *Country Post*, Post Office Department Building, Washington, D.C.
1938. National Archives.

strongly implied that it was crucial for realistic handling of the subject to be augmented by scrupulous attention to historical fact. Dunbar's *History of Travel in the United States* was recommended as a visual reference text; postal contestants were exhorted to verify the accuracy of their draftsmanship against Dunbar's canonical stagecoaches, steamboats, and period costumes.

Doris Lee neglected to study Dunbar. She opted instead for one of the two contemporary topics on the National Competition list— "The Development of the Post in the Country."[83] Her winning sketches for *Country Post* and *General Store and Post Office* showed rural types in what was, for the artist, a characteristically light-hearted way. The pair of scenes exaggerated the pandemonium that erupts when Rural Free Delivery comes to a country crossroad. A shipment of tools brings a farmer's son at a trot, a half-plucked chicken dangling from his hand. A youngster astride a team of horses still hitched for plowing gallops from the fields to find his letter. Even the farmyard dog begs to hear news from town. At the general store, stout ladies in their come-to-meeting finery lay claim to long awaited crates of baby chicks, and rustic sages gathered about the potbelly stove delegate one of their number to read the weekly newspaper aloud.

It was precisely Lee's whimsical, countrified approach to genre painting which alarmed the Section. Her letter of appointment tied ultimate acceptance of murals prepared from the sketches to a thorough revision thereof and elimination of two glaring mistakes. First, she was counseled, the heads of the figures were too large for their bodies, and second, the element of caricature discernable in their faces and postures was unduly blatant.[84] The affectionate charm of Lee's personal manner depended on her practice of giving

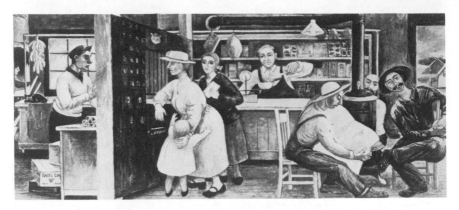

Doris Lee, preliminary sketch for *General Store and Post Office*, Post Office Department Building, Washington, D.C. 1935. National Archives.

adults the topheavy proportions and awkward gestures of overgrown children; but for more than a year, instructions from Washington worked to neutralize the storybook innocence which gave her work distinction.

Lee was ordered to prepare a full-sized color cartoon for the *Country Post* panel—it measured 13½ by 6 feet—as a stern check on her caprice and was further told to prepare the cartoon from live models, both human and animal. Four months of anatomical criticism followed. Rowan felt that the revised conception still failed to please; the figural draftsmanship remained woefully deficient in "accuracy." Worse yet, the faces of the principals, once purged of caricature, had grown monotonous. In March of 1937, Rowan turned up at Lee's New York studio unannounced. She had been allowed to begin painting and he found new bones to pick with the mural proper:

[Miss Lee] has continued to discard the caricature of her preliminary sketches and the mural looks quite dignified. . . . I called her attention to the fact that in the painting the door of the barn and the barn as a whole seemed smaller than it [sic] did in the color cartoon. She admitted that she herself had noticed that, and that she was going to correct it. She does not seem pressed at the moment for money, so that she will not present the second full-sized cartoon until the first panel is almost complete.[85]

Rowan made a casual and unwarranted assumption about the artist's financial status. She did need the money—there were those models to pay—and so continued to follow orders that diluted her style beyond recognition. Her cooperation satisfied Edward Bruce a good deal more than her murals. After he too popped in on Lee, his final word on the Post Office panels was archly condescending in tone: "They possess a kind of provincial dignity somewhat naive in

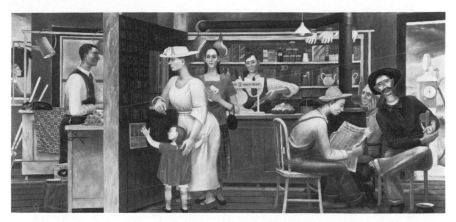

Doris Lee, *General Store and Post Office*, Post Office Department Building, Washington, D.C. 1938. National Archives.

character. They will certainly add a new note to the series of decorations." This grudging endorsement was echoed in the catalog of a 1939 Section exhibition which verged on apologizing for inclusion of *Country Post*, with its residual taint of deviation from photographic realism: "Although slight caricature is introduced into the drawing of the figures, the finished work suffers no loss of dignity."[86]

The pair of murals installed in April of 1938 was even duller than the monotonous cartoon Rowan had decried in June of 1936. The figures are vapidly pretty and wholly static. Deprived of the juvenile vitality of the sketches, farm folk are swallowed up in a slough of meaningless but accurate factual detail. Every clapboard and every brick of the questionable barn can be counted, along with every blade of grass. Accessories painstakingly copied from the Montgomery Ward catalog clog the action: the point of the paintings is lost. In the *General Store* panel, the homely rustics who had snuggled into their mothers' skirts, shuffled impatiently in line, and guffawed over a halting recitation of world events were replaced with handsome nonentities doing nothing of note. These robots in honest-to-gosh Levi Strauss overalls are far less interesting than their clothes or the carefully labeled canned goods ranged behind them on the grocer's shelves.

The Section opposed the obscurity of art made for art's sake. In this instance, however, the Section promoted the incoherence of fact for fact's sake. Dignity was incompatible with gentle humor. Like the telling exaggerations of social realism, caricature did not fulfill the demands of the new realism of the American Renaissance. Or did the Treasury sachems dread the day when a stolid delegation from the Iowa Grange might penetrate the upper reaches of the Post Office Building and take mortal offense at seeing themselves por-

trayed as rollicking rubes? The specter of potential controversy in the nation's capital, in the course of the first big mural competition, played some part in the fanatical purification campaign directed against Lee's drawings. Stefan Hirsch's National Competition sketches are lost, but when they were reworked for the Aiken, South Carolina, Court House, it was the people who clamored for factual realism and suspected Yankee ridicule. Washington's elusive standards of quality cannot be chalked up in toto to aesthetic fascism spreading its bureaucratic tentacles in the darkness of a cataclysmic Depression. The Aiken controversy discloses the bond of dynamic tension that linked the American Renaissance to the variform cultures of Small Town, U.S.A.

From the very beginning, the Aiken commission promised to test the premises of federal mural patronage. In response to his letter of invitation, Hirsch declared himself amenable to thematic guidance from the Section, because he was troubled by the prospect of offending local sensibilities. "While I believe that the artist's social philosophy can and should express the thought of the people," he wrote, "this is only feasible in a culture which has occupied itself traditionally with such integration of artistic thought into popular thinking. And I don't feel that we have, as yet, arrived at this point, although you have certainly started to set the direction." His National Competition sketch had been based on fact: one portion depicted an incident that took place in Princess Anne County, Maryland, where the governor had called out the National Guard to protect a black prisoner from a lynch mob. This kind of subject, Hirsch knew, "would naturally be quite inappropriate in South Carolina." What alternatives might the cumulative experience of the Section suggest? "I do not consider a definitely outlined subject matter a restriction of the artist's creative impulse."[87]

Rowan demurred: the Section "in as far as possible" was not in the habit of telling artists in advance what to paint. This rule did not cover sketches in hand, however. Drawings for Hirsch's *Justice as Protector and Avenger* reached Washington in December of 1937 and triggered an opaque and extended disquisition on what not to paint.[88] The proposed mural was a triptych. In the center stood "Justice," barefooted, wearing a rumpled shift that evoked classical costume without duplicating the dress of the blindfolded goddess.[89] Similarly, her pose referred to a set of scales nowhere in evidence. Her right hand was raised toward a tranquil rural scene alluding to her function

as "Protector" of the law-abiding, and so captioned. Her left hand was lowered upon a panel showing arson, burglary, murder, and a convict about to be locked in a cell. The "Avenger" group surmounted an inset portrait of a machine gun; a plow appeared beneath the pastoral study. The design as a whole was, in Rowan's phrase, "unusual" but the "Avenger" segment was, in a fashion that defied verbal transcription, too startling: "In our estimation [it] should be much more subtle than indicated in the present presentation."[90]

Hirsch was mystified. Where, exactly, was this subtlety called for? In the style, with its dramatic contrasts of light and shadow? In the iconography, with its brutal inventory of misdeeds? In the drawing, perhaps? Rowan's answer was short on specifics: "Please remember that the people sitting in the courtroom are compelled to look at the mural over a period of several hours, and any obvious treatment of crime and horror would be too much for the public."[91] Cautioned only to remember the public, Hirsch was authorized to proceed to Aiken, where he planned to paint his mural directly on the courtroom wall and to confront his public in person for the first time. Now it was Aiken's turn at mystification.

Hirsch arrived on February 7, 1938. Nobody in Aiken expected him, nobody knew anything about a mural for the courthouse, and nobody did much to help. His message to Washington, dispatched on the eve of his precipitous departure from South Carolina, hinted at a frosty reception indeed and made no mention of meaningful public discussion of crime, punishment, or the American mural Renaissance. Court was in session. Local permission to work on the premises was not forthcoming. Lines of authority were tangled.[92] Hirsch had been treated to a runaround by some touchy citizens who had scarcely hustled him out of town before they began to bombard an assortment of federal agencies with letters of complaint and inquiry. Where had this Hirsch fellow come from? What was going on? "I have been told by the artist," the custodian of the courthouse reported incredulously, "that this painting will cost approximately Two Thousand Dollars ($2,000.00). Frankly, this a lot of money for the work and I certainly wish that the funds could be spent for some better and more useful work."[93] Besides, he added, a mural might foul up the acoustics of the courtroom!

Neither the artist nor his employers read the absence of Southern hospitality as symptomatic of local qualms. The Section, in a memo relayed through the National Parks Service, told the indignant care-

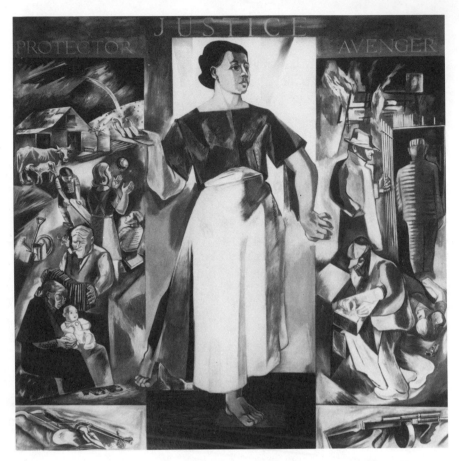

Stefan Hirsch, intermediate study for Court House, Aiken, South Carolina. 1938.
National Archives.

taker that murals were excellent reflectors of sound. There matters
rested until August, when Hirsch suddenly turned up again and hoist-
ed *Justice as Protector and Avenger* into position.[94] Wire-service dis-
patches from Aiken tell what happened next. U.P. broke the story
on September 26:

United States District Judge Frank K. Myers today took a look at a mural, "Jus-
tice, the Protector and Avenger", recently installed in the federal courtroom
here, called it a "monstrosity", and quickly ordered it covered. The mural was
executed by Stephan [sic] Hirsch . . . and was a project of the federal govern-
ment's art program. Judge Myers termed the painting a "disgrace". Some of the
spectators in this courtroom in the South said the central figure, a woman rep-
resenting Justice, resembled a "mulatto".
In a telephone conversation last night from Aiken, Judge Myers said . . . he
had never been consulted or advised concerning the placing of the mural in the
federal courtroom.[95]

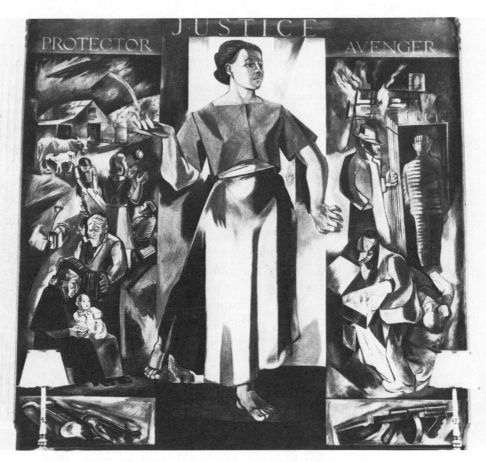

Stefan Hirsch, *Justice as Protector and Avenger*, Court House, Aiken, South Carolina. 1938. National Archives.

The Associated Press version hit the Washington *Evening Star*:

The central theme is represented by a woman who resembles a mulatto walking down a step barefooted. The woman wears a red blouse and a blue dress. On her right are depicted a group of peaceful citizens and a rural scene. . . . On the left is shown a burning house, a "shyster" lawyer freeing a prisoner from jail and a burglar pursuing his trade.[96]

The Aiken *Standard* recapped events on September 28 under a headline that read: "Judge Myers Orders Mural Covered, Hirsch Declares Myers Comment Not Important." In this version, "corrupt officers" are responsible for freeing the jailbird, and the Treasury Department is finally assigned responsibility for the mural. But the real news was a heavily edited synopsis of Hirsch's reaction to the A.P. report. According to the *Standard*, Hirsch dismissed local reaction in a few haughty words: "Judge Myers' comment is not important.

Such things will be common as contemporary art makes its way to recognition."[97]

The week ended in a flurry of telegrams. Washington told Hirsch to button his lip, and Hirsch came close to blaming Rowan for his troubles. "I was leaning over backward to understand and follow your various criticisms, precisely in order to avoid something like this incident," he pointed out. "But I suppose we cannot figure out in advance *all* the perversities of *all* people at *all* times."[98] Meanwhile, custodian Henderson pleaded for some official to come down and dampen the hysteria of the newspapers and the radio stations. He had done his duty. He had, after all, chased around and bought some yardgoods to muffle the mural, but he couldn't cope with the judge, who incessantly asked why the picture was put up and on who's say-so: "I couldn't answer the 'Why' part of the question."[99] The Section decided to buy time by stonewalling. "We will take no action at the present . . . to see if the matter will not die a natural death. A quiet investigation is being made by us."[100]

After the situation had already passed the point of amicable resolution, Washington found out about the ill-feeling attached to the new Aiken Court House itself. Investigating the controversy in distant retrospect, however, it becomes apparent that the courthouse was a contributing factor in the dispute but was by no means the chief reason for local ire over the mural. Insofar as the story can be pieced together from newspaper accounts and petitions of protest, the people of Aiken could not tell what Hirsch's picture portrayed. The "Avenger" panel was universally believed to glorify crooks and crime and venal public servants. And "Justice" was a caricature, a condemnation of racial attitudes in the South. In correspondence with the Section and in the lengthy rejoinder to the A.P. release — the rejoinder which the Aiken papers declined to reprint — Hirsch denied both charges. He had no intention of becoming the Diego Rivera or the George Biddle of South Carolina. "My idea," he swore, "was to create a symbolic figure of justice with gestures indicating the meting out of justice to the deserving and the undeserving."[101]

Had Hirsch made himself conversant with Aiken before delivering his designs — had he or the Section caught wind of hostility to unilateral decisions made in Washington that abrogated state and local rights — the artist might have been able to avert disaster. But Section procedures did not require him to do so, and, in fact, since his Justice sketch had been highly regarded by the National Competition

jury, local contact was hardly mentioned during the preliminary phases of his work. Rowan sensed that a generic "public" could be disconcerted by Hirsch's objectification of criminal behavior but failed to anticipate alternative responses to the "Avenger" panel and quirks of Southern sensitivity. Hence policies that second-guessed public sentiment without ascertaining the people's true wishes brought the Aiken mess to a boil. On the other hand, the Section did champion a return to the facts and tended to use representational accuracy as a guarantee of "dignity" and a check on caricature and other stylistic evils that ran counter to purported popular demands for legibility in art.

The Aiken case demonstrates only too clearly that readable fact was a popular desideratum, not a figment of Watson's imagination or a projection of Bruce's personal biases. Fact could, of course, mean many things. Yet in Aiken in 1938, people could not tell if Hirsch's prisoner was going into his cell or coming out of it. They could not tell if "Justice" was an unreal symbol in red, white, and blue or a real woman of mixed blood. And those facts mattered to the man in the street, the Chamber of Commerce, and the habitues of Judge Myers's courtroom.

During the opening rounds of the fight, the judge took pains to establish that he had not called "Justice" a mulatto; his objections centered on whether the picture was a "work of art" or a "monstrosity." He always enclosed the former term in quotation marks when haranguing Washington about "the mural or painting of 'Contemporary Art' which I found had been installed in the Aiken court house. I am now again requesting the removal from the courtroom of this 'work of art.' "[102] Myers found it hard to put his aesthetic feelings into words, except by a liberal use of quotation marks. It is ironic that, among the principals involved, only Hirsch was able to articulate the perceptions of his prime adversary: "My own interpretation of the case is that the judge likes sweet stuff and hates contemporary art in its more advanced phases."[103] *Justice as Protector and Avenger* was not a sample of advanced abstraction. Nonetheless, Hirsch's cubist vocabulary—the arbitrary pattern of highlight and shadow, and the "bright" color mentioned in all the lay descriptions —looked modernistic to Aiken. A local editorial, commending Myers's determination to see the mural removed at the people's behest, quoted citizen opinion: "The painting is by no means a credit to the court building, . . . is not in keeping with the architecture of the

building, and . . . is certainly not the Southern conception of art."[104] Although the Southern conception of art was nowhere spelled out, Cubism wasn't it. Style, like subject matter, can convey meaning in a "work of art," and Hirsch's style spoke volumes. It said non-Southern, alien, big city—watch out! If that weren't bad enough, you still couldn't tell if the prisoner was going in or coming out.

The existence of distinctive, indigenous American cultures was an article of faith in the '30s. Benton, John Steuart Curry, and Grant Wood were hailed as the fathers of a Middle-Western "Regionalism" that owed much to manifestos of regional solidarity issued by Southern agrarian writers of the '20s.[105] Holger Cahill realized that the activities of the FAP had helped to reverse the drift of artists toward New York; and when artists stayed home, they discovered the fallacy of the "standardized America" foreseen by media prophets of more prosperous times:

Because of the development of local or regional . . . creative projects, the young artist has tended for perhaps the first time within the modern period to attack the problems of art at home, in his own setting, among familiar surroundings, in the midst of a social life which he is likely to know well. This situation —part of it enforced by the depression—has meant at least a beginning toward a naturalization of art in all our communities, an outcome which must be achieved if our art is to anything more than an effervescence along the Atlantic seaboard.[106]

The Section found itself in the anomalous position of directing a homogenizing, national Renaissance in an era of ardent belief in sectional distinctions that were both cultivated and challenged by New Deal programs. The most prominent institutional manifestation of regionalism in the '30s, the Tennessee Valley Authority, used sectional redevelopment of resources as a model or "yardstick" for national energy policy. In general, however, short-term relief measures confirmed parochial interests while long-range experiments in social engineering denied them. The FAP and the state guidebook series issued by the WPA Writers' Project endorsed and even idealized cultural pluralism, while the accelerating drive toward big government under Roosevelt—vide the Social Security Act or the ill-fated NRA—transferred power from town halls and statehouses to offices on the Potomac. Like the administration whose brainchild it was, the Section assumed an ambivalent stance in the tug-of-war between the sentimental appeal of regionalism and the realpolitik of nationalism.

By Treasury mandate, the Section had been ordered "so far as consistent with a high standard of art" to pay heed to definitions of art prevailing at the grassroots level, in the scattered communities where murals were to find a home. Finding a national yardstick against which regional values and tastes could be gauged turned every patronage decision into a juggling act. When one of the aesthetic balls fell, it was (as often as not) that marked with the brand of the Western or Midwestern or Southern "conception of art."

A Southern, small-town perspective made Cubism abhorrent to Aiken, South Carolina. And for all its habitual caution in anticipating public displeasure, the Section failed to reckon with that eventuality. Doris Lee's murals, in an important federal facility, had been laundered so that style would not convey the impression of condescension toward the mid-American theme depicted. Georgina Klitgaard's mural, in an obscure post office in upstate New York, had been deodorized, too, so that style would not distort the familiar appearance of sights that local people cherished. That a tinge of modernism might prove to be the prime source of local paranoia, an inflammatory challenge to the code of regional culture, was never a postulate of Rowan's forewarnings to Stefan Hirsch.

As the Aiken dispute dragged on into 1939 and 1940, Washington's inability to grasp the regionalist point at issue frustrated negotiations. Rowan could not see beyond his mental picture of a redneck jurist, to whom he attached no more complex artistic feelings than militant bigotry. Hence the mulatto "Justice" became the red herring of the Aiken case. Newspaper stories had drawn Walter White of the NAACP into the controversy. Speaking for his organization, he begged Secretary Morgenthau and the Treasury to stick to their guns: "If Judge Myers' sole objection to the mural is the fact that the central figure is that of a person who is not white, then a new low in judicial conduct and racial prejudice would seem to have been reached."[107] White's "if" was Rowan's gospel. In a confidential letter meant to mollify a racist, he attested to Myers that "the artist's wife, a most distinguished lady," and presumably a caucasian lady, "posed for the figure of justice," although he knew otherwise. By Hirsch's own admission, "the head . . . was not done from the model."[108]

Whereas the Section harped on racial purity, Judge Myers and the citizen groups that continued to insist on the removal of the mural skirted all reference to the dusky "Justice." Because snide displays of quotation marks and appeals to the "Southern conception of art"

were lost on Washington, Myers quickly shifted the terms of the debate toward the implicit specter of states' rights. Again and again, he specified that this was the crux of Aiken's distress. Neither the people nor their presiding judge had been consulted before this "work of art" was thrust rudely upon them.[109] As he saw things, Washington's stubborn disinclination to take the picture back was motivated not by aesthetic principle—the bureaucrats ignored Southern ideas on that score—but by a desire to assert federal hegemony over Aiken. Late in 1939, he conceded victory to the Section. The boys in Washington had succeeded in keeping their loathsome mural up for a year; maybe the time had come to put a quiet end to this unequal contest of wills: "Now that the real purpose of refusing to remove this misplaced and locally objectionable 'work of art' has been accomplished, I would suggest, as man to man, that, if it is of the high value declared by your Department, it be quietly removed so as to avoid permanent injury to the painting."[110]

Veiled threats against the safety of the mural trickled in from less eminent figures, too, rousing Bruce to take a personal look at the voluminous Aiken file.[111] He attributed the trouble to rustic ignorance: "For anyone to object shows a dismal lack of feeling [for] good art and the knowledge of what good art should be and should stand for."[112] On that pettish note, hostilities resumed in earnest, the Section taking the high ground of racial justice and "good art" and Aikenites flailing about helplessly with a defensive barrage of inelegant appeals to John C. Calhoun, Southern taste, and imminent vigilante justice for "Justice." When all else failed, the judge played his trump card. He applied pressure to the Section through the Justice Department and its Office of U.S. Courts, although neither had legal jurisdiction over his courthouse, arguing for excision of the mural on grounds that "the representation of justice as an avenger . . . is out of place in the court."[113] No jurist with an ounce of common humanity could pass sentence "on some poor devil" under that damned picture.[114] *Justice as Protector and Avenger* spelled the end of justice in Aiken.

Hirsch had previously disavowed any ideological ties to social realism, but this final sally elicited a belated confession: "I was trying to paint a socially realistic painting—whatever justice should be or whatever some people believe or like to believe it is, it is today still an avenger, even though it is also a protector."[115] The people could be discounted when they fumed over imaginary "shysters" or mulat-

tos. Judge Myers could be laughed off when he sputtered about modernistic, carpetbagger style and mixed art with antebellum vitriol. But when the argument came to rest on the factual content of the mural, Hirsch found himself at last in the arena where artist and layperson could debate on an equal footing, the place where he and his adversary, the judge, might with profit have met and argued before the mural was painted. By returning to the facts, Myers won his case.

It is impossible today to reconstruct the devious maneuvers whereby the great Aiken compromise of 1940 was hammered out. As the father-in-law of Governor Burnett Maybank, Judge Myers had some political clout in his home state. Ceaseless local pressure had kept the Hirsch mural on the front pages of the Charleston *News-Courier* and the Columbia *State* for two years running. The removal campaign picked up steam after the Office of U.S. Courts heard Myers's views on avenging justice, however, and a furious exchange of memos between the Justice and Treasury Departments coincided with Rowan's decision to go to Aiken in January of 1940 for the first on-the-spot assessment of the situation. His field report aimed to save the faces of everybody except "Justice." That lady, he decreed, must be repainted in pallid hues. The mural would stay. But he authorized purchase of "a tan velvet curtain on a drawstring . . . to be placed over the mural—so that it can be covered through court sessions and opened to the public on request."[116]

Early on in the skirmish, Hirsch had resigned himself to taking the mural down:

If you fight the thing out, first you will probably win, but the citizens will hate the mural and the Federal Government which has thus offended them. American art, as administered by you, won't gain by this either. After all, we paint these things for the people and we try to paint them in such a way that—at least in the course of time—they will like them.[117]

On the advice of Judge Myers, Stefan Hirsch did not return to Aiken and did not repaint his doomed lady in tones of peaches and cream. Why stir up more animosity? Whenever the courthouse was open, court was in session and whenever court was in session, swags of tan velvet hid *Justice as Protector and Avenger*, a phantom mural for a phantom people who didn't live in Aiken, South Carolina.

NOTES

1. Quoted in Helen Appleton Read, "January Report of Work Done in Connection with a Grant from the Carnegie Corporation to Study Art in Federal Buildings," February 16, 1939, 129 [Folder: Field Reports], p. 9. This document is in the collection of the National Archives, Washington, D.C., in Record Group 121 (Records of the Public Building Service), Preliminary Inventory Entry 129.

Hereafter, materials in Record Group 121 will be cited by a descriptive phrase followed by an Inventory Entry number and a box number, in those cases when a given entry is extensive enough to require filing in more than one storage box. Hence, "January Report of Work Done in Connection with a Grant from the Carnegie Corporation to Study Art in Federal Buildings," February 16, 1939, 129 [Folder: Field Reports], p. 9, means that Inventory Entry 129, within Record Group 121, constitutes a single box which contains several folders, one of them holding a document bearing this heading and date, and that the information cited in my text appears on p. 9 of the document in question. It should be noted that not all documents are contained in folders, nor are all folders titled.

Inventory Entries that contain more than one box of documents are cited by the Entry number, followed by the relevant box number, and additional descriptive information. Hence a note reading "White to Black, June 1, 1930, 135 (Box 203)" means that a letter bearing that date may be located in Box 203 of Entry 135 in Record Group 121.

When I refer in consecutive notes to a variety of documents, all located in the same Inventory Entry and box, the first note on the topic cites the numerical location data. Subsequent notes cite only the descriptive title of the particular document being quoted.

2. "January Report," p. 10.

3. Treasury Department Order PWB-No. 2-C, approved October 14, 1934, as cited in a report by Forbes Watson, Adviser to the Section of Painting and Sculpture, to F.P. Troth, Executive Assistant, September 18, 1935, 129. Until the fall of 1938, this agency was known as the Section of Painting and Sculpture; see also Order, October 13, 1938, signed by the Director of Procurement and approved by the Secretary of the Treasury.

The most comprehensive administrative history of the Treasury's role in Depression art patronage is found in Belisario R. Contreras, "The New Deal Treasury Department Art Programs and the American Artist: 1933 to 1943," Ph.D. dissertation (The American University, 1967). The shifting position of the Section within the federal bureaucracy is outlined in Richard D. McKinzie, *The New Deal for Artists* (Princeton, New Jersey: Princeton University Press, 1973), pp. 35-39.

4. "Mr. Cahill's Lecture before the Metropolitan Museum of Art," March 28, 1937, mimeographed copy in the Emanuel Benson Papers, The Archives of American Art (Smithsonian Institution, Washington, D.C.) and Holger Cahill, introduction, *New Horizons in American Art* (New York: Museum of Modern Art, 1936), p. 14.

5. Quoted in Francis V. O'Connor, *Federal Art Patronage, 1933 to 1943* (College Park, Maryland: The University of Maryland Art Gallery, 1966), pp. 7-8. The complete text of this letter, dated May 9, 1933, appears in George Biddle, "An Art Renascence under Federal Patronage," *Scribner's Magazine*, XCV (June, 1934), p. 428 and in his *An American Artist's Story* (Boston: Little, Brown & Co., 1939), pp. 268-269.

6. For an American perspective on the Mexican mural movement, see Jean Charlot, *The Mexican Mural Renaissance, 1920-1925* (New Haven: Yale University Press, 1967); Bertram D. Wolfe, *The Fabulous Life of Diego Rivera* (New York: Stein and Day, 1969), esp. pp. 141-166; and Anita Brenner, *Idols Behind Altars, the Story of the Mexican Spirit* (Boston: Beacon Press, 1970), revised ed., esp. pp. 244 ff.

7. Garnett McCoy, "Poverty, Politics, and Artists," *Art in America*, 53 (August-September, 1965), p. 105, discusses trips to Mexico by George Biddle (1933) and Philip Guston (1934-5). Jean Charlot, Paul O'Higgins, Grace Greenwood, and Marion Greenwood were Americans who executed independent commissions under the auspices of the Mexican mural program, while Lucienne Bloch and Ben Shahn worked with Rivera on his controversial Rockefeller Center mural in 1933; see Harrison's remarks in Karal Ann Marling and Helen A. Harrison, *7 American Women: the Depression Decade* (Poughkeepsie, New York: Vassar College Art Gallery and A.I.R. Gallery, 1976), pp. 21-23, 28-29, and bibliography.

8. Diego Rivera, *Portrait of America* (New York: Covici, Friede, 1934), p. 27.

9. Alan Balfour, *Rockefeller Center, Architecture as Theater* (New York: McGraw-Hill, 1978), p. 185.

10. The ideological controversies roused by Rivera, Orozco and Siqueiros in the United States are summarized in Helen A. Harrison, "Social Consciousness in New Deal Murals," M.A. thesis (Case Western Reserve University, 1975), pp. 21-23.

11. Kirstein in Julien Levy and Lincoln Kirstein, *Murals by American Painters and Photographers* (New York: Museum of Modern Art, 1932), pp. 9-10. Hugo Gellert, William Gropper, and Ben Shahn dealt with explicitly Marxist themes.

12. Biddle was not alone in foreseeing a renaissance predicated on mural painting and the Mexican example. In 1932 artist Kenneth Callahan, later to become a Section muralist, expressed the same opinion in a published report on his recent trip to Mexico. At the time, Callahan was the art critic for the *Seattle Town Crier*. See Kenneth Callahan, "Mural Freedom," *Art Digest*, VI (August 1, 1932), p. 17.

13. Watson in Edward Bruce and Forbes Watson, *Art in Federal Buildings, Mural Designs, 1934-1936*, Vol. I (Washington, D.C.: Art in Federal Buildings, Inc., 1936), p. 4.

14. It is important to realize, too, that federal patronage prior to the New Deal had always been concerned with the finished product—the embellishments on the walls of national monuments—rather than with the support and encouragement of the artist as an end in itself. See Francis V. O'Connor, *Federal Support for the Visual Arts: the New Deal and Now* (Greenwich, Connecticut: New York Graphic Society, 1969), p. 17.

15. This 1926 fresco is entitled *Night of the Rich*; see Wolfe, *The Fabulous Life of Diego Rivera*, plate 77. In the '20s, cities also built and decorated structures that responded to this impulse, and the Los Angeles Public Library, for which an important early mural competition was held, is a good example of the type. The winner of that competition was Dean Cornwell, a magazine illustrator with no prior mural experience, and his situation reflects the odd state of affairs created by a sudden demand for murals during a period when artists had not begun to think of wall painting as a significant aspect of their profession. Cornwell, for example, won the commission and promptly sailed for England to study mural painting under Frank Brangwyn. See Patricia Janis Broder, *Dean Cornwell, Dean of Illustrators* (New York: Balance House, Ltd., 1978), pp. 22 and 25.

16. Grauman's Chinese Theatre opened in 1927; Ben M. Hall, *The Golden Age of the Movie Palace* (New York: Clarkson N. Potter, Inc., 1961), pp. 157-159. The murals in Loew's State were executed in 1920. Under Section auspices, Daugherty later painted murals for a housing project in Connecticut and the post office in Virden, Illinois; "Geographical Directory of Murals and Sculptures Commissioned by the Section of Fine Arts, Public Buildings Administration, Federal Works Agency," *American Art Annual* (1938-41), Vol. 35 (Washington, D.C.: American Federation of Arts, 1941), pp. 627 and 634.

17. Maurice Sendak, *The Maxfield Parrish Poster Book* (New York: Harmony Books, 1974), p. 6.

18. Oliver W. Larkin, *Art and Life in America* (New York: Holt, Rinehart and Winston, 1960), revised and enlarged ed., p. 423. Larkin cites what is still the most cogent discussion of the Kaufmann murals, Lloyd Goodrich's regular column in *The Arts*, 16 (February,

1930), p. 390. Through the good offices of Vassar College, a student in my mural seminar in 1975, Terry Gruber, photographed the panels in storage. I am relying upon those color slides for my analysis here.

Cahill, *New Horizons in American Art*, p. 31, singles out the work of Robinson and Benton as the source for "a revival of public interest in mural painting" and the point of origin of "a general movement." See Harrison, "Social Consciousness in New Deal Murals," pp. 36-37, and Thomas Hart Benton, *An American in Art, A Professional and Technical Auto-biography* (Lawrence, Kansas: University Press of Kansas, 1969), pp. 51-52.

19. It was widely believed in the teens and '20s that modernism was degenerate and un-American, "a bedlam of half-baked philosophies and cockeyed visions"; for extreme statements of this view, see Thomas Craven, *Modern Art: The Men, the Movements, the Meaning* (New York: Simon and Schuster, 1934), p. 312, and Milton W. Brown, *American Painting from the Armory Show to the Depression* (Princeton, New Jersey: Princeton University Press, 1970), pp. 52-58.

20. Hoover's remark, made on March 7, 1930, is quoted in Robert Goldston, *The Great Depression, the United States in the Thirties* (Greenwich, Connecticut: Fawcett Publications, Inc., 1970), p. 48. Popular concerns of that year—films, sports, etc.—are summarized in Cabell Phillips, *From the Crash to the Blitz, 1929-1939* (New York: The Macmillan Company, 1969), pp. 38-39, 395, 430, and *passim*.

21. Stuart Davis's comment is quoted in the introduction to Francis V. O'Connor, ed., *Art for the Millions, Essays from the 1930s by Artists and Administrators of the WPA Federal Art Project* (Greenwich, Connecticut: New York Graphic Society, Ltd., 1973), p. 23. For an extended discussion of the meaning of history painting and the historical mural in the cultural context of the 1930s, see Karal Ann Marling, "A Note on New Deal Iconography: Futurology and the Historical Myth," *Prospects, An Annual of American Cultural Studies*, IV (New York: Burt Franklin & Co., Inc., 1979), pp. 420-440.

22. Brown, *American Painting from the Armory Show to the Depression*, p. 192, dates the Kaufmann murals to 1929 and thus encounters difficulties in relating Robinson's work to Benton's New School Cycle of 1930 and to Benton's seminal role in the historical mural Renaissance. Prior to beginning the Kaufmann cycle, however, Robinson was clearly familiar with Benton's cubistic mural panels, executed for no particular site, and collectively entitled *The American Historical Epic*. These works, frequently exhibited in New York during the '20s, date chiefly from 1919 through 1926 and are described in Matthew Baigell, *Thomas Hart Benton* (New York: Harry N. Abrams, 1974), pp. 62-79. Robinson could have seen the *Epic* on exhibit at the Architectural League in New York; Benton and Robinson had also previously worked together at the Chilmark art colony.

23. The term "the usable past" was coined by Van Wyck Brooks in his *America's Coming-of-Age* of 1915. The concept is discussed in Alfred Haworth Jones, "The Search for a Usable American Past in the New Deal Era," *American Quarterly*, 23 (December, 1971), pp. 710-724.

24. John Dos Passos, *The Ground We Stand On: Some Examples from the History of a Political Creed* (New York: Harcourt, Brace, 1941), p. 3.

25. Thomas Hart Benton, "The Arts of Life in America," in Whitney Museum of American Art, *The Arts of Life in America: A Series of Murals by Thomas Benton* (New York: Whitney Museum of American Art, 1932), descriptive pamphlet, p. 5.

26. Thomas Craven, "Politics and the Painting Business," *The American Mercury*, 6 (December, 1932), p. 471.

27. Thomas Hart Benton, *An Artist in America* (New York: University of Kansas City Press/Twayne Publishers, 1951), p. 315.

28. Benton received his commission from Joseph Urban, architect of the building, who also hired Jose Clement Orozco to decorate another space in the School. The Orozco mural

juxtaposed the oppressed races of the world with Gandhi and Lenin, their liberators. This subject matter was offensive to a number of patron-backers of the New School, who withdrew their financial support from the institution in protest; Alma Reed, *Orozco* (New York: Oxford University Press, 1956), pp. 164 and 203-214. In 1929 Benton, who was sympathetic to Orozco's work, had arranged an exhibition for him at the Art Students' League.

29. Benton, *An Artist in America*, p. 272.

30. Baigell, *Thomas Hart Benton*, p. 123.

31. These are the titles of three typical Section murals. *Lincoln as Postmaster of New Salem* by Vladimir Rousseff was painted for the post office in Salem, Illinois, in 1938; *Experimenting with the First Model of the Cotton Gin* (1939) by Edna Reindel was for the post office in Swainsboro, Georgia; *Episodes in the Life of John Brown* (1937) by Arthur Covey was for the post office in Torrington, Connecticut: see 135 (Box 203). 135 (Box 203) contains several folders of descriptive mural-placards, edited by Forbes Watson. These provide biographical sketches of Section artists and detailed explanations of subject matter; they are a key resource for any iconographic appraisal of New Deal mural art.

32. Benton, *An Artist in America*, p. 272.

33. Dr. Alvin Johnson, quoted in Reed, *Orozco*, p. 211.

34. Reed, *Orozco*, p. 211.

35. William F. McDonald, *Federal Relief Administration and the Arts, The Origins and Administrative History of the Arts Projects of the Works Progress Administration* (Columbus, Ohio: The Ohio State University Press, 1969), pp. 358-359.

36. O'Connor, *Federal Art Patronage*, p. 8, makes this observation.

37. Shortly after he learned of the President's interest in his plan, Biddle consulted with Benton, Robinson, Henry Varnum Poor, and Maurice Sterne and drew up a prospectus called "A Revival of Mural Painting" to amplify his ideas. That document read, in part:

1. A few social-minded, creative artists of the first rank, representing the modern movement, and experienced in mural painting.
2. The assignment to them by the government of public wall space on which to express the social ideals of the government and people.
3. The understanding that in the personal expression and technical execution, the artist be given as complete freedom as possible. Interference would only tend to emasculate his work. The government may exercise the right to assign mural subjects and veto any expression of opinion which it considers embarrassing.

This prospectus is quoted and discussed in McDonald, *Federal Relief Administration*, p. 358.

38. Quoted in Robert E. Sherwood, *Roosevelt and Hopkins, An Intimate History* (New York: Grosset and Dunlap, 1950), p. 57.

39. From a conversation with F.D.R., reconstructed in Biddle, *An American Artist's Story*, p. 273.

40. Quoted in the *Washington Post*, December 21, 1933. Biddle maintained close contact with Tugwell during the months of discussion that preceded creation of the PWAP and Tugwell's statement is clearly related to Biddle's "A Revival of Mural Painting," cited above.

41. Contreras, "The New Deal Treasury Department Art Programs," p. 26, quotes correspondence between Edward Bruce (and Forbes Watson) and J. J. Haverty. Contreras concludes that "Bruce was primarily concerned with setting up quality, professional standards and . . . relief was to be a secondary consideration."

42. James M. Dennis, *Grant Wood, A Study in American Art and Culture* (New York: The Viking Press, 1975), p. 138.

43. Forbes Watson, Technical Director of the PWAP and Mrs. Juliana Force, Chairman of PWAP Region 3, quoted in the *New York Times*, December 22, 1933. Statistics on artists employed and works produced appear in McKinzie, *The New Deal for Artists*, p. 27.

44. This letter from Bruce to Mrs. Franklin D. Roosevelt is dated May 10, 1935, but is certainly consistent with Bruce's beliefs in 1933. The document, which accompanied a statement entitled "In Support of Project to Employ Artists Under the Emergency Relief Appropriation Act of 1935" is in the WPA files at the National Archives (Record Group 69) and is cited by McDonald, *Federal Relief Administration*, pp. 360-361.

45. Cahill, *New Horizons in American Art*, p. 18.

46. *Washington Post*, December 12, 1933. The contrast between the philosophies of Tugwell and Bruce is discussed in Contreras, "The New Deal Treasury Department Art Programs," p. 13.

47. Cahill, *New Horizons in American Art*, p. 18.

48. See Note 41, above.

49. Undated letter, Browne to A. Craton (ca. 1933-4), quoted by Contreras, "The New Deal Treasury Art Programs," p. 52.

50. Edward Bruce to William M. Milliken, PWAP Director for Region 9, March 28, 1934, 109 (Box 1).

51. *Washington Post*, April 30, 1934.

52. For an illustrative, in-depth study of the operations of a typical Regional Committee—Region 9 included Ohio, Michigan, Indiana and Kentucky—see Karal Ann Marling, *Federal Art in Cleveland, 1933-1943* (Cleveland, Ohio: Cleveland Public Library, 1974), pp. 12-31.

53. The wire was directed to Forbes Watson, Technical Director of the PWAP and Bruce's second-in-command. Watson passed it on to Bruce; Watson to Bruce, June 2, 1934, 114 (Box 2).

54. *San Francisco Examiner*, July 4, 1934. Wight had previously apprenticed in fresco painting with Rivera.

55. For illustration and discussion of the Zakheim and Arnautoff murals, see "A Sampler of New Deal Murals," *American Heritage*, XXI (October, 1970), pp. 50-5. Another mural by John Langley Howard also pictured a copy of *Western Worker* being perused by a miner in a gold-panning scene, a detail which was not overlooked by irate members of the San Francisco Art Commission; Evelyn Seeley, "A Frescoed Tower Clangs Shut Amid Gasps," *Literary Digest*, 118 (August 25, 1934), p. 24.

56. Wire, Bruce to Heil, June 29, 1934, 116 (Box 6).

57. Quoted in McKinzie, *The New Deal for Artists*, p. 25.

58. Bruce to Edward B. Rowan, July 27, 1934, 114 (Box 2). Rowan was the Assistant Technical Director of PWAP. He and Watson were Bruce's chief administrative deputies and stayed with the Treasury after the Section was formed.

59. *San Francisco News*, October 13, 1934. The headline reads: "Hundreds Attend Opening of Coit Memorial."

60. Victor Arnautoff, "A Vital Question," *San Francisco Art Association Bulletin*, 1 (September, 1934), p. 1.

61. Helen A. Harrison interviewed Guston in regard to his *Work and Play* mural in 1975 and goes on to note that "the area in question, as it appears today, bears no resemblance to the . . . Russian flag, even though the boy's foot still crosses the dog's tail." Her interview with Abraham Lishinsky, painter of *Major Influences in Civilization* at Tilden High School, discloses that the artist felt the "441" incident to be "a ridiculous display of reactionary paranoia"; Harrison, "Social Consciousness in New Deal Murals," pp. 105-108.

62. As the need for relief accelerated in 1935, Bruce—although he would not accede to plans for housing a massive art-relief program within the Treasury, where it might have remained immune to Congressional displeasure—did accept a grant from the WPA to hire relief-eligible artists for mural work in public buildings that did not have the 1% reserve available for adornment. With WPA funds, he set up the Treasury Relief Art Project (TRAP),

which operated under modified Section rules and largely concerned itself with older buildings, for which the 1% had already been spent. For a brief history of TRAP, written by its first director, see Olin Dows, *The New Deal's Treasury Art Programs: A Memoir*, 40-page pamphlet reprinted from *Arts in Society*, Vol. II (Madison, Wisconsin: The University of Wisconsin, University Extension Division), undated.

63. The text of the Morgenthau directive appears in the informational magazine published by the Section to assist artists in preparing competition entries and to announce awards; *Bulletin No. 1*, Section of Painting and Sculpture, Public Works Branch, Procurement Division, Treasury Department, Washington, D.C. (March 1, 1935), pp. 3-4, 130 (Box 215).

64. Quoted, without citation of documentary source, in McKinzie, *The New Deal for Artists*, p. 37.

65. The Morgenthau order did not include mention of the 1% reserve. In 1939, the presidential order making the Section a wing of the Public Buildings Administration, under the Federal Works Agency (remaining WPA programs were also consolitated within FWA in 1939) did guarantee the percentage point for embellishment. Although the paperwork needed to secure approval for Section expenditure of the 1% from the Procurement Division on a case-by-case basis was onerous, the ad hoc procedure in practice created few problems.

66. Reported in the *New York Times*, December 5, 1936, and December 13, 1936.

67. Average and ideal rates of compensation are discussed in a number of Section documents. A letter from Bruce to W.E. Reynolds, Commissioner, Public Buildings Administration, February 18, 1942, 124 (Box 133), notes that "the average price which we have paid for our mural work is from $10 to $20 per square foot." A memorandum to the Director of Procurement, titled "Exhibit A" and dated October 26, 1935, 124 (Box 132), uses the $20 rate for the pictorial murals proposed and the $10 rate for over-all, presumably decorative ensembles. An undated memo, 124 (Box 139), to the Supervising Architect, corrected in Watson's hand, takes up the problem of adequate compensation in buildings with small reserves and notes that "post offices in [small communities] cost an amount which does not permit, on the 1% basis of allocation, the artist to design a mural in correct proportions, as to width and height, for the standard price of $20 per square foot, this being our standard price. . . ."

"Report on Buildings Under P.W.A. and E.C.P. Programs Which Are Either Completed Under Contract Or on Which Bids Have Come In," from "Status Report No. 14, as of January 31, 1935," 12 pp., 129, notes that an authorization was signed for the Aiken project allowing $1,200 to be spent. The records are silent on the reason for the addition of $1,000 to the reserve.

O'Connor, *Federal Support for the Visual Arts*, pp. 81-2, arrives at the $1.80 figure by computing Edward Laning's pay for his 1,000-square-foot mural in the Aliens' Dining Room on Ellis Island and contrasts that rate with the $10 to $20 paid by the Section.

68. *The Sears Roebuck Catalogues of the Thirties, Selected Pages from the Entire Decade* (New York: Nostalgia, Inc., 1978), unpaginated entries for 1937.

69. The Barnesville, Ohio, post-office competition closed on May 1, 1935, and the Arlington, New Jersey, competition on September 3, 1936, 131 (Box 206). The phraseology of these printed forms is standard.

70. Undated (ca. 1941) 8-page catalogue, "Exhibition of Preliminary Sketches for Murals, Section of Fine Arts," 135 (Box 203).

71. Ludwig Mactarian to Rowan, October 12, 1938, 133 (Box 3).

72. The details of the Aiken commission are chronicled in a case file of correspondence and clippings in 133 (Box 99: South Carolina, Aiken York). A similar file exists in this record group entry for every building the Section decorated. Facts not attributed to other

documentary sources in my discussion of Aiken are drawn from this file. For example, Hirsch's arrival in Aiken is mentioned in a letter from Thomas R. Henderson, Custodian of the Aiken Court House, misdirected to Charles A. Peters, Jr., National Park Service, February 8, 1938.

73. The vicissitudes of the Goshen mural are traced in Karal Ann Marling, "Federal Patronage and the Woodstock Colony," Ph.D. dissertation (Bryn Mawr College, 1971), pp. 388-96. The letter to the Section cited here is dated May 22, 1936.

74. Rowan to Klitgaard, June 10, 1936; Marling, "Federal Patronage and the Woodstock Colony," p. 388.

75. Klitgaard to Rowan, October 11, 1936; Marling, "Federal Patronage and the Woodstock Colony," pp. 389-390.

76. Funds were not forthcoming from the office of the Treasury's Supervising Architect for the second mural. Employment transcripts for FAP personnel are on deposit in the National Personnel Records Center (Civilian Personnel Records), St. Louis, Missouri, a division of the General Services Administration. Klitgaard's transcript is among them.

77. Kaj Klitgaard, *Through the American Landscape* (Chapel Hill, North Carolina: The University of North Carolina Press, 1941), pp. 56-60.

78. Forbes Watson, "The Return to the Facts," *American Magazine of Art*, 29 (March 1936), pp. 147, 152-53.

79. McKinzie, *The New Deal for Artists*, p. 60, quotes the Commission, whose role in the Justice Department controversy is discussed at length by Contreras, "The New Deal Treasury Department Art Programs," pp. 184-195. Benton eventually declined a Post Office Department Building commission and Robinson went to work at Justice. The appointees are listed in Bruce and Watson, *Art in Federal Buildings*, p. 286.

80. See Watson to Rowan, March 14, 1936; Rowan to Members of the Section, March 12, 1936; and Rowan to Biddle, November 19, 1935, 122 (Box 3).

81. Treasury Department, Section of Painting and Sculpture, *Announcement of National Competition for Mural Decorations in the Department of Justice and Post Office Buildings* (Washington, D.C.), undated flyer, 130 (Box 125), misfiled.

82. Treasury Department Art Projects, Bulletin No. 8 (January-February, 1936), p. 5, 130 (Box 215). This public announcement shows that the final phase of the National Competition was thrown open "to all American artists" and was not limited to the invited few.

83. See "Federal Winners," *Art Digest*, X (December 1, 1935), p. 26, and "Postal Art Test Winners Named," *Art News*, XXXIV (November 16, 1935), p. 23. The winning sketches were exhibited at the Corcoran Gallery of Art; "New Federal Art Shown, Washington," *American Magazine of Art*, XXVIII (November, 1935), pp. 690, 700-701. Lee's studies for this pair of murals in the 6th floor (north) elevator lobby of the Post Office Department Building appear in Bruce and Watson, *Art in Federal Buildings*, unpaginated plates arranged alphabetically by name of artist. Each panel measured 13'6" wide by 6' high and the total award was $3,000. Thus the prize paid was about $18 per square foot.

84. For the problems of Lee's commission, see Marling, "Federal Patronage and the Woodstock Colony," pp. 367-376.

85. Field Trip Report, Rowan to Section (Bruce, Watson and Ealand), March 1, 1937, 129. See also Marling, "Federal Patronage and the Woodstock Colony," p. 369.

86. Field Trip Report, Bruce to Ealand and Watson, April 18, 1938, 129, and E. B. Rowan, introduction and notes, *Mural Designs for Federal Buildings*, mimeographed catalog of winning designs in the Forty-Eight States mural competition, etc., Section of Fine Arts, Public Buildings Administration, Federal Works Agency (Washington, D. C., 1939), p. 13. *Country Post* was entry #57 in this catalog.

87. Stefan Hirsch to Rowan, March 22, 1937, 133 (Box 99).

88. Rowan to Hirsch, March 26, 1937.

89. The costume of the woman, which is vaguely modern without being fashionably contemporary, and vaguely classical without being archaeologically correct, suggests theatrical costuming of the period. See John O'Connor and Lorraine Brown, eds., *Free, Adult, Uncensored, The Living History of the Federal Theatre Project* (Washington, D.C.: New Republic Books, 1978), plates pp. 222-23.

90. Rowan to Hirsch, December 13, 1937.

91. Hirsch to Rowan, December 29, 1937, and Rowan to Hirsch, January 2, 1938.

92. Hirsch to Rowan, February 8, 1938.

93. E.g., Thomas R. Henderson, Custodian, Aiken Court House to Charles A. Peters, Jr., National Park Service, February 8, 1938.

94. Rowan to B. C. Gardener, NPS, April 29, 1938, and Henderson to Rowan, August 6, 1938.

95. This United Press report, datelined in Aiken on September 26, 1938, was carried in *The State*, Columbia, South Carolina, on September 27.

96. This Associated Press report, also dated September 26, 1938, was carried in the *Washington Evening Star* on September 27.

97. *The Aiken Standard*, September 28, 1938. The complete text of Hirsch's reply to the Associated Press is appended to Hirsch to Rowan, September 27, 1938:

[The mural] is no longer my property and it belongs to the Federal Government. I am therefore in no position to take any action in the matter. I can say however that I consider it a good and dignified painting, and when it was installed it received enthusiastic comment from the local press of Aiken, S.C. The right hand panel does not represent a shyster lawyer freeing a prisoner. After all prisoners do not back out of cells. It represents a sheriff putting a convict into custody. The central figure was conceived as an abstract representation of Justice, far from any idea of caricature or racial issues. The kind of action which the judge has taken is unfortunately nothing new in the annals of contemporary American art, and, in the long run, is of no great importance. To be a learned and just judge under the law does not imply a corresponding knowledge and justice in other fields.

98. Wire, Rowan to Hirsch, September 27, 1938, and reply, Hirsch to Rowan, September 27, 1938.

99. Henderson to H. L. Wooten, NPS, September 28, 1938, and Charles A. Peters, Jr., General Manager of Buildings, NPS, to Treasury Department, September 27, 1938, enclosing wire from Henderson.

100. Rowan to Hirsch, October 3, 1938.

101. Hirsch, quoted in the *Washington Evening Star*, September 27, 1938, and Hirsch to Rowan, October 7, 1938.

102. Myers to Rowan, December 7, 1938.

103. Hirsch to Rowan, October 7, 1938.

104. Unidentified clipping cited in Hirsch to Rowan, March 4, 1939.

105. Nancy Heller and Julia Williams, *The Regionalists, Painters of the American Scene* (New York: Watson-Guptill Publications, 1976), pp. 31-33.

106. Cahill, *New Horizons in American Art*, pp. 20 and 30.

107. Walter White, Secretary, NAACP, to Morgenthau, February 24, 1939.

108. Rowan to Myers, November 4, 1938; see also an undated letter, Hirsch to Rowan (ca. late 1938), attached.

109. E.g., Frank K. Myers to Rowan, October 6, 1938.

110. Myers to Rowan, September 23, 1939.

111. Cited in, e.g., T. D. Quinn, Administrative Assistant to the Attorney General, to Bruce, June 28, 1939.

112. Bruce to Quinn, June 9, 1939.

113. Quoted in Elmore Whitehurst, Administrative Office of U.S. Courts, to Bruce, February 28, 1940.

114. Quoted in Hirsch to Rowan, May 16, 1940, reporting a telephone discussion with the judge.

115. Hirsch to Rowan, May 16, 1940.

116. Rowan, Memo to Mechanical Engineers, January 30, 1940, and pencil notations on the reverse in Rowan's hand.

117. Hirsch to Rowan, March 4, 1939.

2

De Gustibus Non Est Disputandum
From Iowa to Missouri

What did the people want? The editors of *Life* divined a partial answer from their mosaic of forty-eight postage-stamp-size reproductions of prizewinning sketches, shoehorned into a three-page spread in December of 1939, under a headline that proclaimed, "This is Mural America for Rural Americans." The pictures, they opined, were "barometers by which the everyday taste of rural America may be judged."[1]

Life was announcing the results of the largest nationwide contest in Section history, the 48 States Competition. It was a gigantic and ambitious undertaking. The 48 States attracted the most entries ever tallied in a Section event: 972 artists sent in 1,477 designs.[2] And it aimed to blanket America in murals, from Dover-Foxcroft, Maine, to Los Banos, California—murals which would capture, in Edward Bruce's words, "the same feeling I get when I smell a sound, fresh ear of corn," murals which "make me feel comfortable about America."[3]

The premise of the contest, set forth in the Section *Bulletin* for June, 1939, was simplicity itself. One small, standard-issue post-office lobby in every state of the Union was to get a mural for the prominent end-wall above the postmaster's door. The sheer geographic scope of the enterprise made detailed thematic coaching impossible. The Section contented itself with "offering" several subjects for consideration—"The Post; Local History, Past or Present; Local Industries; Local Flora and Fauna; Local Pursuits, Hunting,

48 States jury in conference with Edward Bruce, 1939. Left to Right: Maurice Sterne, jury chairman; Henry Varnum Poor; Edgar Miller; Olin Dows; Edward Bruce; and Edward Rowan. National Archives.

Fishing, Recreational Activities; Themes of Agriculture or pure landscape"—footnoting the list with a tacit confession of past miscalculations: "Experience has indicated that subject matter, based upon knowledge of the particular locality, frequently aids the artist in his desire to achieve vitality."[4]

"Vitality," of course, was a synonym for "acceptability" to the natives of Greybull, Wyoming; Westerly, Rhode Island; Kellogg, Idaho; Delhi, New York; and the forty-odd other small towns in line for a new post office with a 42-foot frontage on Main Street, U.S.A., courtesy of the Procurement Division's architects, and thus honored by inclusion in the roll call of the 48 States Competition. The sonorous litany of the states suggested that Regionalism had at last become a proposition to be reckoned with; the published admonition to know the locale seemed to acknowledge the existence of regional conceptions of art and sectional styles of life. The star-spangled, sea-to-shining-sea ballyhoo of the competition had considerable tactical validity if this was indeed a campaign to achieve detente between Regionalism and the national mural Renaissance. Short of mounting a costly local competition for every mural painted in America, giving

artists an incentive to stick to their home territory was the surest means at Washington's disposal to avoid the nastier consequences of making down-home art by touristic excursion.

Yet, in a very real sense, belated Regionalism by fiat was a chimera. The majority of painters who might or did enter the 48 States Competition were bound to be tourists in the backwater communities slated for mural work. The 48 States gimmick relied upon assembling forty-eight virtually identical structures, with low per-unit mural costs: the average commission was $725. This expedient eliminated big and middling population centers from the pool and, as *Life* noted, gave the contest a rural focus. But the demographics of art did not correspond to the map showing the 42-foot post offices of the United States. The incorporated village of Delhi, New York, for example, harbored fewer than two thousand souls, none of whom submitted a design for the local post office in the 48 States Competition.[5]

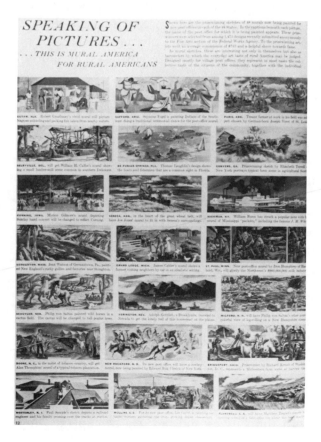

Life's 48 States issue, December 4, 1939. Life Picture Service/National Archives.

The state of Wyoming ranked forty-seventh in population according to the 1930 census, and the hamlet of Greybull was not of sufficient prominence to merit a passing mention in the encyclopedic *National Year Book* for 1939.[6] Thirty-four Greybull sketches trickled in nonetheless. Ten came from New York and seven from California. Pennsylvania, Rhode Island, Missouri, New Mexico, South Dakota, Mississippi, New Jersey, Illinois and the District of Columbia contributed one apiece. Neighboring Montana sent two, but so did far-off Connecticut. A lone quasi-native, Verona Burkhardt, designed a Greybull modello. Burkhardt spent her summers at the Klondike Ranch in Buffalo, Wyoming—75 miles from Greybull as the crow flies, 150 by road—and used that as the return address on her entry. Her working studio was in Tenafly, New Jersey, however, and the Klondike Ranch notwithstanding, she did not place in the competition. Manuel Bromberg, the winner, was affiliated with the Colorado Springs Fine Arts Center, where an intensive course in mural painting generated three Greybull designs. Bromberg freely confessed to having used Colorado models for his serenading Wyoming cowboys. Cowboys were cowboys; he did not go to Greybull.[7]

By 1939, artists had learned from experience with the artistic bureaucracy how to "paint Section."[8] The 48 States Competition did little to disabuse them of the conviction that local color could be concocted out of thin air so long as mural themes were bland enough to antagonize nobody and mural styles were legible enough to win swift approval from everybody who counted at Washington headquarters. Unless Matthew Ziegler of Ste. Genevieve, Missouri, took the warning to know the locality with a grain of salt, he must have spent the months between the opening of the contest in June and its finale in October sleeping in the back seat of his car. Ziegler, at any rate, felt sufficiently in harmony with the local folkways of assorted wide places in America's backroads to muster a whole portfolio of 48 States drawings: three for Missouri, three for Illinois, and one each for diverse points in Iowa, Wisconsin, and Georgia. Was he surprised, one wonders, to learn that his wheat-field design won the competition for the Flandreau, South Dakota, post office, a building for which, unaccountably, he had failed to prepare an entry?

Whereas *Life* perceived the small-town orientation of the contest, its romantic picture of artists roving the countryside, inspired by democratic congress with the natives, did nothing to explain a high

Philip Von Saltza, *Wild Horses by Moonlight*, USPO, Schuyler, Nebraska. 1940. National Archives.

incidence of local fury over the results of this mythical process of divining folk predilections:

Designed mostly for village post offices, [the sketches] represent in most cases the collective taste of the citizens of the community, together with the individual taste of the artist. Each artist was required to visit the locality for whose post office mural he was competing, and to discuss possible subjects for mural treatment with local townspeople. As the several captions reveal, some citizens have since objected to the mural proposed for their post office and in some cases the subject is being redesigned to suit their taste.[9]

Those captions listed one mural, for Kellogg, Idaho, under fire for its "pessimistic attitude" and five more subject to immediate revision. The latter group included some of the submissions that the special Section jury had seen fit to detach from the communities whose interests and tastes they purportedly embodied, to fill vacant walls elsewhere. The article omitted mention of the practice, leaving bemused readers and artists who had not yet caught the knack of "painting Section" to marvel over the aesthetic miracle that could transform a conception wrested from the soil of the heartland into a perfect evocation of the Pacific coast. Cosmetology was the secret. Regionalism, 48 States-style, was a matter of props, juggled with the perfunctory aplomb of a Hollywood set decorator. The illustration labeled "Shelton, Oregon" showed a trail boss, his cowhands, and his herd on the plains of the Dakotas. The caption breezily remarked that "Richard Haines's design for a prairie campfire scene will be altered to show lumberjacks with whom Shelton's residents are more familiar." Goodbye, bandanna. Hello, oilskin. Shelton got fishermen!

Safford, Arizona, had elicited a bumper crop of highly regarded

Lew Davis, 48 States sketch, *Indian Pony Round*, for USPO, Safford, Arizona. 1939. National Archives.

entries. Philip Von Saltza's *Wild Horses by Moonlight*, designed for Safford, was shuttled northeast to Schuyler, Nebraska, and the artist was urged to effect this transplantation by changing stumpy desert cacti into tall prairie poplars.[10] Lew Davis's band of Indian riders for Safford was adapted to the town of Los Banos, California, by a quick costume change. Muffled in serapes and sombreros, the braves passed for a troop of Spanish caballeros.[11] In neither instance was the retooling of motif accomplished without rousing citizen consternation.[12] When the awards were made public, Nebraskans were puzzled by those cactus plants and Californians rightly wondered at the local relevance of a scene set in the Upper Gila Valley. *Life*'s illustrated report was a catalyst, in fact, spreading discontent with standard operating procedures hitherto immune from mass scrutiny and giving every prospective taxpayer-patron with access to his or her favorite weekly magazine a crack at genuine involvement before the local mural was irrevocably glued into place.

If *Life* erred by assuming that artists had consulted with their public and arrived at subject choices by popular consensus, this fanciful conclusion became something more than a rhetorical flourish culled from a Section press packet: it was a self-fulfilling prophecy. *Life*'s readership came to believe themselves entitled to a say about the hometown mural and wasted no time in making their wishes plain. Thus, because the supercharged publicity surrounding the 48 States contest abrogated the Section's unwritten code of troublefree consultation by omission or stealth, 48 States murals can, as *Life* insisted, be taken as "barometers" of public taste in the 1930s.

Washington anticipated public hostility in cases where winning designs, chosen for technical merit, had no discernible basis in local fact. Oregon cowboys, Nebraska cacti, and the like were already slated for revision in October of 1939, before official press releases

Lew Davis, *Early Spanish Caballeros*, USPO, Los Banos, California. 1940. National Archives.

were prepared.[13] Albeit perplexing to the person from Main Street, Section artists were routinely commissioned on the strength of pictorial qualities divorced from or tangential to the regional content of their submissions. Stefan Hirsch went to Aiken because he had dealt satisfactorily with the theme of justice, and not, alas, because he possessed an intimate knowledge of South Carolina habits and scenery. Georgina Klitgaard went to Goshen because of an ably rendered sketch for the Post Office Department Building, a drawing that had nothing to do with the lore of the trotting horse. How odd this method of selection seemed to people outside the mural bureaucracy was revealed by public outcry against the more flagrant anomalies among the successful 48 States entries. Louisiana townsfolk who knew that the Eunice post office was one of the chosen forty-eight and were not privy to impending design changes objected vociferously to a lady artist's apparent intention to paint them a picture of a deserted Army base in Marfa, Texas.[14] *Life* treated the blooper with exquisite delicacy: "Laura Lewis' sketch of a sultry Southern scene will be changed to fit Louisiana's more active life."

That oblique explanation of a common-enough practice was worthy of E. B. Rowan himself and was probably ghostwritten by his staff. During the course of preparing descriptive copy for the *Life* captions, Rowan inadvertently stumbled across a kindred situation in Iowa that had not arisen from his jury's propensity for rearranging the geography of the American continent. Seeking more local color than a drawing provided—textual proof that the contest had tapped the picturesque grassroots of the nation—Rowan wired Marion Gilmore of Ottumwa, Iowa, and asked for anecdotal background on her prizewinning *Band Concert* sketch for, and to all appearances of, downtown Corning.[15] Miss Gilmore shot back this alarming revelation: "Corning mural design is adaptation of scene in Hendrick [Iowa].

Marion Gilmore, 48 States sketch, *Band Concert*, for USPO, Corning, Iowa. 1939. University of Maryland Art Gallery.

I have been in Corning and their band stand and topography not suitable for my design or typical of most small towns."[16] Rowan's riposte was a masterpiece of pious horror:

If your bandstand is not suitable for a mural in Corning it is imperative that you redesign to make it so. I cannot help but feel that there is a typographical error in the telegram which I received. In this program of embellishing public buildings we regard the public as the patron of the artist and feel that the public should be given full consideration. This is achieved by the artist incorporating subject matter appropriate to and reflective of the locale, particularly when an artist selects the activities of the people for subject matter.[17]

"Consideration" for the public, as this letter defined the artist-client relationship, came down to a literal transcription of fact. When contemporary iconography was proposed, when the public could detect disparities between the painted image and the local scene arrayed beyond the post-office door, prudence mandated that a *Band Concert* for the Corning, Iowa, post office show a band concert, by God, in Corning, Iowa. In light of the shell game being played behind the scenes with bronco-busting fishermen and pseudo-Spaniards even as Rowan was rebuking Gilmore, his position appears at best inconsistent. But the phrase "activities of the people" provides a key to his reasoning. Migratory 48 States designs fell into two categories: images, like Von Saltza's or Lew Davis's, set in an indefinite historical past, to which no living witness could take exception, or depopulated topographical views, like Lewis's, subject in any case to complete restudy. Depiction of the human present called for extraordinary caution; documentary fact, the forthright accuracy of which militated against assumption of a debatable point of view on the part of the artist, was the federal patron's safeguard against the possible displeasure of the public patron. The federal regionalism of the 48 States Competition, grounded in deadpan realism, thus undermined the

tenets of an established Regionalist aesthetic practiced in the Midwest of the 1930s.

Iowa's own Grant Wood would have been sympathetic with Gilmore's decision to alter and augment what she had seen in Corning because the bandstand park there was not "typical of most small towns" in Iowa. The force of his icons of the Midwest depended upon a paradoxical confrontation between particularized fact and paradigmatic typology. The farm couple of *American Gothic* eerily "haunts the national imagination," not because Wood's depictions of his dentist and his sister are accurate portraits—although in the absence of firsthand knowledge of the dramatis personae the clarity of his draftsmanship carries a sense of factual conviction—but because Wood has distilled a type with which his audience is already familiar and has done so with dogmatic finality.[18]

In 1935 Wood ran ads in newspapers throughout Iowa, Illinois, and Minnesota calling for a suit of red flannel underwear, "vintage 1880," a prop for a picture subsequently abandoned.[19] The story "Painter Looking for Underwear" made good copy in the popular press. Naturally! Wood's folksy search for the quintessential union suit was also a search for a popular archetype, for a factual embodiment of a pluralistic, ev'rybody-knows-what-I'm-talking-about idea of longjohns, bagged out at elbow and knee, a little worse for a winter's wear, faded and fuzzed in spots. The genuine article, in other words, served as a repository for a collective store of people's memories and images. In his projected picture of *The Bath*, as in *American Gothic* of 1930, Wood's Regionalism plumbed the popular significance of fact. Fact per se was singular and unique. The typical, presented as singular fact, constituted a powerful social bond between the painter and the people whose familiar, even conventional images of their America found confirmation and new resonance in his prim faces, his yards of rickrack, his red-flannel skivvies. Regionalism was an art of national stereotypes.

It is ironic that Stuart Davis, a modernist scarcely in step with the Section's long march back to the facts, launched the critical attack on Regionalism in 1935, the year of Wood's quest for the typical union suit, with the same charge Rowan later leveled against Marion Gilmore. Davis accused Wood, Curry, and Benton of failing to report the extant facts of life in mid-America. Regionalism, so the argument ran, neglected factual observation to spin sugarcoated yarns about "the wonderful meals . . . farm help" get in Iowa, about

heroic farmers who battle "Mother Nature acting tough in Kansas." What rankled Davis was a story in *Time* praising the Regionalists' "passion for local Americana and . . . contempt for the foreign artist and his influence."[20] Davis, a Cubist partisan, set out to expose these homespun frauds who played freer and looser with American fact than any devotee of Paris; the only recourse of such louts, given their obvious lack of inventive capacity, was to copy shopworn pictorial stereotypes. Facts were true, stereotypes bogus.

Davis meant to humiliate a passel of barnyard chauvinists by rubbing their noses in their own blundering misapprehension of fact, hence truth. The possibility that Wood and his hayseed confreres knew exactly what they were doing in collating a repertory of stereotypes did not occur to him, nor did he appreciate the nature of their fine distinction between the factual and the typical, the former isolated and inert, the latter universal and socially useful. Their pointed and ofttimes public search for the collective archetype, which aligned their aesthetic with mass culture through the consistent rightness of selected fact, did not make the Regionalists leery of popular stereotypes. On the contrary, the imagery of the mass media of the '30s is the salient analogue to their functional pictorial language. Davis judged Regionalism against the high art of the decade. He might better have judged Wood's red-flannel underwear against the popular art of Hollywood, whose business was identification and exploitation of a typology of consensus.

Movies were successful—and profitable—in direct proportion to their ability to arouse and stimulate the latent content of the popular imagination. Movies spoke to everybody, at 25¢ a head, in a familiar tongue, the imagistic argot of the people. The cowboy, the hood, the common man, and the Midwestern farmer were instantly recognizable amalgams of operative myth, fiction, legend, and half-remembered dreams of childhood, and they were factually manifested by a white Stetson; a Jimmy Cagney; a Gary Cooper; the plain, long face of a Henry Fonda. People readily grasped the movie stereotype and with it an archetypal cluster of allied meanings and messages. "Yes," they exclaimed. "I remember now! It was like that. It is like that." And in that respect, Fonda's face and Grant Wood's haunting farmer occupied the same perceptual terrain.

When art moved out of the cloisters of the elite to shift for itself in the popular arena, those same popular stereotypes, the working cultural symbols of the decade, became a factor in public response

to the mural, a frozen movie projected gratis on the post-office wall. The inability of Aiken, South Carolina, and Washington, D.C., to come to terms with each other's perceptions of *Justice as Protector and Avenger* stemmed from conflicting perceptions of what order of judgment, what mode of approach, was appropriate to a visual experience that occurred in the people's aesthetic environment. The Section dumped art into that terra incognita without paying much attention to the mores and rules in force there, and prattled on about principles of "good art" applicable in the halls of high culture where Rowan, Stefan Hirsch, and Stuart Davis might conceivably rub elbows, where a redneck judge would get short shrift. Fact was Washington's intuitive concession to the ethos of Everyman, a concession made in lieu of an assessment of the character and contents of the visual culture of Main Street.

When Aikenites, for instance, looked at the Hirsch mural and decried the presence of a "shyster lawyer," a mockery of justice, the plausible source for what struck Washington as an unaccountable misreading of fact—an irrational Southern fantasy—was a cinematic type Rowan could not and did not associate with art and noble visions of national artistic rebirth. Aiken saw a shyster on the courthouse wall. The shyster—the corrupt fixer from Manhattan, played with curled-lip urbanity by William Powell and John Barrymore—was a stock type in the films of the early Depression years.[21] People had seen Hirsch's shady fellow in the fedora before in episodic visual parables from RKO and Warner Studios not unlike the scenic compendium posted in the Aiken Court House. The people of Aiken did, in fact, participate in the public dialogue opened by the mural, on the same terms that matinee audiences reveled in movies called *The Mouthpiece* and *Lawyer Man*, and rejected the mural, in part at least, on the warrant of popular typology. People hissed the villain. Standards of "good art," newly purged for the people's benefit of the elite hocus-pocus of abstract and academic conventions by a wholesome infusion of plain facts, still did not allow for hissing in the courthouse or the post office.

The knotty relationship between federal efforts to promote regional content in small-town murals and the co-extensive movement known as Regionalism is hard to unravel. Regionalism was never a programmatic movement with manifestos and membership pledges. Benton, the putative group leader, later remarked that the term "was applied to Wood, Curry, and me with some degree of fitness

but mainly, I suspect, because the fashions of the time called for classifications."[22] Likewise, the mountain of official literature cranked out by the Section refuses to yield up a systematic theory of local-scene painting. Commentators have sensed that the idiosyncratic, mannered Regionalism of the Midwestern triumvirate of Wood, Curry, and Benton constitutes a special case, distinct from a widespread regionalist tendency in the art of the '30s. The genus "regionalism" is sometimes called American Scene painting and the Regionalist label reserved for the particular species thereof concocted by the Big Three.[23] Yet semantic frustration over distinguishing Regionalism from regionalism has not resulted in a workable definition of either term, let alone consideration of where murals said to be drawn from indigenous local ingredients fit within this confused spectrum of American Scene cum Regionalist stuff.

Pitting nationalism against regionalism, or Regionalism, is a tempting ploy. But gross distinctions between a nationwide, federally imposed mural Renaissance and countervailing sectional inclinations are of questionable use in considering a program like the one run by the Section, whose procedures for conducting its principal business of making art—"good art"—did not consistently mate local artist with home place and did not systematically prevent that marriage from being consummated. Then, too, the course of production, in which the bureaucracy was enmeshed, is less crucial to resolving the Regionalism vs. regionalism debate than the reception of art. Conversely, fact of place qua pictorial content, directly pertinent to the American Scene mural of the 48 States contest, is seldom of import to the Regionalists. Their art cannot be exhausted by reference to local Midwestern motifs. "We went from place to place to place," Benton testified, "from region to region, from one time period to another."[24]

The unifying factor in capitalized Regionalism is, in the strictest sense, neither style nor iconography. It is an attitude of mind, the artist's appraisal of who constituted his audience. As Grant Wood remarked, putting his emphasis squarely on the recipient of the object, "a work which does not make contact with the public is lost."[25] Motifs were plucked from the public domain because the artist believed that his work ought to make its impact there. Since Regionalism was pitched at the man and woman in the street, the Regionalist aesthetic was fundamentally concerned with the texture of America's popular perceptions. For that reason, fact garnered from immersion in the spe-

cifics of a given place had negligible value. Stuart Davis's bill of indictment against his Midwestern adversaries focused on factual credibility. The man and woman in the street, he implied, could not trust a Regionalist to tell home truths. Davis was right, of course. At the same time, his critique was profoundly beside the point. And since fact was extraneous to Regionalism, fact is also extraneous to locating the watershed between Regionalism and the regionalist Section mural, in the yawning rift between popular culture and high culture.

Regionalism stood defiantly on the side of popular culture, unstable and mercurial. Tethered to the visual ambiance of movies and tabloids, the Regionalist looked first at how ordinary people were liable to view Depression America and what symbols in their mutual experience they found meaningful. The movement sank taproots so deeply into the shallow and passing sensibilities of the instant that, the endlessly haunting *American Gothic* notwithstanding, Wood and the rest risked creating instant period pieces. By holding the mirror of art up to the experiential dimension of the '30s, rather than to the facts, Regionalism deliberately sacrificed the temporal detachment other men of the '30s, gazing back in wonder at the enduring mural traditions of the past, associated with qualities they found in the "good art" of the ages and proposed to reactivate as the bases for a lasting new Renaissance in national expression. The Section, then, stood on the side of the promises tendered by the high culture of the artistic masterpiece—stability and timelessness. Fact became an obsession with the bureaucracy of the American Renaissance insofar as the Section opted to recreate American art in the image of a model deduced from contemplation of mural masterpieces forever resistant to the tides of popular fashion.

Essentially, the conflict between Section regionalism and Regionalism parallels a broader sociocultural conflict of the Depression years, namely, divergent answers to the question of how to cope with a national catastrophe touching everyone's life. The Depression was a collective catastrophe; bureaucrat and Regionalist alike acknowledged that truism. Wood spoke of a public to be touched at all cost. Rowan said that the "public should be given full consideration" as the true patron of the Section mural. There agreement ended. The Regionalist was prepared to accept the topsy-turvy American experience as it was, to deal with the crisis of the present in its own terms. The Section was prepared to do battle against the Depression by redirecting the disjointed consciousness manifest in the popular cul-

ture toward fixed values impervious to present flux and confusion. Seeking stability above all, Section theorists turned to an examination of masterworks that the passage of time had proven universal in their appeal. They went to the "good art" of times past in search of ingredients that might lend contemporary American murals the same capacity to transcend time and social adversity.

Forbes Watson's discussion of the Renaissance mural tradition shows that in the course of this expedient search, the Section found the unvarnished facts to which the American Renaissance would return under federal auspices:

> The masters of the past were not in the least discouraged either by the demands of liturgical accuracy or by the requirement to make their earthly story-telling clear to multitudes incapable of understanding art. It is inconceivable that an altarpiece could have been acceptable to church or other patron if, for instance, it exemplified so highly specialized a field of untraditional abstraction that the humble worshipper could not recognize the biblical story it was designed to illustrate.[26]

As a cogent account of how mural masterpieces came into existence — the dynamics of the painter's interaction with his public in his own epoch — the passage is ludicrous, and Watson sums up his argument with a grandiloquent peroration that is a virtual admission of analytic failure:

> Back of all great mural painting is a belief. The painter shares this belief with his audience. The belief may be religious as in the thirteenth century in Italy, or it may be social as in the twentieth century in America.[27]

Yet hope and belief — belief in the possibility of escape into the promises of a "usable" artistic past — forged the Section's otherwise inexplicable link between fact and timeless serenity, between accuracy and national salvation. That "firm ground other men, belonging to generations before us . . . found to stand on" was reclaimable in the historical iconography of America's past, usable by virtue of its apparent factual fixity; and in the stylistic characteristics of Europe's artistic past, usable by virtue of its astonishing capacity for psychic survival.

Looking at the walls of Italy with the eyes of belief, looking for ways to erase the accidents of time, the pilgrim from accident-prone, Depression America found Tuscan peasant girls robed as madonnas, or the proud Gonzaga rulers of Mantua, all alive and vigorous, thumbing their accurately rendered noses at their own mortality. Somehow

(and analysis of just how it had been done faltered badly in the calm pictorial presence of the Renaissance world) fact had triumphed over time. Watson's ignorant "multitudes" of the past needed facts that, paradoxically, elevated great art above the culture whose facts it reported. Could Rowan's insistence upon the factual needs of the American public produce similar results? Could the chaotic present, pictured in factual terms, become a counterforce against insecurity, a "usable present," a new kind of contemporary history?

The list of acceptable subject matter for 48 States murals contained an odd turn of phrase indicative of the Section's readiness to treat the experiential present as history. That document encouraged muralists to paint "Local History, Past or Present." "Present History" was not, in the Section's lexicon, a mazed contradiction in terms. It was instead the logical, salvific end-product of painting local fact. 48 States regionalism is Present History, a repudiation of the myopic contemporaneity of the movement called Regionalism.

Rowan chastized Gilmore for the same failure Davis ascribed to Regionalism. Painting a small town in southwest Iowa, Gilmore bypassed the facts of Corning to achieve a generic sense of what concepts and ideas attached themselves in 1939 to life in the typical small town in mid-America. She chose her pictorial contents accordingly. Her repertory of small-town symbols included a Civil War cannon and an obelisk flanking the bandstand on the village square. She had seen details like these in Hendrick, Iowa, and elsewhere in the state. What she was up to in the Corning mural, however, and what she resisted giving up in the teeth of harsh criticism, went beyond collection of observed detail. Gilmore had assumed a point of view about her material. Like a Regionalist, she selected and detected features of the Midwestern scene that were not restricted to Corning but could stand for qualities generally accruing to the Midwestern town in 1939. By painting the typical—a version of facts already filtered through the popular mind—Gilmore put the contingent present at the center of the Corning mural.

Before Rowan's letter reached Marion Gilmore, the 48 States issue of *Life* did. "I read that my mural was to be changed to suit Corning," she wrote. "Will you please tell me what changes are desired?"[28] After she received the order to get her facts straight for the sake of "the public as the patron of the artist," Gilmore yielded slowly to federal pressure. She also seized the opportunity to explain

herself and to argue for retention for her antifactual concept:

I have reluctantly eliminated the small monument and cannon which were in the original sketch. This was done because of the publicity in *Life* magazine which stated that my picture would be changed to suit Corning. There is no monument or cannon in Corning. The bandstand shown is the same as theirs. The garden on the left is identical with one in their park. If, for the sake of the design, you wish the cannon and monument restored, I shall be only too glad to do so. As you know, they are typical of the smalltown parks out here.[29]

"Marion Gilmore's mural depicting Sunday band concert will be changed to reflect Corning," *Life* reported. Corning, then, was one of those instances in which "the subject is being redesigned to suit [the] taste" of the local townspeople. Thanks to *Life*, even without Rowan's misleading hint of local outrage before her, Gilmore assumed that the demand for fact which would "suit Corning" came from Corning. And as the tone of her reply indicates, she rather hoped the Section would see her side of things, favor the merit of a sketch already endorsed by the jury, and comprehend her desire to paint the typical small-town band concert.

The mural now hanging in the lobby of the Corning, Iowa, post office need not represent Corning, although the municipal park a few blocks away with its garden, paths, benches, and bandstand — without cannons and monuments — resembles the scene shown in the revised and expurgated *Band Concert*. A row of old buildings straggles along the flank of the park in Corning. These structures should be visible in the background of the mural, beyond the bandstand. In their stead, Gilmore inserted a dense wall of foliage that, unbeknownst to Washington, never existed in Corning (or in Hendrick, for that matter), even though the trees made their first appearance in the prizewinning sketch. The trees are not fact; by screening out the world beyond the little park, they help make the park a peaceable kingdom, sealed off from the woebegone commercial block of the real Corning. The trees were not there, but they should have been because they reinforced the idyllic, pastoral mood of shared pleasure, which is the theme of *Band Concert*. Whether the place is Hendrick or Corning or any one of a hundred other Iowa villages is not germane to Gilmore's assemblage of neighborly farmers and townsfolk, drawn together under the nighttime sky by the radiance emanating like music from the bandstand at the heart of the picture to shine on each family, couple, and cluster of friends, uniting them all with flickering touches of golden pigment.

Gilmore intended to paint her mural directly on the post-office wall, with an audience watching.[30] She set to work, only to find that the oil-based finish applied to the plaster a year earlier repelled the gesso undercoating necessary for direct painting. After three frustrating weeks, she gave up and went back to Ottomwa to execute the mural on canvas. Gilmore enjoyed her stay in Corning, however, and described her experience in some detail to Rowan:

Corning showed the greatest curiosity and civic pride in what painting I accomplished while there. So many questions were asked that I typed a lot of information about the medium, the Section of Fine Arts, etc., and tacked it on the scaffold where people could read it, alongside a photograph of the cartoon. Many amusing comments were made. One old codger very much wanted to be shown in the picture. I told him he could be if he'd grow a mustache. When I left Corning, he'd started one. The band leader objected that I showed his pants unpressed and he always had them pressed before a concert. The assistant postmaster thought it would be nice if her dog could be pictured. While painting on Sunday, to avoid constant public interest, one elderly gentleman quoted scripture at me. I quoted back.

I enjoy Corning and deplore not being able to paint their picture for them on the spot. Also, the countryside is full of exciting subject matter, Saturday nights, church suppers, sale barns, horseshoe pitching, auctions, coal miners' carnivals, etc. The town is "nuts" about horses. They breed them and go to the races in Omaha. The bookie hangs out in the barber shop most of the time.[31]

Gilmore did like Corning, the people she met there, and the sights she saw. Had she not been among the errant minority singled out for failing to "suit" local taste, she could have served as a shining example of the kind of artist *Life* adulated for democratic interaction with townspeople; she was far from indifferent to the social implications of painting in full view of her public. Nevertheless, these sentiments did not change Gilmore's attitude toward the role of fact in mural art. Her initial response to Rowan's plea for factual accuracy was reductive: she took out obviously alien details. But on the scene in Corning, she kept her fictitious trees. Despite affection for the kibitzers around the scaffold, Gilmore did not think it important, to them or to her picture, to add pressed pants. If the "old codger" grew a mustache to conform to a figure already in the design, he was free to think he was in the painting. Yet the painted mustache clearly preceded the one he was still trying to raise when Gilmore left town. There are no portraits in the Corning mural, no sharp, distinctive features that might suggest derivation from specific persons. There are, instead, types, as familiar as old friends: farmers in bib overalls,

Arthur Rothstein, *Saturday Night, Main Street, Iowa Falls, Iowa*. 1939. Library of Congress.

housewives in print dresses and white pumps, old patriarchs sporting grizzled mustaches, townies resplendent in off-the-peg suits.

Arthur Rothstein was taking pictures in rural Iowa in 1939 for the Farm Security Administration. A documentary photographer, Rothstein favored candid portraits; when he asked people to pose for the camera, he lamented, "their forlorn attitudes gave way to . . . Sunday-snapshot smiles." When he worked without alerting his subjects to his presence, "this method gave me what I wanted, a factual and true scene."[32] A Rothstein candid titled *Saturday Night, Main Street, Iowa Falls, Iowa, 1939* shows one of the "exciting" and apparently typical small-town scenes Gilmore was coincidentally discovering in Corning. Because *Saturday Night* is a photograph, "factual and true," it comes as something of a shock to realize that Rothstein's record of life in north-central Iowa is strikingly like Gilmore's factually suspect interpretation of life in southwest Iowa.[33] Both are set in a sociable nighttime. By taking his picture of the sidewalk processional from the darkened street and from behind a row of parked cars, Rothstein avoided provoking his subjects into grins for the benefit of the camera. Indeed, the photograph is noteworthy for the absence of portrait images.

The strong artificial light of a movie-theater marquee wipes out the features of those few faces that are turned toward the onlooker. Most of the crowd of thirty or so standing about in conversational groups and parading down Main Street appear in lost profile or rear view. Yet, as in Gilmore's mural, the impression of knowing what is

98

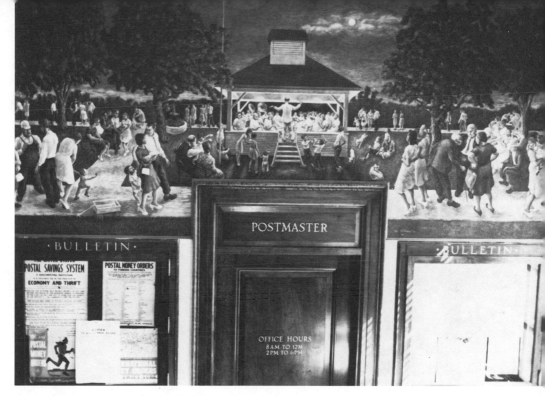

Marion Gilmore, *Band Concert*, USPO, Corning, Iowa. 1941. National Archives.

happening here and who is making it happen is overwhelming. The print dresses and pumps, the cheap suits and workpants—unpressed —establish types that are recognizable although the individuals are not. The title only pins down to one place in Iowa what the image itself makes plain. This floodlit oasis of camaraderie *is Saturday Night* in a small town in the Midwest, a peaceful, old-fashioned idea of what America is all about when folks get together, and one altogether in keeping with Gilmore's Sunday-night concert in a small town in the Midwest. If Gilmore, blasé about documentary detail, and Rothstein, ever on the lookout for the "factual and true" scene, both arrived at a situational truth, a typological truth that is not premised on unique facts, what are the cultural archetypes that stand behind their rural nocturnes? What makes it possible to believe that their pictures show exactly what life is like in Iowa and what it must feel like, deep in the heart, to be there?

In the case of the Corning mural, the title of the work is suggestive. *Band Concert* was also the title of a Walt Disney cartoon released in 1935 and much noted at the time because it was the first Mickey Mouse short presented in Technicolor.[34] The setting could be Corning or Hendrick or Iowa Falls. On a bandstand in a small town park

Scene from Walt Disney's *Band Concert* cartoon. 1935. © Walt Disney Productions.

someplace in the Midwest, Mickey Mouse is leading an animal orchestra through a spirited performance of the William Tell Overture. The program of light classics is soon interrupted. First, Donald Duck wanders by in the guise of an ice-cream vendor. His musical tastes run to the likes of "Turkey in the Straw"; every time the band pauses for a beat, the duck plays his populist anthem on an inexhaustible supply of toy flutes. When one is confiscated, another materializes and cultural conflict rages until the town is suddenly assailed by an external force, evoked by the increasingly desperate tempo of the overture. A John Steuart Curry tornado swoops down and twirls Mickey, his band, his audience, and the duck high into the air. Mickey keeps on conducting, regardless. The swirling musicians keep on playing, too. At the musical finale, everybody falls back into the park to conclude the afternoon's concert. A toy fife steals from the recesses of a dented tuba and the film closes with the duck's "impertinent rendition of 'Turkey in the Straw'."[35]

Disney's cast is made up of cartoon animals with human attributes. Clarabelle Cow, the flutist, is a barnyard Guernsey in a cotton housedress; Horace Horsecollar, the percussionist, is a plowhorse in a

merchant's derby. Cows can't play flutes, but Clarabelle seems no more incongruous in the Disney context than a bandleading mouse. He is the little guy, temporarily in charge and grittily determined to fend off any disaster that threatens aesthetic order or undermines his ability to get the job done. She is the rural matron, awkwardly doing something she does not ordinarily do and dauntless in her commitment to the cause of culture. The animal characters help to set the scene in farm country; they also serve as metaphors for the types of country people whose clothes they wear and whose actions they mime. Disney's Mickey Mouse cartoons were updated animal fables beamed at a catholic audience made up of children and everybody else. And Mickey's adult fans realized something not always apparent in movies with live actors and serious themes: fables were meant to address problems and situations broader than the primary content of the cartoon might suggest. Disney's Academy Award-winning "Three Little Pigs" of 1933 was commonly understood to be about exorcizing the "Big, Bad Wolf" of the Depression.

Band Concert has a more complex metaphorical structure. The duck's conflict with the mouse, for instance, is on one level a classical confrontation between the dissident spirit and the authority figure, the village atheist and the rigid, small-town pecking order, the individual and society. But it is also a sly lampoon of high cultural pretensions assailed and finally subdued by popular culture. The duck may not know anything about art; he certainly knows what he likes. Under other circumstances, Donald Duck could be envisioned writing vitriolic letters to E. B. Rowan lambasting the "so-called art" in the local post office. The running battle between mouse and duck punctuates a dominant story line that pits order against chaos, the band concert against the tornado, the collective spirit of the Midwest against the Depression. The tuba gets dented, but when folks work and play together, things turn out just fine. That is the situation celebrated by Disney's *Band Concert*.

Marion Gilmore was not working with a plot unfolding over time. She did not tell a story with the complications of Disney's, although had she chosen to do so, the episodic mural format of Thomas Hart Benton, which encouraged the eye to trace temporal sequences much as a movie showed causes followed by effects, provided a Regionalist model for plotted narratives in paint. Even without plot, Gilmore's emphasis on the spirit of neighborly unity occasioned by the ritual Sunday *Band Concert* in Corning gives her mural the optimistic fla-

vor of a Disney cartoon. The Corning mural depicts an ingathering of hometown folks, a dream of peace and harmony in the countryside. Gilmore did not insert a menacing tornado that her concertgoers must unite to resist, but she is aware, pictorially, of forces external to the grassy park, forces that the collective ethos alone keeps at bay. The Iowa sky is inky and threatening. The trees form a bulwark against realities that the radiant light of the bandstand cannot penetrate. Indeed, Gilmore looks in on her *Band Concert* at a moment that parallels the last sequence of the Disney cartoon. The tornado has come and gone, as it were; the dark forces around Corning have already been conquered by the pervasive light that shows Corning to be an island of harmony in a black, unknowable world. Corning has already become an ideal of mid-America, implicitly resistant to whatever lurks outside the unifying circle of fellowship and collective grace. That ideal is also reflected in Rothstein's photograph of an island of *Saturday Night* good cheer in the darkness beyond Iowa Falls. Their ideal Midwest is inhabited by ideal types, by generic presences. One particular old codger is of as little use to Gilmore's fable as a newsreel clip of FDR is to Disney. The old codger type, like the cow-matron or the horse-grocer, serves the cause of fable-telling and myth-making far better.

There is no reason to believe that Arthur Rothstein or Marion Gilmore studied the Disney cartoon. Disney was, however, the consummately successful popular artist of the '30s. When Disney pictures an ideal mid-America made up of types that a mass audience must recognize, even when shown as cows or mice, it becomes apparent that the popular culture Disney tapped contained these ingredients. A Mickey Mouse cartoon need not be considered a direct source for the Corning *Band Concert*. The *Band Concert* cartoon does, nonetheless, help to confirm the attitudes of the man and woman in the street. The typological, idyllic Midwest summoned up repeatedly by Disney, Rothstein, and Gilmore was among the operative archetypes of the '30s, endorsed and cherished by an audience that included kids and parents, Section muralists, and documentary photographers. If Corning wasn't like that, it should have been. America knew what Iowa looked like.

Did the people of Corning, Iowa, endorse this vision of their hometown? Indeed they did and given an opportunity, it seems, Corning would also have cherished the obelisk and cannon banished "to suit their taste." In March of 1941, the *Adams County Free Press* devot-

ed a front page to the Corning mural, recounting Gilmore's problems with the wall surface and discussing her recent return to hang the finished canvas. The headline read: "Mural to Adorn Postoffice Wall." And the large photograph beneath showed not the mural but the 48 States sketch, "typical," unrevised, and, if the cheerful text of the article is to be believed, perfectly satisfactory to all concerned in its own right.[36]

The Section customarily solicited local reaction to murals by asking postmasters to forward press notices and to summarize opinions expressed by visitors to the post office. The postmaster of Corning sent along a clipping, adding that "there were earlier reports which made favorable comment on the work but I have not been able to get a copy for you." As for the public, he wrote, "Many comments are made on the merit of the Painting by patrons of the office and of other localities. A few of them are unfavorable which is to be expected but as a general thing the picture is liked and has created a great deal of interest."[37]

General "liking" was hard to verify. Enraged taxpayers wrote letters; unsolicited testimonials were a rarity. This letter, from one T. B. Turner of Corning, both delighted and puzzled Washington:

Enclosed herewith a portion of the front page of our Adams County Free Press (about the livest County paper in the state) with cut of Miss Gilmore's Post Office mural.

The prominence given indicates not only the high esteem in which our people hold our splendid Post Office building, but also their appreciation of its crowning glory—this mural which so artistically and yet so truthfully depicts the happy, community "way of life" in the finest little town in the most liveable section of the most prosperous state of the most democratic country in the whole topsy turvy world, in this problematic year of 1941.

I think it all helps to boost our confidence in the constructive nature and eventual success of our governmental program. Therefore I am taking the liberty of taking time out to send in my congratulations on a piece of good work so well done—now that the whole project seems to be completed.[38]

Who was T. B. Turner? A mural shill? One of the artist's shirttail relatives? He was, Gilmore testified, "an older man, one of Corning's citizens who is known as 'well-to-do' and is a brother of ex-governor Dan Turner of Iowa and Corning. Republican, too!"[39] Turner was also a citizen critic of no little sensitivity. He saw truth in *Band Concert.* What he meant by truthfulness was not factual verisimilitude; the clipping he sent Rowan was the article that confused the offending sketch, nonexistent obelisk and all, with the expurgated mural.

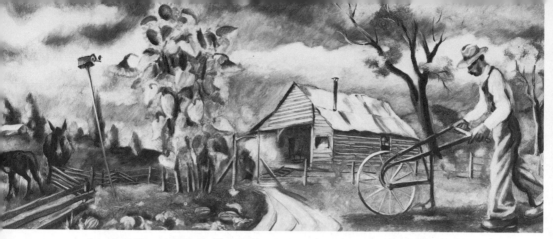

Joseph P. Vorst, 48 States sketch for USPO, Paris, Arkansas. 1939. National Archives.

Truth, for Turner, was Gilmore's pervasive sense of "the happy, community 'way-of-life,'" an emblem of mid-American bliss set off against dark forces pent up behind the barricade of fictitious trees that marked the border between the cosmos of Iowa communality, as Iowa saw it, and the chaos of a world rent by Depression and the ominous specter of war.

Gilmore was exceedingly pleased at this empathetic response ("No mural," she bubbled, "can be as good as Mr. Turner's letter") because it confirmed the nature of the local reactions she had already reported to Rowan, after her final trip to Corning:

> The folks of Corning seemed to get a . . . "kick" out of the mural. They would point out to each other one detail after another and say things about how that was just the way folks did things and how they looked, [and they] asked me if I hadn't been to lots of band concerts there.[40]

Folks liked *Band Concert*, not because Gilmore had returned to the objective fact demanded by Washington, but because she had shown them the Corning that existed subjectively, in their mind's eye. And that was "just the way folks did things" in "the finest little town in the most liveable section of the most prosperous state" in the Midwest of the heart. Gilmore's Corning was home, that "state of mind" to which a little farm girl called Dorothy Gale returned in the 1939 film after a tornado sent her on her excursion through the "great and terrible" Land of Oz.[41] "Isn't it funny?" Judy Garland exclaimed as Dorothy. "This is the place I was looking for all the time. And I never knew it! This is the most beautiful place in the whole wide world! . . . Oh, Auntie Em, there's *no* place like home."[42]

The magic of home, as homefolks perceived it, was not to be tampered with, even when there was factual justification for doing so.

"German-born Joseph Vorst of St. Louis" was the 48 States winner for Paris, Arkansas, and had chosen, *Life* noted, to depict "a tenant farmer at work in his field."[43] The sketch showed a mean, bleak home place, as familiar in its way as a typical Iowa small town. Beneath a glowering sky, a ragged Negro, rooted to the soil by his ponderous boots, listlessly cultivates a scrap of scrubland with a manual tiller. A couple of spavined mules can barely muster the energy to watch. His cabin, listing toward the dirt road that marks the central axis, is a ramshackle hovel, roofed in peeling tarpaper. As if to comment on domestic blight, the birdhouse in the yard lolls at a crazy angle on its pole, sounding a note of picturesque decay heightened by the piquant gaiety of a clump of sunflowers blooming nearby. The branches of dying trees claw at the heavens like desperate fingers.

This glimpse of rural Arkansas provides pictorial confirmation for Erskine Caldwell's impassioned polemic on the evils of tenant farming in the South:

The sharecropper of yesterday is the wage worker of today, the man who peddles his brawn and muscle for twenty-five and thirty cents a day and who is lucky . . . if he can collect it in cash instead of cornmeal or old clothes. The sharecropper's place has been taken by the renter, who pays for the rent of the land whether there is anything left for himself or not.

This once-flourishing farming country is now a desolate land. . . . Fewer tenants can find employment. White men are being replaced by cheaper, more tractable Negroes. . . . There are hundreds of sections in the South where the land has been bled of all fertility and now lies unproductive. . . . Tenant houses, rotted and roofless, are the homes of families hoping that this year, next year, some year soon, will provide food, clothing and shelter.[44]

Caldwell's text lays blame for the tenants' plight at the feet of Southern politicians. In the author's native Georgia, for instance, no direct relief was provided for displaced sharecroppers. Governor Eugene Talmadge, "the self-styled 'wild man', the dictator of three million people" shifted that burden to the New Deal while thwarting the efforts of federal agents and looting federal coffers: "He holds one hand behind his back to receive the money sent down from Washington to keep alive the men who voted him into power."[45] Caldwell wrote *Some American People* in 1935. The book brutally exposed the political venality responsible for tenant poverty. But its effects—the deformity of lives molded by greed and graft and penury—became Caldwell's special fictional province. His portraits of the gro-

tesque social ramifications of poverty in the rural South were requisite features of the popular portrait of America in the '30s.

In 1933 the New York Society for the Suppression of Vice charged Viking Press with obscenity for releasing Caldwell's *God's Little Acre*. The widely heralded court decision dismissing the accusation emphasized the documentary character of the novel. "It was written," Magistrate Benjamin Greenspan concluded, "with a sincere attempt to present with truth and honesty a segment of life in the Southern United States." The unsavory doings of Ty Ty Walden's Georgia cracker clan, he added, portrayed "in a realistic fashion . . . life as lived by an illiterate Southern white farm family. There is interaction between the run-down farm life and the mill town life. [The] people are primitive and impoverished. They are deprived of the opportunities for development, and their activities are largely sexual."[46] In 1933 this primitive, run-down South hit the headlines again when *Tobacco Road*, a play adapted from his 1932 novel by Caldwell, in collaboration with Jack Kirkland, began a seven-year Broadway run that set a new longevity record in American theatrical history.[47] Jeeter Lester's tumbledown cabin on the bare stage of the Forrest Theatre became a documentary artifact, an emblem of the sordid, suffering South that Vorst documented from life in 1939.

Unlike most 48 States competitors, Vorst had done field research. "Whether the Arkansas Parisiens wish to admit it or not," he averred, "I made that sketch from life during my recent visit to Paris and it *is* authentic."[48] The artist was answering a body of citizen protests lodged with the office of Congressman Fadjo Cravens and duly passed along to the Section, which summarily decided that "the artist would be the first to understand the logic of the protests and . . . will be instructed to confer with the Postmaster relative to the subject matter and redesign in order to meet the local requirements."[49] Vorst did not respond to this decree with the smoldering indignation of a social realist debarred from using his art to second liberal calls for federal intervention on behalf of Southern tenants. He told Rowan to advise the Congressman "that steps are being taken to please the Paris citizens, but not, I may add at the sacrifice of genuine Art." Whatever he meant by "genuine Art," art worried him more than tenancy in Arkansas:

Naturally, if restrictions are too great, or unreasonable demands too insistent I will not be able to do the work. After all, I came to this country partly to attain artistic freedom.[50]

106

His correspondence, which ever extols creative liberty in America, is innocent of any twinge of protest against the exploitation of tenants, black or white. By the wildest contortions of the imagination, neither his prose nor his painting can be wrenched into conformity with Caldwell's sexual metaphors for oppression. By Vorst's reckoning, he had painted a genre scene, pure and simple. He had painted the facts of a run-down, barren tenant farm, observed in Paris with his own eyes. Those facts, he realized, were not altogether lovely. As for the local flap, Vorst decided, "No doubt the reason behind it all is that the selected sketch is not too flattering."[51]

Vorst was right, for the wrong reasons. Some facts were both reality and myth. People objected to his depiction of Paris not merely because it was unflattering but because it was unflattering in a particularly repugnant manner. The editor of the *Paris Express* was clear enough on that score when he sent a reproduction of the heinous 48 States sketch to Congressman Cravens with the following wounded commentary:

I believe you will agree that this picture is not appropriate for our state. Arkansas has been the butt of jokes for many years, [and] I do not believe in perpetuating this attitude by placing a painting of this type upon the walls of our most prized building, the post office.
Every citizen contacted has expressed an opinion conforming with my own. We appreciate the honor of having our post office selected among the 48 to receive murals, but believe we prefer doing without than [sic] to have the selected subject.[52]

What ancient jokes about Arkansas were making the rounds in 1939? Editor Guion expected his congressman to grasp the gist of the objections from a passing glance at a picture of a tenant farm; he did not find it necessary to spell out the nature of the pictorial offense. And Cravens seems to have understood the basis of the complaint perfectly. Arkansans, therefore, took a picture of a dilapidated tenant farm to be the latest jibe in a lengthy campaign of ridicule directed against their home state and felt the slur obvious enough to require a minimum of exposition. That run-down farm was the old joke, a negative stereotype.

Regionalism extracted usable stereotypes from the culture to prove the pungent uniqueness of the American scene, to rally confidence in a unique national identity predicated on a collective delight in recognizing the signs and emblems of a patchwork America composed of peaceable small towns and deliciously wicked cities. But

familiar sectional stereotypes were not uniformly appealing to the people upon whom two-dimensional symbols were based and to whom they were promptly applied. Iowans had reason to enjoy being shown in the guise of friendly, simple folk. That image conveyed largely positive, praiseworthy qualities and glossed over the bookie in the Corning barber shop. If the Main Street stereotype also skimmed lightly over flinty-eyed commodity brokers in Des Moines, intellectuals in Iowa City, and Grant Wood's citified clientele in Cedar Rapids, Regionalist typology lumped them in mythic, beatific union with the virtuous farm communities of the state. As analysis of the workings of a farm economy, Iowa Regionalism was not entirely wrongheaded. As a pleasant way of confirming one's own sturdy roots and splendid traits of character, it inflated the pride of villager and sophisticate alike. Bathing in reflected glory is pleasant and Iowans all were the salt of the earth. So, in general, were Midwesterners, the '20s lampoons of Sinclair Lewis and Sherwood Anderson notwithstanding. So were a few carefully selected Southern types; FDR, the presidential yeoman farmer ensconced in Georgia, rather fancied the title "Squire of Warm Springs."[53]

Not all sectional stereotypes were so benign. In Vorst's sketch, Arkansas Parisiens saw an old, hackneyed picture of the Ozarks revived. That he had seen this particular tenant cabin, that he had reported the facts accurately, was beside the point. Arkansans had seen this place often enough before, too, but far from serving as a unifying principle in which the Paris community could take pride, the tenant cabin was reckoned an outlander's joke, a denigration of home, the latest instance in a tradition-laden conspiracy to misrepresent a backward Arkansas.

The Arkansas of legend was the homeland of the murderous "Arkansas Toothpick"—the Bowie knife. Its shiftless hillbilly ways had been codified as early as 1847 by minstrels and carny pickers in the lyrics of the popular folktune "The Arkansaw Traveler." Vorst had not managed to assemble every one of the classical elements folklorists demanded in dramatic presentations of the ballad. Total authenticity required "an idle squatter drinking corn liquor in a log cabin buried in the hollow, surrounded by a stringy-haired wife, a passel of barefooted young uns, and a couple of razor-backed hogs."[54] Vorst had, however, suggested most of the notions traditionally attached to the subliterate Ozark folk community and hence to all Arkansas communities: isolation, a marginal standard of living, dependence on

an unyielding land, and, above all, a limitless tolerance for squalor. "The Arkansaw Traveler" was often sung in dialogue form. A wandering horseman questions a hillbilly fiddler idling his life away before a ruinous cabin he sees no reason to fix. The best-known lines of the exchange immortalized rural Arkansas as the home of the deservedly poor. "Why don't you put a roof on the house?" asks the interlocutor. "When it's dry," the Arkansan replies, "I don't want a roof; when it's wet I can't."[55] A rhyming version of the lyrics gave the same sentiments a jaunty air of pride in shiftlessness:

> But the old man kept on a-playin' at his reel,
> And tapped the ground with his leathery heel.
> "Get along," said he, "for you give me a pain;
> My cabin never leaks when it doesn't rain."[56]

When Benton made a sketching trip through Arkansas and southern Missouri in the late '20s, he breathed fresh life into an Ozark stereotype of decadent indolence. His autobiographical travelogue, *An Artist in America*, published in 1937, was peppered with drawings that contained germs of reportorial fact yet seemed typically hillbilly. Vorst of St. Louis was familiar with the work of Benton of Neosho and Kansas City: his slewfooted farmer is a trademark Benton rustic. *Sharecropper's Shack*, a plate from Benton's book, would have made an excellent cover illustration for "Arkansaw Traveler" sheet music.[57] The only sign of modern times is a Model-T rusting in weary sympathy with a leaky cabin that by 1939 had become an explosively multivalent symbol.

Benton's lopsided cabin conformed to the shiftless folksong legend of which Arkansans were thoroughly sick. The stage-set cabin of the Lesters drew on that established, folkloric tradition, extended now to cover the decay of the old Confederacy. As Caldwell developed his theme, the cabin became an emblem of angry protest, a proletarian instrument for reform. Reform of a quieter type was the goal of the Farm Security Administration, which sent photographers south to collect visual evidence in support of legislative redress. FSA workers were instructed to concentrate on the plight of the cropper and the tenant and their struggle to wrest a living from exhausted land they did not own.[58] Tenants' faces told the tragic story; Walker Evans's pictures of their swaybacked houses told it with heightened drama. In 1936 Evans and James Agee were in Hale County, Alabama, under FSA and *Fortune* auspices, preparing notes and photographs for *Let Us Now Praise Famous Men*, the Depression's most compelling study

Thomas Hart Benton's *Share Cropper's Shack*, ca. 1937. From
Tom Benton's America. (Photo: Pat Osthus)

of Southern deprivation and a document centered on the leitmotif
of the tenant shack, "tender with rottenness, the ragged wood of the
porch . . . littered with lard buckets, scraps of iron, bent wire, torn
rope, old odors."[59] The battered homes of Hale County, strewn with
their preserved refuse, supplied every evidentiary detail a Benton
needed for folk humor, a Caldwell needed for wrathful protest. Yet
Evans's meticulous photographs argued that although Squincy Gud-
ger and Sadie Woods needed help, they were not the hopeless riff-
raff of the hillbilly stereotype, the imbecilic monsters of *Tobacco
Road*, helpless victims without will or energy. In primitive kitchens
and parlors, these tenants had struggled to create an orderly world
despite the constraints of poverty. In Evans's pictures, at least, they
had succeeded. Their cabins bespoke the dignity and courage of the
South.

Whether commentators on tenant life used the moldering dog-run
cabin to raise an affectionate guffaw, to rally protest, or to affirm
American valor, the cabin was a pictorial stereotype affixed exclu-
sively to the South. To the Southern citizen in 1939, the kindly in-
tention of the artist paled in comparison to the pejorative connota-
tions the symbol bore in its wake. Valor in the face of poverty still
identified poverty with places south of the Mason-Dixon line. Calls
for action also called attention to conditions of life in the South
adjudged wanting. And jokes about slatternly behavior implied that

there was something to joke about, something hilarious or queer about one's home. Most of the regional stereotypes through which America pictured the South in the '30s could not help but be alienating and galling to a great many Southerners. Margaret Mitchell's bestseller of 1936, *Gone With the Wind*, partially reversed the trend, although the crumbling walls of Tara that dominate the novel had a peculiarly contemporary resonance in 1936. Mitchell, of course, was an Atlanta girl, and the blockbuster movie of the same name helped to put the blush back on the peach when it premiered in Georgia's capital in 1939.[60] Nevertheless, trading on a revival of the cavalier tradition did little to bolster the image of the present-day South, an image that remained backward and unsympathetic, the projection of critical, crusading interlopers.

Need a good example of poverty? Just send the FSA crew to Hale County! Looking for blatant racial injustice? How about the Scottsboro case? Incest and who-knows-what-God-awful depravity? Why, go see *Tobacco Road*! Aiken's free-floating paranoia about a Yankee painter and his mulatto "Justice" had some basis in experience. So did Parisiens' conviction that a tenant mural—and not a word was mentioned about the racial characteristics of the tenant—was perpetuating a national bad joke about Arkansas. Vorst's personal intentions are difficult to read from his 48 States sketch. There is, perhaps, a touch of lazy humor akin to Benton's Ozark scenes. There is some emphasis on hard living in hard times, far more muted to be sure than in Caldwell's several varieties of social protest. There is a feeling for the human touches in the poorest man's home, an empathy Evans could have appreciated or inspired. On balance, however, the sketch remains an unremarkable genre piece depicting a symbol to which a plethora of unhappy thoughts and bad dreams clung in 1939. Vorst probably explained his content best when he said simply, "I made that sketch from life during my recent visit to Paris and it *is* authentic." Authentic or not, Paris rejected the negative values adhering to the particular, stereotypical fact Vorst chose for mural treatment.

Vorst went to Arkansas in December of 1939, just after the appearance of the tenant cabin in *Life* magazine widened the ripples of local discontent. He went to Arkansas to find out what Paris wanted:

As you will recall, quite a commotion was stirred-up over the subject which was selected for the Post Office Mural . . . but I am happy to report that every-

thing's lovely now. Their contention was that Arkansas had been the butt of "backward" quips long enough and that now, the "truth" should out—that Arkansas is a modern and progressive state.

. . . I was pleased to meet with a committee of leading citizens, including the Postmaster, Editor and Banker. Everyone was very kind in going out of his way to explain that their criticism was directed only at the subject and not at the art. Experiences like these make me love this country of ours more and more. Where else in the World could one find the earnestness, the serious interest shown by one and all in every move of the government, local, state and Federal, even to the choice of a subject for the village Post Office. Everyone has a voice and uses it![61]

Well, maybe not everyone! During his meetings with those "leading citizens," Vorst learned that the supposed groundswell of citizen protest against his "backward" theme had surged up in the offices of the *Paris Express* and had oozed first from the typewriter of editor Guion, "a native Arkansan of 6 months standing." That native son had been busy. The editor singlehandedly tipped off the congressman, engineered the Section's order to scrub the tenant scene, lobbied the banker and other stalwarts in the business community, and marshaled the ad hoc advisory committee that decided what Vorst would paint for Paris and about Paris. Guion's panel of go-getters—Vorst called them "the civic-minded citizenry of Paris"—seems not to have included everyone. It did not include, for instance, the sort of "backward" man pictured in the original sketch, the sort of farmer who belonged to the Arkansas-based Southern Tenant Farmers' Union, the sort of black Arkansas tenant who described his cabin and his life to Walter Rowland, an interviewer from the WPA Federal Writers' Project, in 1939:

We misses screens de mos' aroun' dis place, pesky flies and mosquitoes is so bad. I said sump'n about it to Mr. Sparrow early dis spring, but guess he forgot—or mebbe he ain't forgot, he jus' doan' *want* us to have no screens. Jus' like I wanted a patch of sorghum, make me some 'lasses with, but he say hit sour the land. What he mean was, hit sour dat ninety cents a bucket he gits for Steamboat. . . . De landlord is landlord, de politician is landlord, de judge is landlord, de shurf is landlord, ever'body is landlord, an' we ain' got nothin'![62]

That species of "ever'body" tailored the progressive, New South image of Paris, an image that Vorst copied verbatim and presented to Washington within two scant weeks of his confrontation with editor Guion's civic-minded good ole boys: "At the left is an up-to-the-minute stock farm, in the center a cotton gin, at the right the process of weighing cotton, at central left background a mine."[63] Between ap-

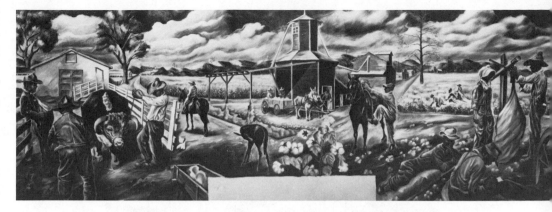

Joseph P. Vorst, *Rural Arkansas*, USPO, Paris, Arkansas. 1940. National Archives.

proval of this revised conception in December of 1939 and installation of *Rural Arkansas* in the Paris post office in June of 1940, little changed except the descriptive terminology applied to Vorst's glorification of Southern prosperity through progress. The official Section blurb on the mural theme highlights the "up-to-the-minute" attractions pointed out to the painter by the local boosters' committee:

At the left of the mural is depicted a modern stock-breeding farm with foreman, hired men and a prize bull. In the far distance is a coal mine. In the middle center is a cotton gin with a wagon load at the suction pipe. In the right foreground two weight recorders are reclining and a sack of cotton is being weighed. In the background are pickers working in the cotton fields.[64]

The mural is packed with houses, barns, stables, and gins, all of them spanking new, freshly painted, and soundly roofed. Nothing lists or leaks. The humblest fieldhand wears neat, presentable overalls. Everybody works hard, unless there is a very good reason not to. Of the fourteen figures shown in the painting, thirteen are intensely busy, including the Negro weight recorders who are working despite the fact that their designated angle of space adjacent to the postmaster's door jamb forces them to lie down on the job. The potbellied foreman is the one exception. And he, like the proud Paris committee beaming with pleasure at their new, up-to-the-minute post-office mural, is assessing the panorama of accomplishment spread before him. He pauses only to emit a small, self-satisfied sigh, as all around him, modern Arkansas explodes with plenty—endless fields of cotton to the right, untold acres of corn to the left, mounted like gems against the black gold of the distant hills.

Tidiness, cleanliness, energy, and plenitude were not the hallmarks of the backward South presented by Erskine Caldwell, Tom

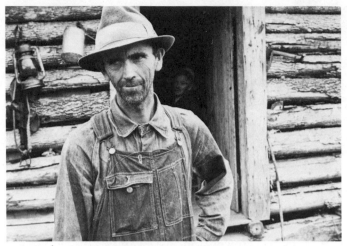

Ben Shahn, *Rehabilitation Client, Boone County, Arkansas.*
1935. Library of Congress.

Benton, and James Agee. *Rural Arkansas* also contradicted Ben
Shahn's Resettlement Administration photograph of an unshaven
candidate for rehabilitation posed, in Boone County, Arkansas, be-
fore the inevitable unscreened cabin riddled with chinks.[65] Yet the
Paris mural looks as factual as the Shahn photograph. The taut draw-
ing possesses a probity missing from the vague and lumpish handling
of form in Vorst's tenant sketch, a document taken from life. The
choice of fact is the principal difference between the Paris the artist
saw for himself and the Paris the community, or the movers and
shakers therein, persuaded him to see. Fact, to a host of Southern ed-
itors who shared Guion's impatience with backward jokes, was a
cherished precept, a weapon against prevailing stereotypes, and one
altogether worthy of the Section's fierce devotion to "getting every
detail right." The Southern press, therefore, roundly praised *These
Are Our Lives*, a 1939 compilation of WPA interviews with the dis-
inherited of the region—with people like the Arkansas tenant who
had no screens and no sorghum patch and a healthy skepticism about
an "ever'body" that included editors and bankers and postmasters.
The simple words of the poor, set down in their own dialects, repu-
diated the popular idea that the needy blacks and whites of Alabama
and Georgia and Arkansas were misfits and degenerates culled from
the pages of *God's Little Acre*. Realism, however unflattering, ex-
posed a real South. Fact—awful, dismal documentary fact—invalidat-
ed abstractions, statistics, generalizations, and stereotypes. "We in
the South," proclaimed the *Greensboro Daily News*, "have been called

II. Louis Freund, 48 States sketch, *Paris, Arkansas—Gateway to Mt. Magazine Federal Park* for USPO, Paris, Arkansas. 1939. National Archives.

an economic problem. That is not true. We are millions of problems! We are millions of individuals."[66]

The facts needed to defeat the old stereotypes could be found in the heartfelt testimony of an Arkansas tenant. It did not follow, however, that Southern realism also demanded a picture of that tenant emblazoned forever on the post-office wall. The facts of usable, Present History that the individuals of the Paris establishment saw fit to deploy in the cause of an unbiased look at the South bore no relationship to the backward symbols of lore. But they were facts, regardless, attested to by a Southern painter who was Vorst's unsuccessful rival for the Paris commission. 48 States entry #133, labeled "Paris, Arkansas—Gateway to Mt. Magazine Federal Park," was the work of H. Louis Freund. Freund taught painting at Hendrix College in Conway, Arkansas, and was a mainstay of the Ozark Art Association. Although born in Clinton, Missouri, he had far better credentials for claiming native-son status than the Johnny-come-lately editor of the *Paris Express*.[67]

While the 48 States contest was in progress, Freund was preparing two Section murals for the Arkansas hill country above Little Rock, near his home. He was assigned to the Heber Springs post office on the basis of competent work in the Vicksburg Competition and received the Pocahontas job because of a meritorious performance in the important St. Louis Competition for the Wellston Postal Station.[68]

Both of these towns, like Paris, stood in the band of foothills rimming the Boston Mountains and the contiguous Ozarks. The regional competition process had encouraged Freund to do his share of poking around the neighborhood, and, during the course of selecting themes for his consolation murals, he traveled extensively in the countryside around Paris. His Section work to date kept Freund to a tight regional focus; he was, at any rate, an Arkansan looking at Arkansas in 1939.

An awkward compositional format probably eliminated Freund's view of Paris from serious contention for the prize. The foreground shows a wheat field at harvest time alongside a modern highway clogged with vacationers dragging trailers behind streamlined sedans. These indications of a booming tourist trade and agricultural wealth are partially concealed by architectural elements. A door covers up most of the harvest scene and a bulletin board breaks the sweep of the road. From a pictorial standpoint, discontinuity of vision induces a queasy sensation of a world ruptured and fragmented from without. From the standpoint of an observer passing through the lobby, the postmaster's elaborate portal appears to lead into a dank cave beneath the wheat field while wanted posters and announcements of commemorative issues float eerily over the fenders of speeding cars. Beyond the field and the highway, Paris lies tucked away in the shadow of the hills, a distant afterthought which is interesting chiefly because of the aspect of Paris an Arkansan chose to emphasize. Most of Freund's Paris is too small in scale to permit detailed examination of streets and buildings. But Paris, judging by the district placed closest to the road and hence most easily seen, is a nascent industrial center.

Factory stacks at the terminus of a grimy railroad trestle belch soot. A moving train is visible, as well as sheds, processing plants, powerlines, tanks, and tangles of electrical apparatus. Somewhere on the raw, unpicturesque edge of town, out toward the new highway, Paris shipped cattle, bagged grain, loaded coal, and ginned cotton. And that looked good to a homestate painter. None of it looked quite the way things would in Vorst's mural, but perhaps "genuine Art" made the difference between a casual snapshot from the side of the road and a formal group portrait of symbols of the good life in *Rural Arkansas*, scrubbed up and lined up to have their pictures taken. Vorst polished facts a group of civic-minded Parisiens commended to his attention. Still and all, they were facts, important enough

to capture the imagination of an Arkansas painter who found his own way to a stretch of road outside Paris in 1939.

As *Life* struggled to deduce some sense of the preoccupations of the American people from the subject matter of the 48 States designs, historical murals proved the easiest to understand: pride in one's heritage spawned those Pilgrims and pioneers. Contemporary themes and neglected themes eluded snappy answers:

Apparently Americans are artistic "stay-at-homes" with a preference for paintings that reproduce experiences and scenes . . . with which they are familiar. [It] is noteworthy that of 48 sketches . . . only a handful suggest the possibility that the most highly industrialized nation in the world has any industry at all.[69]

To extrapolate the sensibilities of the people from 48 States designs, *Life* ought to have stopped the presses and followed the case histories of pictures the people cordially loathed. Offended, angry people made those murals into mirrors of home by insisting on control over the facts reflected. Yet even murals people helped to paint were magical Lewis Carroll looking glasses, beaming back some facts and swallowing up others. Mural mirrors reflected facts, but they also reflected superimposed images of dreams and visions as tangible as any tenant cabin. The comments of "prominent Paris citizens" deploring the tenant sketch were quoted approvingly in many Arkansas newspapers in 1939. W. S. Elskin said, "Arkansas is away ahead of this picture." Lewis C. Sadler said, "I don't think it is in keeping with the progress of the state." Ralph Cravens—kin to Representative Fadjo Cravens?—said, "It is not a fair representation of our state."[70] Progress meant industry, which other Southerners who were not prominent businessmen found alongside other highways in 1939.

The state of Tennessee did not exude regional flavor in the 48 States sketch for Lenoir City, a design *Life* found exceptional: "David Martin's sketch of men putting up a power line near Lenoir is one of the few industrial murals."[71] The tight, schematic rendering diagrams the TVA's program of rural electrification, but the place, featureless and vague, could be any place where a power station is going up. Despite the lack of tenant cabins and dogwoods, this is a Southern site and was depicted by a Tennessee painter whose sympathies clearly lay with Messrs. Elskin, Sadler, Cravens, and Guion on the side of progress. *Life* missed the regional significance of a rare industrial topic destined for a town in Tennessee. Like Louis Freund and Joseph

Vorst, after his conversion experience, David Stone Martin saw something outside Lenoir City that struck him as important enough, as characteristic enough, to merit mural treatment and that was devoid of regional flavor as the indolent South was pictorially stereotyped. Power lines and up-to-the-minute suction tubes were not generic Regionalist images, galvanizing national consciousness of a picturesque America by enshrining the popular stereotypes of the moment in an enduring mural art, tied to specific places that were home to the people who lived there. *Rural Arkansas* was a shimmering, magic mirror held up to the changing South, not a window on a static tableau of the old South of the popular imagination. The Paris mural was, therefore, intensely regional—intensely parochial—in that it served the needs of an Arkansas audience, a Paris audience, a downtown Paris audience intent on internal change and scornful of external beliefs. Industrial Paris, in the post-office mural, mirrors a home place where problems are being addressed and solved through commercial revival and technological optimism, where folks are modern American folks just like everybody else—not picturesque freaks. Mural Paris is observable fact and faith in the future; it is the proud homeland of a New South.

The Paris mural is also, therefore, profoundly chary of events in Arkansas reported on the front page of the *New York Times*, events that fed the old Arkansas legends. *Rural Arkansas* puts an enormous psychic distance between a productive Paris and cabins where "many a tenant could study astronomy through the opening in the roof and geology through the holes in his floor."[72] Paris did not wish to recall the headline-making campaign of terrorism mounted by landowners against the Southern Tenant Farmers' Union in 1934 and vividly described by an Arkansas victim: "We Garded our House and been on the scout untill we are Ware out, and Havent any Law to look to. thay and the Land Lords hast all turned to nite riding."[73] Modern men of substance in Paris shaped a federal mural wherein the social, racial, and economic tensions that sparked violence and sustained the "backward" image of Arkansas—"the mistering of the niggers and stirring them up to think the Government was going to give them forty acres" was one native's explanation of how trouble started—have been forever resolved in paint.[74] Modern Paris on the post-office wall can look forward to a dynamic new Arkansas of profits and progress through agribusiness.

Life's treatment of the 48 States contest was brief and upbeat:

neither the editors nor their Section advisers tried to correlate mural imagery in a systematic way with the scanty profits and stalled progress of the Depression economy. But the article does nibble at the possibility that economic problems and the painted American Scene are obscurely linked together in a bond of evasion and metaphor too convoluted for rationalization by a *Time-Life* quip. An undercurrent of conjecture about how people looked at or did not look at the nation's work, business, and industry through the mural window muddles a simple assertion that murals reflect America. *Life*'s staffers were cognizant of tenant poverty, idle factories, and the sinking prices of Midwestern wheat and corn, big election issues in the recession year of 1938. The matter of how America made a living—how people felt about the hazards of economic survival—gnawed at the edges of a story that vacillated between acceptance of blithe pleasantries about a picturesque America and dismay over what had become of a capitalist America, missing from the 48 States pageant.

The *Life* text began with a sweeping claim: the contest was a countrified affair—"Mural America for Rural Americans." The piece concluded rather oddly by wondering at artists' inattention to the facts of American industry. Like MGM's technological Oz glittering above a lush Grant Wood landscape, the Mural America *Life* hoped to see was apparently a place where every sorghum patch sprouted a crop of steel mills. The Paris mural, of course, showed a *Rural Arkansas* something like that filmic Land of Oz. Having harnessed the riches of the land with up-to-the-minute methods, Paris now exudes the prosperous optimism of a Rotary luncheon.

Life dimly sensed that, from the people's perspective, pictures of industrial stuff were not universally relevant symbols of everybody's problems with the economic collapse of "the most highly industrialized nation in the world." 48 States pictures were, after all, "Mural America for Rural Americans" who did not live cheek by jowl with the industrial plants that forged their mechanical harvesters. But *Life* only toyed with the provocative thesis that agricultural murals in general, although bereft of smokestacks, harbored latent economic meaning: "In the Midwest, where a man's livelihood may depend on the turn of the weather, harvest time is its own justification for beauty."[75]

Three 48 States sketches dealt exclusively with harvest time. Matthew Ziegler's "simple but moving mural of a field after the wheat has been stacked" moved the *Life* caption writer because, in the ab-

Matthew Ziegler, *Wheat in the Shock*, USPO, Flandreau, South Dakota. 1940. National Archives.

sence of human actors, the ranks of fat wheat bundles resting on the prairie of Flandreau, South Dakota, summon up human feelings of weary accomplishment—the feelings of the tired farmers who grew the crop. The bald simplicity of the image also leaves room for other emotional responses. Sensations of inert exhaustion in the midst of plenty remind the viewer that the farmers of Flandreau, having harvested their wheat, now await the economic verdict of the commodity market with the mute resignation Ziegler invests in the wheat itself. The South Dakota wheat harvest of 1939 is a bittersweet blessing.

Joe Jones's wheat-harvest sketch for Seneca, Kansas, and Edmund Lewandowski's corn-harvest sketch for Hamilton, Illinois, permit no elegiac woolgathering. Their fields fairly crackle with the hell's-a-poppin' energy of great machines that reap and grind and bag—brisk, efficient factories on wheels attended by busy farmers too intent on the bushel count to look up from the whirling blades and far too enmeshed in the technological process for speculation on the futility of their enterprise. In 1939 John Steinbeck made the machine the grim nemesis of his Joads:

The tractors came over the roads and into the fields, great crawlers moving like insects, having the incredible strength of insects. . . . Snubnosed monsters, raising the dust and sticking their snouts into it, straight down the country, across the country, through dooryards, in and out of gullies in straight lines. . . . The man sitting in the iron seat did not look like a man; gloved, goggled, rubber dust mask over nose and mouth, he was a part of the monster, a robot in the seat.[76]

In John Ford's 1939 movie version of *The Grapes of Wrath*, the machine Jones and Lewandowski treated as the presiding deity of the cornbelt becomes a mechanical Frankenstein; Steinbeck's renegade tractors were all the more menacing because their villainous maraud-

ing challenged and reversed a prevailing faith in economic progress through agricultural technology.

The Agriculture Building at the 1933 Century of Progress exposition in Chicago resembled a laboratory grafted onto a factory. A sermon of rural progress was cheerfully delivered therein by Steinbeck's robot:

That which intervenes between the humanity of today and the famines of older days is the material of [this exhibit]. It is a long step from the old-fashioned farm to our ultra-modern practice of shooting vitamins into food with light rays, and here we can see it done. A 10-foot robot, a mechanical man, gives a lecture, and as he talks, he points to a lighted chart, he gestures, bows and bends, and finally he opens a door in his stomach and, pointing with iron fingers, describes his own digestive process.[77]

"Today," chortled the official Fair Guidebook, "agriculture is a trinity—an art, a science, and an industry." Science and industry nosed out the art of farming. In the livestock exhibit, a figure of a cowboy watching his herd on a morning in 1833 was plunged into darkness; when the lights came up, a modern, mechanized feedlot of 1933 had taken his place and, almost without human agency, "moving trains of livestock cars are on their way to market." The popular International Harvester pavilion, at the heart of the complex, needed no robots or gimmicky dioramas. It was enough to amass "a quarter million dollars" worth of balers and reapers, "the machines and implements which science and industry have devised to lighten drudgery" and quicken the imagination.[78]

Scientific, machine-tooled apparatus meant progress and prosperity to the fairgoers of the '30s, bombarded from every side of the midway with the purr of a futuristic technology that, in some mysterious fashion, did what the abandoned factories and mortgaged combines of the present could not seem to do at all. These mechanical wonders worked right. They delivered the goods; they produced instant prosperity. The technological "Democracity" of the future inside the Perisphere at the 1939 New York World's Fair was a world without anxious farmers and unemployed punchpress operators. The General Motors "Futurama" on Flushing Meadow was a diorama of American bliss in 1960, the landscape extruded by a series of streamlined, mechanical megasystems. According to designer Norman Bel Geddes, advanced technology was ushering in a new era of plenty through efficiency and speed: "A free-flowing movement of people and goods across our nation is a requirement of modern living and

Joe Jones, *Men and Wheat*, USPO, Seneca, Kansas. 1940. National Archives.

prosperity."[79] International Harvester and General Motors did not need to tell goggle-eyed tourists just how speed, more and better machines, and a fanatical devotion to scientific efficiency could rid a South Dakota farmer of worries over whether the price of the crop would cover the cost of the seed. Shiny machines were icons of a new futurological faith, idols beyond the grasp of mundane reason and worry. The agricultural machines of Seneca and Hamilton are idols attended by acolyte-farmers; in the eyes of the worshipper, the Dynamo/Virgin of the Great Plains rewards unalloyed faith in progress with profits and prosperity.

The Chicago Fair paid more attention to agricultural technology than did the New York extravaganza of 1939. Large delegations of grainbelt agribusinessmen were not expected to make the trek east. Had they done so, however, they would not have missed the throngs of urbanites lined up outside the Borden Company pavilion to gasp at life on the farm in the "Dairy World of Tomorrow." The Borden show was the apogee of ultra-modern farm magic. It revealed "new wonders and secrets of science" via an "electronically operated rotolactor" that washed some 150 pedigreed cows, dried each one with "an individualized sterilized towel," milked them mechanically, and dispatched the fluid through "stainless steel pipes" to machines that pasteurized, irradiated, bottled, and capped the finished product and zipped it off to the adjacent Dairy World Restaurant.[80] From "moo" to "mmm" in less than a minute! Dazzled by the spectacle of gurgling, germfree milk for all, the most churlish onlooker would have hesitated to discourse on chronic problems of oversupply and plummeting prices in the dairy industry. Encased in the spaceship splen-

Edmund D. Lewandowski, 48 States sketch for USPO, Hamilton, Illinois. 1939. National Archives.

dor of stainless steel, it was hard to recall the shotgun-toting dairy-men who had hijacked milk trucks only a few years before and in desperation had watered the green fields of Wisconsin with gallons of Borden's finest.

Consumerism was alive and well on the mechanized farm of the 1930s and the modern machines that covered the fields of Seneca and Hamilton sang a siren's song of prosperity tomorrow. "Sorry, we want an younger man," bellowed an ad in a 1938 issue of *Time*. The sad fellow pictured below can't get a job because he's bald. And he's bald because he didn't subdue his dandruff with "Kreml." If only he had bought a tube of patented magic![81] Consumption for personal happiness and success was the pitchman's stock in trade. During the Depression, promises of jobs added a new wrinkle to the psychology of selling scientifically formulated products with modern sounding names and *Good Housekeeping* laboratory endorsements. Ads never cited unemployment statistics. They guaranteed that you, Mister, could beat the odds; a healthy head of scientifically managed hair — more hair, better hair — would whisk you into a future state of grace, a Depressionless Oz of paychecks and security to which the alert, up-to-the-minute consumer gained admission merely by flashing his *Good Housekeeping* Seal.

Technology on the farm made the same wondrous promises. The ever-normal granary provisions of the revised Agricultural Adjust-ment Act passed by Congress in 1938 required stringent production controls. Surplus lowered prices; scarcity pointed the way out of the Depression.[82] Farm displays at the Fairs of the '30s entitled the farmer to think otherwise. More and better and speedier production

Fred Conway, 48 States sketch for USPO, Jackson, Missouri. 1939. National Archives.

appealed to his secret heart-of-hearts wherein he, like the bald job seeker in the city, mistrusted statistics. Cooperative controls and national agricultural policy had little allure to the farmer pictured in and looking at Joe Jones's wheat field. On the wall of the Seneca, Kansas, post office, the farmer saw limitless, unrestrained production and assurance that he and his machines would beat the odds. The farmer looking at Lewandowski's Illinois cornfield saw abundance, an invocation of an abundant future attained through unremitting faith in the steel blades of benevolent "snubnosed monsters."[83]

The slogan of the 1939 World's Fair was "Building the World of Tomorrow." The Borden rotolactor whirled the cows of today directly into the stainless steel future of sparkling milk bottles as far as the eye could see. Why, as little Dorothy Gale might say, if you closed your eyes and wished and clicked your heels together three times in rhythm with the clinking of the bottles, the future was already there! Machines gave solid form to faith in the future, but a modern, rural cast of mind existed independent of them. The machine was a symbol for optimism, for an agile pursuit of up-to-the-minute ideas, for looking forward. Mitchell Siporin, a Chicago muralist intent upon developing a meaningful symbolic language for the '30s, was heartened by a recent trend in the depiction of American agriculture by historical painters.

An example is the concern felt by the midwestern mural painter to express the "squint" in the eye of the prairie farmer, for generations accustomed to gazing beyond the prairies. These squinting eyes . . . [and] gnarled, knotty hands ready to seize the plough for an assault on the earth—these are the elements

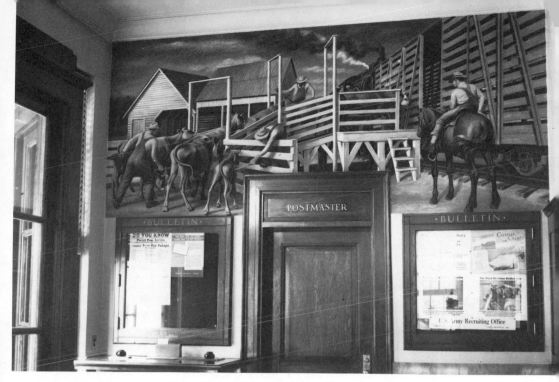

James Baase Turnbull, *Loading Cattle*, USPO, Jackson, Missouri. 1940. National
Archives.

which truly symbolize agriculture and not . . . the prop symbol of the Greek
goddess with her cornucopia.[84]

The squinting eye of the modern farmer gazed beyond 1939 to a
marvelous future that was the Canaan of the up-to-the-minute doer,
poised for action, always looking far past the present. The progres-
sive stance adopted by Paris, Arkansas, to have its picture painted
relies less on the obtrusive presence of the machine than on the sheer
hustle of the place, ready for an immediate leap into the future, be-
cause its ethos is ultra-modern and up-to-the-minute. Other rural
communities, unperturbed by tenancy and a bad press, also relished
self-portraits that signaled a modern approach to the American way
of life on the farm and impatience for moving on.

The 48 States jury had a hard time deciding which of two excel-
lent sketches by homestate artists should be chosen for the Jackson,
Missouri, post office. Fred Conway's picture showed a herd of cattle
grazing quietly beneath four exceptionally tall and bulbous haystacks.
James Turnbull's picture showed a stock-loading operation going full
tilt at a railhead: a few head of cattle can be seen, but chutes, ramps,
pens, steel wheels, cattle cars, and jets of smoke from the locomotive
zoom out of the foreground and overwhelm both men and livestock.

Torn between two first-rate designs, the Section declared Conway the winner for Jackson and Turnbull the winner for Purcell, Oklahoma. Purcell stood still for the switch; when folks in Cope County, Missouri, caught wind of the decision, however, they were peeved. The *Southeast Missourian* took up their cause in banner headlines: "Contented Cow Scene Mural for New PO at Jackson, Gov't Rejects Stock-Shipping Scene to Substitute One Showing Less Activity." Action, modernity, and machinery were just what Jacksonians wanted to see in the Jackson post office, for Jacksonians were a modern breed:

With no bad blood toward cows in a pasture and a few innocent hay stacks, most Jacksonians, it might be ventured, would have voted for the stock-loading scene. . . . James B. Turnbull of Maplewood . . . suggested as his theme the loading of fine Cope County cattle on the station platform at Jackson with a couple of hefty red-faced farmers busily engaged at getting the animals into the Missouri-Pacific cars for their first and last ride from Byrd Township to the dinner tables of America. That would have been a honey. Many a died in the wool native of these parts will turn a little sick at the slip of the judges who let that depot scene get away. . . .

Now Purcell may have sent a few calves to market but Cope County is known from one World's Fair to the other as a producer of steaks on the hoof. Byrd Township, Hubble Township and all the others may have wonderful family cows, the kind to be painted eyeing the haystacks, but their citizens may petition Uncle Sam to . . . let Jackson have a picture that will get the county seat far from the eight ball.[85]

Those "contented cows" were tantamount to an insult. The Missouri Pacific train rocketing off toward the Trylon and Perisphere of the "World of Tomorrow" with a metallic roar was the progressive image Jackson coveted.

Jackson got its wish after the Co-operative Shipping Association badgered Congressman Orville Zimmerman in the name of Missouri modernism: "The patrons of the Jackson, Missouri Post Office and some of the leading citizens of the town are greatly disturbed over the selection of . . . the grazing cow scene."[86] Jackson got Purcell's mural, Fred Conway was shipped off to Purcell, and Turnbull's chutes and wheels were subsequently much admired around Cope County. "The mural," wrote the postmaster, "is indeed an attraction . . . and we are all very proud of same."[87]

"Mural America for Rural Americans" was a strange and contradictory place. It was home. It was the home of Mickey Mouse and Dorothy Gale and the Chamber of Commerce, a land of robots and rotolactors. It was a serene, idyllic Main Street of yesterday, where

folks itched to board a Missouri Pacific streamliner to tomorrow. The milk train through Mural America ran from Peace—back there a-ways, in Iowa—to Plenty, a-way up ahead in Missouri. The train whistle sounded throughout Arkansas, Illinois, Kansas, and South Dakota. But the train never stopped at Depression, USA.

NOTES

1. "Speaking of pictures . . . This is Mural America for Rural Americans," *Life*, VII (December 4, 1939), p. 12.

2. *Life* reported submission of 1,475 designs. There are, however, 1,477 entries listed in the Section's 74-page tally of entries; 124 (Box 134), [Folder: 48 States Competition]. All statistical data on contestants discussed below is based on this list.

3. Bruce, quoted in McKinzie, *The New Deal for Artists*, p. 57.

4. *Bulletin*, #19 (June, 1939), pp. 4-30, 130 (Box 215). One ground plan served for all the buildings, although separate elevations were provided for all post offices except those in Island Pond, Vermont, and Westerly, Rhode Island, for which architectural plans had not been completed and for which mural funds were, accordingly, still pending. All the lobbies were described as follows: "The public lobbies are approximately 42 feet long and 13 feet wide. It should be noted there is a vestibule usually about 10 feet away from the wall where the mural is to be located over the Postmaster's door." *Life* correctly set the per-unit cost of the murals at $725, the average commission. The jury for the 48 States Competition, in addition to key Section personnel, included Maurice Sterne of San Francisco, Henry Varnum Poor of New York City (both of whom had painted major Section cycles in Washington), Olin Dows of upstate New York (a muralist, a neighbor of FDR, and the first Director of the Treasury's Relief Art Project), and Edgar Miller of Chicago (who had served on several Section juries for Illinois competitions).

5. *The 1929 World Almanac and Book of Facts, Facsimile Edition* (New York: American Heritage Press, 1971), p. 468. See also the Section's 48 States tally, discussed above.

6. *1939 National Year Book* (New York: P. F. Collier and Son, Corp., 1939), p. 747.

7. Bromberg to Rowan, December 28, 1939, 133 (Box 116).

8. Erica Beckh Rubenstein, "Government Art in the Roosevelt Era: An Appraisal of Federal Art Patronage in the Light of Present Needs," *Art Journal*, XX (Fall, 1960), pp. 7-8, uses the term, coined in her "The Tax Payers' Murals," Ph.D. dissertation (Harvard University, 1944), p. 28, in this way: "To an artist this meant to produce a capable, pleasant, and safe mural, dealing with local industry or historical episode, which would antagonize nobody and would get quick approval from everybody." According to McKinzie, *The New Deal for Artists*, p. 54, this amounted to painting "potboilers they knew pleased Section officials."

9. *Life*, "Mural America," pp. 12-13.

10. See, e.g., 133 (Box 61), notification of award, October 16, 1939.

11. *The Fresno Bee*, June 29, 1940, 133 (Box 7). The Los Banos mural is now in the collection of the Ralph Milliken Museum, Los Banos, California. See Peter Bermingham, *The New Deal in the Southwest, Arizona and New Mexico* (Tucson, Arizona: The University of Arizona Museum of Art, 1980), pp. 18-19.

12. The Westerly, Rhode Island, *Sun*, December 7, 1939, lists a number of local disputes, which seem to have been the subject of wire-service reports, in Los Banos, Kellogg, Schuyler, and Eunice, Louisiana; 133 (Box 98).

13. See 133 (Box 7), *re* Los Banos, California; Lew Davis to Rowan, October 25, 1939, replying to notification of award, October 16, 1939.

14. See 133 (Box 39) *re* Eunice, Louisiana; Rowan to Robert W. Jacobs, editor, *Big Bend Sentinel*, undated (ca. October, 1939) and Rowan to Laura B. Lewis, January 19, 1940.

15. See 133 (Box 29) *re* Corning, Iowa; wire, Rowan to Gilmore, November 22, 1939.

16. Wire, Gilmore to Rowan, November 22-24, 1939. A variant version of this statement is quoted in Virginia Mecklenburg, *The Public as Patron: A History of the Treasury Department Mural Program Illustrated with Paintings from the Collection of the University of Maryland Art Gallery* (College Park, Maryland: University of Maryland Art Gallery, 1979), p. 64. For a color illustration of the preliminary sketch, see p. 15.

17. Rowan to Gilmore, December 15, 1939.

18. Dennis, *Grant Wood*, p. 85.

19. Darrell Garwood, *Artist in Iowa, A Life of Grant Wood* (New York: W. W. Norton & Co., 1944), pp. 185-187.

20. Stuart Davis, "The New York American Scene in Art," from *Art Front* (February, 1935), reprinted in Diane Kelder, ed., *Stuart Davis* (New York: Praeger Publishers, 1971), p. 152. Davis wrote in response to an article entitled "The U. S. Scene in Art" which appeared in *Time* on December 24, 1934. *Time*'s comments, in effect, both christened and crystallized Regionalism as a movement.

21. Andrew Bergman, *We're in the Money, Depression America and Its Films* (New York: New York University Press, 1971), pp. 18-19, 23-29.

22. Benton, "American Regionalism: A Personal History of the Movement" in *An American in Art: A Professional and Technical Autobiography*, p. 148.

23. See, for example, Matthew Baigell, *The American Scene, American Painting of the 1930s* (New York: Praeger Publishers, 1974).

24. Benton, "American Regionalism," p. 148.

25. Quoted in *This is Grant Wood Country* (Davenport, Iowa: Davenport Municipal Art Gallery, 1977), compiled by Joan Liffrig-Zug, edited by John Zug, in cooperation with Nan Wood Graham, p. 1.

26. Watson, in Bruce and Watson, *Art in Federal Buildings*, p. 4.

27. Watson, *Art in Federal Buildings*, p. 4.

28. Gilmore to Rowan, December 11, 1939.

29. Gilmore to Rowan, June 26, 1940.

30. *Adams County Free Press*, undated clipping (ca. August-September, 1939).

31. Gilmore to Rowan, September 13, 1940.

32. Quoted in William Stott, *Documentary Expression and Thirties America* (New York: Oxford University Press, 1973), p. 61.

33. *The Depression Years as Photographed by Arthur Rothstein* (New York: Dover Publications, Inc., 1978), p. 75.

34. Leonard Maltin, *The Disney Films* (New York: Bonanza Books, 1973), pp. 266-267.

35. Christopher Finch, *The Art of Walt Disney, From Mickey Mouse to the Magic Kingdoms* (New York: Harry N. Abrams, 1973), p. 121.

36. *Adams County Free Press*, March 6, 1941. According to this article, Manuel Bromberg, 48 States winner for Greybull, Wyoming, assisted Gilmore in the installation.

37. A. C. Peterson, Postmaster, to Rowan, May 19, 1941.

38. T. B. Turner to Rowan, March 11, 1941.

39. Gilmore to Rowan, March 27, 1941.

40. Gilmore to Rowan, March 13, 1941.

41. In a 1938 version of the shooting script for *The Wizard of Oz* discarded before filming began, Dorothy and the good witch Glinda try to define Kansas. "Why—it's a state," says Dorothy. "A state of mind?" asks Glinda. See Aljean Harmetz, *The Making of 'The*

Wizard of Oz,' Movie Magic and Studio Power in the Prime of MGM—And the Miracle of Production #1060 (New York: Alfred A. Knopf, 1977), p. 50.

42. The closing soliloquy from the film is quoted in Harmetz, *The Making of 'The Wizard of Oz'*, p. 51, and in Doug McClelland, *Down the Yellow Brick Road, the Making of 'The Wizard of Oz'* (New York: Pyramid Books, 1976), p. 32.

43. *Life*, "Mural America," p. 12.

44. Erskine Caldwell, *Some American People* (1935), quoted in Harvey Swados, ed., *The American Writer and the Great Depression* (New York: The Bobbs-Merrill Company, Inc., 1966), pp. 131-133.

45. Caldwell, *Some American People*, p. 131.

46. Erskine Caldwell, *God's Little Acre* (New York: Duell, Sloan and Pearce, 1949), Uniform Edition, unpaginated "Appendix to the Fifth Printing" contains the text of the judicial decision. Playwright Marc Connelly was among those presenting letters in support of Caldwell to the court. Connelly's *The Green Pastures* opened on Broadway in 1930 and retold the Old Testament with a black cast; see Marc Connelly, *The Green Pastures, a Fable* (New York: Farrar & Rinehart, Inc., 1929). God creates, watches over, and despairs of an Eden and a Canaan set in rural Louisiana, and the tumbledown sets of both the stage production and the 1936 MGM film based on the play feature tenant cabins and farms not unlike Caldwell's.

47. Phillips, *From the Crash to the Blitz, 1929-1939*, p. 365.

48. Joseph P. Vorst to Rowan, November 11, 1939, 133 (Box 4). Vorst had submitted 2 Arkansas sketches, as well as 5 for Missouri and 3 for Kansas. Presumably, he had also visited Jackson, Missouri, and Seneca, Kansas.

49. Congressman Fadjo Cravens to Rowan, October 31, 1939, and Commissioner of Public Buildings to Cravens, November 8, 1939. Rowan's letter to the artist, dated November 6, 1939, is missing from the files, but the response to Cravens on November 8 presumably represents the Section's position as reported to the artist.

50. Vorst to Rowan, November 11, 1939.

51. Vorst to Rowan, November 11, 1939.

52. John Guion, Editor and Publisher, the *Paris Express*, to Honorable Fadjo Cravens, October 28, 1939.

53. See Theo Lippman, Jr., *The Squire of Warm Springs, FDR in Georgia, 1924-1945* (Chicago: Playboy Press, 1977).

54. Richard M. Dorson, *American Folklore* (Chicago: The University of Chicago Press, 1959), pp. 90-91.

55. Tristam Potter Coffin and Hennig Cohen, eds., *The Parade of Heroes, Legendary Figures in American Folk Lore* (Garden City, N. Y.: Anchor Press/Doubleday, 1978), p. 326.

56. *American Folklore and Legends* (Pleasantville, N. Y.: The Reader's Digest Association, Inc., 1978), pp. 161 and 166.

57. Thomas Hart Benton, *Tom Benton's America, An Artist in America* (New York: Robert M. McBride & Company, 1937), unpaginated plates following p. 156.

58. James C. Curtis and Sheila Grannen, "Let Us Now Appraise Famous Photographs, Walker Evans and Documentary Photography," *Winterthur Portfolio*, 15 (Spring 1980), p. 7.

59. James Agee and Walker Evans, *Let Us Now Praise Famous Men* (New York: Ballantine Books, 1966), p. 72.

60. Richard Harwell, ed., *Margaret Mitchell's 'Gone With the Wind' Letters, 1936-1949* (New York: Macmillan Publishing Co., Inc., 1976), pp. 257-258 and passim.

61. Vorst to Rowan, December 15, 1939.

62. WPA/Federal Writer's Project interview, conducted in Holly Grove, Arkansas, in 1939 and quoted in Tom E. Terrill and Jerrold Hirsch, eds., *Such As Us, Southern Voices of the Thirties* (New York: W. W. Norton & Company, 1979), pp. 55-56. The STFU, discussed

in this interview, is also chronicled in more detail, pp. 41-42.

63. Vorst to Rowan, December 28, 1939.

64. "One-Page Summary Sheets on Murals and Artists," 135 (Box 203), arranged alphabetically by artist: see Vorst, Joseph, 1940, "Rural Arkansas," Paris, Arkansas.

65. F. Jack Hurley, *Portrait of a Decade, Roy Stryker and the Development of Documentary Photography in the Thirties* (New York: Da Capo Press, Inc., 1977), p. 49.

66. Robert Register, "Book Delves in History of People," *Greensboro Daily News*, May 21, 1939, quoted in Terrill and Hirsch, eds., *Such As Us*, p. xxii. *These Are Our Lives*, collectively written by the Federal Writer's Project, was published by the University of North Carolina Press in 1939.

In 1938 FDR had indeed called the South "the nation's number one economic problem"; see "US Survey of the South Prelude to Long Range Plan," *Newsweek*, 12 (August 22, 1938), p. 9.

67. *Who's Who in American Art* (1940-7), Vol. IV (Washington, D. C.: The American Federation of Arts, 1947), p. 179.

68. See letters of appointment to Freund, dated June 23, 1938 (Heber Springs), and April 15, 1939 (Pocahontas), 133 (Box 3). Freund also decorated post offices in his native Clinton, Missouri (1936), and in Windsor, Missouri (1938), Herrington, Kansas (1937), and Idabel, Oklahoma (1940).

69. *Life*, "Mural America," p. 13.

70. *Times Record* (Fort Smith, Arkansas), October 29, 1939. The headlines read: "Paris Residents Don't Like This Design for Mural" and "Maybe It's Art, But Paris Doesn't Like Post Office Mural." The Little Rock, Arkansas, *Gazette*, October 29, 1939, 124 (Box 134), describes the work: "A rural scene with a log cabin in the background and a lean, big-footed farmer pushing a garden plow."

71. *Life*, "Mural America," p. 13.

72. Herman Clarence Nixon, *Forty Acres and Steel Mules* (Chapel Hill: University of North Carolina Press, 1938), p. 23.

73. From a letter to Norman Thomas written in 1935 by a Mrs. T. P. Martin of Marked Tree, Arkansas, in the extreme eastern Ozarks, quoted in William E. Leuchtenburg, *Franklin D. Roosevelt and the New Deal, 1932-1940* (New York: Harper Torchbooks, 1963), p. 138.

74. Leuchtenburg, *Franklin D. Roosevelt and the New Deal*, p. 138, discusses the racial overtones of the situation and cites this interview from the *New York Times*, April 16, 1935, to make his point.

75. *Life*, "Mural America," p. 13.

76. John Steinbeck, *The Grapes of Wrath* (New York: Bantam Books, 1954), pp. 29-30.

77. Allen D. Albert and Rufus C. Dawes, *Official View Book, A Century of Progress Exposition* (Chicago: The Reuben H. Donnelley Corp., 1933), unpaginated. For a summary of advances in farm technology in the '30s, see Broadus Mitchell, *Depression Decade, From New Era Through New Deal, 1929-1939* (New York: Harper Torchbooks, 1969), pp. 220-222.

78. *Official Guide Book of the Fair* (Chicago: A Century of Progress, 1933), pp. 74 and 76.

79. Donald J. Bush, *The Streamlined Decade* (New York: George Braziller, 1975), pp. 162-163.

80. *Official Guidebook of the New York World's Fair, 1939* (New York: Exposition Publications, Inc., 1939), pp. 106-109.

81. *Time*, XXXII (September 5, 1938), p. 39.

82. See Raymond Moley, *After Seven Years* (New York: Harper & Brothers, 1939), p. 369.

83. For a consideration of the futuristic implications of New Deal murals, see Marling, "A Note on New Deal Iconography: Futurology and the Historical Myth," pp. 433-440.

84. Mitchell Siporin, "Mural Art and the Midwestern Myth," in O'Connor, ed., *Art for the Millions, Essays from the 1930s by Artists and Administrators of the WPA Federal Art Project*, p. 67.

85. *Southeast Missourian*, October 26, 1939.

86. Adolph E. Kies to Congressman Orville Zimmerman, October 30, 1939, 133 (Box 57).

87. Charles G. Macke, Postmaster, to Rowan, July 8, 1940.

3

Murals as Murals Should Be
From Maryland to Idaho

Mural America was bound for glory in any vehicle that could be coaxed into motion. The spiritual itch for moving on to a better life and a better future was justification enough for Jackson, Missouri, and home-loving communities like Jackson to relish murals salted with locomotives and family Fords careening toward parts unknown. Thomas Hart Benton's *Power* panel in the New School for Social Research stages a tortoise-and-hare race between an ordinary coal-burning engine and a propeller-driven, futuristic supertrain suspiciously akin to a 1932 Raymond Loewy design for the Pennsylvania Railroad.[1] That hypothetical dirigible on tracks never glided off the drawing board, but its moderne pizazz was optimally suited to Benton's purpose: he was, in spite of personal skepticism about the outcome, starting America's headlong race out of hard times toward an ideal, technological tomorrow.

The contrast between dreamers' flights of the spirit and the awful realities of enforced migration during the Great Depression was underscored with bitter irony in Dorothea Lange's photograph of two vagrant children *Heading Toward Los Angeles, California* on foot in 1937. They trudge on, eyes glued to the dusty highway, oblivious to a Southern Pacific billboard showing a Pullman seat whizzing along effortlessly, like a modern magic carpet. "Next time," the roadside message suggests, "try the train—relax!"[2] Nomadic boys and girls, propelled into restless motion by "the quest for jobs, the lure of adventure, escape from broken, unhappy or poverty-stricken

Dorothea Lange, *On U. S. 66 Near Weatherford, Western Oklahoma*. 1939. The Oakland Museum, Dorothea Lange Collection.

homes" were the decade's shame.[3] And hard on their heels came whole families of Okies, joining the Joads to chase hope down Highway 66, "the mother road, the road of flight . . . the path of a people in flight, refugees from dust and shrinking land, from the thunder of tractors."[4] On any given day in the '30s, two million refugees were roaming the country, riding the rods, hitching rides, looking for work, looking for something lost back there where the exodus began. "The Depression," observed *Fortune* icily, "along with its misery produced social curiosities, not the least of which was the wandering population it spilled out on the roads. Means of locomotion vary but the objective is always the same—somewhere else."[5]

Lange found a family of four walking toward somewhere else *On U. S. 66 near Weatherford, Western Oklahoma* in 1938.[6] She planted her camera in front of them, stalling them in midflight on an axis that angles perpendicular to the highway, against the westward rush of the road. At the right, the mother clasps her baby and looks anxiously toward her husband. At the center, their tiny daughter stands isolated between her parents, peering timidly at the camera and the route ahead. At the left, the father stares down at the ground in an attitude of mortified defeat. Because the family has been checked in a motion that if continued, would bring them into the viewer's space, their plight becomes a moving part of the viewer's experience. Their

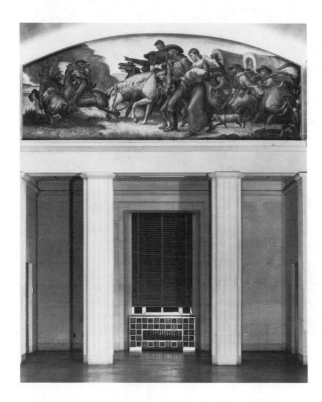

John Steuart Curry, *Movement of the Population Westward*, Department of Justice Building, Washington, D.C. 1937. National Archives.

stasis is the onlooker's frustration, too. Because father, mother, and child are bound together in a unified spatial plane, yet markedly separated from one another, the integrity of the family unit is caught in a moment of maximum stress. The child stands alone while her mother looks for guidance to a father who has run out of ideas and hope. To stop is to lose sight of tomorrow; the image is pathetic because it is fixed forever in motionless despair.

The lonesome whistle that called this Okie family to come away, go somewhere else, and start afresh echoed through a Mural America obsessed with the migrations of the frontier era. It called migrants on the road to California and awakened painted settlers of historic yesterday, calling them to join in today's task of moving on and building a bright new tomorrow. John Steuart Curry's *Movement of the Population Westward* on the fifth floor of the Justice Building is the Depression's classical paean to American restlessness and hope: "[We] see," caroled the Section press release, "families of pioneers with their covered wagons and cattle facing the hardships of the trail and the dangers of the unknown."[7] There is, in fact, only one family marching westward across Curry's lunette—the heroic American fam-

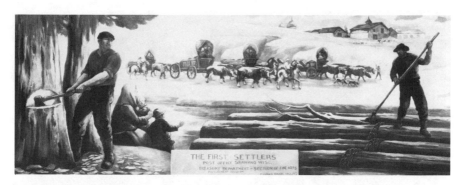

Eugene Higgins, intermediate sketch for USPO, Shawano, Wisconsin. 1939. National Archives.

ily of all time and of 1937. Father takes the lead. With his young son clinging to his side, he squints into the setting sun, looking confidently beyond the prairie and his time in history. Mother solemnly cradles her baby and bows her head, a lithe pioneer madonna in homespun. Their steady gait, measured off in human terms by three left legs striding forward in sinuous unison, sets a processional cadence. The

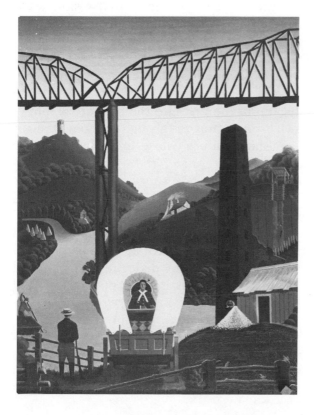

Bertrand Adams, *Early Settlers of Dubuque*, USPO, Dubuque, Iowa. 1937. National Archives.

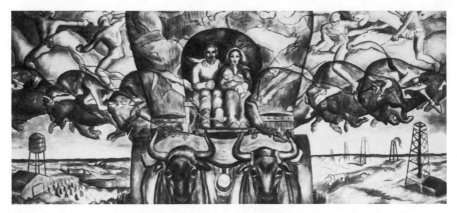

Louise Ronnebeck, *The Fertile Land Remembers*, USPO, Worland, Wyoming. 1938. National Archives.

mass of rearing horses, covered wagons, and ox teams presses on behind them and at their pace. The energy and determination of the family control and guide the inexorable movement of a nation bound for somewhere else.

Curry starts the great historical trek of the '30s at a slow walk. The tempo picks up in the Shawano, Wisconsin, post office, as woodsmen watch *Early Settlers* streaming past in a lumbering wagon train.[8] At Dubuque, Iowa, the prairie schooner heads straight out of history into 1937 through the girders of a modern trestle.[9] And in Worland, Wyoming, the Conestoga and the pioneer family also face the onlooker and seem to rumble out of the past into the post-office lobby: "The covered wagon drawn by oxen presses through galloping Indians and bison, figures of a vanishing culture whose forms have become shadowy and disappear into the past under the white man's determination to open up new lands. The landscape at either side depicts the irrigated fields and oil wells of the present" with fleets of 1938-model tank trucks rumbling along at a modern, breakneck speed.[10] In Wisconsin, the pioneer migration is a stately metaphor. In Iowa and Wyoming, the rumble of the wagons becomes a pointed simile. The pioneers' trek is drawn into an urgent dialectic with the hard travelin' present, and America's ceaseless movement picks up still greater speed in Tennessee and Mississippi and Minnesota, as the historical saga rolls on into the epoch of the iron horse and the sidewheeler.

Section murals in post offices in the sticks and in the marble halls of Washington insist that movement is a generative force in American life, that speed means progress, that journeys have always ended in

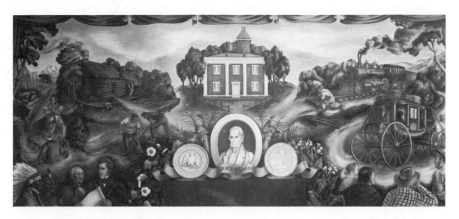

Minetta Good, *Retrospection*, USPO, Dresden, Tennessee. 1938. National Archives.

dreams come true. Consider Dresden, Tennessee, in 1938. Minetta Good called her mural *Retrospection*; the town and the ladies of the Dresden Garden Club prized the picture of life in antebellum days "for its exquisite beauty, the splendid workmanship, and for [what] it means to us."[11] The Garden Club and the other modern day citizens of Weakley County who stand with the viewer in the foreground of the mural looking back into times past find Dresden's rise contingent solely upon rapid comings and goings. First, pioneers clear a trail. Next, a stagecoach pushes off down a corduroy road. Finally, a train chugs into Dresden barely a foot behind the workers still laying the track to 1938.[12] Or consider Amory, Mississippi, in 1939. A horsedrawn carriage bogs down in a muddy thoroughfare, the fitting companion of the town pigs and the local drunk, while *Amory in 1889* roars to prominence on the mainline of the Memphis and Birmingham Railroad. *Amory in 1889* is a railroad town and a boomtown. New businesses sport spanking new signboards. A gaggle of ladies casting disdainful glances at the bemired sot from the heights of a new board sidewalk stand in the center of John McCrady's mural principally to show off their brand-new store-bought finery, shipped from Memphis or Birmingham.[13] The locomotive courses toward 1939, trailing clouds of local prosperity.

Or consider Grand Rapids, Minnesota, in 1940. In the center of James Watrous's mural, the ladies and the lumberjacks of Grand Rapids dance for joy when the "Andy Johnson" noses up to the dock. The tall facade of a new hotel peers over the river and the settlers cavort to whistles on the Mississippi that play the sweet melody of progress, of "the growth of the town during the lumbering

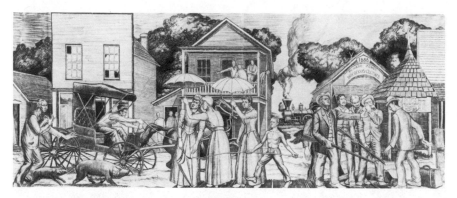

John McCrady, cartoon. *Amory in 1889* for USPO, Amory, Mississippi. 1939.
National Archives.

and river trade period" still vivid in the memories of "local poten-
tates" who took issue with the paddle rigging of a steamboat headed
for 1940.[14]

And so the pictorial nineteenth century strode, galloped, chugged,
and wheezed into the 1930s, ever moving, questing, building. Towns
have always boomed when wagons creak, when trains scream, when
packet boats steam down mighty rivers. The faster the pace, the
brighter the promise—the nearer tomorrow. The mural saga of trans-
portation across America was an object lesson to the '30s. The wes-
tering spirit of the pioneers made sense of a Depression generation
"spilled out on the roads" in despair, trudging slowly toward Califor-
nia and the last frontier. America had passed this way before, in hope
and confidence, walking through John Steuart Curry's Justice De-
partment mural. In that time and in the eternal present of Mural
America, homeless wanderers found their dreams. Pare Lorentz filmed
the Okies on the road in 1936, hiding from the dust in their broken-
down cars. But his Dust Bowl documentary spoke to stay-at-home
Americans when it bid the nation to keep faith with *The Plow that
Broke the Plains.*[15] The swift machines that transformed the land
when grandfather settled Amory and Grand Rapids made eminent
sense to a nation intent upon leaving the Depression behind and
reaching the future in the family jalopy, a Raymond Loewy rocket
train, or, if need be, on an International Harvester haybaler. Machines
built America, and the offspring of the pioneers had only to gaze
beyond the moment to see a technological frontier still beckoning
him or her toward tomorrow.

The didactic message of the murals was obliquely put. But a sur-
feit of old-timey costumes and vintage engines kept one from won-

138

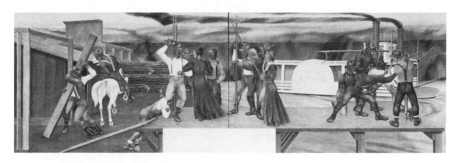

James Watrous, *Life in Grand Rapids and the Upper Mississippi*, USPO, Grand Rapids, Minnesota. 1940. National Archives.

dering if the nation had always zipped about with the frenetic energy of a Busby Berkeley chorus line in a Warner Brothers musical, pioneer legs pumping like syncopated pistons.[16] On occasion, however, the meaning of the electric current of motion joining the frontier past with the frontier of the future was stated with the purity of a prayer, the mystical clarity of a parable. The post-office mural in Goose Creek, Texas, makes such a statement. Pioneering pictures in New Deal post offices are readily ignored by virtue of the meticulous historical touches that give them the forlorn air of old civics textbooks left in an attic. Barse Miller's Goose Creek mural is impossible to ignore. His *Texas* is so blatant an invocation of the wishful mythmaking embedded beneath the pioneer trappings of Shawano and

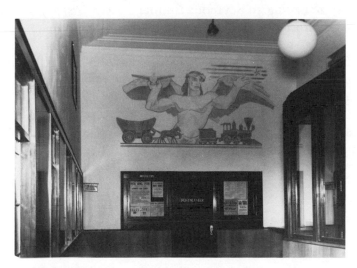

Barse Miller, *Texas*, USPO, Goose Creek, Texas. 1938. National Archives.

Dresden that it takes an act of will to stand in the lobby without profound embarrassment. The hopes of the '30s are too close to the surface of this wall. The urgency is, quite literally, naked. The deus ex machina is indeed a machine that did not accomplish the miracles so earnestly anticipated by the children of the Depression.

Texas is a giant, muscular deity who thrusts his nude torso from the partition above the postmaster's door and prepares to fire a tiny airplane—an updated lightning bolt—into the crowd lined up at the parcel post window:

Along the baseline of the mural are a covered wagon drawn by mule team and an early type of locomotive. Rising above is a winged figure which represents the spirit of the Texas pioneers. One hand holds an airplane, symbol of modern progress. The other hand reaches toward a star, as if to remind the present Texans of those qualities of vision and determination which have shaped the destiny of their State.[17]

Why not call him "America," reaching out of the Depression to grasp the distant star of destiny in 1938?

The zest for moving on aboard a winged stagecoach bound for distant stars was also expressed in a format tailored to the post-office construction boom of the '30s and the Section mural program for post offices. Indeed, few topics were more assiduously plumbed during the opening years of the mural campaign than the transportation history of the U. S. postal service. The National Competition of 1935 sent artists scurrying to Seymour Dunbar's 1915 *History of Travel in America* for prototypes, and with good reason. The majority of the winning designs for the Post Office Building on Federal Triangle involved fascinating and dramatic ways of moving the mail. *Pony Express*, *Stage Coach Attacked by Bandits*, and *Covered Wagon Attacked by Indians* were replicated ad nauseum in towns where "Local History, Past or Present, Local Industry, Pursuits or Landscape" lacked the theatrical chutzpah of turning wheels.[18] The picture album of Section accomplishments edited by Bruce and Watson in 1936—Volume One of a projected series on *Art in Federal Buildings*—included fleets of stagecoaches and wagons, lifted bodily from the postal competition. Stagecoach murals cropped up all over the map, from Stockton, California, to Catasauqua, Pennsylvania, from Raton, New Mexico, to Bridgeport, Connecticut.[19]

Among the muralists given postal commissions in 1935 without competing, Benton—who declined to sign a contract in the end—showed the greatest restraint in the matter of vehicular technology.[20]

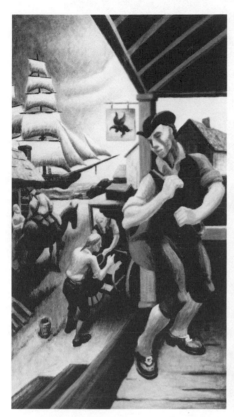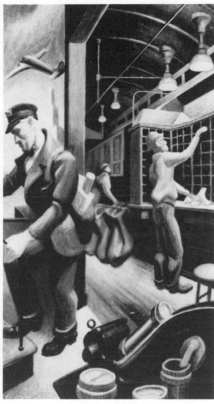

Thomas Hart Benton, color sketch for Post Office Department Building, Washington, D.C. 1935. National Archives.

As his New School murals amply demonstrate, Benton loved nothing more than a charging engine, but his color sketch treating contemporary postal activities confines a limited amount of action to the staid interior of a railway mail car, while the colonial post is personified by a mail rider carrying his pouch up the front steps of a wayside inn. In both panels, Dunbar material appears in small doses—the prow of a clipper ship, the rear gate of a stagecoach, a distant view of an air-mail plane soaring over a skyscraper. The airplanes in Rockwell Kent's treatment of recent expansion of postal service to the territories are curiously incidental to the flight of the first letter sent by Eskimos in one panel and opened by Puerto Ricans in the other. And modern transportation had tangential bearing on the message that winged between them. According to Arctic explorer Vilhjalmur Stefansson, "gibberish" syllables inscribed on the sheet of stationery

141

Rockwell Kent, detail (destroyed) from *Delivery of Mail in the Tropics*, Post Office Department Building, Washington, D.C. 1937. National Archives.

were actually words of an obscure Kuskokwin dialect and were a call to arms: "To the people of Puerto Rico, our friends! Go ahead. Let us change chiefs. That alone can make us equal and free."[21]

The resulting controversy, adroitly stage managed by Kent, was a transcontinental affair. Puerto Rico decided that the islanders had been portrayed "as a bunch of African bushmen," Alaska realized that the Eskimos looked "like a bunch of rebels," and a newspaper editorial from Bridgeport, Connecticut, branded both pictures "subversive."[22] Bridgeport could afford to be smug: its own post office had just been decorated with the saga of mail delivery from the stagecoach era to the airplane age, and whatever Robert Lambdin's politics, the task of illustrating each and every piece of mechanical gear in postal history and getting every fact straight left him little

Peppino Mangravite, study for *English Dirigible R34 Delivering Mail to the United States at Hempstead Field, 1919*, USPO, Hempstead, New York. 1936. National Archives.

scope for covert rabble-rousing. The Kent case was the Section's own Rivera incident, confirming that agency's predisposition to mistrust painters with causes on their minds and to scrutinize the smallest detail of axle and propeller. But the episode did not impugn the glamorous reputation of the air-mail plane Kent crammed into the background of *Delivery of Mail in the Tropics*, nor did it dampen muralists' zeal for idolizing the latest methods of speeding innocent missives between farflung points.

Peppino Mangravite pushed Buck Rogers modernism to its tragic limits in his mural for the post office in Hempstead, Long Island. Mangravite was a runner-up in the National Competition, but tossed his outdated copy of Dunbar aside in planning *English Dirigible R34 Delivering Mail to the United States at Hempstead Field, 1919*.[23] The mural was hung in 1937. In May of that year, as the nation listened on the radio, the airship Hindenburg crashed at Lakehurst, New Jersey, shattering the last illusions of visionaries who believed that the zeppelin was the bellwether of the space age and that the future would shortly waft to a halt at the mooring mast expectantly perched atop the Empire State Building.[24] The risk of immortalizing streamlined anachronisms was still worth running, however, for aerodynamic shapes epitomized modernity, efficiency, and progress. Scientifically graphed by Lloyd C. Douglas hero-scientists in lab coats, they conjured up modern exploits more daring and much more pressing than the stale legends of the pony express.

Rolling Power, an easel painting produced by Charles Sheeler in

Charles Sheeler, *Rolling Power*. 1939. Smith College Museum of Art, Northhampton, Massachusetts. (Photo: David Stansbury)

1939, on assignment for *Fortune*, is a hypnotic closeup of the gleaming drivers and pistons of a Hudson class 4-6-4 locomotive, designed for the New York Central Railroad by Henry Dreyfuss, architect of the futuristic "Democracity" at the New York World's Fair.[25] The image is sterile and spare. The canvas is a vacuum, pumped clean of all potential save imminent acceleration, the raison d'être of the machine. Sheeler probes the bare crankrods of the locomotive with the

Dan Rhodes, *Communication by Mail*, USPO, Marion, Iowa. 1939. National Archives.

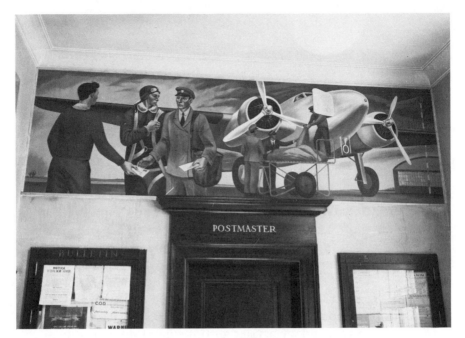

Dan Rhodes, *Air Mail*, USPO, Piggott, Arkansas. 1941. National Archives.

intensity of a Roman augur inspecting the entrails of a talismanic bird of flight. He isolates the happy omen that tells *Fortune*'s business audience that the end of the Depression is near; the acceleration of the economy is at hand; and decisive, well-oiled action will carry the day.

Far from the altars of commerce, wreathed in the sweet attar of Sheeler's prophecy, the same portent of tomorrow reappeared in 1939 in the quiet Marion, Iowa, post office. *Communication by Mail* bridges the compositional interval between a letter box and a postal worker on a station platform with the polished undercarriage of the locomotive that hurtles the mail from country to city. Thief or sincere flatterer, artist Dan Rhodes built his mural around Sheeler's homage to *Rolling Power*. Then he turned up the throttle and lifted the flaps under his own power in 1941, with the *Air Mail* mural in Piggott, Arkansas. "I feel the Air Mail is of unusual significance to the smaller and more isolated communit[ies]," Rhodes explained, "linking them as it does with more distant centers." His image of flight had an almost purely symbolic significance for Piggott in any case. Rhodes's aircraft bore a striking resemblance to the new DC-3, the first airliner to turn a profit on passenger service without depen-

dence on federal mail contracts; the DC-3 rarely touched down in the northernmost corner of Arkansas. But Rhodes had other reasons for studying teardrop nacelles and propellers in Piggott: "I have tried to convey a sense of stream-lined power which is behind the mail service."[26] Streamlined power was justification enough for painting a futuristic phoenix arisen from the ashes of the Depression.

Under the Christmas trees of the '30s, kids were playing with electric replicas of rolling stock fresh from the carshops. Marx Toys offered both "the latest-type Commodore Vanderbilt" passenger train in service on the New York Central and the Union Pacific's articulated City of Salina streamliner. The same "flying streamliners" could also be had in windup models, at a saving of $2.70; the Lionel version of the Commodore Vanderbilt was stoked by no less an eminence than Mickey Mouse. For fifty-nine cents the mail-order houses would deliver a "13 Piece Municipal Airport Set," a cardboard terminal plus "a famous Tootsie Toy transcontinental tri-motor plane, a TWA cabin plane, and a Chrysler automobile of unbreakable metal, averaging 5 inches, 4 passengers and 5 dummy tools." Old-fashioned parents had a harder and harder time finding lead cowboys and Indians. Nowadays, Junior was torn between yearnings for a "Stage Coach Dan" playsuit with six-shooter, lasso, and fringe, and the "Genuine Buck Rogers Six-Piece Outfit," including a "toy rocket pistol (harmless)."[27]

By 1936, Parchesi and picture books were playtime anachronisms. The little boys in cowboy suits who scooted along Main Street on their streamlined tricycles were reenacting a matinee serial that was playing with monotonous regularity on the walls of America's post offices. In the aftermath of the National Competition, the pictorial saga of danger, action, adventure, and futurism in the postal service was becoming a cliche, a fable best left to varooming kiddies with cap pistols. By 1936, iconographic instructions for Section competitions were squandering turgid paragraphs in the cause of sparking a new approach to the Mail theme:

. . . the Committee feels it important that the artist realize that the central idea of the Postal Service is communication, by which experiences, ideas and goods are shared throughout the civilized world. This element of communication the Committee believes need not be represented by the more obvious symbols of airplanes, trains, packet ships, etc., but might take on great dramatic and human significance. The Post Office, moreover, is the one concrete link between every community of individuals and the Federal Government, and in addition to mail

146

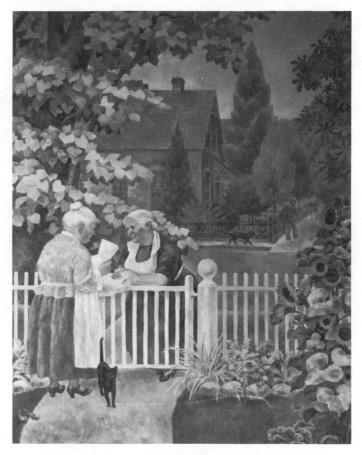

Frances Foy, *The Letter*, USPO, East Alton, Illinois. 1936.
National Archives.

service, through such departments as postal savings, money orders, etc., func-
tions importantly in the human structure of the community. As distinguished
and vital a conception along such lines is desired.[28]

For all its pains, the Arlington, New Jersey, committee that was so
deeply concerned with the "dramatic and human significance" of the
post got a landscape and a cityscape without discernible postal signi-
ficance. And some artists did try to find that drama, only to be re-
warded with boring or bathetic results. In 1936 Frances Foy aimed
at human significance in her East Alton, Illinois, mural. The postman
has just turned the corner. Over a picket fence, two chubby old bid-
dies and a cat are dissecting the contents of *The Letter*. So little is
happening, however, that Foy had yards of space to spare and filled

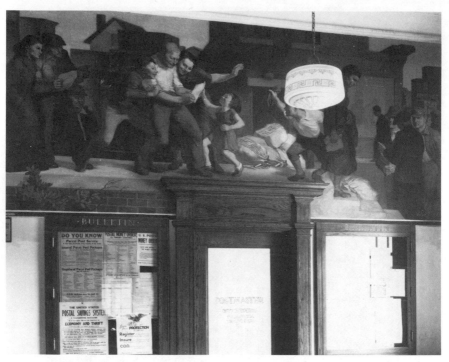

Alan Tompkins, *The Arrival of the Mail*, USPO, Martinsville, Indiana. 1937. National Archives.

up most of the mural with floral arrangements. A speeding mail train would have helped matters no end. *The Arrival of the Mail*, painted the following year for the Martinsville, Indiana, post office is full of people and emotional brouhaha:

The mural depicts a scene on the porch of a Post Office in a typical small American town. The central figure has received a letter of good news and his family

Nicolai Cikovsky, preliminary study for USPO, Towson, Maryland. 1939. National Archives.

and friends join in the surge of good feeling. The woman descending the steps at the right has received tragic news. The two figures at the extreme left have not yet learned the nature of the news contained in their letter. Their mood of anticipation serves as an introduction to the extremes of joy and grief in the other groups.[29]

The extremes of emotion depicted are enough to make a boxholder think twice about picking up his bills. A third-class postcard is a ticket to bedlam in Martinsville, and artist Alan Tompkins seems to have surpassed his own mild desire "to convey a sense of the genuineness of friendly interest in others in American community life as well as the idea of the importance of the mail in the daily drama of our existence."[30] Pictures of the DC-3 had the virtue of being easier on the nerves than Tompkins's stricken widows!

The postmaster of Towson, Maryland, still thought streamliners and the like perfectly delightful in 1939 when he presented his iconographic schema to artist Nicolai Cikovsky with the perky confidence of a man unaware that he has just reinvented the wheel:

I would suggest that the painting depict the Pony Express, Stage Coach, Early Railroad Train and Steam Boat, as a background for a Streamliner Train and modern Clipper Ship, to be the focal points in the work. In addition to the methods of transportation I have recommended, I would suggest that consideration be given to including an Indian Runner and Smoke Signals, the entire theme being directly related to the evolution of communication.[31]

Groans emanated from the upper reaches of the Treasury, of course. There was "no special objection to the subject matter as such, but

Nicolai Cikovsky, preliminary study for USPO, Towson, Maryland. 1939. National Archives.

149

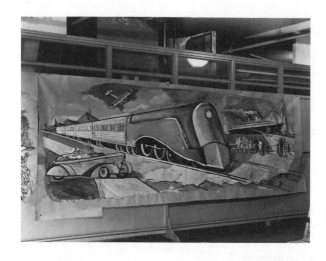

Nicolai Cikovsky, full-scale detail rendering for USPO, Towson, Maryland. 1939. National Archives.

Nicolai Cikovsky, detail, *Milestones in American Transportation*, USPO, Towson, Maryland. 1939. National Archives.

it has been used again and again—Evolution in the method of handling the mails. A little research on the artist's part would undoubtedly produce subjects of real historical interest."[32] Redundant contemplation of a stock theme was not required of the artist, however, and work proceeded with startling alacrity. The postmaster mailed his bright idea to Cikovsky in January, the five keyhole vignettes entitled *Milestones in American Transportation* were glued into place above the service windows on Saturday, June 24th, and by Thursday morning, June 29th, newspapers from Towson to Baltimore were screaming for their removal.[33] Postal officials in Towson were not sure just why the press was in full cry. Sure, they had heard mutterings about "the execution of the work and also the theme," but the

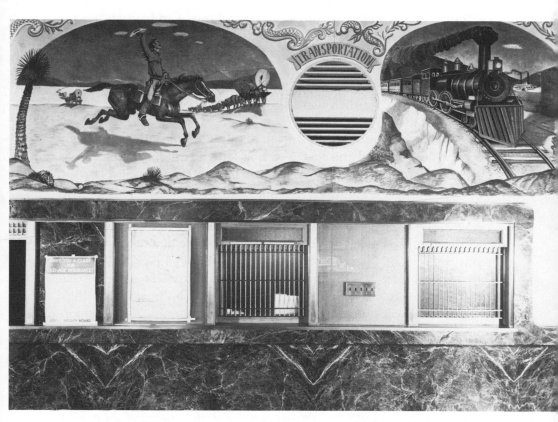

Nicolai Cikovsky, detail, *Milestones in American Transportation*, USPO, Towson, Maryland. 1939. National Archives.

Nicolai Cikovsky, detail, *Milestones in American Transportation*, USPO, Towson, Maryland. 1939. National Archives.

custodian of the building could not bring himself to believe that the splendid topic chosen could be at fault and wondered if the trouble might not lie elsewhere. "The photographic sketches submitted with your letter of February 6th," he reminded Washington, "did not indicate that there would be any legend on the scrolls over the ventilators and in the finished work the inscription 'Milestones in Transportation' [sic] appear[s]."[34]

True enough, the scrolls had been blank in Cikovsky's exceedingly sketchy sketches and the new lettering which stretched some forty-eight feet across the lobby was regarded as an eyesore. The Towson *Jeffersonian* devoted a lead article, an editorial, and the picture page to Cikovsky's "JOKE" on the 30th, as if determined to enumerate every hideous facet of the ensemble. The banner-like scrolls ranked high on the list. According to the headline of the news report on the front page, "One Citizen Says Interior Now Looks Like Cheap Movie Theatre Lobby." Below, another unnamed protester agreed "that much better art work can be seen on roadside billboards." A third "said all that was needed was sawdust on the floor and a pink lemonade stand in the corner to give the interior of the building a circus side-show atmosphere."[35] In the editorial—"AWFUL!"—title scrolls and the subject matter of Cikovsky's "disgrace" were lumped together in infamy:

Its title is "Milestones in American Transportation" and, in five painful panels, is supposed to carry the beholder through a pictorial presentation of the progress made in transportation from pioneer days to the present time. Of course, as to subject matter, the New Towson Post Office "Mural" is better suited to a railway station or a bus terminal, and who knows, it may have been painted origin-

ally for such a place, although its first four panels suggest that it may have been copied from one of Buffalo Bill's old side show banners.[36]

The photo caption delivered the coup de grace: "These might be posters advertising 'The Covered Wagon', Movie Thriller, or 'The Union-Pacific', but are not—they are 'murals' painted by Nicolai Cikovsky."[37] In an odd way, those were the kindest words the *Jeffersonian* ever printed about *Milestones in American Transportation*, and the casual analogy between the mural and two very popular movies was, intentionally or not, more insightful than glib. Both films were self-conscious epics of American history and hymns to American progress. Both described progress by means of vehicular movement across the landscape. And both, like Cikovsky's mural, were very, very long. The topic Cikovsky painted had been a popular one in movies of the '20s and retained enormous appeal throughout most of the '30s. The content and the flashy format of the Towson post-office cycle in fact invited comparison with the genre of Hollywood historicism upon which its critics fastened in disgust.

James Cruze made the film *The Covered Wagon* in 1923. In 1939 it was a relic of the silent era, ripe for plundering by Cecil B. DeMille, whose *Union Pacific* was a box-office bonanza of that year. Despite a close thematic parallel and some stolen scenes, the radical difference in sensibility between *Union Pacific* and *The Covered Wagon* defines a cultural watershed between the popular idea of wheeled progress in the '20s and the unique significance of locomotion in the '30s. Cruze's film exploits a documentary technique and a running time of ten reels to underscore the sluggish pace of national progress westward. The camera stands still and makes wagons creep across the frame, inch by painful inch, crossing the frontier at a crawl far slower than Curry's pioneer processional. DeMille's movie puts Barbara Stanwyck and Joel McCrea aboard a succession of trains that seem, over the course of 135 minutes, to have thundered down several thousand miles of main line.[38] The camera moves, the trains speed by, and the plot, a pastiche of climactic moments from every Western released to date, is an excuse for pure, repetitive action.

The epic of the '20s sets a goal: Cruze moves his wagon train resolutely toward Oregon, pausing to diagram every tedious step along the way. The epic of the '30s is a "spectacular," a supercharged, orgiastic marathon: DeMille's destination is absorbed into the frantic scramble to get going. The will to act is reason enough for flamboyant action. Movement feeds on itself and accelerates with the force

of the Hudson 4-6-4 in Sheeler's *Rolling Power*. Whereas *The Covered Wagon* plods toward a clearcut yesterday and an historic rendezvous with the west, *Union Pacific* hustles toward a vague place, the autochthonous tomorrow that was the spiritual home of the '30s. The trains are mechanical migrants in flight from reality, chasing hope down the tracks of time.

Calling *Milestones in American Transportation* a Hollywood poster could be considered a backhanded acknowledgement of the epic intentions of the mural and its contemporaneity. On the other hand, Cecil B. DeMille epics, always lauded for sheer entertainment value, were also notorious for a staunch disregard of fact. When the Baltimore *Evening Sun* entered the mural fray, Cikovsky's facts rapidly became the point at issue. Collating opinion from other Maryland papers, the *Sun* totaled the pictorial mistakes: "The pony express rider 'looks like a tough Apache', and he 'has his holster on backward.' In the third panel 'the oxen pulling the covered wagon aren't hitched to the wagon.' "[39] Half of Maryland had descended on the Towson post office to look for more errors. "The place has been overrun with curiosity seekers," the story continued, "and a check of visitors discloses the fact that nearly all of them pronounce the five panels as horrible."[40] An anonymous letter to Bruce pointed out that smoke rarely blows in opposite directions from a fixed location and marveled at the inability of an artist with "a gold edged diploma . . . to paint a decent child." Bruce's correspondent, who described himself as a "common Layman," hinted at hanky-panky: "When I saw your friend's, Mr. Cikovsky's, smearing on the Towson, Maryland post office I knew that some brush slingers will get a commission to paint a mural no matter what their work looks like. . . . Not everyone is blind to what is going on in this mural business."[41] The most sympathetic letter received by the editor of the *Jeffersonian* observed that the mural wouldn't look so bad "if the critic would stand near the post office door, or better still, outside the door."[42]

Demands for action rained down on the Section chiefs. Rip the blankety-blank thing off the wall! Don't pay the artist! Get somebody else to paint "local historical subjects" instead![43] In August of 1939, the Section tried to end the shouting by sending Cikovsky back to Towson to rectify the worst of his mistakes.[44] "Today," the papers announced, "no capital 'I' carries a dot. Today there is no baby that doesn't look like a baby. . . . And now the artist has touched up the paint job a bit to make the smoke from the tugboats

blow in the right direction."[45] The cleanup effort was simply that— a stopgap. Had the public been so inclined, quibbles over peculiar aspects of the mural might have continued indefinitely. The Queen Mary, Cunard's eighty-thousand-ton waterborne marvel, made a straightforward statement about modern progress, once the tugboat smoke had been properly aligned.[46] But Cikovsky left a doomed dirigible hanging piteously over the Manhattan skyline, and his streamliner, streaking south out of Pennsylvania Station remained, to say the least, problematic. In the preliminary drawings, the engine was the Commodore Vanderbilt—or Marx Toys' rendition of same—pulling the Twentieth Century Limited west out of Grand Central Station by a most circuitous route. In the mural, the simplified engine is clearly a Lionel wind-up edition of a Union Pacific locomotive, far from the City of Salina, tearing through a Cecil B. DeMille fantasyland—not Maryland.

With the corrections made, discussion of the errors ceased, however, and the debate moved to a higher plane:

The mural has been altered as a result of criticism. It is, admittedly, an alteration that applies to details only. The more sweeping criticism, that the whole conception is as stale as an oyster that was opened day before yesterday, has had no effect on the Postoffice Department.[47]

Towson now wanted "a better mural," a conception that was not "trite," a picture reflective of the interests and tastes of the community:

Plainly, the artist had not followed the excellent suggestion made by the head of the Treasury Department's art projects, to wit, that it is a good thing for artists to visit the community for which their work is intended, learn something of its history, and generally "get the feel of the place." What he did was to ignore Towson and produce a jumbled assortment of ships and prairie schooners with the most conspicuous panel being devoted to a badly drawn pony express rider —a picture which might conceivably have been printed on the cover of one of the oldtime nickel paperback thrillers but which would hardly have made an acceptable poster for a third-rate Wild West show. . . .

The chief objection to such an art job, as we see it, is this: that the artist deliberately foisted something upon a community which didn't understand it and didn't want it. He produced a fake "primitive"—don't imagine that he really *couldn't* draw any better than that—according to some theory of his own, without any consideration for the feelings of the community. That is not the way to interest people in art, or to win friends for Federal art projects.[48]

In September, the Towson *Jeffersonian* mounted a drive to have the "gaudy . . . poorly executed" cycle expunged and replaced by

"murals done as murals should be, depicting local historical subjects." Congressman William P. Cole, Jr., had worked to get the appropriation for the building, so it was to Representative Cole that the local editor addressed this deathless verse, written under the nom de plume of Gum Shoe Harry:

> Of all the murals under the sun
> Them Post Office ones are the worst ever done
> They hurt folks' eyes and they hurt their pride
> And everybody feels artist Cikovsky took the Government for a ride.[49]

After a delay of several months, during which time he was sure that the Post Office Department or the Treasury would have to come to their senses, Cole tried to have *Milestones in American Transportation* discreetly carted away. He was tired of being "hammered, week after week, by a broadly read paper" and worried about the new post office in Catonsville, currently "free of any 'murals' or anything else to bring about criticism" but scheduled for Section ministrations.[50] The *Jeffersonian* had assumed the role of mural vigilante and was dropping broad hints about the 1940 elections. If Towson's "sideshow banners" remained, Cole's days in office were numbered. The Towson case had also threatened to become an issue in the Radcliffe-Bruce battle for a Senate seat, for Bruce was hardly a popular name in Maryland in 1939.

Art, no less, was gumming up serious affairs of state, and Gum Shoe Harry's whimsical sallies had taken on a nasty edge:

Tomorrow the new post office at Catonsville will be dedicated and opened to the service of the public—and, next Saturday, who knows but what the interior walls of this handsome structure will be desecrated with some of Mr. Cikovsky's horrible murals. For what this means in vivid color, etc., see the interior of the new Towson post office. So far we have heard no plans for murals in the Catonsville building. But that signifies nothing. When the new Towson post office was dedicated there was no hint that Mr. Cikovsky's brilliantly dobbed [sic] murals were soon to spoil its chaste interior walls. These "art offerings" were sprung on the unsuspecting Towson public and placed before anything could be done about it. . . .

The people of Catonsville can profit by Towson's experience. We suggest they guard their new post office carefully and if they see anybody wearing blue velvet trousers and a Windsor tie entering the building with a bucket of red paint in one hand and a covey of brushes in the other that they immediately call out the police and the fire department.[51]

Forewarned, the Section moved into Catonsville late in 1940 with a cautious tread and an accommodating smile and parlayed directly

Movie Poster. 1938.
(Photo: Pat Osthus)

with the Catonsville Committee on Art, set up at a public meeting of concerned citizens prepared to guard their post office against bohemian intruders, as the *Jeffersonian* had counseled.[52] The Committee furthermore insisted upon "murals done as murals should be, depicting local historical subjects." And as for Towson, the town learned to live with *Milestones in American Transportation*: Washington could not be persuaded to whisk the murals away on a southbound streamliner.

The poetasters and poison pen pals of Towson offered lots of reasons for their hostility to *Milestones in American Transportation.* The murals were poorly executed. They had appeared without warning. Nobody had been consulted. Shady deals had been made. Folks would have preferred Maryland history. These were, by and large, objections reasoned out after the shock wave that hit Towson on a spring Saturday in 1939 had passed. From the beginning, the mural cycle grated on the nerves in ways people later struggled to put into logical phrases. Why? First reports spoke disparagingly of movie posters and wild-west shows. Cikovsky, it would appear, had trespassed over the faint line that separates art from popular art, a breech of decorum manifest in the broadside style of his work but more especially in his definition of a normally innocuous theme. The modern—the futuristic—end of his temporal spectrum was dispensed with in a single vignette. The remainder of the cycle, with the exception of the clipper ship, was cowboy and Indian stuff, for-

eign to Maryland, which could have come straight from the silver screen. The great DeMille himself might have hesitated to show self-propelled wagon trains with Cikovsky's reckless brio, but that slapdash technique was an accepted convention of B-movie Western ads. Republic's poster for a 1938 John Wayne oater called *Pals of the Saddle* gave no intimations of a storyline that involved cowboys rounding up foreign spies for violation of the Neutrality Act; it featured instead a charging wagon train to which horses were apparently hitched by their reins and manes alone.[53]

As far as Towson was concerned, *Milestones in American Transportation* was a Hollywood horse opera fated to run forever at the post office. It was one thing to understand the conventions and connotations of popular culture, as the Regionalists tried to do, and to tap the wellsprings of people's concerns in a readable pictorial language related to the argot of the media. It was another thing altogether to scissor style and content directly out of the current matinee program at the Bijou and freeze it for generations to come on the walls of a public building. At the very least, the viewer was entitled to wonder whether Cikovsky spent the six months before he did just that worrying about why the Commodore Vanderbilt, the Queen Mary, and the covered wagon were popping up so frequently in the mass media, in formulary poses. Public art was not a license to patronize the public. The muralist who conceived his role in the public arena as a process of meditation between the residual elitism of Section standards for great art and the anything-goes free-for-all of the magazines and the movies was not obligated to pander. Towson sensed condescension in Cikovsky's attitude. Editors, politicians, and postal patrons in Maryland had no edge on a judge in Aiken, South Carolina, or a gin operator in Paris, Arkansas, when it came to saying what art in their part of the public domain ought to be like. Yet the charge that Cikovsky had painted a "fake 'primitive'"—that he could have drawn babies and holsters properly had he not been working "on a theory of his own"—constitutes a negative definition of public art. Public art was not an artist's amusing notion of giving folks a dose of their own schlocky species of art, popular art à la Cecil B. DeMille, especially when Western flicks had nothing whatsoever to do with Towson.

Gum Shoe Harry at his ill-tempered worst would not have argued against painting a wild-west epic with scrolls and legends in Nutley, New Jersey, a town which liked to recall *The Return of Annie Oak-*

Paul Chapman, *The Return of Annie Oakley*, USPO, Nutley, New Jersey. 1941. National Archives.

ley, making trick shots for the Mutoscope camera before a suspended bedsheet. Movie nonsense meant something to Fort Lee, New Jersey, where the film industry began, and the post-office mural showed *Early Moving Pictures* being made on open-air stages. It meant something to Burbank, California, where people worked for Warner Brothers and the post-office mural showed a Mexican dance scene being staged. Real six-guns and sagebrush meant something to Giddings, Texas, where the post-office mural showed *Cowboys Receiving the Mail.*[54] But Giddings, Texas, in 1939 was not much like Towson, Maryland.

In an epoch happily ignorant of structuralist interpretations of the Western, the theory that Maryland moviegoers examined pressing social problems in darkened loges while the Union Pacific built itself in two hours and fifteen minutes deserved the derision slathered on Cikovsky's vignettes.[55] Cecil B. DeMille's epic was entertainment, escape. Contrariwise, people did not go to the post office to be entertained by cowboy epics. If mailing a letter was a less perilous errand than Martinsville, Indiana, believed, it was nonetheless an official transaction with the U. S. Government. The post office was a prominent feature of the downtown scene and would be for years to come. The new building was the mark of the federal presence, a hard-won distinction acquired through the zealous efforts of "Bill" Cole, who may have been a slouch at getting things taken down but was a real whiz at getting them put up.

The Towson post office was a consequential, enduring monument,

adorned with a frivolous featurette. Too late, Towson opted for
"local historical subjects," for "murals done as murals should be"—
murals possessed, therefore, of qualities associated with local appre-
ciation of the architecture that housed them: dignified sobriety and
resistance to the passage of time. Quite apart from the gaudy Western
movie flavor, the transportation theme chosen for the Towson post
office was not equal to those demands. By 1939, the Section and the
town judged the topic trite and stale. Themes, whether embodied in
murals or movies, have imaginative half-lives of their own: the wider
their imagistic spread across the media of cultural expression, the
shallower their bite into the depths of culture. The historical onset
and evolution of progress came to be addressed in the '30s through a
hierarchical canon of moving vehicles. Wagons, steamboats, cars, and
trains dominated DeMille's *Union Pacific*, John Ford's *Stagecoach*,
Sheeler's *Rolling Power*, Edna Ferber's *Cimarron*, Steinbeck's *The
Grapes of Wrath*, Roy Acuff's twangy recording of "The Wabash
Cannonball," and scores of New Deal murals.[56] These symbols cloyed
through repetition and lost definition. Through familiarity, the
legions of trains and stagecoaches filled up that imaginative distance
from the texture of daily experience that allows a book or a song or
a mural to shock and delight. Turning wheels became ordinary and
trite.

The meaning of the symbols dissolved apace. The extraordinary,
at close range, becomes humdrum. In fact, the cumulative gathering
of technological forces for one last scramble into a streamlined to-
morrow showed signs of running out of gas in 1939 at the New York
World's Fair. The Trylon and Perisphere epitomized futurism, but
they were hollow structures antithetical to stability and poised, *sui
generis*, on the brink of obsolescence. Tracing the path of mechani-
cal progress that pointed out of the past toward an ideal future bur-
dened muralists with artifactual symbols of that kind. Hence the
change that painters strained to picture always threatened to loosen
the imaginative hold of a modern locomotive with rust spots forming
on the carapace or a millenial airship no longer in service, before the
paint dried on the post-office walls. Cikovsky recited the gospel of
progress by rote in the Towson post office, and his litany of wagon,
steamboat, and streamliner exposed the waning potency of both
facets of the formula. The technological past annoyed Towson. So
did a tomorrowland where smoke blew the wrong way.

Perhaps the promises of speed and power and machines had been

made once too often. Perhaps people who lived within sight of the technological marvels framed by Cikovsky's final vignette were immune to the rumble and the roar. *Life* magazine thought it odd that "the most heavily industrialized nation in the world" gave technology no place of honor in Mural America in 1939.[57] But all the painted stagecoaches and locomotives had roared straight down the spiritual cul-de-sac that petered out at the Towson post office. Towson yearned for the past, for local history. Local history meant staying put and staying home, turning a deaf ear to the nighttime whistle of the 4-6-4 as it zoomed off toward a paradisical, machine-driven tomorrow. The roar of the dream machine was an evanescent echo on the wind. Home and history were as solid as the post-office wall. A great and troublesome paradox of Depression history surfaced upon that wall in Maryland: the track toward somewhere else always wound back toward home, like all the weekend excursion routes mapped out in the WPA Guide to the Old Line State.[58]

Industrial towns in the '30s did not contemplate murals with Ludism in their hearts. People were adamant, however, in their demand to see scenes consistent with local fact. Hence, in communities with an industrial focus, muzzy World's Fair futurism was as little appreciated as emblematic ladies in cheesecloth brandishing locomotives. Barse Miller won the 48 States Competition for Island Pond, Vermont, a lumbering center, but the father of the technological god of Goose Creek, Texas, did not venture to thrust naked fantasy upon the chilly factory and mill towns of the northeast corridor. His Apollo of Aviation hitched up his britches and picked up a saw. When industry was woven into the fabric of home, the work of the community and the manner in which it was accomplished in pictures were charged with the emotions accruing to home places. Where home and technology intersected, on the post-office wall, conflicting values often clashed: industrial progress with stability, movement with permanence, action with history. Among the various controversies kicked off by the 48 States contest of 1939, the Westerly, Rhode Island, and Kellogg, Idaho, mural disputes were unique because they revolved about the tension between home and industry. Kellogg chose to turn away from certain painful realities of the modern mining industry, into the make-believe serenity of the past. Westerly chose to unite industry with local history.

Life took no special notice of the Westerly sketch in discussing the "handful" of 48 States drawings with industrial topics. Paul Starrett

Barse Miller, 48 States sketch for USPO, Island Pond, Vermont. 1939. National Archives.

Sample pictured "a railroad engineer and his family crossing over the tracks at [a] station," according to the caption.[59] In compositional terms, however, the importance of the engineer's family is open to debate. The style is metallic and moderne and the sketch is controlled by a lateral thrust following the sharp plane of the railroad tracks. A caboose, box cars, and an updated steam locomotive wrapped in a streamlined shroud also describe a horizontal band across the design surface; a river retraces the tracks in the background. The family group elevated on the bridge is too generalized to sustain visual interest. The group is primarily a centering device for the energetic composition, a vertical pin which keeps the eye from passing over the mural completely in the compelling horizontal charge from right to left.

When the 48 States contest was announced, the Westerly post office was still in the preliminary drafting stages. Funds for a mural had not been authorized, and interested artists were advised to proceed by analogy with a wall in Norway, Maine, for which the competition brochure also featured no schematic drawing.[60] The Westerly situation was vague enough to justify a corresponding fuzziness on the part of artists vying for the job. Sample's drawing, as Westerly realized from a cursory inspection of the *Life* reproduction, was not based on anything he could have seen there. The prize-winning design was another version of the tried-and-true fast-train-to-tomorrow theme, modified slightly to suggest that the engineer who gazes away from his wife and son, down the main line to somewhere else, occasionally comes home.

Westerly harbored no grudges against homebound engineers or the railroad industry, but two days after *Life* tipped Westerly off to Sam-

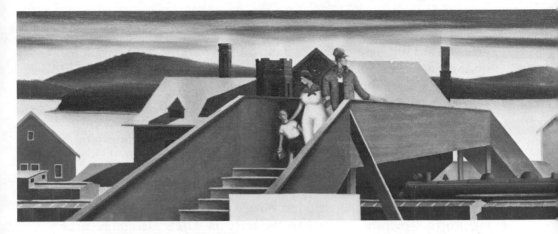

Paul Starrett Sample, 48 States sketch for USPO, Westerly, Rhode Island. 1939. National Archives.

ple's plan, the Providence *Bulletin* began to ask why a Casey Jones picture had been chosen:

There's a slogan put out by the Westerly Chamber of Commerce to the effect that the town is a "good place to live, work and play." But to be consistent with future decorations in the town itself, the chamber will have to tack an addition on the slogan, pointing that it's also a good place for railroad engineers and for a railroad underpass, overlooking the fact that there's already a railroad underpass that does valiant service for late commuters. The inconsistency between the town itself and a segment of the future decorative plans comes to the citizens through the above picture, but not without leaving them slightly surprised. Artist Paul Starrett Sample's sketch may be Westerly, they admit, but they unanimously agree it's inclined to make a man mighty homesick—for Gary, Indiana.[61]

The newspaper printed a droll survey of local reactions. People agreed that if an artist were bent on showing an engineer crossing the tracks, then an overpass suited his or her purpose better than an underground tunnel. They felt better about the idea that the engineer might be a symbolic "representative" of the workers of Westerly after locating one "spare" engineer for the New Haven "by the name of Oscar M. Whitlock living at 16 Robinson Street." So, the *Bulletin* admitted, "Sample's casting is technically right," but rather than changing the natural bed of the Pawcatuck River to conform with the engineer's tracks, "they'll vote to change the picture instead. It's an easier contract and less conducive to wet feet."[62]

The down-East humor of the poll, which went on to compare Westerly's plight to that of Los Banos, California—currently stuck with a painted tribe of Arizona Indians—sparked a needless dispute. The

jury was at fault here, as in Los Banos. The Westerly competition had been won by a sketch Sample made for the Island Pond, Vermont, post office, a building also lost in the limbo of appropriations contingencies, but in October of 1939 the Section and the artist had agreed upon a total revision of the railroad concept. Sample was the artist-in-residence at Dartmouth College in Hanover, New Hampshire; as soon as the academic term ended in the spring, he expected to go to Westerly for a first-hand look.[63] Until *Life* broke the story, nobody thought to tell Westerly what was going on. Vermont's lumber dealers never knew that they had just missed getting the all-purpose, rolling-progress picture credited to Westerly in *Life*'s December issue. Meanwhile, the Chamber of Commerce and the quarrymen of Westerly scratched their heads over the ubiquitous fast freight to the future and decided not to make the trip.

It was their contention that Washington was bound by repeated Section pledges to base even such outre forms of mural expression as might be suitable for an ultramodern building on a local version of modernity. An editorial in the Westerly *Sun* elicited agreement on that score from Rowan, who dusted off the same paragraph he had been using on inattentive muralists for several years:

The members of the Section feel as keenly as your readers that the murals which we are placing in Post Offices throughout the country carry the most meaning for the people when they deal with subject matter with which the people are familiar and [when] they reflect the local interests, aspirations and activities, past and present, of the public for whom the work is intended.[64]

The *Sun* credited the Citizens-Taxpayers Committee of Westerly with organizing opposition to the published sketch.[65] That group, formed six months before the Section itself was established, was not an ad hoc club for disgruntled art haters. When it held a mass meeting "to demand a revised mural which will reflect the life and history of the town," people turned out and voiced opinions sent to Washington four days after the *Life* picture spread containing the railroad drawing reached Rhode Island newsstands. The summary of Westerly's deliberations at the town meeting began with a bit of local history. The taxpayers' committee had spearheaded the drive to have a new post office built in Westerly and thus considered itself the offended party when the odd content of the Sample sketch was made public:

We have labored diligently in an effort to have this public building truly repre-

sentative of the town and so constructed as to be an honor, and a lasting memorial to this historical section of God's earth. When it was learned that an emblematic Mural was to be made part of the adornment for this modern building, the citizens . . . were greatly pleased.

The executive board of the Citizens-Taxpayers Association had been so excited by the prospect of obtaining "an emblematic Mural . . . for this modern building" that its members sent away for Section literature governing competition procedures. And having done their homework, they were prepared to insist 48 States regulations be followed to the letter in the Westerly mural, particularly "the first requirement . . . that it must be based on historical or industrial grounds, or both." This was, to be sure, a highly selective reading of a topic smorgasbord in which history and industry were buried away among a half-dozen other options and in no way paired. But according to that interpretation, the railroad picture in *Life* had "no bearing whatever upon the historical or industrial town in which it was to be placed." The Association's parting shot was inevitable:

Therefore a vigorous protest is hereby registered against the placing of such a misconception and ill-advised understanding of this historical town and its leadership in one of the oldest and most substantial industries, a native product, GRANITE.[66]

The Westerly Chamber of Commerce did not capitalize the word "granite" in its protest to Washington, although the subject was mentioned in an argument which, like that of the Citizens-Taxpayers Association, decried the proposed mural because it "in no way depicts our industries or our history." Perhaps granite was a moot point; Frank Sullivan, the president of the Chamber, did make his case on the letterhead of the Sullivan Granite Company:

There is no overhead bridge at the railroad station and never [has] been, and it seems to us a more appropriate subject could have been selected for this New England town where for over 100 years our citizens have found employment cutting and carving Westerly granite, and later making 4 color rotary presses for national magazines and textiles, and earned a livelihood in many of ther diversified industries.[67]

In the meantime, the Association had turned up and endorsed a mural sketch of which both groups heartily approved. Alexander G. Sawyer, a Westerly native, had submitted a granite quarry sketch in the 48 States contest.[68] Because he did not place in the judging, his drawing was returned and went on exhibit in December of 1939 at

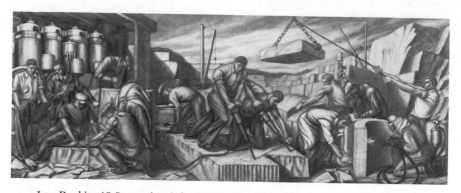

Leo Rankin, 48 States sketch for USPO, Westerly, Rhode Island. 1939. National
Archives.

the public library, as Westerly's homegrown alternative to the Paul
Starrett Sample train for all seasons.[69]

Despite the exhibition at the library, local civic groups made no
effort to inflict Sawyer on the Section by birthright. But his picture
surely crystallized the iconographic self-portrait Westerly presented
to Washington and helped laypeople visualize the conflation of his-
tory with industry emphasized in all the protest documents. Of the
fourteen Rhode Island designs judged and rejected in the 48 States
Competition, at least five dealt exclusively with the granite theme
Westerly preferred.[70] On aesthetic grounds, the decision of the jury
made some sense: most of the discarded drawings lack the technical
sophistication of the Sample sketch, and none approaches its angular
verve. What the surviving quarry designs have in common is concern
with the human dimension of industry, and the tools and techniques
men use to "earn a livelihood." Leo Rankin's design, for instance,
contains fourteen sturdy figures who fill the foreground and spread
across the quarry in a dense, frieze-like configuration, a mass of hu-
manity as solid as a slab of Westerly granite. Taken together, the
actions of the men constitute a picture guide to quarry work: me-
chanical drilling, power sanding, hand finishing, and hoisting are il-
lustrated with schematic precision. A shiny bank of air compressors
is balanced off by the muscular strength of a laborer struggling to
raise a block by pulley. Modern industry is played off against the
craft tradition and machine power against human might. This same
analysis holds true for Paul Rudin's composition, concerned with
the drilling and sawing operations that precede extraction of the
stone and for Alfeo Verrechia's hoisting scene. *Activities at Rock
Quarry, Westerly* by Bruce Mitchell puts those activities in a wholly
historical context; the same processes are accomplished without

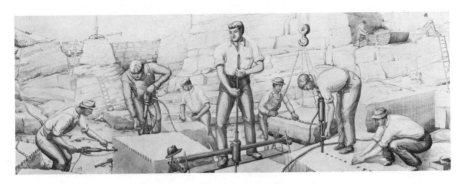

Paul Rudin, 48 States sketch for USPO, Westerly, Rhode Island. 1939. National Archives.

modern equipment, and the train that carries the granite away could have found a place among the nineteenth-century vignettes in the Towson post office.

The Westerly quarry sketches make enormous and insistent demands on the viewer's haptic sense. Every figure in every drawing holds, touches, grasps, grips, or seizes something: every drawing concetrates on *homo faber* so engaged. This worker's appeal to tactile manipulation of the hand quantifies stock academic symbolism. The outmoded goddess who clutches a wheat sheaf and the sci-fi godling who wields a modern airplane like a benevolent King Kong are pictorial stand-ins for the poorly arranged knots of figures who work in the Westerly designs. But making every fist work intensifies the value of working. All the grasping and seizing also specifies what the isolated symbol does not, namely, that work has actually been accomplished, not through the intervention of a heroine who holds the finished product or through the miraculous agency of the hero's technological attribute, but through the collective force of human beings whose manual competence and commitment to grasping the tools outweigh the power of the tools themselves and the value of what is produced. In that sense, the self-propelled streamliner in the Towson mural and the inherent dynamism of Sample's railroad composition lump those futuristic works together on the margins of an academic sensibility. Action hinges on externals. Machines act, and people, like Sample's engineer, look idly on. The train is, in effect, the Spirit of Goose Creek, Texas, in a metallic costume. Similarly, in Joe Jones's mechanized harvest scenes, the fruits of the soil are products of a technology to whose efficient operations people are ancillary. The Seneca, Kansas, reaper is, in effect, the goddess of the wheat sheaf.

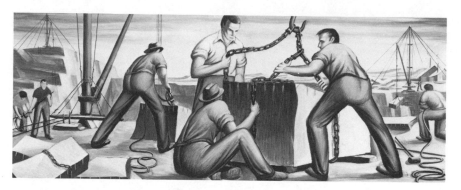

Alfeo Verrechia, 48 States sketch for USPO, Westerly, Rhode Island. 1939.
National Archives.

In this one respect, the technological school of '30s mural painting has a common ground with the radical left and the social protest school. The look of the Depression years is often illustrated today by the canvases of the Soyer brothers, with their hordes of unimportant, idle people, waiting and watching in employment offices, relief bureaus, and railroad stations.[71] Moses Soyer meant his massed portraits to reveal the truth about the times: he warned fellow artists against "being misled by the chauvinism of the 'Paint America' slogan. Yes, paint America, but with your eyes open. Do not glorify Main Street. Paint it as it is—mean, dirty, avaricious."[72] Raphael Soyer's *Transients* of 1936 and Moses's *Employment Agency* of 1935 typify the dumb misery of Main Street through the inaction of the figures. More striking are their oversized hands, which have nothing to do and nothing to seize. Jobless people stranded in the Soyers' waiting rooms clench empty fists, dangle their heavy hands in their laps or between their knees, or touch themselves, stifling a yawn and patting a cheek as if the feel of their own flesh will solidify an existence of which they are no longer sure. The only movement is the twitch of the hands. They intertwine their fingers nervously as they wait—for the miracle train to somewhere else?—pitiable because they cannot act for themselves. The haptic itch has no outlet. Hands reach out, but the tools of deliverance elude the grasp of the waiters and watchers. Whatever they await will happen to them; people who watch and fidget are at the mercy of external forces their restless fingers cannot control.

Soyer called Main Street "avaricious." The Westerly sketches describe avidity, if not avarice, in the grasping action of scores of hands which forceably reverse the Soyers' brief for powerless inertia. The

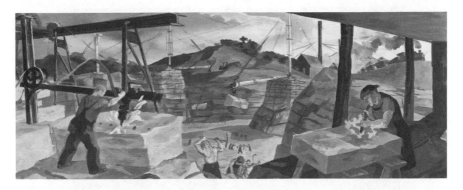

Bruce Mitchell, 48 States sketch for USPO, Westerly, Rhode Island. 1939. National Archives.

quarrymen's hands hold the tools to build a future conceived in human terms and shaped by human action. And they hold on to their tools for dear life! The nature of the tools, although the Westerly competitors attended carefully to specialized equipment, contributes less to the meaning of the conceit than do the hands that use jackhammers and pneumatic drills. The old technology and the new are peripheral to the act of working, with any instruments available. Work is the primary content of the Westerly designs, and the constructive actions of the worker explain the perceptual connection between industry and history upon which the Chamber of Commerce and the Citizens-Taxpayers Association were fixated. For those groups, the granite industry was coextensive with the story of life in Westerly over a hundred-year span of time. In the world of the quarry sketches, techniques of the past and modern ones are interchangeable. The controlling constant is work itself and the concentrated dedication of the workmen who hew the stone. Life is earning a livelihood.

It is futile to probe the history of Westerly, asking whether work and work in the granite quarries preoccupied the place for a century with quite the preternatural fervor the workers pictured in 1939 bring to their jobs. This is purposeful history, rewritten in and for 1939—the "present history" of a decade-long construction slump, an economy sputtering fitfully through cycles of dim prospects and worse ones, unemployment pending even when granite lay in the quarries and hands ached to grasp the tools for working it. The specter of joblessness palpable in the stale air of the Soyers' waiting rooms was held at arm's length by painted arms that reach for tools and painted hands that pick them up. Those hands, for a century

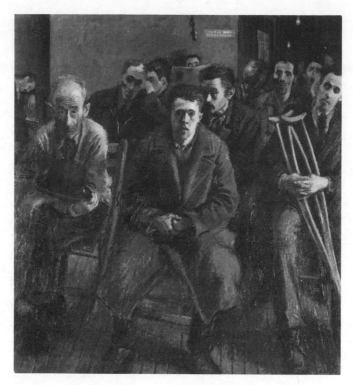

Raphael Soyer, *Transients*. 1936. The James and Mari
Michener Collection, The Archer M. Huntington Art Gallery,
The University of Texas at Austin.

now, had proven capable of earning a livelihood for Westerly by
wresting building blocks from the Rhode Island hills. Whether they
did so with laborious deliberation or modern efficiency scarcely
mattered. Westerly worked.

The Chamber of Commerce slogan called Westerly "a good place
to live, work and play." In 1939, and in the 1839 of the imagination,
Westerly lived and worked by prehensile energy. Or rather, the peo-
ple of Westerly worked. In the logging camps, the steel mills, the fac-
tories, and the mines of Mural America, people threw themselves into
their work with grateful abandon. In vast tracts of Mural America,
nobody looked for work, waited for a job, or fled west on the roof
of a boxcar. Nobody sat in the station with folded hands waiting to
be whisked away to somewhere else, because everybody could pick
up the tools and do the job at home. In Barse Miller's 48 States de-
sign for Island Pond, Vermont, his winged spirit of transportation
and flight has settled down, donned a workshirt, and joined a crew
of lumbermen who cannot spare a minute to make divine forays into

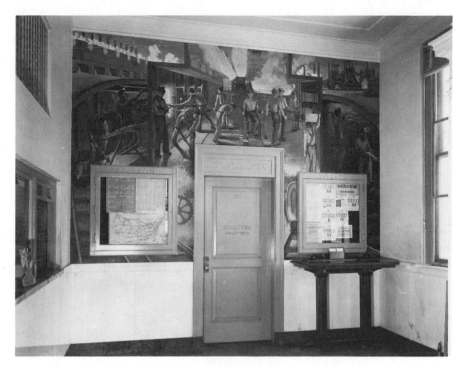

Frank Anderson, *Spirit of Steel*, USPO, Fairfield, Alabama. 1938. National Archives.

the wide world outside their camp. They are too busy sawing logs, and work comes first.[73] Nor is the *Spirit of Steel* in Fairfield, Alabama, a posturing putto bearing a garland of iron pigs to wreath the gears that spin about the postmaster's door. The spirit Frank Anderson ran to ground in the mills was human, collective, and sweaty. A dozen workmen raise their shovels to feed the converter, preparing for "charging the furnace and making the bottom" at U. S. Steel.[74] In Russellville, Alabama, workmen attired in the picturesque costumes of 1817 bring a comparable intensity and simpler tools to bear on running the first Bee Hive iron furnace built in Alabama.[75] Men always worked hard in the mills of Alabama.

For Plymouth, Wisconsin, the self-styled "Cheese Center of the World," Charles Thwaites painted a cheddar factory. Workers in white tend the vat, stack the hoops, test the mix, and store the wheels as if their livelihoods depend on proving the town motto true in a single workday. Yet, as the Section noted with delight, "the faces of the workers in the cartoon all have such pleasant expressions. It is a very nice relief as so many workers depicted look so grim and sad about their tasks."[76] During the late spring of

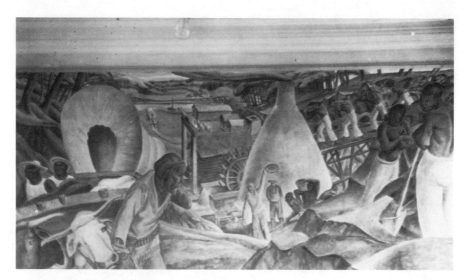

Conrad Albrizio, *Shipment of the First Iron Produced in Russellville*, USPO, Russellville, Alabama. 1938. National Archives.

1937, while Anderson was making his preliminary sketches and strikes were raging in the plants of "Little Steel," Philip Murray's Steel Workers Organizing Committee was signing up the last of the U. S. Steel subsidiaries, without precipitating a bloodbath. The steelworkers in the Fairfield post office look a bit thoughtful, as if they were remembering their CIO pledge cards and mulling over the odds that the union could keep them working forty-hour weeks, with time-and-a-half for overtime and a 10% wage increase.[77] But "sad"? "Grim"? The working people of Mural America are too busy to worry about arranging their faces to please the Section, too energetic to pause for smiling daydreams, consumed by the will to work. And when the workers hop off the train and stream out of the grain elevator for *The "Lovers' Leap Bridge" Benefit Dance* in the Columbus Junction, Iowa, post office, why, they square dance with the same fierce gusto, the same absorbed expressions.[78]

A Midwestern artist who worked for the Section dismissed New Deal iconography as an affair of "wheels rampant and workmen couchant," Washington's official equivalent of windy academic folderol under a thin '30s veneer.[79] The heroic worker, weighed down by an emblematic cogwheel and bent to his labor with the herniated expression of a marble Hercules abandoned in a post office around the corner from the Augean stables should, by rights, look grim and sad, if that particular fellow ever lived and worked in Mural America. He didn't, of course. The workmen who stoke the blast furnaces in

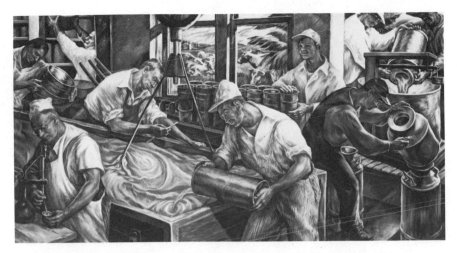

Charles Thwaites, composition sketch for *Cheese Making*, USPO, Plymouth, Wisconsin. 1941. National Archives.

Fairfield surmount the machinery on display in the lower reaches of the mural literally and figuratively. They work, without a second to spare for posturing in "couchant" attitudes. They run the machines with no help from a mythical "Genius of Steel": they are themselves "The Spirit of Steel," en masse. Heaps of ore and a film of coal dust infernally lit by the glow of the converter hardly remind Fairfield steelworkers of the Augean stables. Besides, if a legendary hero strains in the murk, who might he be? The stoker? The miner? The crane operator? The foreman? Each man's effort matches that of

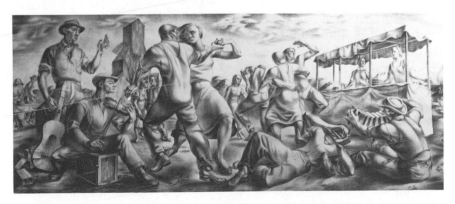

Sante Graziani, cartoon for *Lovers' Leap Bridge Benefit Dance*, USPO, Columbus Junction, Iowa. 1942. National Archives.

his neighbor and each performs his ordinary job—a part of the larger enterprise—without a fuss. Heroes? It is the working people of Fairfield and Plymouth—and every person works—who might merit that title were they not too caught up in the workaday rhythm of the four-to-twelve shift to flex their biceps and clench their jaws like regulation heroes—say, big strong Clark Gable in a denim workshirt saving the oilfield in the last reel of MGM's *Boomtown*.[80]

Work demanded the will to work and a collective commitment to grasp the tools, feelings to which histrionic stoicism and heroic eyeball-rolling were emotionally superfluous. Work was the fiber of the past and the key to the future; it was the steady, business-as-usual heartbeat of Mural America. Grim or sad expressions, even pleasant ones, are hard to find there. The visages of the American workers are, at their emotional extreme, merely preoccupied; they hold their breath at the thrill of a job. Most of the time, they are sublimely contented and content to let their faces register the homely, humdrum routine of a welcome day's work, well and truly done. The only cause for sad looks among the workers of Westerly was the fact that they never got to drill and blast and hoist the granite blocks in the post-office lobby. Sample was too busy to watch them work, construction bids on the building were snarled in red tape, and the mural project evaporated in 1940, sadly enough.[81] But at the height of the controversy over whether the worker's actions or the robot whiz of the machine should represent Westerly, the Providence *Bulletin* stiffened local resolve to fight by relating the story of an industrial mural hounded out of a post office in Idaho because it was too sad to contemplate: "Kellogg, Idaho, turned thumbs down on its proposed painting of a pair of miners trundling an injured companion to the hospital or the morgue, the picture didn't say which. 'Too pessimistic,' said Kellogg."[82] "Ghastly," said the Boise *Statesman*.[83] "Local residents have objected to the pessimistic atmosphere of Fletcher Martin's mining scene," said *Life*, declining to dwell on the implications of a picture that, according to its own inventory of the contents of Mural America, ought never to have been painted at all. The most bitterly contested sketch of the chosen forty-eight was reviled because it cast aspersions on the saga of industry in "the most highly industrialized nation in the world."[84]

When the storm of protest first broke, Fletcher Martin told the Associated Press "if the townspeople objected to [the] subject," he was more than willing to scrap *Mine Rescue*.[85] It was Rowan who

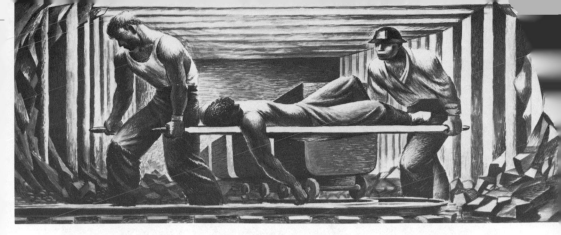

Fletcher Martin, 48 States sketch, *Mine Rescue*, for USPO, Kellogg, Idaho.
1939. The University of Maryland Art Gallery.

told him flatly, and by wire, "Do not undertake Redesign."[86] The
Section was reluctant to discard the strongest piece of work to emerge
from the 48 States talent hunt. Moreover, convinced of the aesthetic
merits of the drawing, Rowan could not bring himself to examine
local objections with the attentive respect they deserved, if for no
other reason, because of the large number of people concerned enough
to protest and the range of interest groups they represented. He
hoped to keep *Mine Rescue*, and mollify a town that confused trag-
edy and trivia, with an additional mural on a slaphappy theme as yet
undetermined:

. . . the members of the Section have the greatest respect for your mural and I
personally regard it as spiritual in content as any pieta. I, nevertheless, am aware
that the seriousness of the subject matter might be regarded as depressing or dis-
tasteful to some people, especially since they have to look at it day after day.
For this reason I have been investigating to find if there is a second space in the
lobby and the availability of the necessary funds to invite you to undertake a
second mural in this building which would represent another side of the Nevada
[sic] experience. May I ask you to await further instructions from me before
undertaking the redesign.[87]

Rowan may well have wished Kellogg were in placid Nevada. The
Yerington, Nevada, natives said nary a word, pro or con, when they
got a look at their proposed mural, a truly depressing ranch-house
scene Adolph Gottlieb painted for Safford, Arizona. Bruce liked
Homestead on the Plains well enough to appropriate the sketch for
his permanent collection.[88] The Section liked *Mine Rescue* even
better, and for very different reasons it too shortly wound up in the
Treasury vaults.

Distaste is too polite a term for the panicky distress that swept

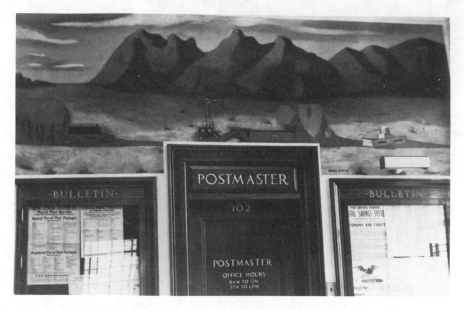

Adolph Gottlieb, *Homestead on the Plains*, USPO, Yerington, Nevada. 1941. National Archives.

through Kellogg, and depression was the last emotion Depression America longed to commemorate for all time in a public mural. Impassioned protests came from the Idaho Art Association, the Kellogg Chamber of Commerce, the Wardner Industrial Union, the Bunker Hill & Sullivan Mining and Concentrating Company, the U. S. Senate, and hosts of unnamed sources quoted in the newpapers of the Coeur d'Alenes district. Letters from the labor force and the business community made much the same point: the picture was an assault on the lead industry. From the mines flowed the lifeblood of home, and not a drop was to be shed in the Kellogg post office. Mine accidents happened, but to associate industry and catastrophe meant giving work in Kellogg a permanent pall of tragedy. Work in the mines of Coeur d'Alenes in 1939 was not a tragedy; it was the miner's triumph, the kind of victory for the worker that John L. Lewis was wont to anticipate at the annual UMW convention. Kellogg had a big company union, however, eleven hundred strong, and "by unanimous vote the subject matter of the mural of Fletcher Martin . . . was condemned as unfit and entirely out of place to adorn the walls of the post office of this community." The union threatened an injunction, sundry "unfriendly acts," and, if all else failed, "serious trouble" that portended the use of pick-ax handles. "Surely," the miners pleaded, "out of the large number of paintings submitted for the Kellogg of-

fice there could be something of an inspirational nature accepted, a picture that would be a pleasure to look at and gain some spiritual value therefrom. Not a depressing death or accident scene from which one turns with a shudder."[89]

Stanley Easton, the president of a local mining company, was a man of rare discernment whose tastes paralleled Rowan's, and he refrained from intimating that he would unleash a goon squad on Martin. Nevertheless, he too counseled a change:

The artistry of the design is good but the subject is weird and distinctively inappropriate. [T]here is so much colorful historical background to this community that many subjects would be far more appropriate and admirable. . . . I have not heard one single word of commendation. [I]n fact the community as a whole is greatly disappointed and I hope that steps will be taken to substitute a more cheerful, realistic and appropriate design.[90]

The president of the Idaho Art Association was altogether less keen on modern art:

Kellogg is one of the most active mining centers in America and though every precaution for safety is employed in these modern mines fatal accidents do occur. To hang a picture depicting such an accident would prove a torture to the families of victims and would certainly be in poorest taste. I can see how such a sordid subject would come from the brush of some so-called modernistic or futuristic artists but I cannot imagine competent judges using such poor judgment.[91]

Kellogg merchants and white-collar professionals scoffed at reports that Martin thought he was "depicting American life" with this "modernistic" chamber-of-horrors view of a mineshaft. "Such a scene is not at all representative of our district and certainly is not typical of American life in this locality," countered one local businessman.[92] The Chamber of Commerce seconded the union's query. Why, oh, why had the judges picked "this monstrosity" when hundreds of "inspiring" sketches "worthy of a great mining area" must have been reviewed?

The picture of two miners carrying a third miner, dead or injured, on a stretcher from a mine tunnel does not appeal to the minds of the people of this district as being symbolic of our leading industry or pleasant to look upon. In fact, we consider the picture a travesty on mining in general and emphatically protest its acceptance for our post office.[93]

The only statement favoring *Mine Rescue* was sent to Postmaster General James Farley, a political mastermind, by a lady who plainly appreciated partisan skullduggery when she saw it and knew how to counter pressure in kind. Farley's confidante was Mrs. Myrtle Fother-

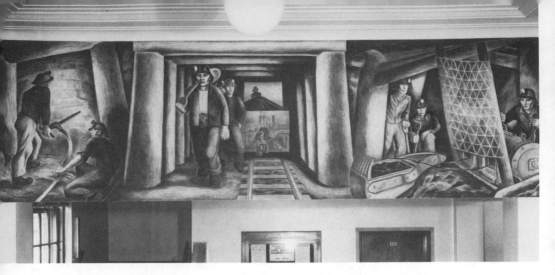

Else Jemne, *Iron Ore Mines, Ely, Minnesota*, USPO, Ely, Minnesota. 1941.
National Archives.

gill, of 204 Y Alley, and she claimed to represent the Ladies Auxiliary of Local No. 18 of the International Union of Mine, Mill, and Smelter Workers, heretofore silent on the subject of the mural. Mrs. Fothergill was not impressed with Martin's picture but chose to offer a weak defense to underline her resentment of the local kingfish who had plotted the spontaneous barrage of protests:

> Mr. Easton, manager of the Bunker Hill, Sullivan mining and milling company spoke before the Chamber of Commerce [and] the Industrial union and opposed the hanging of the mural. Of course his speech did much toward swaying the sentiments of those hearing it; but we . . . feel this mural to be much more appropriate for this district than lots of others including the "Cataldo Mission" because after all mining is the industry in this locality.[94]

Her support for the picture is tentative and barely touches on the content of the image. *Mine Rescue* is preferable to a scene out of the fastness of history because "mining is the industry in this locality." Her opponents not only conceded but crowed about the importance of the mines to Kellogg. Mrs. Fothergill and the organized protesters parted company over the issue of what a mural ought to stand for and accomplish in the community. The bigwigs and their employees wanted a view "typical of America life" in a locality bound to the mines. It followed, then, that a portrayal of the typical run of life would be "admirable," "inspirational," and "realistic" and that it ought not to look too "modernistic or futuristic" insofar as "isms" generally meant weirdness. This mishmash of contradictory, half-baked aesthetic logic came down to one simple truth: Kellogg wanted normality. No accidents, no blood 'n' guts. No suggestions of

catastrophe, extant or imminent. No harm to anybody. No nagging hints that their mine was a minefield, that the dominant local industry was or could be headed for some nebulous disaster, that working along in the American way in Kellogg in 1939 was fraught with peril! No Depression or depression! The sad and grim need not apply here! No metaphoric overtones or undercurrents of a negative type, please. Move along, Mr. Martin, or else contend with a shift's worth of sore miners! Oh—and no heroes either, while we're at it, fella!

Everyday pedestrian realism in the workplace did not mean the proletarian fury of Paul Muni playing Joe Radek, heroic miner, and threatening to blow the mine to kingdom come unless the bourgeois bosses mended their ways; Warner's *Black Fury* won John L. Lewis's ringing endorsement in 1935 but was not popular fare in the Coeur d'Alenes. Before his conversion to minimal class-consciousness, Miner Joe's basic philosophy was simple: "Work like a mule!"[95] And with considerably more dignity than mules have, the miners of Ely, Minnesota, worked happily in *Iron Ore Mines*, a mural begun in 1939 and closely modeled on Martin's controversial sketch. As in *Mine Rescue*, the low rectangle of the mine shaft is centered on the composition, the timber vaulting eddies back into the earth, the figures are bulky enough to establish the confined dimensions of the tunnel, and the lighting is restricted to jangling contrasts of shadow and electric beams. The figure types are also similar—wide in comparison to their stature, pneumatic, squeezed by the force of gravity. Else Jemne's drama is strictly stylistic, however. The clash of darkness and spotlight illumination and the painful compression of space form a setting for routine work and modern machinery. Steel nets, claw shovels, backhoes, compressors, jackhammers, and ore cars serve three groups of workers who grab the tools and perform their segmented tasks with unheroic absorption, wearing the bland expressions of Plymouth's pleasant cheesemakers. Their faces are visible, even in the dim mine shaft, to show that they are plain people and this is an ordinary workday. Martin uses chiaroscuro to make a different point. The face of the miner carrying the head of the stretcher in *Mine Rescue* is lost in the gloom of his sad, black thoughts. His opposite number is selectively lit, bringing the tense set of his jawline into relief: he is an angry man. Not a ray of light softens the inky penumbra around the upper body of their fallen comrade. Darkness separates the quick from the dead.

Else Jemne had traveled to Ely in 1939, just before the Kellogg

story hit the wires. The town was not unlike Kellogg and the other lead and silver centers of the Black Hills that snaked out of the Iron Range of northern Minnesota: "The only industry in the city is mining, bolstered by a summer resort business." The Ely people with whom she spoke—and she cast her net of contacts wide—were split in their preferences: some favored a mining theme, but an equal number wanted a view of the recreational "Wilderness" about the Range. Jemne painted the forest in 1939 so satisfactorily that local pressure on the Section brought her back to Ely in 1941 to revive the complementary mining panel. The people and the postmaster could not find words adequate to express their praise for *Iron Ore Mines*:

About eighty percent of our population are engaged in the mining industry. The miners, in the majority, are emigrants from Yugo-Slavia and Finland and their descendents. To have a painting that depicts their daily work is regarded as a flattering tribute to their activities and daily comments of satisfaction are heard in the lobby as groups of miners pause to survey the painting and discuss the story it tells. Also the merchants and townspeople indirectly supported by the mining industry, are loud in their praises of the beauty of the mural and the subject it so suitably portrays.[96]

There is no question that Fletcher Martin created the superior work of art. Rowan smote Martin's critics with proof positive of the aesthetic merits of *Mine Rescue* and told its lone defender that "it is comparable to some of the great religious paintings of the past, such as the picture[s] of the Crucifixion, the Descent from the Cross and the Deposition and its spiritual content seems as important to a number of people since it represents the sacrifice which a good citizen makes in faithfully carrying out his humble duties."[97] Jemne painted the better public mural, and the secret of her success was the story she told. The story made the mural "beautiful" in the eyes of Ely. The Kellogg sketch, of course, bristles with the narrative connotations Rowan cited, with high drama and barely suppressed emotion. At first blush, a story line is difficult to extract from the unremarkable, monotonous incidents Jemne presents: one guy drills, another runs his mechanical claw. Perhaps the story is too ordinary to notice unless the viewer worked the mines of the Range in the '30s, but the miners in the Ely post office read it with ease and pleasure. First of all, it is their story, a day in their working lives. The tale is remarkable, paradoxically, because nothing remarkable is happening. In a narrow sense, work is not interrupted by a Kellogg-style mine accident. In a more general sense, nothing threatens the fixed patterns

and rituals of making a living. External catastrophe—labor troubles, falling steel prices, slack demand, jobless transients forced out on the roads beyond Ely, the Depression itself—is sealed out of this airless mine where people work today and can work forever. And it is the people, the ordinary Joes who make this perfect world. They master the machines and their own destiny with quiet will and competence. Heroes need not apply!

Myrtle Fothergill and the Ladies Auxiliary of Local No. 18 approved of *Mine Rescue* because "after all mining is the industry in this locality" and accepted the sketch despite the heroic, even melodramatic content of the image. Or did Local No. 18 see the lead industry of Kellogg in Martin's terms, as an heroic contest between brave, brawny miners and the Mr. Eastons of a cruel and dangerous world? Was Myrtle Fothergill the only clear-eyed realist in a town full of self-deluded dreamers and capitalist lackeys with a vested interest in singing lullabies to edgy miners? *Mine Rescue* verges on social protest: singular, larger-than-life responses to catastrophic situations in industry are invited by the triune revelations of murder, suffering, and rage. Jemne's tableau is apparently conservative. The collective values exemplified in it threaten the status quo only insofar as the normality achieved is itself a subversive wish, antithetical to the way things are, appreciative of the way things could be and indeed once were when men picked up their tools and worked.

Towson, Westerly, and, in the end, Kellogg, Idaho, chose local history over emblems of sorrow and symbols of flight. If home and work and the plain people who worked in Kellogg faced tangible uncertainties in the present and elusive glories down the road of time, the past was a snug harbor of bedrock fact. Rowan's push to secure two murals for the Kellogg post office foundered on the reefs of budgetary stringency in the Public Buildings Service.[98] The protesters remained unpersuaded by arcane analogies to the crucifixion. The Section reluctantly set up a local advisory committee: Myrtle Fothergill never attended a meeting, and Mr. Easton, her nemesis from the Bunker Hill & Sullivan Mine, quickly took command.[99] *Discovery* was hung in the Kellogg post office in May of 1940: "The mural depicts Philip O'Rourke and Noah Kellogg, the two miners who, with their burro, are credited with the discovery of the B.H.&S. mine."[100] The battle of Kellogg was over. In the painted Idaho of 1885, everybody smiles; even the burro seems vaguely pleased. And so was Kellogg in 1940. According to the postmaster, "the Mural has created

Fletcher Martin, *Discovery*, USPO, Kellogg, Idaho. 1940. National Archives.

considerable interest among the patrons of this office and so far the public seems to be well pleased with both the design and the painting."[101] Fletcher Martin pointed his station wagon west, pleased to see the last of Kellogg, and in the ironic finale to the story, drove straight into "a beautiful accident on the highway in Nevada and completely demolished my [car]."[102] The story acquired a moral. Beware the siren's call of the open road and the rumble of the singing wheels! Stay home, America. Stay home.

NOTES

1. C. Hamilton Ellis, *Railway Art* (Boston: New York Graphic Society, 1977), pp. 113-114. The Loewy design appears in Bush, *The Streamlined Decade*, pp. 58-59. The period's fascination with speed, futurism, and wildly impractical vehicular design is the topic of Tim Onosko, *Wasn't the Future Wonderful? A View of Trends and Technology from the 1930s* (New York: E. P. Dutton, 1979), esp. pp. 156-163.

2. Reproduced in Hurley, *Portrait of a Decade, Roy Stryker and the Development of Documentary Photography in the Thirties*, p. 31. A similar photograph by Lange's husband, Paul Taylor, taken in the San Joaquin Valley, California, in 1938 shows migrant children and their families camping beneath another Southern Pacific billboard, suggesting that the passerby "Travel While You Sleep"; Dorothea Lange and Paul Schuster Taylor, *An American Exodus, A Record of Human Erosion in the Thirties* (New Haven: Yale University Press for the Oakland Museum, 1969), pp. 86-87. This collection of photographs of migrants was originally published in 1939; both photographers were with the FSA.

3. Newton D. Baker, "Homeless Wanderers Create a New Problem for America," *New York Times*, December 11, 1932, reprinted in David A. Shannon, ed., *The Great Depression* (Englewood Cliffs, New Jersey: Prentice-Hall, Inc., 1960), p. 56.

4. Steinbeck, *The Grapes of Wrath*, p. 103.

5. "No One Has Starved," from *Fortune* (September, 1932) quoted in Don Congdon, ed., *The Thirties, A Time to Remember* (New York: Simon and Schuster, 1970), p. 103. Studs Terkel, *Hard Times, An Oral History of the Great Depression* (New York: Pantheon

Books, 1970), p. 29, titles his chapter on the nomads of the '30s from Woody Guthrie's lyrics to "Hard Travelin'."

6. Stott, *Documentary Expression and Thirties America*, unpaginated plate following p. 144, from the 1939 edition of *An American Exodus*, discussed pp. 225-231.

7. "Descriptions of Completed Murals and Data on Artists," 135 (Box 203), folder containing captions supplied with press photographs of recently completed murals, most of those in the Federal Triangle. See flimsy sheets for the Department of Justice.

8. For discussion of Eugene Higgins's 1939 mural, originally titled *The First Settlers*, see Mecklenburg, *The Public as Patron, A History of the Treasury Department Mural Program*, p. 72.

9. The commission for the Dubuque, Iowa, post office and courthouse was awarded by means of a regional competition held in 1935, and the decorations were completed in 1937 by Bertrand Adams and William L. Bunn. Both murals had vehicular themes. Adams's *Early Settlers of Dubuque* shows a covered wagon and Bunn's work is entitled *Early Mississippi Steamboat*; see 130 (Box 215), *Bulletin*, #3 (May-June, 1935), p. 12 and #14 (July, 1937-January, 1938), p. 18. See also "Form Announcements of Competitions" for Dubuque, Iowa (July 15, 1935), 131 (Box 206) and *Treasury Department Art Projects, Painting and Sculpture for Federal Buildings*, catalogue of an exhibition held at the Corcoran Gallery of Art, Washington, D. C., November 17-December 13, 1936, entries #1 and 44, 130 (Box 215).

10. "Descriptions of Completed Murals and Data on Artists," 135 (Box 203), hereafter cited as "Descriptions," for Louise Ronnebeck, Worland, Wyoming, post office (1938), *The Fertile Land Remembers*. Consistently, the fastest movement of the pre-rail era occurs in Oklahoma Section murals, a number of which deal with the predictably popular theme of the Oklahoma Land Rush of 1889. Of special interest are post-office murals at Drumright (Frank Long, 1941), Sayre (Vance Kirkland, 1940), and Yukon (Dahlov Ipcar, 1941). See Nicholas A. Calcagno, *New Deal Murals in Oklahoma* (Miami, Oklahoma: Oklahoma Humanities Committee, 1976), pp. 7, 32-33, and 43.

11. The Dresden Garden Club (Mrs. J. E. Shannon, Pres.; Miss Ida Baxter, Sec'y; and Mrs. J. E. Jones) to Rowan, October 17, 1938, 124 (Box 132) [Folder: Artists' Letters].

12. "Descriptions," for Minetta Good, Dresden, Tennessee (1938). "David Crockett" appears in the pioneer group at the left of the composition. At the right are "a departing stage and the coming of an early train."

13. "Descriptions," for John McCrady, Amory, Mississippi (1939). Between the 2" scale sketch and the cartoon stage, McCrady reduced the number of gleaming signboards and fictionalized the names of the merchants. The Section, of course, frowned on the use of details that might be mistaken for ads, even when the firms in question were long defunct. But in both versions of the design, one sign remained posted on the depot at the right of the scene: "Amory Does Not Want Yellow Fever. Strangers Keep Out." One such stranger is met by an armed posse; one man shields his mouth with a handkerchief. Yellow fever epidemics were rampant in Mississippi throughout the late nineteenth century, but it is impossible to connect the sign with a specific outbreak in 1889. In this instance, the benefits of speedy transportation are mixed. I am grateful to Sue Birdwell Beckham, an Amory native and one of my graduate students, for her work on this mural.

14. James Watrous to Rowan, April 3, 1939, 133 (Box 52). According to undated clippings from the local newspaper, *Life in Grand Rapids and the Upper Mississippi* was not well received. The clippings carp mistakenly on the relief aspects of the work and call it a "WPA" project. Repeated mention is made of the fact that Watrous was not a Minnesotan and did the work in Madison, Wisconsin, where he resided. Whatever the real cause of the complaint, objections came to focus on the name of the boat. Locals insisted that the famous early steamer was called the "Andy Gibson." Since no correspondence remains in the Grand

Rapids file after the pro forma request that the artist check his facts, and since the boat is still called the "Andy Johnson" in the post-office mural, one must assume that the artist had some factual support for his decision and that the townspeople were indeed upset by a Wisconsin reliefer in their midst.

15. Bergman, *We're in the Money, Depression America and Its Films*, pp. 165-166. Lorentz's short documentary was financed by the government. For discussion of the utopian strain in the social planning of the '30s, see Richard H. Pells, *Radical Visions and American Dreams, Culture and Social Thought in the Depression Years* (New York: Harper and Row Publishers, 1973), esp. pp. 74-76.

16. Arthur Hove, ed., *Gold Diggers of 1933* (Madison, Wisconsin: The University of Wisconsin Press for the Wisconsin Center for Film and Theater Research, 1980), pp. 20-21.

17. "Descriptions," for Barse Miller, Goose Creek, Texas (1938).

18. *Pony Express* (1937) in the North Corridor, 5th floor, of the Postal Building is by Frank Mechau. *Stage Coach Attacked by Bandits* and *Covered Wagon Attacked by Indians* by William C. Palmer are in the North Corridor on the 7th floor. See *Bulletin*, #14 (July, 1937-January, 1938), p. 16, 130 (Box 215).

19. Bruce and Watson, *Art in Federal Buildings*, unpaginated plates. See also:
Moya del Pino, *Mail and Travel by Stage Coach* (1936), Stockton, California, *Bulletin*, #14 (July, 1937-January, 1938), pp. 12-13, 130 (Box 215).
F. Luis Mora, *The Arrival of the Stage* (1936), Catasauqua, Pennsylvania, *Bulletin*, #14, p. 24.
Joseph A. Fleck, *First Mail Crossing Raton Pass* (1937), Raton, New Mexico, *Treasury Department Art Projects* catalogue, entry #94, 130 (Box 215).
Robert L. Lambdin, *Stage Coach*, etc. (1936), Bridgeport, Connecticut, *Treasury Department Art Projects* catalogue, entry #163.

20. Thomas Hart Benton to Olin Dows, undated (received May 15, 1935), 133 (Box 124) does carefully inventory just such secondary details:

Here is the listed subject matter.

Postal Conveyance (Old)
Foot Carrier
Stage "
Horse "
Clipper Ship

(New)
Foot Carrier
Postal Car
Airplanes
Pneumatic Tube.

Benton declined the contract in an undated letter to Rowan, posted from Jefferson City, where he was working on his important Missouri Capitol cycle (ca. late autumn, 1936). He reconsidered because "the subject matter of the Post Office was just a bore to me. I only undertook it because I wanted to be in on something which I believe has genuinely significant cultural prospects for the country."

21. The outlines of the Kent controversy are established in the Bruce Papers, 135 (Box 137) [Folder: Rockwell Kent], in an undated "Interview by Edward Bruce" and a typed extract from a report in *Time*, September 20, 1937. Resolution of the controversy is discussed in Watson's "Memorandum to the Director of Procurement," November 1, 1937. This document reports the results of a meeting between Rowan, Kent, and Watson at which the artist initially agreed to paint in a new message suggested by Rowan ("May you persevere and win that freedom and equality in which lies the promise of hap-

piness") but changed his mind when the Director of Procurement insisted on a motto ("To commemorate the far-flung front of the United States Postal Service"). The original message, with Kent's agreement, was obliterated by someone else and the native now holds a blank letter. It is clear that Kent had gone to enormous lengths to put one over on the Section and to be sure they found out. Bruce said, for example, that "it hardly seems necessary to send a Latin inscription to Alaska and get it translated by an illiterate Eskimo boy."

22. For discussion of the political ramifications of Kent's prank, see McKinzie, *The New Deal for Artists*, pp. 63-64.

23. *Bulletin*, #7 (December, 1935), p. 9, 130 (Box 214) and David Shapiro, ed., *Art for the People — New Deal Murals on Long Island* (Hempstead, New York: The Emily Lowe Gallery, Hofstra University, 1978), p. 58 and plate, p. 15. James Brooks had won a competition for the Hempstead post office in 1935 but did not accept the commission. TRAP funded the Mangravite mural, although he was commissioned through regular Section channels, as a runner-up in the National Competition.

24. For consideration of streamlined imagery in what the author calls "WPA murals," see Martin Greif, *Depression Modern, The Thirties Style in America* (New York: Universe Books, 1975), p 36, and diagram, p. 42.

25. Illustrated and discussed in Bush, *The Streamlined Decade*, pp. 78 and 80; see also "Power. A Portfolio by Charles Sheeler," *Fortune*, 22 (December, 1940), pp. 73-83.

26. Rhodes to Rowan, November 4, 1940, 133 (Box 2). See also Bush, *The Streamlined Decade*, p. 38.

27. *The Sears Roebuck Catalogues of the Thirties, Selected Pages from the Entire Decade*, unpaginated selections from the year 1936.

28. See announcement of the Arlington, New Jersey post office competition of 1936, 131 (Box 206) [Folder: Form Announcements of Competitions, A-H].

29. "Descriptions" for Alan Tompkins, Martinsville, Indiana (1937).

30. "Descriptions," Martinsville (1937).

31. Copy of a letter, Ernest Green, Postmaster and Custodian of the Building, to Nicolai Cikovsky, January 3, 1939, included in Rowan, Memo to Acting Supervising Architect, March 31, 1939, 133 (Box 44). Tompkins hit upon the same idea in his Wabasha, Minnesota, post office mural, *The Smoke Message* (1939).

32. Note from the desk of Louis Simon, dated March 21, 1939.

33. Custodian of the Building to Treasury Department, July 1, 1939.

34. Custodian to Treasury, July 1, 1939.

35. The Towson *Jeffersonian*, June 30, 1939, feature article, "Mural in New Towson Post Office Regarded as Joke, Crude Painting by Nicolai Cikovsky, a P.W.A. Artist, Stretches Across Entire Corridor Wall, Technique Very Poor. . . ."

36. *Jeffersonian*, June 30, 1939, editorial, "Awful!."

37. *Jeffersonian*, June 30, 1939, caption beneath five photos showing: *Pioneer Covered Wagon and Mississippi Steamboat, Coast Lighthouse and Clipper Ships, Pony Express, Railroad Train ca. 1860,* and *Modern Train, Queen Mary, Autos, Planes, Dirigibles.*

38. Kevin Brownlow, *The War the West, and the Wilderness* (New York: Alfred A. Knopf, 1979), p. 368 and Paul Trent, *Those Fabulous Movie Years: the 30s* (Barre, Massachusetts: Barre Publishing/Vineyard Books, 1975), pp. 172-173. Western films of the '20s and '30s are treated in detail in my "Thomas Hart Benton's *Boomtown*: Regionalism Redefined," *Prospects*, VI (1981), pp. 119-123.

39. Baltimore *Evening Sun*, June 30, 1939, quoting the Towson *Jeffersonian* and the *Union News*.

40. Folder of miscellaneous clippings, June, 1939, 133 (Box 44).

41. Anonymous letter to Edward Bruce, undated (ca. June-July, 1939), 133 (Box 44).

The smoke discussed is that in the final panel of the sequence, and the tugboats are not the only problematic example. A steam engine in the left foreground belches smoke toward the left also. The child in question is the blob-like infant in the covered wagon.

42. Folder of miscellaneous clippings, letter to the editor of the *Jeffersonian* (ca. June-July 1939), 133 (Box 44).

43. Folder of miscellaneous clippings, 133 (Box 44). This report, which suggests that the government should have insisted on local history in the first place, mentions the local postmaster "who has a queer sense of humor and a queerer sense of fine art, [and] thinks the Cikovsky murals are masterpieces, but he is having a tough time convincing citizens that they rank with the work of the old masters."

44. Cikovsky to Rowan, August 24, 1939.

45. Two reports in the *Baltimore Evening Sun* and the *Sun*, August 29, 1939.

46. John Maxtone-Graham, *The Only Way to Cross* (New York: Collier Books, 1972), pp. 268-269.

47. Baltimore *Sun*, August 29, 1939.

48. Baltimore *Evening Sun*, August 29, 1939.

49. Towson *Jeffersonian*, September 29, 1939, editorial and open letter to William P. Cole, Jr.

50. Cole's undated letter (ca. February, 1940) is quoted in Smith W. Purdum, 4th Assistant Postmaster General, to W. E. Reynolds, Commissioner of Public Buildings, February 15, 1940.

51. Towson *Jeffersonian*, January 12, 1940.

52. The committee—composed of a minister, a high school teacher and another person whose profession is not cited—is discussed in John W. Loeber (interim Chair and attorney) to Lenore Thomas, December 5, 1939, 133 (Box 43). The committee rejected plans for exterior sculpture and requested an historical mural. Avery Johnson was appointed to depict *Incidents in the History of Catonsville* but his sketches came in for severe factual criticism from the committee in 1941. See Rev. Trumbull Spicknall to Hopper, January 18, 1940, and Letter of Appointment to Johnson, December 3, 1940. The committee critique, all four pages of it, is enclosed in Johnson to Rowan, August 12, 1941.

53. Alan G. Barbour, *The Thrill of It All* (New York: Collier Books, 1971), p. 110, and George N. Fenin and William K. Everson, *The Western From Silents to the Seventies*, revised ed. (New York: Penguin Books, 1977), p. 223.

54. These works are: Paul C. Chapman, 1941, Nutley, New Jersey, post office, *The Return of Annie Oakley*; Henry Schnakenberg, 1941, Fort Lee, New Jersey, post office, four-part cycle including *Early Moving Pictures* also called *Moving Pictures at Ft. Lee*; Barse Miller, 1940, Burbank, California, post office, *People of California* in two panels, one called *Motion Pictures*; and Otis Dozier, 1939, Giddings, Texas, post office, *Cowboys Receiving the Mail*. In fact, the cowboys were sketched by Dozier before he went to Giddings and found himself in the heart of chicken country. He proposed to draw that subject instead but was told by Rowan to retain the cowboys because the chicken "subject is too unpleasant to incorporate in a single decoration in the Post Office"; Rowan to Dozier, August 11, 1938, 133 (Box 105).

55. For a particularly obtuse specimen thereof, see Will Wright, *Sixguns and Society, A Structural Study of the Western* (Berkeley, California: University of California Press, 1975).

56. Bill C. Malone and Judith McColloh, eds., *The Stars of Country Music, Uncle Dave Macon to Johnny Rodriguez* (New York: Avon Books, 1976), p. 125.

57. *Life*, "Mural America," p. 13.

58. Jen Yeh, *WPA—The Writers Project* (Hempstead, New York: David Filderman Gallery, Hofstra University, 1978), p. 2.

59. *Life*, "Mural America," p. 12.

60. *Bulletin* #19 (June, 1939), p. 24, 130 (Box 215).

61. Providence *Bulletin*, December 6, 1939.

62. Providence *Bulletin*, December 6, 1939.

63. Rowan to Sample, October 20, 1939, and November 10, 1939, 133 (Box 98).

64. Rowan to the Editor, the Westerly *Sun*, December 28, 1939, *re* editorial of December 7.

65. Westerly *Sun*, news article, December 7, 1939.

66. A. Fred Roberts, Sec'y, The Citizens-Taxpayers Association of Westerly (organized May 25, 1934), to Rowan, December 8, 1939.

67. Frank A. Sullivan, George B. Utter and Rogers E. Trainer, Westerly Chamber of Commerce, to Rowan, December 12, 1939, and December 15, 1939.

68. 124 (Box 134), "Forty Eight States Competition," p. 55.

69. Westerly *Sun*, December 7, 1939.

70. 124 (Box 134), "Forty Eight States Competition," lists the following entries: 342, 101, 1074, 1146, 367, 416, 1108, 555, 752, 1187, 403, 467, 177, and 1084

71. See, e.g., Stott, *Documentary Expression and Thirties America*, p. 103.

72. Quoted in Baigell, *The American Scene, American Painting of the 1930's*, p. 61.

73. The Island Pond sketch, illustrated in *Life*, "Mural America," p. 15 was never executed; see also *Bulletin*, #20 (November 1939), p. 17, 130 (Box 215).

74. Frank Anderson to Rowan, November 17, 1937, 133 (Box 1). In 1917-1919 Anderson had been a housing planner for U. S. Steel. Although the community liked the mural, Rowan refused to allow the cartoon to be reproduced in the Birmingham *News* and criticized the drawing mercilessly.

75. Originally, Conrad Albrizio planned to show a quarry but protests from Speaker of the House W. B. Bankhead and the Russellville Businessmen's Club led to a design change. Dr. J. M. Clark, Natchez Trace Association, to Bankhead, July 19, 1937, 133 (Box 2) argued that the quarries "we have with us now and possibly will always have. The old furnace is rapidly being lost to humanity, leaving no conception to future generations of its methods or operations." Hence the topic was changed to *Shipment of the First Iron Produced in Russellville*.

76. Maria Ealand to Charles Thwaites, August 16, 1941, 133 (Box 115).

77. Leuchtenburg, *Franklin D. Roosevelt and the New Deal*, p. 240.

78. The preliminary color sketch makes it clear that Graziani began with the idea that the dance was a momentary hiatus in the workday. Rowan, pleading special knowledge of Iowa on the basis of seven years spent there, mandated a number of changes: the train went and the harmonica player put his shirt back on. In the final version, the occasion has become a town festival or carnival with cake booths and a supper being laid, but the facial expressions remain unchanged. See Rowan to Sante Graziani, February 9, 1942, 133 (Box 29).

79. For a discussion of the heroic-worker motif in the '30s, see Marling, "A Note on New Deal Iconography: Futurology and the Historical Myth," pp. 422-423.

80. Romano Tozzi, *Spencer Tracy* (New York: Pyramid Books, 1973), pp. 87-8. The film was released in 1940.

81. Rowan to Sample, October 24, 1940, 133 (Box 98). There are no further entries in the Westerly file.

82. Providence *Bulletin*, December 6, 1939.

83. Boise *Statesman*, November 9, 1939.

84. *Life*, "Mural America," p. 13.

85. Wire, Martin to Rowan, November 7, 1939, 133 (Box 19).

86. Wire, Rowan to Martin, November 8, 1939.

87. Rowan to Martin, November 9, 1939.

88. A complete copy of the Yerington file is in Bruce's own file, 124 (Box 133). See also Harriet (a Section sec'y) to Rowan, May 3, 1940, 124 (Box 139) requesting the Yerington sketch to hang with Bruce's other personal favorites: John Sharp sketch, Bloomfield, Indiana; William Bunn sketch, Hickman, Kentucky; Paul Faulkner sketch, Kewaunee, Wisconsin; and J. H. Fraser sketch, Little Rock, Arkansas.

89. J. P. O'Neill, recording sec'y, Wardner Industrial Union, to Public Buildings Administration, November 6, 1939, 133 (Box 19).

90. Stanley A. Easton, President, Bunker Hill & Sullivan Mining and Concentrating Company, to Federal Works Agency, November 9, 1939.

91. L. J. Bell, President, Idaho Art Association, to Bruce, October 28, 1939.

92. Spokane *Chronicle*, October 28, 1939.

93. R. L. Brainard, President, and W. A. Tuson, Sec'y, Kellogg Chamber of Commerce, to Federal Works Agency, November 6, 1939.

94. Mrs. Myrtle Fothergill, Local No. 18, Ladies Auxiliary, International Union of Mine, Mill and Smelter Workers, to James Farley, November 14, 1939.

95. Bergman, *We're In the Money*, pp. 105-106.

96. Stuart Schaefer, Postmaster of Ely, Minnesota, to Rowan, January 30, 1941, 133 (Box 52). See also Jemne to Rowan, July 8, 1939.

97. Rowan to Fothergill, December 20, 1939, 133 (Box 19).

98. See Form Memorandum to the Commissioner of Public Buildings, December 13, 1939.

99. Rowan to Easton, December 20, 1939.

100. "Descriptions," 135 (Box 203) for Fletcher Martin, Kellogg, Idaho (1941).

101. Arthur T. Combs, Postmaster of Kellogg, to Section, May 26, 1941, 133 (Box 19).

102. Martin to Rowan, June 10, 1941.

4

An Article of Faith
From Minnesota to Arizona

Local history, according to the post-office walls of Mural America, was rife with happy accidents. Lady Luck smiled upon Messrs. Kellogg and O'Rourke and their burro. Within the year, another trio of fortune hunters was pointing, grinning, and dancing for joy in Lovelock, Nevada, where Ejnar Hansen's mural reenacted *The Uncovering of the Comstock Lode*. This time, the cast of characters consisted of "Old Frank"—a Mexican prospector—and the two Grash brothers, who have just stumbled on a deposit of "rich silver quartz in a canyon at the foot of Mount Davidson." Old Frank may be the stuff of silvery legend, but what happened next is the golden history of a $300 million strike: "This find led to the discovery of what was the greatest deposit of precious metals ever found in the world and was the beginning of the mining industry in the state of Nevada."[1]

In 1940 Betty Carney reminisced with old-timers, rifled through bales of old newspapers, and did some prospecting of her own in the Chisholm, Minnesota, public library. She unearthed the story of a *Discovery of Ore* made by a fluke of fate: "John McCaskell discovers ore under a tree while prospecting for lumber in 1891. This is not the first discovery, but one that established the length of the Mesabi Range and the importance of the western part."[2] And there, on a rich vein of unalloyed chance, the substantial bulk of the new Chisholm post office now stood. On the wall inside, the bearded McCaskell ponders two handfuls of red ore he has scooped from the roots of a large tree toppled by lightning. At the right edge of the picture,

Betty Carney, *Discovery of Ore*, USPO, Chisholm, Minnesota. 1941. National Archives.

a bird takes to the wing, as if to flutter out of 1891 and spread the news through the succession of years yet to come. The postmaster of Chisholm knew that Carney's bird flew on the wings of progress:

The discovery and exploration of iron ore on the Mesaba [sic] Range of Minnesota occurred during the settlement of this territory by the older residents of our community, and they have, during their life time, seen the development of iron ore mining from open banks of iron ore loaded into railway cars by wheel barrow to the present method of loading 50 and 75 ton ore cars with 5 or 6 dips by monster electric shovels. . . . [The] true attestation of the popularity is the fact that the older persons of the community, who have seen the whole period develop, come in repeatedly to admire the mural.[3]

Mother-lode murals uncovered the *fons et origo* of places such as Kellogg, Lovelock, and Chisholm and made legends of the pioneer adventurers who found the seams of ore that burrowed toward the industrial present. But these pictures were also quirky celebrations of twists of fate: runs of dumb luck somehow turned out all right. A luckless epoch was fascinated with the good fortune that befell unprepossessing folks like Old Frank and John McCaskell, local demigods in a populist, half-commercial new folklore of a reclaimed and kindly past. It was no happy accident that lumberjack McCaskell, with his big boots and his square jaw, resembled the monstrous cement Paul Bunyan, a folk tourist attraction set up in 1937 along Route 71 at Bemidji, Minnesota, just down the road from Chisholm.[4] There is something wondrously quirky, too, about the forgotten

snippets of history that muralists turned up in the musty stacks of local libraries, a vast repository of weird facts about life in America that they promptly stashed away in their pictures as a hedge against the colorless grind of hard times. Musing on the matter in 1942, before the last of the *American Guide* series had been issued, Alfred Kazin noted an identical penchant for oddities among the social researchers of the Federal Writers' Project, assigned to prepare the New Deal's multivolume U. S. Baedeker:

And here . . . was the humorous, the creepy, the eccentric side of the American character: the secret rooms and strange furtive religions; the forgotten enthusiasms and heresies and cults; the relics of fashion and tumbling mansions that had always been someone's folly. . . . Here . . . was a chronicle not of the traditional sobriety and industry and down-to-earth business wit of the American race, but rather a childlike, fanciful, impulsive, and absent-minded people.[5]

Tour #2 in the *Ohio Guide* is creepy and eccentric throughout. It dawdled along U. S. 6 from Chardon to Bryan, between the Pennsylvania line and the Indiana border. At the junction of State 61, the weekend vacationer was steered left, toward Berlin Heights, "pop. 569," nestled in groves of peach and apple trees. The town seemed pleasant and a little dull but the guidebook told a different tale:

During the 1850's and 1860's men and women from the East settled in Berlin Heights . . . and soon proved themselves able orchardists and businessmen. Their neighbors called them Free Lovers. Never very numerous, they were, nevertheless, a perpetual goad to the solid citizenry. They livened the local newspapers with their letters, always out-talked their opponents, held meetings and conventions with irritating frequency, and distributed their publications with abandon. . . . In time many of them moved to other places; those who remained became respectable.[6]

A bit farther west, near the State 4 cutoff, lay Parkertown, home of tall corn and tall stories from pioneer days that could send a prudent tourist skuttling for cover:

A Mr. Ramsdell, while hoeing his cornfield, heard a grinding noise overhead. He looked up and saw a dark mass twisting through the air . . . [and] pointing his hoe at the mass as if it were a gun, he bawled out a loud "bang!" Down fell a lot of the finest grindstones that were ever seen between Lake Erie and the Ohio River. A discreet man, Ramsdell never inquired where they came from.[7]

Even stranger things had transpired within the modest compass of 663 square miles in upstate New York, if the WPA guidebook to Rochester and Monroe County was to be trusted. A pretty little park marked the melancholy remains of the "lost city of Tryon"; a suburban housing development ringed a ghost town once known as Cala-

bogue, a nest of outlaws, moonshiners, and squatters "unshackled by moral . . . influences."[8] Downtown Rochester was a hotbed of bizarre lore. In 1844, berobed Millerites roosted in the trees on Pinnacle Hill waiting for an apocalypse that passed them by. On March 31, 1848, in Corinthian Hall, the Fox sisters established the first telegraphic communication between this world and the next, via muffled, bogus rappings that spelled out messages from the dear departed. In 1829 Sam Patch, in the throes of inebriation, took his pet bear by the paw, leaped from a scaffold above the steep falls of the Genesee River, and died before a rain-drenched crowd of 8,000 farmers.[9]

Following the suggestion of Robert Cantwell, Kazin saw the ghost towns and spooks, the lost cities, the shattered hopes, and the deadly plunges as "a terrible and yet engaging corrective to the success stories that dominate our literature." His theory found a weary, Depression-bred realism at the heart of the new folklore:

> For here, under the rich surface deposits of the factory and city world, lay the forgotten stories of all those who had failed rather than succeeded in the past, all those who had not risen on the steps of the American Dream from work bench to Wall Street, but had built a town where the railroad would never pass, gambled on coal deposits where there was no coal, risked their careers for oil where there was no oil: all the small-town financiers who guessed wrong, all those who groped toward riches that never came.[10]

Kazin's reasoning is ingenious and as splendidly silly as much of the folklore concocted by the muralists and guidebook writers of the '30s. It is foolish, at any rate, to suppose that the return to the facts mandated by the Section and pursued by the Writers' Project and the documentarists of the FSA had as a primary or covert object the destruction of the Horatio Alger myth of luck and pluck. Betty Carney did not uncover facts about the obscure expedition of big John McCaskell to convince Chisholm of an American tradition of bad luck and blighted dreams. Beneath the "surface deposits" of industrial Minnesota, she found happenstance resonant with the portent of modern good fortune. Chisholm had luck on its side and recognized such in the post-office mural.

A historical mural like Carney's revels in peculiar localisms because they are peculiar and local. Painted history was a counterforce to the powerful tides of big agriculture, big business, and big government. In murals, regional separateness and local idiosyncracies, however offbeat, buttressed home against the creeping currents of national homogeneity. A Writers' Project anthology of 1937 was called *Amer-*

ican Stuff, and "American Stuff" is a good sobriquet for a heterogeneous assortment of historical murals with off-kilter, guidebook themes.[11] Whatever regions they explored, substantial numbers of Section muralists went looking for the "stuff" of a unique and various American experience, the oddball, cockamamie facts and the tall stories, delight in which revealed a "childlike, fanciful" side of the American character but appealed to its prideful instincts as well. Strange and eerie things—just plain swell stuff—once happened on Main Streets all too ordinary to the naked eye. The most ordinary home places had claims to distinction made with the braggadocio of a Mike Fink whose tongue was not quite hidden in a puffed-out cheek. The authors of the *American Guides*, for instance, were fond of collecting dubious "firsts," and by the reckoning of project researchers in Rochester, New York, that clothing and camera center had garnered its fair share of them. The first voting machine, mail chute, trolly-car transfer, fountain pen, medicated cigarette, and gold dental crown had all been unveiled to a breathless world on the rim of the Genesee gorge into which Sam Patch disappeared.[12]

The history of "firsts" constituted the modern folklore of a Depression epoch whose own firsts were liable to be on the order of record unemployment figures. It was apolitical, popular history, and it was ferociously egalitarian. If the first trolly-car transfer was a serio-comic ticket to greatness, then most towns could rustle up some reason for thinking themselves interesting. Despite the lusty hooting of Chambers of Commerce, not every town qualified as the "Cheese Center of the World." But most places did have a skeleton in the civic closet, a strange garbled story of the early days or some crackbrained "first"; by those standards, most wide places in the road on the WPA's national tour had an engaging charm. Holding any fragment of genuine American Stuff dear might make for sentimental, even trivial folk history; yet things people found interesting, like the forgotten stories of ghost towns and the failures of obscure ancestors in the guidebooks, gave human depth and richness to Anyplace, USA, an ensemble of two filling stations, a five-and-dime, Joe's Lunch, and a post office. American Stuff was the self-administered love pinch that told folks America was alive, okay, and real. Like the screwball movie comedies of the period, murals premised on American Stuff were just whacky enough to be interesting. In the post office, the folk hagiography of the American past was democratic, too. The celebrities who made Mural America such an interesting place

Fred Carpenter, *The Clemens Family Arrives in Monroe County*, USPO, Paris, Missouri. 1940. National Archives.

were often anonymous and rarely idolized. Or rather, if a Great Man appeared, he was liable to be shown before destiny knocked, when only the neighbors could have caught the glimmer of impending immortality.

To look at Fred Carpenter's mural in the Paris, Missouri, post office, one would never guess that it celebrates the prenatal history of Mark Twain. The storybook style, full of curlicues and the promise of hidden glimpses of fairies and trolls, seems an oddly apt choice for a picture of a carriageload of people in costume, fording a river as if bound for an ice-cream social in the American long ago. The kewpie-doll manner may prefigure illustrated nursery editions of *The Prince and the Pauper*, for the mural is called *The Clemens Family Arrives in Monroe County*:

The mural depicts the Clemens family crossing the Salt River as their long journey from Tennessee is nearly ended. In the foreground, on horseback, are Mr. Clemens and Benjamin, at that time the youngest son. In the open carriage are Mrs. Clemens and the two daughters. Orion, the eldest son, is driving and beside him is Jennie, their slave girl. At the left is pictured the house which was to be their first Missouri home, which was later to be Mark Twain's birthplace.[13]

The Paris mural is a fine example of the extremes to which the passion for obscure local data could lead; a well-informed native could have understood the picture without a genealogical chart in hand, but the passerby needed a copy of the *Missouri Guide*. So equipped, of course, alert tourists suddenly realized they had stumbled upon some interesting Americana, as they merrily picked out little Benjamin and Orion and Jennie the slave girl. How fascinating! The first of three panels in the Torrington, Connecticut, post office, depicting an ordinary little boy and an ordinary lady standing before an

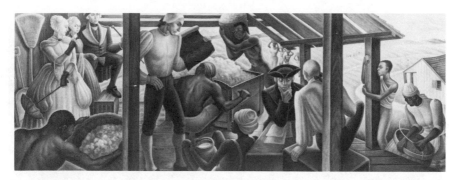

Edna Reindel, *Experimenting with the First Model of the Cotton Gin*, USPO, Swainsboro, Georgia. 1939. National Archives.

old-fashioned house seems unremarkable, too, until one inspects the subsequent episodes and discovers that Torrington was the birthplace of the firey John Brown.[14] That ordinary little boy is the abolitionist in miniature. Fascinating indeed!

The battle scene tucked away in the Monroe, Michigan, mural is not similarly helpful in making sense of a courtship tableau, a picture of a house, and scattered bits of agricultural and industrial flotsam. But the *Romance of Monroe*, as artist Ralf Hendrickson wrote about it, was considerable and, well, interesting:

The figures at the right represent the tragic River Raisin Massacre of 1813. The figures in the center symbolize the romance of General [George Armstrong] Custer and Miss Elizabeth Bacon. In the background is the home in which they lived after their marriage, now the site of the present Post Office. Monroe's industries of today, paper making and flower raising, are represented at the right.[15]

The life of a famous man sprung from an out-of-the-way place was not always a bed of roses, despite the pictorial evidence of loving mothers, happy families, and idyllic trysts. Edna Reindel painted *Experimenting with the First Model of the Cotton Gin* in Swainsboro, Georgia, to expose the little-known fact that Eli Whitney invented the gin in 1791 in the Swainsboro home of General Nathaniel Greene's widow. Along with several elegant friends, the Widow Greene watches as Whitney consults his blueprint and shows slaves how to work the mechanism. Notice that shifty pair skulking nearby, though! "In the right foreground are the plotters whose schemes later defrauded Whitney. The epoch-making invention was stolen and copies and adaptations of the machine were soon in use throughout the South."[16] And that is certainly a shocking and interesting thing to learn!

The presence of the celebrities who conferred distinction on Halstead, Kansas, and Alexandria, Indiana, was not required in those

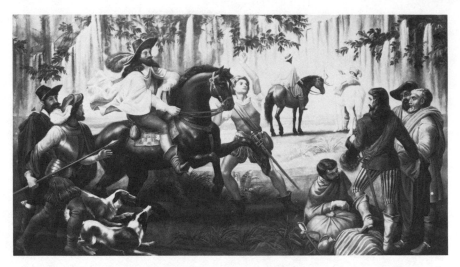

William Dean Fausett, *La Salle's Last Expedition*, USPO, Rosenberg, Texas. 1941. National Archives.

post offices, even in embryonic form. The Halstead mural purported to show the place *Where Kit Carson Camped*, or may have camped, in an unspecified year and season a long time back. In fact, the picture was an unexpurgated view of modern day Riverside Park, at the union of the Little Arkansas River and Black Kettle Creek, and over at the right stood a run-of-the-mill oak the painter called "Kit Carson's Tree."[17] Kit himself was nowhere to be seen. *The Sledding Party* in Alexandria was a winter genre scene, circa 1900. Among many figures are two which painter Roland Schweinsburg identified as "the 'raggedy man who tends the horses 'n feeds 'em hay' [and] old Aunt Mary who stands in the doorway." Natives and peripatetic literary buffs would surely recognize these characters from the poems of James Whitcomb Riley, "who was born in this vicinity."[18]

Merely passing through the neighborhood was ample warrant for starring in a mural, especially if a juicy plot had been hatched en route. "Historical records" studied by William Dean Fausett proved that *La Salle's Last Expedition* in search of the Mississippi River brought him across the Brazos to a point near Navasota, and there, in the general vicinity of the county in which the Rosenberg, Texas, post office stood, he met his death at the hands of a traitorous comrade. In Fausett's pseudo-Baroque painting, La Salle, his troops, and four conspirators who have not yet begun to cast sinister glances at their chief "are dressed in the romantic French costumes of the period."[19] Rosenberg knew the seamy truth. The group as depicted,

however, might easily be bound for a diverting *dejeuner sur l'herbe*, and mutiny does not mar a pleasant day. Even the mildly sinister Joseph Bonaparte, Napoleon's brother and "former King of Naples and Spain," who turns up unexpectedly in the Bordentown, New Jersey, post office, is a nice guy, wooing American tykes of the post-Waterloo epoch by letting them go *Skating on Bonaparte's Pond*. Every inch the monarch in exile, King Joseph surveys his holdings from a sleigh and directs his coachman to dispense "apples and hot chestnuts" to his guests.[20]

The *American Guide* approach to the hidden lives of the famous covers a varied range of imagery. There may be somber grace notes in the stories of happy little John Brown, Custer wooing his lady, La Salle bravely bound for the Mississippi, and Eli Whitney tinkering with his invention. Even Kit Carson's campsite could qualify as one of Kazin's haunted, "creepy" places. Yet the stories are sadder by far in the telling than in the seeing. With their fancy dress costumes, inexplicable events, and historical-society details, the murals are intriguing, tantalizing, and—in the context of a Rosenberg, Texas, or a Halstead, Kansas—more than a little exotic. It is not difficult to understand how a muralist first admonished to return to the facts and then shipped off to a town where the paper mill was the high spot on the local tour could be swept away by bona-fide Stuff buried in the library. And curious things are afoot in these post offices as a result; the murals bring undercurrents of unexpected lore to light in surprising ways. In this sense, folk biography in mural form makes an appeal tantamount to that of the village eccentric, who achieves a place in the community through sheer erratic grit. There is an intense, almost defiant, provincialism at work in these murals. From a strictly visual standpoint, the pictures are local rebuses, secret codes with the arcane appeal of a Masonic handshake.

Outsiders whose curiosity is piqued, as well it might be, by a regal figure dallying in a sleigh in New Jersey cannot break the code from the data supplied by the mural. They need a guidebook, or, better yet, a Section publicity blurb. American Stuff biography, in this respect, takes its stand on the post-office wall at the farthest possible remove from the terrain of Regionalism, which makes a broad, national appeal on the basis of a typology derived from the mass media and a style consistent with the look of today. It is significant, therefore, that the greater number of these strange historical images are couched in defiantly retrogressive styles, ranging from letterpress

copies of seventeenth-century battle pieces to revivals of fairy-tale illustrations of the late nineteenth century. Edna Reindel's Swainsboro mural uses the least anachronistic style of the lot, a treatment of mass that recalls the modified Cubism of Boardman Robinson. But her gesture in the direction of contemporary expression is mitigated by admixtures of High Baroque rhetoric, in the four attendant Negroes displaying pots and baskets like so many displaced Bernini river gods, and storybook sugar, in the group of admiring observers.

Perhaps the old-fashioned, fairytale flavor is appropriate to these homegrown legends. The Section placards reporting the odd facts concealed in the murals, as artists reported the facts to Forbes Watson, are often the only way the code of localism can be broken. Yet, with the exception of the Swainsboro caption, the dates at which these doings took place are left to the imagination or, at best, vaguely indicated. This procedure is inconsistent with the close attention paid to the minutiae of personality and geography. Invisible rivers are named; so are tertiary characters, such as Jennie the slave, whose importance to the scene depicted is surely marginal. Time thus takes on the magical, storybook quality of once-upon-a-time and that, as every child knows, can mean a hundred years ago, the day before yesterday, or just this morning. Historical time is permeable, while the facts of place and character so assiduously recorded give historical incidents the density and specificity of the present day.

Anecdotal history is as real as the oak and brass fittings in the lobby of the Paris, Missouri, post office; like daily life itself, it is clogged with names and landmarks and trivia. Historical personages named Miss Elizabeth Bacon and Jennie Clemens take on the familiar substance of a neighbor lady named Mrs. Mary Jones. And these painted folks, just like folks today, negotiate their way around town via landmarks called Black Kettle Creek and Bonaparte's Pond. Names and facts attach historical figures to the small-town America of the guidebooks. Like the ghosts befriended by the Fox sisters, however, these historical phantoms exist in an amorphous dimension of time, where the dead can rattle chains that wake the living. The boundaries between then and now are curiously fluid, despite the rigid geographic framework to which the ghosts are tethered in the murals. Spirits do not possess places they once knew so much as places possess the ghosts of their history and trap them in a pictorial once-upon-a-time with seances conducted on the walls of the local post office. Through

the mural medium, Depression America contrived to haunt its own past.

The fortunate spooks of the guidebook past are blithe spirits. Mark Twain and James Whitcomb Riley built their later fame on the small-town activities over which their benevolent shades are required to preside in the Paris and Alexandria murals. Other lives, according to the framed texts beneath the pictures, had "creepy" fates. Brown and Custer and La Salle met tragic ends; Whitney was going to be duped and defrauded. None of these dire things came to pass in the hometown murals that housed them, however, although the pictures issued warnings of doom. Doom struck after the heedless celebrity had finished with the local event depicted in the mural and deserted home and hearth. The lives they lead in the pictures are so pleasant in comparison to the gory details cited in the texts that questions must arise. What if John Brown had stayed in Torrington? What if La Salle had settled down among the natives on the Brazos? What if Custer had refused to budge from his marriage bed, if Whitney had shown his machine to that dear old Widow Greene and kept an alien audience out of her toolshed? Famous folk started their notorious journeys into the history books from nice quiet places in the WPA guidebooks, places that, pictorially at least and years after the fact, aimed to reverse history and to keep their own safe and happy forever in the bosom of home. In a staggering paradox, the historical facts that earned a folk celebrity a place of honor in the local mural were banished from the post office by the stubborn provincialism of his or her modern neighbors and admirers. American Stuff often meant "what if?" history. The guidebook past was "usable" and guidebook history was "present history." Arduous research confirmed what sensible natives already knew: Swainsboro and Monroe were nice places to stay at home in. Even the resident ghosts were happy, neighborly souls.

Historical kitsch does not exhaust the infinite variety of guidebook murals: "firsts," strange tales and relics, obscure and indigenous folk heroes, and weird events are also represented. The discovery of a territory or the founding of a city are common enough themes, but the "firsts" which reveal the passion for American Stuff generally feature queer artifacts. The 1817 Bee Hive furnace in the Russellville, Alabama, mural is one such pictorial "first." Another, the championship status of which is barely tarnished by the parenthetical

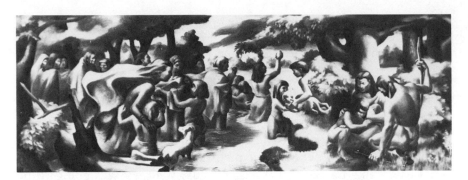

Lorin Thompson, *The Legend of the Singing River*, USPO, Pascagoula, Mississippi. 1939. National Archives.

honesty of the Section's companion text, is the *Horse-Drawn Railroad* displayed in the Akron post office in western New York:

The first railroad in the country (except for one only three miles long from Buffalo to Black Rock) was built in 1835, and ran from Medina to Akron. It had wooden rails, one passenger car and one freight car. It was drawn by two horses, one ahead of the other. The mural depicts the horse-drawn train as it passes through the countryside.[21]

From a collector's cabinet of American rarities or a corner of "Ripley's Believe It Or Not" column came *The Indian Ladder* erected in the Delmar post office, in eastern New York:

The mural depicts a scene in Thatcher Park with the old Indian Ladder. This ladder was constructed by the Indians from crude tree trunks and branches and it served as a means of climbing the cliffs to where Bear Path trail was continued.[22]

Indian relics were tame stuff in comparison to *The Legend of the Singing River*, recounted to Lorin Thompson one night in Pascagoula, Mississippi, when the dancing waters began to play a haunted melody. Artist Thompson realized the danger of getting "slushy" about his maudlin theme or "hamming" up the story, and tried to show Rowan he was a hardboiled skeptic when it came to questionable tourist attractions:

The legend was undoubtedly created to explain the peculiar humming sound emanating from the river as it enters the Gulf. . . . The story in short is that the Pascagoula Indians, a small (but brave and beautiful, of course) tribe were practically wiped out by the Natchez [sic], a strong and vicious tribe of the Gulf region. Rather than become the slaves of the Natchez, the women and children, old men and such warriors as were left . . . formed a procession and walked, chanting religiously, into the river which swallowed them up and which has dutifully chanted every evening since then (two hundred years ago) to the delight and amazement of visitors. The phenomenon, which has never been satisfactorily explained, is one of the major attractions of Pascagoula.[23]

The mural, at the height of the 1939 season, became a second stop for tourists who "have read of the legend and . . . endeavor to find in the moody painting the feeling that the Indians had on that mythical day of long ago."[24] The "less artistic" natives were relieved to find no lettering on the canvas identifying the various Indians, since in the canonical version of the story, the Biloxi wiped out the Pascagoula; then again, it was impossible for most tourists to tell a Biloxi from a Natchez and the Section corrected matters in the official description.[25] They were also appalled to find no Spanish moss in the picture, but in the words of the postmaster, that deterred no one from "gazing wonderingly at the mural." People were proud of a vanished local tribe "who chose death to defeat" and in the process put Pascagoula on the tour map.[26] For verification of the legend, should Washington doubt that the celebrated dirge did regularly issue from the stream, Rowan was referred to Speaker Bankhead and Congressman Colmer, two among the many tourist notables who came to listen and marvel.[27]

Tourists did not flock to West Palm Beach, Florida, because of *The Legend of James Edward Hamilton, Mail Carrier*, spread across six ample panels in the post office. Nor were they likely to grasp the complicated story of the local folk hero in the time it took to mail a picture postcard, even though the ensemble was an obvious oddity. Postmen rarely did much more in murals than toss mail sacks or, like the *Postman in Storm* in Independence, Iowa, pull down their regulation grey earflaps in the course of the swift completion of their appointed rounds.[28] Hamilton was made of sterner stuff:

These panels depict the course of James E. Hamilton, mail carrier, in one of his trips on the Barefoot Route between Lake Worth and Miami. Great strength and endurance were required to walk this difficult postal route and Hamilton lost his life in the line of duty on October 11, 1887.[29]

There is a cryptic quality about the explanation mounted in the lobby, suggesting that Hamilton was a strictly local treasure, a Delphic mystery uninitiates would have to stick around to unravel. Indeed, the placard text concluded by directing the persistent to the high priest of the cult: "A detailed description of the six panels may be obtained on request from the Postmaster."[30]

Reflecting the parochial self-esteem of towns with cherished local legends unintelligible to the rest of humanity bothered some painters. Mordi Gassner followed the Section's advice and wrote to the postmaster of Lynden, Washington, when he received that commis-

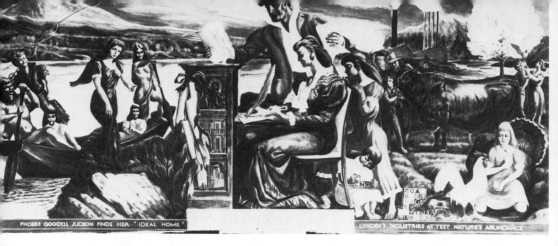

Mordi Gassner, *The Three Ages of Phoebe Goodell Judson*, USPO, Lynden, Washington. 1942. National Archives.

sion in the summer of 1941. Back came a crate of prime American Stuff: snapshots, old newspapers, landscape sketches, and "the memoirs of the first settler, a remarkable woman with a naive but charming flair for telling her story." The townsfolk had already decided on the theme, which was to feature the pioneer heroine coming to northwest Washington, witnessing the rise of the town as she raised her numerous brood, and, finally, casting a celestial smile over the industrial panorama of modern Lynden. The mural already had a title, too: *The Three Ages of Phoebe Goodell Judson*. Gassner reported himself in the throes of "wrestling with this" fait accompli and with a continuing stream of supplemental data "so kindly and quaintly" directed to his Santa Monica home by Judson fans in Lynden.[31] For the sake of unwary tourists passing through Lynden, Gassner might well have wrestled with the stuff a bit longer than he did. The exceptionally strange mural he completed in 1942 places Phoebe in the center, surrounded by her family. She scribbles her memoirs with a huge quill pen at a writing desk bedecked with a shock of corn and a stack of three bas reliefs, in the manner of Donatello. These show, in descending order, a covered wagon, a nineteenth-century house, and a factory. The left side of the picture is consumed by a watercraft with distinct overtones of Delacroix's *Barque de Dante* and overloaded with a crew of stark-naked water nymphs.[32] A Rubensian Phoebe disembarks from her barge with all the pomp of Marie de Medici landing at Marseilles and wears a costume not inappropriate for a royal levee at the French court. This astounding episode is labeled "Phoebe Goodell Judson Finds Her 'Ideal Home.'" The right side of the picture, "Lynden's Industries Attest Nature's Abundance," reveals smoking factories, a prize bull, a fruit tree, a turkey,

a rooster, and a Judson granddaughter spelling out the names of the products of an ideal Lynden with alphabet blocks—corn, salmon, beet sugar, lumber, cement, and so on. The import of this tableau is fairly obvious to the reader of alphabet blocks, but the smirking authoress whose titanic husband fingers wads of manuscript pages and the nereids and tritons becalmed on the Nooksack River are apt to inspire incredulous guffaws on the part of viewers unrelated to the Judson clan.

Gassner must have viewed his own work with some measure of sheepishness. A guilty conscience, at any rate, seems to have moved him to write a long, somewhat bitter, and often pretentious letter of self-defense to Rowan in January of 1942. Gassner opened with an attack on the general practice of contrasting the past with the present in Section murals "to gratify civic pride . . . and suggest the scope of local development." The theme was a waste of time, he said, because "the contemporary condition will always be present to the citizenry by way of contrast with the primitive beginnings and as these present day conditions alter they will date the artist's portrayal of what was in his moment the 'modern' state of affairs." Whether this insight was in aid of selling Rowan on his timeless art-historical nudes is not entirely clear, for Gassner dropped that train of thought to condemn historical-contrast murals on debatable compositional grounds. The schema always made for an "irrational stasis" of parts and "an arbitrary juxtaposition having as justification the geographical and historical facts but no artistic compulsion." And with that salvo at iconographic stuff which subsumed all painterly considerations, Gassner arrived at a telling point:

This opinion of mine is one which I have entertained since the beginnings of the Section's activities. It applies as a criticism to the whole attitude toward local Americana. I think a weakness apt to be encouraged (and one which I think has been sponsored unwittingly) is a stress on the details of locality business at the expense of the whole ideological nexus between the locality as a living part of the whole, the whole being America. The large principles distinguishing America and animating the parts as they do the whole, are thus obscured in vaunts of local success having no visible origin in our peculiar civil liberties nor any clear contribution to make toward evolving them.[33]

This was a harsh indictment of the parochial taste he had served with feverish despair, and of a national mural renaissance hostage to local quirks. His final words go to the heart of the provincialism—the ersatz Regionalism—fostered by a guidebook history of aboriginal legends and tasty tidbits:

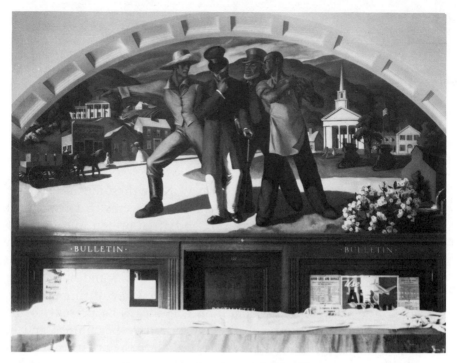

Amy Jones, *Lincoln's Arbiter Settles the Winsted Post Office Controversy*, USPO, Winsted, Connecticut. 1938. National Archives.

. . . I think that local genius in contemporary America will grow most strong and true to itself in devoting itself . . . to the large American aims and ideas and experiences, utilizing whatever of local tradition or episodes or activity distinctly bears on the larger scope. I do not think an atomistic regionalism is either wholesome or in harmony with a period in which even nations are coalescing in larger loyalties than those in which they originated.[34]

With World War II raging and the Atlantic Charter newly endorsed by fifteen anti-Axis countries, a global view which set the national identity above *The Three Ages of Phoebe Goodell Judson* was overdue. America's Four Freedoms were suddenly more absorbing than local "firsts," esoteric relics, and "quaint and curious" tales. But that was not true in 1938 and 1939, when murals in Winsted, Connecticut, and Bay Minette, Alabama, commemorated a pair of preposterous historical feuds, one of which ended in an act of mass civic larceny.

The Winsted squabble had some faint tinge of national relevance in that it took the intervention of the President of the United States to quell hostilities. *Lincoln's Arbiter Settles the Winsted Post Office Controversy* also called to mind countless citizen uprisings of the '30s involving the local postal station, although painter Amy Jones

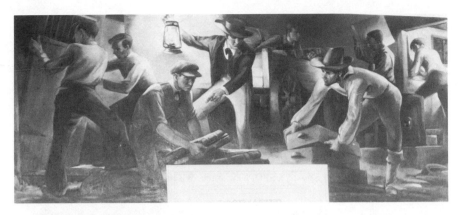

Hilton Leech, *Removal of the County Seat from Daphne to Bay Minette*, USPO,
Bay Minette, Alabama. 1939. National Archives.

was fortunate enough to avoid one in Winsted. The historical out-
burst she portrayed centered on a protracted tug-of-war between two
Winsted factions. The first post office had been built in the East End:

This infuriated the settlers in the West End and they succeeded in having it
moved to their settlement. The East settlers were then very much upset at losing
their Post Office and sought to regain it, but it remained in the West End until
the railroad came through. Since the railroad station was to be placed in the
marshy flat between both settlements, it seemed logical to put the Post Office
there.[35]

Putting the building on neutral turf sounded like an amicable com-
promise, all right, but the suggestion only enraged West Enders and
East Enders alike and they teamed up to bombard Washington with
protests. Lincoln sent a representative to straighten things out peace-
ably, and in the painting this Solomon is listening patiently to vehement
arguments from the rival factions. What happened next is left as
vague as the date of the first tremors of anger. And out of Lincolnian
charity toward the descendents of the vanquished, neither the mural
nor the Section placard reveals the arbiter's solution, which presum-
ably worked, since the 1939 post office that replaced the contested
one did not require the intervention of a Roosevelt envoy.

By contrast, the Bay Minette mural fairly chortles over the sneaky
ploy that ended hostilities between rival claimants to the county seat
and the appurtenances thereto attached:

In the year 1902 the county seat, then located in Daphne, was removed by vote
of the people to Bay Minette. The officials of Daphne refused to recognize the
law and continued to carry on with their offices in the courthouse at Daphne.
The irate citizens of Bay Minette took matters into their own hands and decided
to remove the county seat by force. One night they hitched up their oxen, went

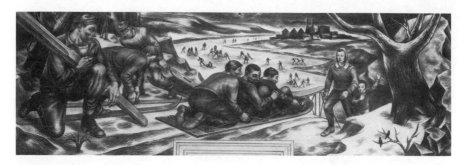

Paul Faulkner, *Winter Sports*, USPO, Kewaunee, Wisconsin. 1939. National Archives.

to Daphne, and quietly loaded the contents of the jail, its prisoners, all records and furniture on their carts and carried them to Bay Minette. The following morning the officials of Daphne were forced to follow their records. This mural is a composite scene of men removing the jail door, gathering up huge ledgers, stacking drawers and loading a wagon in the background, all under the guidance of the man who holds a lighted lantern.[36]

Local folks thought *Removal of the County Seat From Daphne to Bay Minette* was "a fine addition to our building and we appreciate it a good deal. . . . It has occasioned a great deal of comment pro and con."[37] Perhaps the negative reactions came from Daphne folks recording deeds at the county seat. Daphne did not get a post-office mural in which to retort to this gleeful celebration of dirty doings with a scene of virtuous clerks beset by thugs from down the road.

The roadside history of the '30s, despite lapses into trivia and cabalistic provincialism, was nevertheless history as people conceived it. When the postmaster of Kewaunee, Wisconsin, learned that a mural was to be painted there by Paul Faulkner, he was not told that a sketch showing contemporary *Winter Sports* had already been approved.[38] The Section's request for his assistance was therefore pro forma but William Wright acted in good faith in marshaling a committee of prominent citizens to advise the artist.[39] Faulkner eventually did base his fresco in the Kewaunee post office on his earlier Wausau Competition design, full of skis and toboggans and localized by the addition of a factory in the background.[40] The work was generally well liked, too; late in November of 1939, "an informal reception was held in the Lobby of the Post Office in honor of Mr. Faulkner" and a splendid time was had by all.[41] In June of that year, however, the local committee, backed up by a delegation from the Kewaunee Historical Society, had explicitly requested a mural, or a second mural if need be, "setting forth some of the early history" of the town. By way of illustration, Rowan received "an old tintype

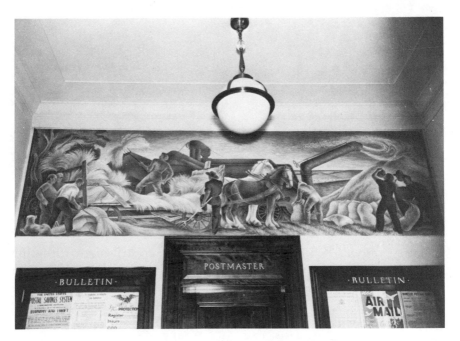

Ethel Magafan, *Threshing*, USPO, Auburn, Nebraska. 1938. National Archives.

taken in 1856 which shows Kewaunee . . . as it was at that early date. This picture shows the first rude building, the first pier, and the first sawmill." With the tintype came a documentary history of the sawmill, a summary of local Indian lore, and a reminder that this kind of pictorial history "would be deeply appreciated by the citizens who have taken part and watched Kewaunee grow out of the wilderness into a thriving Lake Port and Manufacturing City. It would be a lasting remembrance to both our older citizens, the present generation and those who are to come."[42]

The sequence of events in Kewaunee was anticipated in Auburn, Nebraska, in 1938. Mrs. H. G. Harris, Mrs. I. W. Irvin, and Mrs. B. F. Larance heard about the proposed "muriel" from Postmaster Harmon and wrote to Washington in February, on behalf of the Art Class of Auburn, to offer local guidance: "The early history of Nemaha County contains some very interesting events, which we believe the artist might be glad to learn of. We boast the first railroad in the state, also the first church located at Brownsville."[43] Rowan had to tell the ladies that Ethel Magafan's design "which depicts contemporary agriculture" was finished, yet when *Threshing* was installed in July, the members of the Art Class pronounced themselves satisfied

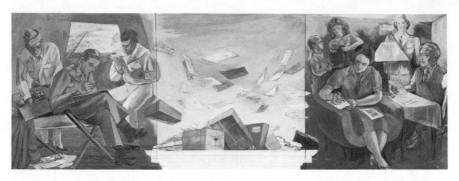

Stefan Hirsch, color sketch for USPO, Boonville, Mississippi. 1943. National Archives.

in every respect.[44] The ladies had, in fact, contrived to turn time upside down by converting a modern scene into an historical souvenir. "The old threshing machine," said Mrs. Harris in a mood of premature nostalgia, "is rapidly going out of use and inside of another generation it will be a thing of the past and this will stand as a memory of the bygone days."[45]

Artists eager "to paint the kind of picture the citizens . . . would appreciate" were themselves appreciative of the populist grounding of guidebook stories, nostalgia, and "firsts."[46] In May of 1941 Stefan Hirsch was teaching at Bard College and with his new job came a consolation commission for the Boonville, Mississippi, post office. He approached the design process with some trepidation but with a steely resolve to "wipe out the defeat which the North has suffered at my hands in the South, in Judge Myers' blitz-attack at Aiken, South Carolina, several years ago."[47] His strategy for storming Boonville took Hirsch straight to "the Federal Guide Books which state that Boonville has been the scene of an all-day fight between Hardee's cavalry and Sheridan's troopers on July 1st, 1862, that it is a prosperous farm trading center and that it now has a garment factory."[48] Unlike Mordi Gassner, Hirsch was eager to try his hand at stuffing any matter of "public pride" into a mural he planned to call *Scenic and Historic Boonville*: the cheese factory, the cold storage plant, the MidSouth Uniform Company, the Battle of Boonville, and whatever lore might be forthcoming from the local social studies teachers were guaranteed spots in the picture. Hirsch's generous instincts were thwarted almost immediately.[49] *The Guide to the Magnolia State* only mentioned the equestrian skirmish between Hardee and Sheridan in passing and Hirsch soon realized why. "After extensive research," he told Rowan, "I have still not been able to

decide which side won. I am afraid it was the North, and I wish it were the South, because I would have liked nothing better than to paint a little serious horse-play."[50] Worse yet, all his requests for help from the townspeople of Boonville went unanswered. Thrown back on his own resources, Hirsch painted V-mail fluttering its way between the homefront and the troops overseas. "And by the way," he noted in his last letter to the Section, "I didn't pull any Kentiana: the writing on the letters and packages is illegible and says nothing at all."[51] And nobody in town cared enough to look for and note the absence of the fascinating story of the Battle of Boonville when the Battle of Midway was being fought in the Pacific.

Whether painters, postmasters, or civic patriots espoused historical themes based on the funny "firsts" and anecdotes of the *American Guide* persuasion, the same catchphrases are used to explain the choice. Hirsch referred to the "public pride," and more than half-seriously to the "serious horse-play" informing his juxtaposition of local history and modern development. Mrs. Harris and her friends spoke of "interesting events" out of the past of which Auburn might "boast"; they wanted to leave behind, in mural form, "a memory of the bygone days." Postmaster Wright stated that a picture of the first sawmill and pier in Kewaunee "would be a lasting remembrance for . . . our older citizens, the present generation and those who are to come." This vigorous usage of history was, as Hirsch realized, intensely "serious." The tired old stories and the forgettable "firsts" gave people a benchmark against which the contemporary situation could be gauged and indeed savored. Kewaunee started from a "first rude building" at a fixed temporal point in 1856 recalled by old-timers who could justly take pride in what Kewaunee had become: they could find reason for pride in today, in the factory at the edge of Faulkner's fresco. The past was a source of pride and comfort at a new point in time, when both were welcome anodynes to hard times. For the sake of the psychic present, Depression America haunted its own history. Had the sequence stopped there, Mordi Gassner's case against provincial history painting might have deserved more attention than it got in Washington. Was puffery in the boon-docks the stuff of a great and lasting art? But Auburn and Kewaunee, having come this far, were also aware that the retrospective views they proposed to deposit in the local post office in 1938 and 1939 would give future generations benchmarks of their own. These future generations were not necessarily or exclusively unborn natives: Au-

burn believed that Ethel Magafan's mural "some day . . . may be as popular as the one painted by Grant Wood—*Dinner for Thresh-ers.*"[52] Towns crated up their precious stuff, told painters their tall tales, and made demands on the Section for historical murals because they believed in the future. The post-office mural was their collective act of faith in tomorrow.

Historical themes spoke to the issue of historical continuity. The murals were bridges, anchored at one end in the past and vaulting over the present into the world of tomorrow. To be sure, today was carefully hidden from sight in murals which presented only past events; a Bay Minette citizen of 1989 would have to stare hard at a yellowing placard to learn that the mural message emanated from a bygone 1939. And in works such as these, the Depression's manifest woes were surgically excised from the temporal march of progress. In the missing center between then and someday, the function of now was to attest to the potency of the American promise, to tend its flame, to pass the torch into a time which would surely be as fascinating and secure as the fixed tableaus of yore. Pictures like the one Hirsch planned to paint in Boonville, setting the past against the present, edited the present to document the new cold-storage plant at the expense of less glittering emblems of the day, for the promise had to shine. Both species of history painting looked forward confidently and hopefully to an America to come.

Gassner had argued that local history was bunk because it ignored "the large American aims and ideas and experiences." But *The Three Ages of Phoebe Goodell Judson* and every piquant detail thereof supported his case only when set apart from Chisholm, Monroe, Rosenberg, and the whole mad gaggle of contemporary murals with historical themes wrought from equally esoteric stuff. Gassner was right only if the implicit content of all that historical imagery could be overlooked in the act of licking and turning guidebook pages. The historical murals of the '30s linked the common people's experience of the Depression years with tiny local events the people chose to ponder. They linked the common idea of coping with and transcending a catastrophic rupture in the progressive course of American history with indigenous heroes, artifacts, and durable legends. Yet the broader national "whole," to reverse Gassner's formula, informed each constituent local part. And the push forward into tomorrow that informed the historical genre was directly relevant to the "large American aims" of the culture of the period. That plucky, indomi-

table spirit was what the postmaster of Kewaunee had in mind when he spoke of a "lasting remembrance to . . . those who are to come." It was what the postmaster of Chisholm, Minnesota, had in mind when he praised Betty Carney's *Discovery of Ore.* The old-timers came in "repeatedly to admire" lucky old John McCaskell while the mechanical shovels of 1940 took ten-ton bites of fresh Mesabi ore. As their lifetimes had fulfilled the promise of 1891, so their vision of purposeful history on the post-office wall pledged a legacy of confident faith to "those who are to come." Yesterday ensured all of America's happy tomorrows.

When the Section issued its final report in 1943, some projects had yet to be finished. Like all of the agency's lists of accomplishments, the accuracy of this document can be challenged by a tourist with an inclination to visit courthouses and post offices; murals have fallen between the tabular cracks.[53] Best estimates have placed the number of completed murals at 1,116, with an additional 89 credited to the Treasury Relief Art Project, which used WPA funds but otherwise followed standard Section operating procedures.[54] Washington had no reason to sort a thousand-odd murals into thematic categories under such headings as "the Post, Local History, Past or Present, Local Industry, Pursuits or Landscape," and so on. Thirty-odd years later, compiling a statistical profile of iconographic types from scattered and incomplete records, particularly when visual documentation is spotty, is a risky business. So is the whole enterprise of determining that a mural combining historical data, contemporary material, and postal trappings, with a piece of farm machinery thrown in for good measure, should fall into one hypothetical classification or another. Among its office files, however, the Section did leave behind a folder of miscellaneous mural descriptions containing over four hundred of the mimeographed sheets supplied to the custodians of buildings in which decorations had been placed.[55] More placards turn up in other portions of the archival record and in public buildings all over the country; there is nothing intrinsically significant about this batch. The folder does, nonetheless, provide a random sample of typological preferences. As Rowan, Watson, and Bruce consulted that swelling stack of commissions successfully retired, they could hardly have failed to notice that history was a very popular theme in Mural America. The overwhelming majority of the murals contained some fragment of historical imagery, some bit of local lore, a glance at early times, a famous forebear, or a comparison

between then and now. But among this ill-assorted lot of 415 murals were more than sixty which dealt exclusively with history, and specifically with one facet of history: the decisive day and deed that created the American hometown of the '30s.[56]

Many of these pictures reflect the prosaic side of guidebook history, albeit their creators set to work with wild and visionary ambitions. Endicott, New York, was a shoe town and always had been and told painter Douglass Crockwell so. Crockwell listened and dreamt of painting something extraordinary indeed, namely "rough columns of marching figures seen slightly from below with emphasis on the feet. The figures represent all types of humanity and indicate Endicott's field of influence through its main produce—shoes." Rowan recoiled in horror from the mere thought of all those tootsies on parade. "This type of design," he replied with heroic restraint, "would not be understood by most of the visitors to the post office."[57] The finished mural, *Excavation for the Ideal Factory* is a bit too elusive in its portrayal of straining percherons and little figures mucking about in a vast pit to grace a corporate letterhead. The topic, however, is an earnest "first" of the sort designed to thaw the chilly hearts of executive vice-presidents:

In the early spring of 1901 the Endicott Johnson Shoe Company purchased 350 acres of land in the township of Union and started erection of the Ideal Factory. The community that grew up around this building formed a nucleus for the Endicott which was incorporated in 1906. The mural depicts the excavating for the foundation of the factory, and so marks the very beginning of Endicott history.[58]

In a grindingly literal sense, then, the Endicott mural is a foundation image, one of a conspicuous number of Section murals that fasten upon the critical time and place the towns depicted came aborning. Crockwell stifled his disappointment over the hole in the ground that replaced his surreal feet, and Endicott was pleased to remember its civic conception in 1901. The foundation theme enjoyed great popular support throughout the period; towns requested the American Genesis motif often enough to give it the shopworn status of pony express riders in some circles. Rarely, of course, did people clamor for postal history. But painters reading about new murals in the Section's *Bulletins* began to cast a jaundiced eye upon history painting in general, without making fine distinctions between the kind of hard-charging history that fellow artists indifferently plucked from the official topic list and this second, constructive type that townspeople frequently imposed on artists.

Kenneth Evett's first sketch for the post-office mural in Caldwell, Kansas, was a stock-shipping scene on the order of the Purcell, Oklahoma, *cum* Jackson, Missouri, design, widely publicized in the aftermath of the 48 States Competition. Lee Pemp, the postmaster of Caldwell, took one look at it and began to see the Old Chisholm Trail above his door instead. In the annals of local history, the trail marked the start of Caldwell. Opened in 1867 through the efforts of cattleman Joseph McCoy, the route ran from Texas to a spot a mile north of the Oklahoma border, which was the terminus of the Kansas Pacific Railroad; Caldwell sprang to life there as the transfer station where the cattle began their rail trip to the Eastern markets. "When you arrive here to do this work," Pemp told the artist, "I would like to take you down where the old trail began and the view would give you more of an idea than I could describe. My idea of the mural would be a herd of cattle on the plains with cowboys driving them along a trail."[59] Evett missed or ignored the point the postmaster tried to drive home and sent Rowan another modern scene:

The subject matter of the sketch, as you see, doesn't correspond with the suggestions offered by the Caldwell Postmaster. I don't want to be uncooperative but must we do historical murals indefinitely? The concept of cowboys herding cattle is especially unexciting to me. Yet here is this Postmaster with his heart set on cowboys herding cattle. Since I'm much more interested in the mural material offered by the barn forms, the animals, machinery, plants and simple human situations . . . I made so bold as to do the sketch about these things.[60]

The mural hung in Caldwell in 1941 was precisely what Mr. Pemp wanted in the first place: *Cowboys Driving Cattle* up the Old Chisholm Trail.[61] Rowan had intervened, not because he fully appreciated the local implications of the theme but because he had grown chary of rejecting local preferences out of hand:

I think the suggestion of a herd of cattle . . . would be a very interesting subject and I am of the opinion that it would be a good policy for you to change to this subject matter since the Farm Scene which you depicted . . . is quite commonplace and the only thing that would distinguish it would be the way it is painted. We are very anxious whenever possible to give the public what they want.[62]

In 1938, Wendell Jones took the time to learn why people wanted foundation pictures. By paying attention to the views of the people of Granville, Ohio, Jones evolved a theory of the way history should be painted that remains the only cogent aesthetic manifesto to emerge from the federal mural renaissance of the '30s. And *First Pulpit in*

Wendell Jones, *First Pulpit in Granville*, USPO, Granville, Ohio. 1938. National Archives.

Granville was researched and executed under conditions that stand as a model of how mural painting was supposed to meld the interests of people and painters in a perfect world, purged of bullheaded muralists, narrowminded citizens, and bungling bureaucrats.

Jones was invited to decorate the new Granville post office via standard form letter, on the basis of sketches earlier submitted in the big San Antonio Competition. Although he lived in the mountains of eastern New York, he made the recommended trip to Ohio and conducted a leisurely investigation of the background and interests of the community. Jones discovered that the founding of Granville was an event of paramount significance to many of the residents who were direct descendents of the original settlers, and that memory of the arrival of the Presbyterian pioneers in central Ohio had been kept alive locally by a treasured history of the trek, written just after 1805 by a member of the expedition. The story of their first Sunday in the western territories moved the artist as well as Granville, and he later described the incident in an article for his own hometown newspaper:

The town of Granville was founded by about 100 young people who had sold their farms in Granville, Massachusetts, and bought land in the Liking River valley of Ohio. Their trip across the mountains of western Pennsylvania was one of considerable hardship over a period of months. Most of the pioneers were Presbyterians and were without a preacher. It is on the story of one of their group, written soon after their arrival, that the picture is based. The writer relates how the first group of about 60 arrived within sight of their new home on a Sunday in September, and how they cut down a walnut tree and with this as a symbol of a pulpit, "they sang hymns around it, weeping for joy in God's grace."[63]

Jones's mural captures the spirit of the pioneer chronicle—a tale of hardship overcome by the united effort of common folk—with an

admirable directness. The tree, which incidentally disguises ventilator openings in the wall, forms the centerpiece of the composition: the rude pulpit or altar of legend, the felled walnut is also the symbolic foundation block of the settlement. Around it, scouts and yeomen, mothers and children gather in celebration of their mutual accomplishment. Although the artist's treatment of topography and personality is generalized, a few salient details are accentuated. The tree is a botanical specimen of stout perfection. The lush vitality of plant life in general is stressed by silhouetting leaves and branches against backgrounds of contrasting tones, a method that magnifies the scale and the succulence of the vegetation. The builders of nineteenth-century Granville exist in a kind of *hortus conclusus*, an Eden of natural abundance redeemed by communal work and faith for their progeny, standing now in the post-office lobby. The enormous turkey that nearly spills out of the picture plane in the right foreground, placed in telling juxtaposition to the pioneer madonna-and-child motif, echoes this implicit theme of plenty and abundance. Within the historical world of the mural, it is no accident that every inch of space is crammed to the bursting point with ample, curving shapes redolent of luxurious natural bounty and increase. This shallow frieze of forestland manages somehow to contain a superabundance of living things: herds of oxen, many horses, and more than forty distinct individuals all conceived in terms of rounded forms, multiplied to infinity in the file of covered wagons that seal Granville off from the surrounding wilderness. The rhythmic infrastructure of Jones's style acts in counterpoint with the frontier imagery to reinforce his meaning. Granville is the ideal peaceable kingdom of dreams come true, an archetype of the land of opportunity attained through the exercise of virtue.

That the mythical dimension of *First Pulpit in Granville* answered specific, articulated community needs in 1938 is hard to determine from the correspondence; things went so smoothly that nobody found an excuse to write to Washington. But the record of interest in Jones's project supports the inference that the mural struck responsive chords in Granville. The artist's initial research and his subject choice were guided by keen local participation, and in the summer of 1938 Jones felt confident enough of his position within the community to publish his preliminary sketches in the Granville *Times* for comment and criticism. At that moment, Mrs. Mabel Evans Hite, a representative of the town's Welsh minority, descendants of a second

contingent of settlers, came forward with a story calculated to make the mural inclusive of the history of virtually all Granville citizens. One Theophilus Rees, a Welsh pioneer, had cleared land in the northeast quadrant of what would become Granville township three years before the advent of the settlers from New England. While searching for a stray cow on a Sunday morning in 1805, he was astonished to hear hymns wafting through the trees in the distance. He crept up on the band of newcomers and worshipped, undetected, alongside these speakers of a strange tongue, a practice he continued until a Welsh settlement grew up in the neighborhood.[64]

Rees was incorporated into the iconographic schema: he appears in the upper-left corner of the composition, parting a clump of bushes. The Granville *Times* had followed the thematic evolution of Jones's painting closely and reported instances of resident input, but the editor was at a loss when the time came to assess the impact of the completed mural. He called it "beautiful," as did admiring crowds in the post office, and let a quotation from Forbes Watson's letter to the local congressman carry the burden of aesthetic judgment:

I am pleased to tell you that one of the experts in the office of Painting and Sculpture regards this mural as one of the most spiritual compositions that has yet been accomplished under the program. We are confident that the finished painting will be a very moving work and will serve as an inspiration to all who visit the post office.[65]

Watson's encomium to the inspirational qualities of *First Pulpit in Granville* was itself inspired by the theological overtones of the story. The spiritual content Jones used his painterly skills to extract from the pioneer journal was neither sectarian nor ecumenical religion, however. Jones found a faith of another order latent in the popular foundation myth and in the prevailing demand for a usable people's history which sent painters like himself to guidebooks, archives, and settlers' diaries. Jones, in fact, called his 1940 essay on mural painting "Article of Faith." It was the people of today who wanted their history told, and Jones therefore opened his treatise with an acknowledgment of the artist's obligation to take contemporary circumstances into account when dealing with the pictorial past. Specifically, he referred to the twin specters of Depression and impending World War:

These are such distracting times that the artist who has always dealt with the aspirations and hopes of man is suffering from palsied inspiration. Fear grips the

whole world. The sense of continuity is broken. The future is uncertain to a degree that few generations have ever experienced. . . . Compared with the new morality of total war our old virtues have the smell of the sacristy. A way of life is breaking up and those who have the fibre to hope for good dread the chaos of its destruction.[66]

As a painter, Jones looked first to abstract form—to style—for a weapon against chaos. Style became a tool with which to propound answers to social questions of the day:

The design is the battleground, so to speak, of the artist's struggle. . . . I am thinking only of the abstract design underlying or embedded in the forms. Turned upside down or sideways, it still has the unbalanced balance of forces or volumes which must hold the peak of the emotional disturbance. But it must be controlled because without control it is as formless as a shriek in a public place. It is simply a stimulant without solution.[67]

For Jones, then, the painter's social obligation to the people with whom he worked to create a piece of public art began with a diagnosis of crisis conditions. The mural proper aimed to come to grips with those circumstances; it was not a warning "shriek in a public place." His halting formulation of a theory of contemporary epic painting merits attention because Jones pinpoints the dynamic, positive aspects of what the 1930s hoped to accomplish through the iconography of the historical creation myth:

Mural painting seems to me to give the opportunity to paint symphonically, a range of great scope being possible on one surface. The building itself is the frame and the surface, and only the epic seems worthy of such dimensions. It challenges the broadest spiritual awareness. The building itself is part of the life of the community. The painting, therefore, must be contemporary and rise out of the spiritual reservoir of that community—a reservoir consisting of nothing more than an unrecorded Indian battle that was fought along the river long ago. Even the statistics of local industry seem to develop into the reservoir from which people get their sense of continuity and self-esteem and faith. It is often evident that the artist has searched the personality of a community and brought forth a costume piece, so difficult is the task of being contemporary, especially when the din of destruction is destroying the sense of continuity. I believe that mural paintings must explain themselves on such common ground with the on-looker that only a title is necessary, if that, to make it understandable and stimulating to a great range of reflection. Epic *and* contemporary. It is perhaps impossible. The spiritual reservoir of society has countless memories which have given man faith, courage, strength and a sense of the abiding goodness of life. But what is the contemporary part? It seems to me that for the muralist it is the pageant of social intercourse, not the self-conscious and heroic but the simple functions of man's contact with man in cooperation and trust. These are contemporary epic possibilities. The brotherhood of man can weather another storm.[68]

Jones's thesis shows how the social concerns of the New Deal artist, in their raw, preconscious simplicity, can confound the tourist of today looking for breadlines, raised fists, and messianic FDRs on the post-office wall. The sense of crisis that afflicted the artist and the people he aimed to serve struck at the fundamental roots of emotional life, far beneath a surface ruled by the laws of politics, economics, or cause and effect. That a specific system has failed and why it failed are documentary insights of little use to Wendell Jones in his attempt to cope with a different order of truth, derived from an empathetic comprehension of basic human needs. The values he felt compelled to defend in the face of national upheaval—the values of "continuity and self-esteem and faith," of "cooperation and trust" —are primitive ones. Creation of the epic mural is likewise a ritual act, a rite of "spiritual awareness" invoking a community gestalt to insure psychological and physical survival. The muralist, to be sure, makes his or her start on the familiar terrain of the usable past, but only because the past is the "reservoir" of a shared, ongoing community life; hence the conventional content of the Granville mural, with its costume pageant of the Protestant ethic. If *First Pulpit in Granville* is interpreted exclusively at the level of conventional meaning, then Jones can be charged with guidebook naivete for his apparent "article of faith" in the efficacy of good old-fashioned American ways. The intrinsic meaning of the mural is not governed by the doings of Theophilus Rees or the migration of 1805, however, nor was the mural adjudged "beautiful" for those factual tidbits. The intrinsic level of content is, on the one hand, more generalized: Jones presents a timeless, time-defying vision of the good life arising from the brotherhood of man, in the guise of Ohio history. The turkeys are plump, the babies are fat, and life is wonderful. That level of content is, on the other hand, more elemental: the archetypes and formal rhythms Jones emphasizes address bedrock issues of survival, continuity, and stability. In effect, then, the epic mural adopts the viewpoint of ordinary people experiencing the world of the late '30s and so responds openly to the experiential dimensions of crisis—to human fears, anxieties, and uncertainties. Talismanic symbols of abundance cannot root out the cause of crisis or put a turkey on every Thanksgiving table, but they can ease spiritual pain. Representations of dynamic homesteaders claiming the fertile landscape are confessions of a primary preoccupation with survival. Objectified pictorially, fears of social paralysis and want can be released, externalized, and mitigated.

Wendell Jones, *Barn Raising*, USPO, Rome, New York. 1942. National Archives.

The mural becomes an emotive, mystical act of faith in America's capacity to survive.

Wendell Jones painted a fine and lovely mural in Granville, Ohio. Public interest helped Jones, but the public did not consist of a monolithic slice of a census report queued up outside the post office to intone the legend of the pioneers like the chorus that helped Paul Robeson recite his capsule history of the "Spirit of America" in the 1939 radio broadcast of *Ballad for Americans*.[69] Jones attended to a journal kept by an individual who wept "for joy in God's grace" and to the local historians who prized it; he appreciated descendents' memories about Theophilus Rees all the more because, as they told their stories, "here was a definite person"; Jones talked to a postmaster, a librarian, and Mrs. Mabel Evans Hite.[70] The way people felt counted, and it was on that experiential basis that Jones painted his Granville mural and evolved his theoretical approach to painting the contemporary epic. The epic mural was a pictorial assertion of continuity. It recognized that how people thought about themselves and their past was the true content of history painting. But people, as Jones learned in Rome, New York, are not always warm and open and trusting of a painter with good intentions. In the summer of 1940, just after he wrote "Article of Faith," Jones spent time in

Rome, as he had in Granville. His trip disclosed neither unanimity of community opinion about a topic worth painting nor a historical fact of overweening significance. Indeed, Jones could persuade no one to show much interest in his assignment. He "toured the countryside extensively," took a long look at the new post office and went home to paint *Barn Raising*:

The Post Office in Rome is a delicate Georgian Colonial—nostalgic colonial—so the mural is "nostalgic." I try to give the burst of vitality of those days of expanding economy and optimism. My own house was once a barn built in the last century at a Bee—the timber structure [pictured] is authentic.[71]

The theme was the beginning of a community built by cooperative effort. *Barn Raising* is a generic foundation image that, if it lacks the temporal specificity of the Granville mural, does so because the artist was cast back upon his own resources by local indifference. Lacking a human sense of Rome's concerns, Jones took the "nostalgic colonial" post office as his symbolic and aesthetic link to the heart of the modern community. "Article of Faith" discussed the architectural ambiance of the mural with a sensitivity rare among painters of the '30s, who had little mural experience and were content, for the most part, to paint enlarged easel pictures. In Rome, Jones used the relationship between architecture and mural decoration to carry the weight of the continuity message and to make that intimate connection between art and the people he had failed to establish in person. The mural was to occupy one end of a cavernous lobby. The surface he was to decorate was broken by an open flight of stairs at one side, a deep recess for bulletin boards at the other, and the overhanging entablature of the postmaster's door in the center. His solution to the problem of relating the mural to the structural framework of the building was nothing less than inspired.

Jones capitalized on the fact that the stairs led to a room over the main lobby, directly above and behind the doorway. On this second floor partition, he showed the forward framing of the barn wall, flush with the inside wall of the post-office lobby and complemented by the rear supports for the barn, rising in exact perspectival harmony with the space occupied by the real upper chamber. Thus the image of a nineteenth-century building project recreates pictorially the actual spatial configuration of the pseudo-nineteenth-century Rome post office in 1942. At the lobby level of the partition, the continuity between the painted past and the real present becomes even clearer. One of the floor beams of the barn projects illusionisti-

cally over the group of pioneer women preparing supper to precisely the same depth that the molding overhanging the postmaster's door projects into the lobby. Jones was perfectly aware of what he had done in peeling away the plaster of the post-office walls to expose the beams and joists of history. In a joking allusion to the practice of paying muralists by the square foot, he suggested a new rate to Rowan: "Some people paint by the yard—that's profitable. This one is by the cubic yard, and nearly killed me."[72]

The cubical illusion replaced the steel I-beams of the post office with the oak timbers of the old barn; the farmers building the Rome of the past also erect, as the spectator looks on, the modern structure in which he and they stand together. Mohawk Valley pioneers build a future neither they nor their audience need trust to the imagination, because the future is absolutely real. Only the thickness of a brushstroke stands between Rome's founders and people going about their errands today. The neighbors who help neighbors and eat pie for dinner might, at any moment, pop out of time, take a place in line at the Special Delivery window, and mingle with other neighborly folks who like pie, too.

The postmaster of Rome, "a coarse gentleman named O'Shea," was not charmed by Jones's contemporary epic with its pictorial "article of faith" in forever, and he wasted no time lounging outside his door mulling over continuity, self-esteem, hope, or the abiding goodness of life. He was merely annoyed that scaffolds had cluttered his lobby. O'Shea attended the ceremony at which the mural was unveiled but scowled fiercely at the wall throughout.[73] The Rome *Daily Sentinel* covered the event, interviewed Jones, and remained sullenly skeptical about the value of the work:

The artist said he studied post office architecture and Mohawk Valley history closely before he set to work. Since the brick building is colonial in design, he said, he figured Rome's prevalent brass and copper mills would be anachronistic and an earlier rural scene more appropriate. His picture shows a group of farmers hoisting hand-hewn timbers into place on a raising bee. Their wives nearby tussle with a bright table cloth, getting together a picnic in a spanking breeze against a background of sun-flecked rolling hills and tethered horses. Jones expressed hope that his painting would bring home the point that "people got along only because they worked together a lot more than they do now!" Even today, he said, people here in the country know a lot more about cooperating than their city cousins. Rome residents, living on a wide flat plain, may wonder about the hills in Jones's mural. The artist said he had toured the countryside extensively and located his picture . . . above Lake Delta, where the hills are "gorgeous."[74]

Jones left for home the next morning as a *Sentinel* editorial took a second look at the mural and to the delight of T. V. O'Shea found it wanting:

It is saddening that the government should have agreed to pay out its good money for a mural painting in the Rome Post Office reputedly representing such a commonplace agricultural affair as a barn raising . . . as common to New England as to New York.[75]

Besides, barn raisings had always been notorious excuses for drunkenness and dissipation and were not in the least edifying. What did Rome want for the $1,400 the Section squandered? A picture of the copper mill, perhaps? In the spring of 1942, war workers were putting in double overtime. No, indeed. The *Sentinel* lamented the fact that Jones had not painted an "important," exciting historical event, unnamed and certainly never mentioned in the artist's hearing while he scoured Rome for inspiration two years earlier. Better still, why not the life of the Mohawk Indians?

Whatever ailed Rome in 1942 could not be cured by visions of bounty and brotherhood. The works and pomps of the New Deal had never bamboozled upstate New York, but after Pearl Harbor the mural program came under attack from every side. "Due to the urgency of the emergency," the Treasury canceled Section commissions for which firm contracts had not been signed.[76] Artists put down their brushes and joined the army; Rowan's arguments seemed frivolous and irresponsible to Brooklyn Draft Board #217, hearing the case of young Abraham Tobias, who was painting a pioneer mural in Clarendon, Arkansas, and needed a month to finish the job. "We feel," stated the examiners, "there is no reason for us to defer induction to the Armed Forces of this man as we feel he is more important serving his country than painting murals."[77] And towns decried wanton expenditures on art when "the funds allocated for this purpose" were better spent "in some urgent defense need."[78] In the palmy days of 1939, however, Rome's ostensible fascination with Indians would have struck towns of the Southwest as peculiar, because the subject smacked of war and bloodshed whereas history, in 1939, was meant to instill the softer emotions Jones prescribed as an antidote to crisis.

Seymour Fogel won the 48 States Competition for Safford, Arizona. That was no mean feat: fifty-eight drawings were in the running and the quality of the work was high.[79] Murals in Los Banos, Schuyler, Yerington, and New Rockford, North Dakota, began life

Seymour Fogel, 48 States sketch for USPO, Safford, Arizona. 1939. National Archives.

as Safford entries. Fogel's sketch depicted "Indians of the Southwest doing a traditional ceremonial dance."[80] It was, without question, the closest thing to outright abstraction approved by the Section to date. Dancers at either flank of the composition bear the marks of linear perspective but are, in fact, the same figure simultaneously shown from front and rear views in the Cubist manner. The masked priest in the center is a hybrid; he has volumetric legs, but his upper torso, arms, and head are totally flat, indeed arbitrary, shapes. The background and the shadows cast by the Indians are also organized in terms of planar forms, some of which, like the bright area to the left of the axial priest, have lost any connection with the objects they purport to picture. Boris Deutsch, another 48 States winner, picked a similar theme for the Hot Springs, New Mexico, post office and gave his dancers a bizarre touch of surrealist angst muddled by leaden humor: his panic-stricken chieftain dances out of the path of the Santa Fe Super Chief locomotive.[81] In both instances, the inspiration behind the designs was the indigenous art of the Southwestern Indians. Deutsch and Fogel abut large and small figures without regard for their relative spatial positions, as though the Indians were decorative patterns on pottery. The flat, angular shapes of Fogel's composition suggest Pueblo textiles, and given the Section's horror of radicalism, it is safe to assume that the look of Indian ceremonials determined the jury's choice, and obscured the wayward Cubism of the conception.

Fogel's decorative arrangement promised to become an excellent mural, on technical grounds alone, for the flat geometric patterns harmonized with the starkly moderne style of the Safford post office and the smooth band of plaster that coursed above the dado containing the usual complement of doors and service windows. The

problem with the design promised to arise from its muralistic virtues. The decorative integrity of the composition minimized its narrative potential. Sketch #1214 seemed to have no fascinating story to tell, at least until the Graham County, Arizona, Chamber of Commerce conducted its monthly meeting in December of 1939 over a copy of *Life*. As far as Safford was concerned, the story was the only issue. The Indian dance did not "properly portray anything pertinent to this vicinity" and was, instead, "obnoxious and unpleasant":

A straw vote taken among the civic leaders of Safford reflects a decided sentiment in favor of a mural portraying either an agricultural or pioneering scene . . . [This] is strictly an agricultural community which was settled by Mormon pioneers. In their early struggles so much trouble was encountered with the indians, whose chief was Geronimo, that any thought of depicting their chief enemy in their public building is distasteful to this generation, many of whose parents were either slain or cruelly treated by the indians.[82]

In vain did the artist swear that he had not painted Apaches and that his dance was a peaceful one, based on authentic factual material "gathered at the Museum of the American Indian" and substantiated by "a report written by Captain John G. Bourke, of the Third Cavalry, United States Army, in 1887, for the Smithsonian." "My sole purpose," he told the Section ruefully, "was to design a panel that was colorful and which would be adaptable not only to the building but also to the surrounding country. Indians suited all three requirements admirably."[83] In vain did the Section attest to the "high aesthetic merit and monumental qualities of the design" chosen "with the understanding that a peaceful scene, symbolic of dancing Indians, would be perfectly appropriate for the decoration of this Federal building." Indeed, Rowan's pledge "that no reference will be made in the mural to Geronimo" only made matters worse.[84] Senator Carl Hayden read the Section a brutal lesson on Arizona's heritage:

The Safford Valley was the center of the most serious, bloody, and longest continued Indian depredations in the history of the United States, and the people who live along the Gila River do not regard the Apache Indian as a thing of beauty but as an abomination upon the face of the earth.[85]

The Chamber of Commerce cared nothing for monumental qualities and resented the New York artist's unilateral choice of a theme about which the local community, contrary to the *Life* report, had not been polled:

The high regard held by the jury for the aesthetic merits found in the choice does not prevail among the people of this community because of their knowledge of the Indian. This knowledge overshadows any of the heroic, and glamour seen in him by others. His dance to us means but one thing, not peace but a sharpening of his emotions for another raid upon the lives and the property of the white man whom he has always held in contempt. . . . We live too close to the Reservation—know too much about the Indian, have seen too much of his real character, know too much of his historical background and this is too fresh in our memories to permit us to admire him. With all this we do not want to perpetuate the Indian's memory in the one building to which most of us will have to go every day.[86]

The vehemence of these responses shows that Fogel's proposed mural amounted to a "shriek in a public place." In a generic sense, Indians in the Safford post office evoked a state of crisis whereas in a specific sense, the symbol focused civic distress on the racial tensions that continued to plague Arizona history. The past, the present, and so the future were thrown into jeopardy by a disembodied entity called "the Indian"—the dark force, the abstract other. Neither the decorative reticence of the design nor the suave balance of planar forces resolved the "emotional disturbance" unleashed. Jones's theory, therefore, must be qualified by the overriding tendency of the mural public to stop short at the narrative content of the image. Jones had mentioned an "unrecorded Indian battle" as a possible "spiritual reservoir" for community memories of a positive sort, and Indians did not automatically trigger terror in Pascagoula and Delmar. Fogel thought, fleetingly, that all would be well if he convinced Safford his accurately drawn Indians were peaceable sorts. Indians often enough suggested a Jean-Jacques Rousseau idyll even when they did not carry symbolic peace pipes. There is nothing threatening about the eponymous squaws who demonstrate "the process used by the Iroquois Indians in making corn meal" in Honeoye Falls, New York, or the "Indian who offers a prayer of thanks for the corn harvest" in Sigourney, Iowa.[87] Both these murals show constructive, even pious, horticulture akin to the agricultural pursuits still characteristic of the towns involved. Beyond that, facts about the Indians depicted have almost no bearing on contemporary issues, save perhaps on the tourist trade drummed up by the Indian silhouettes which advertised rustic campsites strewn from the Finger Lakes to the "Wigwam Village" motor court in Bardstown, Kentucky.[88]

Indians on the warpath were generally most acceptable when they

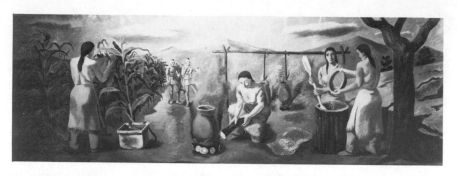

Stuart Edie, *Iroquois Indian Panel*, USPO, Honeoye Falls, New York. 1940. National Archives.

bit the dust. Rowan fought a long and losing battle of his own against a persistent town historian in Greensboro, Georgia, who demanded an additional mural after one showing "two pickaninnies . . . wrestling with a large slice of watermelon" in a cotton field had been installed without incident.[89] Dr. T. B. Rice, who was a self-confessed "crank" as well as a popular and garrulous columnist for the Greensboro *Herald-Journal*, demanded a picture of an horrific Indian attack which had occurred in the summer of 1789 on the site of the new Civic Auditorium. As Rice told it, the Indians "set fire to the fort, surrounded the village, stampeded the citizens, killed and wounded men, women and children, and set fire to every house in town."[90] The Section had previously nixed this theme. "We are not interested in promoting scenes of warfare, Indian or otherwise," Rowan curtly informed painter Carson Davenport.[91] But Congressman Paul Brown and the local chapter of the DAR, harassed for historical backsliding with every issue of the *Herald-Journal*, eventually harassed Washington, and funds were found for the second painting. Caught between Rowan's official pacifism and Rice's lip-smacking delight in mayhem and gore, Davenport trembled every time the historical script required him to wound a participant. "I could revive him," he wrote, concerning one Sam Dale, who was a stellar hero in Rice's books, "so he would be leaning on one elbow and possibly firing with the other hand (pistol)."[92]

Early History of Greensboro mirrors the artist's confusion. The foreground gives the Indians free rein to commit bloodcurdling acts of violence while in the right background, Sam Dale and Peter B. Williamson, despite grievous wounds, deliver the guilty marauders to the Green County militia and thus to their timely ends. And that, of course, was the point of T. B. Rice's novella-length commentary, mounted beneath the mural alongside a "copy of a letter from Gov-

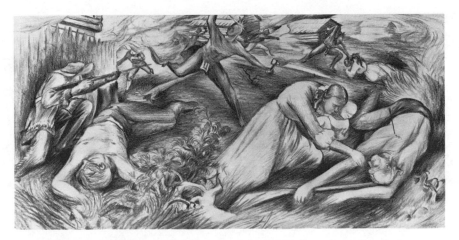

Carson Davenport, preliminary pencil sketch for USPO, Greensboro, Georgia. 1938. National Archives.

ernor George Mathews to the . . . President of the Continental Congress notifying him of the destruction of GREENSBORO, GEORGIA by the Indians."[93] This battle, unrecorded no longer, was a spiritual reservoir for the proud descendents of the courageous settlers who won. Like drought or a plague of seven-year locusts, the Indian was a natural obstacle overcome by the pioneer builders of America.

Along the Eastern seaboard, Revolutionary history was so familiar that painted Indians could win a battle or two. Everybody knew that they lost the war to the minutemen of Painted Post, New York, where Amy Jones illustrated the chilling tribal method of *Recording the Victory*, for which the town was named:

During the Revolution, a war party returns to Painted Post with captives and booty. The Indian Chieftan records the victory on an oak post which has been stained red with the juice of wild strawberries. Each cross represents one of the enemy. Those shown with heads mark the number captured and those without heads represent the number killed in battle. The captive soldiers depicted here are from a Pennsylvania regiment.[94]

But the Indians faded into the forests, leaving behind only a place name to which a tinge of derring-do still clung by gracious leave of the pioneers who swept their adversaries aside and built a town in the Southern Tier. And the eighteenth century was a long, long time ago; nobody in Greensboro or Painted Post woke to nightmares of parents slain by the woodland tribes.

In Safford, peaceful poses and aesthetic harmony could not silence

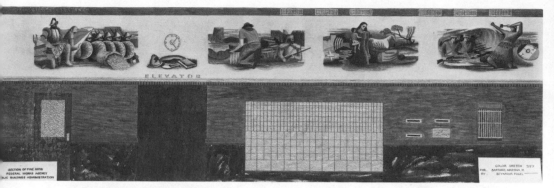

Seymour Fogel, compositional sketch for USPO, Safford, Arizona. 1940.
National Archives.

the instinctual shriek of alarm set off by a theme which meant distress, caused distress, and revived distressing memories. Fogel grudgingly accepted the inevitable and prepared to "placate the citizens of Safford with a panel based on the early days of the pioneers, or whatever they think they can digest."[95] That the poll taken by the Safford Chamber of Commerce in the throes of a civic crisis disclosed a spontaneous preference for a pioneer theme proves Jones's iconographic insight true. The continuity, stability, and faith implicit in the genesis story relieved the emotions experienced in crisis and appealed all the more strongly, then, under conditions inimical to self-esteem and serenity. Fogel never understood the cultural dynamic at work in Safford, particularly since pioneering seemed destined to raise the specter of the Apache once again. His revised drawing, submitted in April of 1940, aimed "not so much to accent the hardships encountered by the first settlers, but rather," according to Safford's wishes, "to bring out the great courage of the people who settled the southwest." He wanted the new picture to symbolize both the people "who opened Arizona to later settlers" and their modern descendents, and "a typically American approach to a problem which requires courage." So far, so good. The positive orientation broke down, however, in the details scattered about the pioneer family:

I have suggested the trials and hardships by the use of easily understood symbols. In the left hand corner of the sketch, half buried in the sand, is a broken wagon wheel, which explains why the family is on foot. The rude cross, made of a wagon tongue, suggests that the west was settled by the strong.[96]

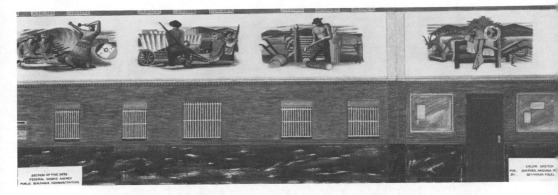

Seymour Fogel, compositional sketch for USPO, Safford, Arizona. 1940.
National Archives.

These symbols easily suggested the Apache menace, of course, and when construction plans for the post office were altered early in 1941 to permit seven vignettes to be painted directly on the wall of the building, with an audience in attendance, Rowan found himself censoring designs that he liked very much to skirt a controversy Fogel could not seem to anticipate.

In place of the pioneer family, Fogel outlined a historical sequence that "paralleled the history of the American Indian" and included an Apache vignette. The Indian with his tomahawk is being brought down by a legion of riflemen, but Rowan still told Fogel to scrap that panel, in the interests of "better spacing." Fogel, in turn, was amenable but puzzled: "At this point our red skin brother has really become the vanishing American!"[97] He was dismayed, too, by changes mandated for *Early Pioneers*, a scene consisting of a bereaved widow with her orphan child, "the charred wagon, the menacing smoke signals and the man lying pierced by an arrow," Fogel's painful "summation of the hardships of these first restless families who sought a new home."[98] Fogel was brusquely ordered to get rid of the smoke signals and cheer up the mother. As things stood, the prone male figure could be mistaken for a sleeping pioneer, if one overlooked a fragment of protruding arrow feathers, and if the woman looked less striken, Rowan reasoned, maybe the Apache reference would pass muster.[99] And so it did, in a busy, prosperous saga of the settlement and building of Safford. As the homesteader sleeps, brave conquistadores march past but conquer nobody. Pioneers camp safely beneath prairie schooners with snowy white sails. Miners pan

229

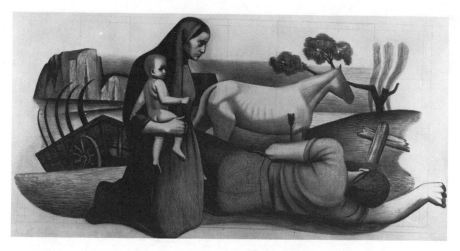

the streams, and riches leap into their hands. Folks cut timber for
their lovely new homes. The saddle and the plow—fat steers and
rolling fields—describe the abundant *Fruits of the Valley*.[100]

The History of the Gila Valley is a rite of community exorcism, al-
laying self-doubts and healing the invisible wounds of conflict. On
the post-office wall, in a land of safety and plenty, the pioneers lay
the sturdy foundations of the good life to come. The mural cycle is
an "article of faith" in Safford. It is also a usable history, revised,
amended, and edited to purposeful ends. It is present history, painted

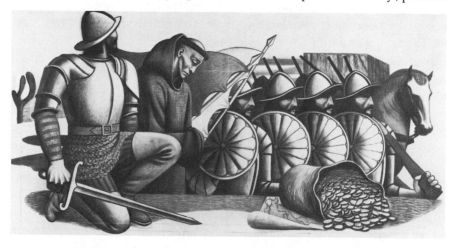

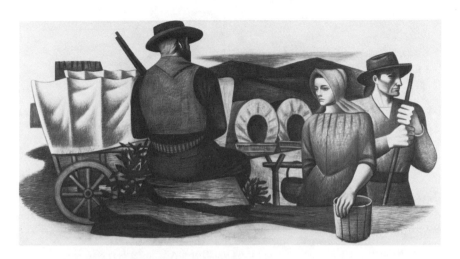

Seymour Fogel, cartoon for *Migration*, USPO, Safford, Arizona. 1941.
National Archives.

for a people who did not, as Kazin believed, cherish guidebook antiquarianism for the sake of "all the small-town financiers who guessed wrong, all those who groped toward riches that never came," or those who fell to the Apache. Safford is not Eldorado, but neither is it a ghost town, a scene of furtive failure and defeat. If Safford today is not as prosperous and tidy and serene as the Safford the painted pioneers found yesterday, it will be: the usable past is the psychic blueprint for the home of the future.

In February of 1949 the General Counsel of the Artists Equity As-

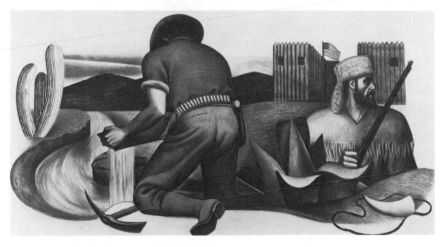

Seymour Fogel, cartoon for *New Lands*, USPO, Safford, Arizona. 1941.
National Archives.

Seymour Fogel, cartoon for *Home*, USPO, Safford, Arizona. 1941. National Archives.

sociation wrote to the Commissioner of Public Buildings about a mural cycle stored for the past five years in the cellar of the Hutchinson, Kansas, post office. These were the eight panels painted for Salina, Kansas, in 1941. Like the Safford murals, this cycle traced the exploration of the region and the accomplishments of the pioneers to a fruitful conclusion. History and it prognostic fulfillment were to have bracketed the lobby, with *Early Settlers* on the west wall answered by lush contemporary *Wheat Fields* on the east wall. In between came *Drought*, *Flour Milling*, *Coronado*, *Juan Pedilla* [sic], *Salt*

Seymour Fogel, cartoon for *Fruits of the [Gila] Valley*, USPO, Safford, Arizona. 1941. National Archives.

Isobel Bate, with Harold Black, cartoon for *Tornado*, USPO, Salina, Kansas. 1942. National Archives.

Mines, and *Tornado*, in that order. Placement should have told a story here, too, a tale of obstacles overcome today and yesterday and gains always registered since the moment when the Spaniards first caught sight of the fertile Kansas plains. Isobel Bate and Harold Black had visited the new Salina flour mill and the salt plant nearby while preparing their cartoons. Father Padilla and Coronado were included because both were commemorated in Kansas in the summer of 1941 by "the Coronado celebrations which traveled up the Southwest last year."[101]

One might have questioned the wisdom of stressing a wrathful nature always ready to smite Salina, and the decision to represent its effects by two women, a modern mother with her dress open nearly to the waistline and a lady of the '90s clutching her ample left breast

Isobel Bate, with Harold Black, cartoon for *Drought*, USPO, Salina, Kansas. 1942. National Archives.

for no apparent reason. When Herschel Logan, a Salina printmaker, went to New York City to preview the panels on exhibit at the Architectural League, he was not impressed by Edward Alden Jewell's review, which praised the "freshness and expert handling" of the decorations, nor by the "efficiency and skill" detected by the *Herald Tribune*, which called the muralistic effect of the grouping "fluid and gracious."[102] In reference to the storm, the dust, and the females who contended with them, Logan told the papers back home that "it would be hard to conceive how so much bad taste, grotesque drawing, and libelous figures to represent Kansas could be crowded on these several canvases."[103]

"Because of strong opposition" and threats that "the post office pens will dig and scratch, as they are wont to do, and throw large gobs of thickened ink and blot out these parodies on our people and their activities," the murals were hidden away for the duration.[104] In 1949, the artists retained counsel and reopened the issue:

The time has now come when these murals should be installed. The reputation and professional standing of the artists is at stake. It is important for the artists that a major work of this character should not be allowed to lie around in a basement.[105]

Rowan was long gone by then. Bruce was dead, and the Section was a collection of files gathering dust in a storeroom. There was nobody left to speak up for the painters and no one to strong-arm Salina into joining the ranks of the mural renaissance. The Commission of Fine Arts heard the case, in the absence of any other federal agency

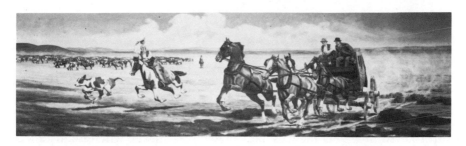

Albert T. Reid, *The Romance of the Mail in the Old Cattle Country*, USPO, Sulphur, Oklahoma. 1939. National Archives.

charged with passing judgment on art in the post-war era. The government had paid for the murals in 1942, and tenuous though their jurisdictional authority was in matters of art for Kansas, the members of the Commission forbade public exhibition of the canvases, had them shipped to a vault in Washington's National Gallery of Art for a private inspection, clamped a tight lid on publicity, and voted to consign the vignettes to limbo in perpetuum: "After viewing the murals on June 21st, the Commission recommended that inasmuch as these paintings are not acceptable to the people of Salina . . . they should not be hung."[106]

The Salina case was a complicated mess from the beginning. A Missouri artist won a regional competition for the Salina post-office award in June of 1939, but six months later a runner-up in the St. Louis Competition was appointed in his stead.[107] He vanished, too, somehow, and by the time the husband and wife team of Black and Bate headed for Kansas in June, 1940, on the strength of his Mississippi and her New Jersey submissions in the 48 States contest, things were already getting ugly in Salina.[108] The Salina *Sun* resented the fact that the job had finally fallen into the laps of outsiders and was suspicious of "the average New Yorker's absurd ideas on Kansas."[109] And on the fringe of the action, being oh-so-helpful to the city fathers and smoldering with private resentment at losing the Salina commission, lurked Albert T. Reid, a Kansas painter who had done three Section murals and was contriving to snatch this one from the city slickers by means fair or foul.[110] His chatty and seemingly casual note to Rowan showed that Reid had the ears of the principal protesters: Mr. Laubengayer, publisher of the Salina *Journal* and owner of the local radio station; Mr. Schwartz, an amateur painter and head of "the largest wholesale hardware concern in the west"; Mr. Logan, New York spy for the group and art director for a big commercial

printing house; Mr. Bailey, a strong contender for the gubernatorial chair; and Congressman Frank Carlson. These guys, Reid said, were "your kind of people"; there was nary an agitator or a rabble-rouser in the bunch. "Considerable feeling" existed in this coterie about the long-delayed decoration of the Salina post office, and Reid also let it slip that some Salina bigwigs had traveled to Olathe when he installed his mural there to find out "how one went about it to get these western paintings." Just to please such nice folks, Reid had made a set of sketches for the Salina post office and was sending them along. If anything should happen to go wrong with those New Yorkers—God forbid—well, he wouldn't be too proud to step in:

The sketches they were interested in were of their country, which of course is my country. One was the building of the Union-Pacific which goes through there —an episode—indians riding around the short construction train, a battle in progress. At Victoria, a few miles away, is a little picket fence grave yard with the seven casualties of the fight, when the rails were being laid to carry the mail that was then going by overland stage. Another was "Commerce Starts on the Old Chisholm Trail" (First Cattle Drive). The third is "The Coming of Coronado" in which they are at present very much interested as old Coronado went right across there 400 years ago this coming spring. . . . If there is any way to switch the chap who has this to another spot and consider my sketches I am sure you will bring joy to these people out there.[111]

It is fair to conclude that the local drive for a historical theme began with the Reid sketches circulating in Salina while the Blacks were touring the new flour mill and sketching modern passersby. Charles L. Schwartz, the hardware magnate, had seen them a full week before Reid wrote to Rowan; Schwartz used those Wild West images to urge the appointment of the Kansan "to portray the real West in the manner that would please our people":

From photographs that we have seen of his designs . . . we judge him to be in the first rank as an artist and ahead of anyone in his knowledge of the history of this section, and as one remarked last night, he might be counted as a worthy successor to another great artist, Frederic Remington.[112]

By changing their program to a historical saga and incorporating Coronado, the Blacks diffused Reid's bombshell and answered the local demands relayed to the Section by the bagful. Yet when the postmaster, with the unanimous backing of civic leaders, refused to allow the cycle to be installed, its historical focus had ceased to be consideration. It was the women of today, depicted in the murals and in a Harold Black drawing of a Kansas farmyard in *PM* magazine, that was the sorepoint. Prevailing standards of beauty and womanly de-

corum made the Salina cycle "an out and out insult to the fine farm house wives of Kansas and the Middlewest."[113] The past was usable and benign; the present was dangerous, particularly when a contemporary scene held a mirror up to a Mural America populated by the lean and the stout, the matron and the floozie, the ideal and the typical. "You will be a sick lot of people if you have to look often upon this insulting and sickening lot of color and colic," shrieked a Kansas taxpayer abroad in a public post office and apoplectic with rage at what he saw there.[114] Even a damned fool from New York City ought to know that folks have feelings: today is just as lovely as yesterday always was.

NOTES

1. "Descriptions" for Ejnar Hansen, Lovelock, Nevada, post office and agriculture building (1940), 135 (Box 203).

2. Betty Carney to Rowan, February 18, 1940, comments on proposed sketch "C," 133 (Box 52).

3. Carl E. Berkman, Postmaster, to FWA, February 5, 1941.

4. Jane and Michael Stern, *Amazing America* (New York: Random House/David Obst Books, 1978), p. 293. I am grateful to Timothy Garvey for discussing his exhaustive research on '30s folk and tourist sculpture in Minnesota with me.

5. Alfred Kazin, *On Native Grounds, An Interpretation of Modern American Prose Literature* (Garden City, New York: Doubleday Anchor Books, 1956), p. 393. Kazin's book was originally published by Harcourt Brace & Co. in 1942.

6. Writers' Program of the Works Projects Administration in the State of Ohio, *The Ohio Guide* (New York: Oxford University Press, for the Ohio State Archaeological and Historical Society, 1940), p. 374.

7. *The Ohio Guide*, p. 376.

8. Federal Writers' Project, Work Progress Administration, State of New York, *Rochester and Monroe County, A History and Guide* (Rochester, New York: Scrantom's, for the City of Rochester and the Genesee Book Club, 1937), pp. 98-99 and 357.

9. *Rochester and Monroe County, A History and Guide*, pp. 90-93.

10. Kazin, quoting Cantwell, *On Native Grounds*, p. 393.

11. Federal Writers' Project, with the Federal Art Project, *American Stuff, An Anthology of Prose and Verse* (New York: Viking Press, for the Guilds' Committee for Federal Writers' Publications, Inc., 1937). This volume was illustrated with FAP prints.

12. *Rochester and Monroe County, A History and Guide*, pp. 73-78.

13. "Descriptions" for Fred G. Carpenter, Paris, Missouri, post office (1940).

14. "Descriptions" for Arthur Covey, Torrington, Connecticut, post office (1937), *Episodes in the Life of John Brown*. The first panel shows his boyhood life; Brown was born in Torrington on May 9, 1800. The second scene shows Brown, at age 38, making his first public speech on the slavery issue. In the center panel, Brown is surrounded by a group of slaves he kidnapped from their masters and, in an 82-day trek, moved from Missouri to Canada. Covey took his story in part from Oswald Garrison Villard's *Fifty Years After*.

15. "Descriptions" for Ralf Hendrickson (also spelled Ralph Henricksen), Monroe, Michigan, post office (1938).

16. "Descriptions" for Edna Reindel, Swainsboro, Georgia, post office (1939).

17. "Descriptions" for Birger Sandzen, Halstead, Kansas, post office (1941).

18. "Descriptions" for Roland Schweinsburg, Alexandria, Indiana, post office (1938).

19. "Descriptions" for William Dean Fausett, Rosenberg, Texas, post office (1941).

20. "Descriptions" for Avery Johnson, Bordentown, New Jersey, post office (1940). This was a 48 States design. According to *Life*, "Mural America," p. 13, "Avery Johnson's winter scene is a rollicking skating party on a pond in Bordentown."

21. "Descriptions" for Elizabeth D. Logan, Akron, New York, post office (1941).

22. "Descriptions" for Sol Wilson, Delmar, New York, post office (1940).

23. Lorin Thompson to Rowan, March 22, 1939, 133 (Box 55).

24. Arthur V. Smith, Postmaster, to Rowan, November 6, 1939.

25. Smith to Rowan, July 20, 1939, and "Descriptions" for Lorin Thompson, Pascagoula, Mississippi, post office (1939). It is instructive to compare the text of the description supplied to the local post office by the Section with the Thompson letter from which it was drawn:

The old Indian legend of the Singing River has been chosen as a subject for this mural. According to the legend, the Pascagoula Indians were almost entirely wiped out in a battle with the Biloxis. The Pascagoula women, children, old men and such warriors as remained, rather than become the slaves of the Biloxis, formed a procession and walked into the river, while chanting religiously. The river swallowed them up and ever since that time a humming sound has emanated from it each evening.

The artist's letter is quoted almost verbatim and corrected with data supplied in Smith's letter. This shows one use to which the case files kept by the Section were put and reveals the tedious process Watson followed in extracting data from the files and squaring information with photographic records of the finished murals as he prepared the official descriptions. Preparation of descriptions was a minor part of the Section's mission, but does show that the bureaucrats did not require all that data from artists on a whim.

26. Smith to Rowan, November 8, 1939, and Thompson to Rowan, September 28, 1939. The artist had already heard about the moss and feared that a "healthy controversy" was brewing. He justified the omission on compositional grounds: "I wanted no vertical Spanish moss in my design."

27. Smith to Rowan, July 27, 1939.

28. The study for *Postman in Storm* by Robert Tabor is illustrated in Bruce and Watson, *Art in Federal Buildings*, unpaginated plates.

29. "Descriptions" for Stevan Dohanos, West Palm Beach, Florida, post office (1940).

30. "Descriptions," Dohanos, West Palm Beach (1940).

31. Mordi Gassner to Rowan, November 7, 1941, 133 (Box 111). Gassner, who was living in Santa Monica, was appointed on July 16, 1941, as a result of competent designs submitted in the New Rochelle, New York, Competition of 1940.

32. That Delacroix painting was among 144 famous paintings reproduced in full-color, large-format plates in Thomas Craven, ed., *A Treasury of Art Masterpieces from the Renaissance to the Present Day* (New York: Simon & Schuster, 1939), p. 483. The appearance of this impressive volume, in which the history of Western art formed a prelude to the painting of the Regionalists, was a major publishing event of the decade. It was also one of the very few art-historical resources with color illustrations and was the forerunner of the popular post-war coffee-table books. It would be interesting to compare the Craven plates systematically with post-1939 murals, for the book surely exerted a major influence, especially on artists such as Gassner, whose inclinations were academic, or whose topics seemed to call for an Old Master treatment.

33. Gassner to Rowan, January 10, 1942.

34. Gassner to Rowan, January 10, 1942.

35. "Descriptions" for Amy Jones, Winsted, Connecticut, post office (1938).

36. "Descriptions" for Hilton Leech, Bay Minette, Alabama, post office (1939).

37. R. B. Vail, Postmaster, to Rowan, June 3, 1939, 133 (Box 1).

38. William Wright, Postmaster, to Treasury Department, April 17, 1939, 133 (Box 115).

39. Rowan to Paul Faulkner, May 5, 1939.

40. *Bulletin*, #18 (February, 1939), p. 18, 130 (Box 215).

41. Wright to Rowan, December 12, 1939, 133 (Box 115).

42. Wright to Rowan, June 10, 1939, and Rowan to Wright, June 15, 1939.

43. Mrs. H. G. Harmon, Mrs. I. W. Irvin, and Mrs. B. F. Larance to Section, February 22, 1938, 133 (Box 61).

44. Rowan to Harris *et al.*, March 8, 1938.

45. Mrs. H. G. Harris to Treasury, July 14, 1938.

46. Stefan Hirsch to Postmaster of Boonville, May 27, 1941, 133 (Box 54).

47. Hirsch to Rowan, May 27, 1941.

48. Hirsch to Postmaster, May 27, 1941.

49. On June 12, 1941, Hirsch sent letters of inquiry to the following: Fred J. Fugett, Postmaster; Manager, MidSouth Uniform Company; F. W. Duckworth, Vice Mayor; Marion W. Smith, Mayor; and Henry Dillon, Manager, Boonville Manufacturing Company. These are not form letters and request very explicit information about product catalogs, local taste, new industries, and historical background.

50. Hirsch to Rowan, May 15, 1942.

51. Hirsch to Rowan, June 10, 1943.

52. Mrs. H. G. Harris to Treasury, July 14, 1938, 133 (Box 61).

53. O'Connor cites the *Final Report*, Section of Fine Arts, Public Buildings Administration, October 16, 1934, to July 15, 1943, in compiling his own list of New York State murals, although the report does not square with the "Geographical Directory of Murals and Sculptures Commissioned by Section of Fine Arts, Public Buildings Administration, Federal Works Agency," *American Art Annual* (1938-41), 35 (Washington, D. C.: American Federation of the Arts, 1941), pp. 623-658. That list also incorporates without distinction the works that the Section undertook through the TRAP program, the records of which O'Connor states are incomplete "because of the nature of the records"; Francis V. O'Connor, "The New Deal Art Projects in New York," *The American Art Journal*, 1 (Fall, 1969), pp. 70-73. Reconciling annual Section reports with the 1943 document, the *American Art Annual* list, and the case files in Entry 133 catches a number of murals that have disappeared from consideration, but making an accurate and complete list would be a labor of years, complicated by the fact that murals are beginning to come down at an alarming rate.

54. The former figure was deduced by Rubenstein, "Tax Payer's Murals," p. 82. O'Connor, "The New Deal Art Projects in New York," p. 63, cites the *Final Report: Treasury Relief Art Project*, undated mimeographed copy, for the latter figure. McKinzie, *The New Deal for Artists*, p. 54, cites a total of 1,371 Section commissions awarded.

55. 135 (Box 203). O'Connor, *Federal Support for the Visual Arts: the New Deal and Now*, pp. 137-143, reprints relevant portions of the standard guide to Section records, *Preliminary Inventory of the Records of the Public Building Service (Record Group 121)*, compiled by W. Lane Van Neste and Virgil E. Baugh (Washington, D. C.: The National Archives and Records Service, General Services Administration, 1958). The inventory of Record Group 121, Inventory Entry 135, correctly notes "most of these records are in the Still Picture Branch, Audio-Visual Records Division; less than 1 foot in the Natural Resources Division consists largely of reports on art and artists."

Because the number of descriptions in Entry 135 is not huge, it has been possible for me to compare the texts against the finished works to verify the accuracy of the descriptions of the works in question—those dealing exclusively with town genesis.

56. There are 415 data sheets. By my count, 62 descriptions, or 15% of the total, deal with this subject, and 55 of those are absolutely confirmed by the visual evidence.

57. This extraordinary exchange, which took place in 1937, is reported with deadpan seriousness in Marlene Park and Gerald E. Markowitz, *New Deal for Art, The Government Art Projects of the 1930s with Examples from New York City and State* (Hamilton, New York: The Gallery Association of New York State, Inc., 1977), p. 40.

58. "Descriptions" for [S.] Douglass Crockwell, Endicott, New York, post office (1938).

59. Lee A. Pemp, Jr., Postmaster, to Kenneth Evett, November 15, 1940, 133 (Box 32).

60. Evett to Rowan, December 3, 1940.

61. "Descriptions" for Kenneth Evett, Caldwell, Kansas, post office (1941).

62. Rowan to Evett, December 9, 1940, 133 (Box 32).

63. Woodstock, New York, *Overlook*, November 4, 1938. This mural and the relevant documentation are discussed in detail in Marling, "Federal Patronage and the Woodstock Colony," pp. 463-468 and in Marling, "A Note On New Deal Iconography," pp. 428-433.

64. Granville *Times*, August 18, 1938.

65. Watson to Congressman William A. Ashbrook, quoted in Granville *Times*, August 18, 1938.

66. Wendell Jones, "Article of Faith," *Magazine of Art*, 33 (October, 1940), p. 554.

67. Jones, "Article of Faith," pp. 556-558.

68. Jones, "Article of Faith," pp. 557-559.

69. The first CBS radio broadcast of the Earl Robinson-John Latouche *Ballad for Americans* took place on November 5, 1939. A 1940 recording has been reissued by Victrola America Historic Recordings (New York: RCA Records, 1976), #AVMI-1736, with album notes by Harvey E. Phillips.

70. Wendell Jones to Mrs. Mabel Evans Hite, August 12, 1938, in the possession of Minnie Hite Moody of Granville, Ohio, her daughter. I am grateful to Mrs. Moody for her assistance.

71. Rome *Daily Sentinel*, April 27, 1942, and Jones to Rowan, January 23, 1941, 133 (Box 77). Copies of Jones's notes and his letters are in the possession of his widow, Mrs. Wendell Jones of Woodstock, New York. I am grateful to Mrs. Jones for her assistance.

72. Jones to Rowan, March 10, 1942.

73. Frederick A. Rahmer, Postmaster of Rome, to author, March 17 and February 21, 1970. A photograph of the mural taken at the time of the ceremony shows Postmaster O'Shea scowling at the wall; *Daily Sentinel*, April 27, 1942.

74. *Daily Sentinel*, April 27, 1942.

75. *Daily Sentinel*, April 28, 1942. See also O'Shea to Rowan, May 12, 1942.

76. See Rowan to Arnold Blanch, *re* commission for the Roanoke, Alabama, post office, November 27, 1942, 133 (Box 1).

77. Local Draft Board #217, Brooklyn to Rowan *re* Tobias, August 7, 1942, 133 (Box 3).

78. See, e.g., Postmaster of Clarendon, Arkansas, to Postmaster General, September 29, 1942, enclosed in Walter Myers, 4th Assistant Postmaster General, to W. E. Reynolds, Commissioner of Public Buildings, October 2, 1942, 133 (Box 3), and B. H. Shearer to Senator Clyde L. Herring, *re* Columbus Junction, Iowa, post office mural, December 12, 1941, 133 (Box 29).

79. "Forty-Eight States Competition," 124 (Box 134).

80. *Life*, "Mural America," p. 12.

81. Hot Springs is now Truth or Consequences, New Mexico. The Deutsch sketch was altered somewhat in execution, and now has less humor and more surrealism; see Peter Bermingham, *The New Deal in the Southwest, Arizona and New Mexico*, p. 36.

82. H. P. Watkins, Sec'y., Graham County Chamber of Commerce, to W. E. Reynolds, December 8, 1939, 133 (Box 3).

83. Fogel to H. P. Watkins and Fogel to Rowan, January 18, 1940. Fogel first heard of the controversy from his brother-in-law in Tucson, who sent him a clipping from the Arizona *Daily Star* dated January 14, 1940, reporting the verdict of the Chamber of Commerce.

84. Rowan to H. P. Watkins, December 15, 1939.

85. Senator Carl Hayden to W. E. Reynolds, January 3, 1940.

86. H. P. Watkins to Rowan, December 27, 1939.

87. "Descriptions" for Richard Olsen, *Indian Harvest*, Sigourney, Iowa, post office (1940) and Stuart Edie, *Iroquois Indian Panel*, Honeoye Falls, New York, post office (1942).

88. Warren James Belasco, *Americans on the Road, From Autocamp to Motel, 1910-1945* (Cambridge, Massachusetts: MIT Press, 1979), p. 157.

89. Unidentified clipping, filed in 133 (Box 17), Greensboro file.

90. *Herald-Journal*, September 22, 1939.

91. Rowan to Carson Davenport, August 12, 1938, 133 (Box 17).

92. Davenport to Rowan, April 15, 1939.

93. *Herald-Journal*, September 22, 1939.

94. "Descriptions" for Amy Jones, Painted Post, New York, post office (1939).

95. Fogel to Rowan, January 18, 1940, 133 (Box 3).

96. Fogel to Rowan, April 18, 1940.

97. Fogel to Rowan, February 15, 1941; see also, official letter of invitation, January 21, 1941. For the seven vignettes—later six, with a small decoration beneath the clock—he was paid $1,850.

98. Fogel to Rowan, June 27, 1941.

99. Rowan to Fogel, July 7, 1941.

100. In addition to the vignette of a scroll, broken Spanish weapons, and a maguey plant under the clock, the main scenes are: *Conquistadores, New Lands, Migration, Home, Early Pioneers,* and *Fruits of the Valley*; see contract, dated February 24, 1941.

101. Isobel Bate and Harold Black to Rowan, January 19, 1941, 133 (Box 54).

102. *New York Times* and *Herald Tribune*, September 20, 1942.

103. Unidentified clipping, September 28, 1942, attached to and cited in Myers to Reynolds, October 2, 1942.

104. C. L. Schwartz to Watson, December 2, 1940.

105. Artists Equity letter of February 24, 1949, quoted in H. G. Hunter, Commissioner of Public Buildings, to Walter Myers, 4th Assistant Postmaster General, March 4, 1949.

106. W. E. Reynolds to Joshua Binion Cohn (acting for Bate and Black), June 28, 1949.

106. See *Bulletin* #19 (June, 1939), p. 2, announcing that Carl C. Mose of St. Louis won the Salina Competition and #20 (November, 1939), p. 7, making Louis Rubenstein a win-107., 130 (Box 215).

108. Bate and Black to Rowan, June 21, 1940, and letter of appointment, May 2, 1940, 133 (Box 34). See also "48 States Competition," 124 (Box 134).

109. Salina *Star*, October 3, 1940.

110. Rowan to Logan, November 28, 1940.

111. Reid to Rowan, November 29, 1940.

112. Schwartz to Rowan, November 14, 1940.

113. Schwartz to Rowan, November 14, 1940.

114. Logan, quoted in Myers to Reynolds, October 2, 1942. The controversial designs prepared by Bate and Black for Salina were used as illustrations in Floyd Benjamin Streeter, *The Kaw, The Heart of a Nation* (New York: Farrar & Rinehart, 1941), a book in the popular "Rivers of America" series, edited by Carl Carmer and Stephen Vincent Benét. The much-discussed farm matron illustration, from *PM*, appears on p. 271.

5

The Naked Truth
From Kansas to Maine

The first glimpse anybody caught of the revised historical panorama of pioneer faith rewarded came late in September of 1942, when Salina's own Herschel Logan took it upon himself to mingle furtively with the opening-night visitors to the Blacks' "Murals for Kansas" exhibition at the Architectural League. Local reaction to his scouting report from Gotham was swift, choleric, and patriotic. Even before the New York show closed, three hundred members of the Salina Art Association had, on the warrant of his horrified appraisal alone, demanded that Congressman Frank Carlson defend the honor of Kansas lest the Sunflower State become "a laughing stock among those who appreciate real works of art. With Salina boys leaving for the service and the Government saying it wants unity, surely the installation of . . . insulting murals can be postponed for the duration."[1] That Harold Black and Isobel Bate were rumored to be on their way to Salina to hang their "libelous" pictures injected a note of flustered urgency into Postmaster R. J. Pafford's list of reasons for heading them off at the state line. The Christmas rush was coming up, for one thing, but more important, "we have some fifteen thousand extra people here in town working on two large defense jobs and our lobby is crowded from morning 'til night. Now imagine scaffolding and chipped off plaster all over the place. With some thirty-five to forty thousand soldiers moving in any day, many of them already here, it is going to put us in a very bad mess."[2]

Mr. Logan, back home and still shell shocked from his aesthetic

skirmish with the suggestive females symbolizing "Drought" and "Tornado" on East 40th Street, also wrapped himself in a battleflag to meet the press. "In the midst of a great war," he declaimed, "I . . . fail to see why we have to have such things crammed down our throats. As one of 20,000 citizens of Salina who are asked daily to buy their war bonds and stamps, I protest this waste of money in desecrating the very building in which we are asked to buy bonds to aid this war effort."[3] In some quarters on the Potomac, the likelihood of "Buy Defense Bonds" posters languishing unheeded beneath expensive and offensive federal murals had become the topic of heated discussion. The Post Office Department, for example, had compiled a fat dossier of war-related complaints against the intention of the Commissioner of Public Buildings to proceed with the installation of the Salina vignettes in the teeth of public displeasure and appended that bulky document to a sarcastic account of recent postal forebearance in the face of artistic frippery:

Under the date of September 30, 1942, a communication was addressed to your agency setting forth the apparent absurdity of expending $26,000 of the taxpayers' money at this time for murals in the Rincon Annex Building, San Francisco, California, and at the same time erecting brick barriers as a protection to this same building against possible air raids. Request was accordingly made that serious consideration be given to abandoning or at least deferring all mural . . . work for the duration of the war.

Heretofore, the arguments of the Post Office had been ignored. In Salina they were going to be heeded, and immediately: "This will not be a case of 'The Public Be Damned', but will come nearer being a case of the 'Artist Be _____!'"[4] And so it came to pass that Rowan placed a long-distance call to Harold Black, who had been detained under virtual house arrest in the bowels of the Salina post office by a postmaster secure in his faith that his militant superiors would carry the day against the forces of art. Rowan told Black to roll up the murals and beat a hasty retreat from Kansas. On overhearing the capitulation, the postmaster "was very much pleased"; party lines hummed and the rest of Salina was soon savoring the taste of victory on the homefront.[5]

Clearly enough, troop movements and plaster dust near the war-bond window had little to do with Salina's refusal to display the murals, although martial appeals got a sympathetic hearing in the Washington offices that cut the orders to put the panels into storage for the duration. Logan's response to the New York exhibition, how-

ever genuine his sputtering rage at a portrait of Kansas wracked by the elements, was only the proximate cause of this sorry denouement. The crisis in Salina, vented in the shrieks of the wartime press, was brought to a flash point by a negative description of home: Dorothy and Toto, in the Blacks' version of the Oz story, would have returned to Kansas to find Uncle Henry's farmhouse in ruins and Auntie Em fled in terror, with her housedress in unseemly disarray. But Salina did not have to look at this portrait of Kansas to despise the pictures. Albert Reid knew that when he sent Rowan his own drawings late in 1940; the Blacks' decision to incorporate his historical emphasis did not lessen local ill will toward whatever images they might ultimately produce. The Salina crisis began on October 3, 1940, and from that day forward, historical sagas, aesthetic virtues— the murals themselves, in short—were moot points. The Salina *Sun* stated the real problem succinctly in a headline that asked, "Which Is the Typical Kansas Farm Woman?"[6]

The question arose from a sketch by Harold Black, published in "a copy of *PM*, the New York daily" on August 2 and "intended to represent his ideas of a typical Kansas farm woman." That the clipping reached Salina at all was an unhappy accident. Black had not made the drawing for use in the murals and did not put the despised figure or anything resembling it into the finished panels. The *Sun*, in fact, knew how and why the picture happened to have been made. The Blacks, it seems, financed the field trip to Kansas recommended by the Section by contracting with *PM* to prepare a double-page spread on the wheat harvest in the Midwest, illustrated with human interest drawings imparting the "local color" of the plains. Their report was a spurious piece of claptrap, according to the *Sun*: "the 1940 harvest was still in Texas" when the Blacks were in Salina, supposedly documenting harvest-time activities. Nor was the sketch of a stout woman in an apron with a skinny dog by her side, posed before a windmill, "the most glaring travesty against Kansas farm folks that appeared" in the *PM* article. It was, however, the picture that best demonstrated the dimensions of the gulf between art and reality in these modern times. "Yokels," of course, "don't understand art," the *Sun* confessed, and "artists paint what they feel"; the contrast between Black's farm woman and a recent snapshot of Mrs. Lawrence Beil of rural Salina (and her dog Joe), printed side by side on the front page of the paper, was a neat demonstration of the fact that modern "artists really do paint as they feel and not what they see on

Which Is the Typical Kansas Farm Woman?

Artists are the most misunderstood people on earth. That, they will tell you, is because the yokels don't understand art. Artists, you will be told loftily, paint what they feel—not what they see. Well, Harold Black, the New York artist who will paint the murals for the Salina post office lobby, must have been feeling pretty awful when he painted the picture at the left above. From the copy which appeared with it in a recent issue of the New York daily, PM, it is intended to represent his idea of a typical Kansas farm woman.

Artist Black was in town early in the spring, and told Postmaster R. J. Pafford that he was here to get local color for the murals. Later came a copy of PM for August 2, which carried Kansas harvest pictures by Black, notwithstanding the fact that the 1940 harvest was still in Texas when the artist was here. The newspaper said it sent Artist Black to the Kansas wheat fields. While not the most glaring travesty against Kansas farm folks that appeared on the double-page spread, this picture goes a long ways toward convincing the lay observer that artists really do paint as they feel, and not what they see on a Kansas farm.

The battle of brush vs. camera is 100 years old this year. As a respectful effort to add to the evidence (guess which side), let us submit the picture at the right above. This is Mrs. Lawrence Beil, Route 1, who lives three miles southwest of Salina. Mrs. Beil may not be art, but she is Kansas farm woman to the core. She doesn't have the bulk and brawn of the Neanderthal female at the left, but she is no isolated instance of hothouse femininity among the wheat stubble. She has four children grown and growing, works in the milk house when the dairy herd is giving up its milk, takes care of a large flock of chickens, and does a job of housework that any housewife with four children and a hard-working husband will understand. Apparently the job of a Kansas farm woman doesn't

(Continued on page 6)

Salina *Sun*. October 3, 1940. National Archives.

a Kansas farm." New Yorkers, by that criterion, felt "pretty awful" in the wheat fields and should probably stay in their toney Manhattan galleries:

The battle of the brush vs. camera is 100 years old this year. As a respectful effort to add to the evidence (guess which side) let us submit the picture . . . [of] Mrs. Lawrence Beil, Route 1. . . . Mrs. Beil may not be art, but she is Kansas farm woman to the core. She doesn't have the bulk and brawn of the Neanderthal female at the left, but she is no isolated instance of hot house femininity among the wheat stubble.

Mrs. Beil was a dynamo in a cotton housedress. The mother of four, she tended the cows and chickens, worked from dawn to dusk, and still found time to spare for leading the Sunflower Farm Bureau chapter and giving piano recitals at St. John's Lutheran Church. And for all of that, she had a certain, winsome *je ne sais quoi*: "Apparently the job of a Kansas farm woman doesn't take the legs and back of a piano mover. Mrs. Beil weighs about 104 pounds, and she seemed cheerful enough when the *Advertiser-Sun* photographer was out to

see her this week." So-called modern art, held up to the facts, was really caricature or propaganda. But attitude, not verisimilitude of technique, was the issue:

You see, Kansas isn't like the photos arranged and shot by the social document photographers (and painters) who have capitalized on the dust bowl publicity in the last few years. This is simply a snapshot of Mrs. Beil . . . taken on the front porch of her home. Inside the house are electric lights, radio, iron, fans, washer, toaster, waffle iron, sweeper and a mixer. There are panes of glass in the windows and carpets on the floor. About the only thing a New York farm woman has that Mrs. Beil lacks is a Democratic governor.

The *Sun* had a familiar point to raise, and one that cropped up whenever an artist's depiction of someone else's home showed something less that the ideal perfection glistening in the inner eye of the hometown booster. The *Sun* was, in effect, arguing that a legitimate Regionalism could not emerge from a tourist's eye view of Kansas, although the case for natives painting natives was clouded by a xenophobic hostility toward New Yorkers in general and artists from the big city in particular. The prevalent local opinion of the latter held painters resident within the precincts of the Museum of Modern Art guilty of "modernistic" tendencies which were, by nature, anti-regional.[7] Intruders with cameras and brushes wore the blinkers of preconception. Adverse publicity blinded them to the difference between an instance and the general rule, albeit that distinction was not readily perceptible, even in the *Star*'s photograph of Mrs. Beil—a faintly chunky lady despite her beauty-contest weight—whose appliances and carpets were absent from the snapshot taken on her front porch. Harold Black had not ventured indoors, of course, because he came to Salina to affirm a feeling, a mental stereotype imported from without. Having found his singular fact, if fact it was, he went away satisfied. But Black had not found "the typical Kansas farm woman," who was Mrs. Beil along with everything the reporter knew about Mrs. Beil, her house, her life, and the lives of scores of other farm women from Salina. Like Black's despised behemoth, Mrs. Lawrence Beil was a stereotype, too, but she was a stereotype that summed up all the facts about Kansas cherished in Salina. The same facts were not necessarily cherished in Topeka, however. When Kansas-born John Steuart Curry painted Mrs. Beil's apparent twin, a ramrod-straight woman with sturdy calves exposed beneath the hem of a sensible, mail-order housedress, he stirred up a hornet's nest of protest. The *Kansas Mother* segment of Curry's State Capitol murals

in Topeka ruffled the Kansas mothers of 1939 because the woman's skirt stopped at the knees and showed too much leg for true matronly modesty.[8]

The process of arriving at a typical and cogent symbol for Salina was a matter worthy of exploration, but as the *Sun* warmed to the task of hoisting Black with his own petard, the demeanor of the spry Mrs. Beil became the subject of the article. Outraged folks who took pen in hand to recommend Black's banishment from Salina had convinced themselves that one of the neighbor ladies, Kansas, women, and virtuous American womanhood were under attack by a depraved radical. *Star* subscribers sent the front-page illustration to Washington with texts of their own devising:

[C]ompare the photograph with Mr. Black's ridiculous sketch. . . . Mr. Black's dog hasn't had a square meal for years back. And the woman—what a beautiful specimen of femininity she is, with a head like a shrunken skull of the Peruvian, the body as muscular, tall and wide as the largest Amazon that ever threw a spear . . . and what Black meant to represent [by] the cornucopia what-not that the woman is carrying in her lion's paw hand is hard to determine.[9]

The Business and Professional Women's Organization of Salina took up the cause of their sisters on the farm. "The modernistic productions as shown in the *PM* illustrations, which are undoubtedly typical of Mr. Black's work" boded ill for any woman in a housedress:

If Mr. Black's interpretation of the Kansas farm woman is placed in our post office . . . it will be an out and out insult to the . . . housewives of Kansas and the Middlewest. Mr. Black's caricatures, to name them in their proper type, would slander the noble types of our citizenship, the farmer and his wife, who are the backbone of this section of the country and a class of Americans who, for patriotism, culture, and moral qualities is not exceeded anywhere in this United States.[10]

Why a corpulent woman with her hair pulled into a practical chignon should be morally suspect, along with her skinny dog, whereas a trimmer figure in the same housedress and apron, standing with a plump collie, should embody the virtues of the heartland is a mystery. Black's farm housewife represents the physical type Jane Darwell brought to her numerous screen roles as an ample, capable earth mother. Benton drew her thus, playing Ma Joad, in his promotional illustrations for Twentieth-Century Fox in 1939, and after a sketching trip through the farms of Oklahoma and Arkansas, left Darwell's broad-beamed form intact in his plates for the 1940 Limited Editions Club reprint of *The Grapes of Wrath*.[11] Mrs. Beil is not precisely a

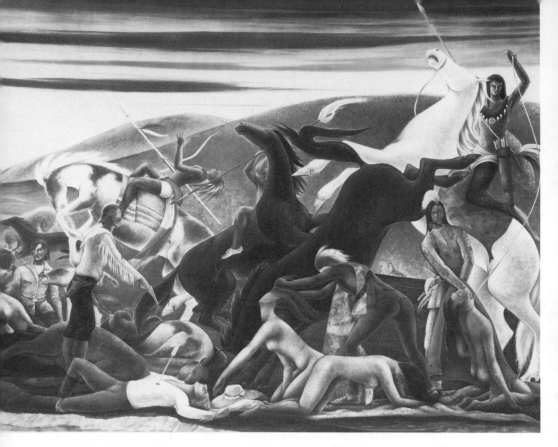

Frank Mechau, detail of *Dangers of the Mail*, Post Office Department Building, Washington, D.C. 1937. National Archives.

tap-dancing Hollywood chorine costumed for a hoedown, but she looks more like Ruby Keeler or one of Bernarr Macfadden's examples of applied *Physical Culture* than she does like the huge Miss Darwell shooing the "little fellas" into the family truck. If Mrs. Beil did not publicly "Reach for a Lucky Instead of Sweet," as svelte motion-picture starlets confidentially urged in American Tobacco's popular ads of the day, she had, nevertheless, kept as "fit and trim" as modern women who were readily persuaded that "too many fattening sweets are eaten by the American people."[12]

In Benton's case, the imposing screen stereotype of the embattled farm mother retained its validity when he compared his publicity picture to women he met in the Dust Bowl. It was a stereotype, however, and one which Black and his *PM* readership knew despite their sketchy knowledge of the harvest-time scene in the Midwest. Salina, meanwhile, was leery of the Dust Bowl stereotypes perpetuated by the "social document photographers (and painters)" and found the

big woman Black drew equally hideous and atypical. At any rate, strapping females, hard times, and slanderous attacks on Kansas together formed the tissue of lies which debarred the murals from the Salina post office. The perky, 104-pound Mrs. Beil, along with her electrical appliances and her record of civic and cultural activism, constituted the modern mold in which Salina cast its countervailing image of the typical Kansas housewife. She was pretty, slender, and every inch a wholesome star.

The public was apt to judge the women of Mural America against Hollywood stereotypes. In 1936, following publication of designs for the Post Office Building murals in *Time*, the Section was inundated with protests against Frank Mechau's *Dangers of the Mail*. In light of the edgy caution with which the Section approached the Federal Triangle decorations and Rowan's later stand against pictorial violence, it is incredible that no one in authority expressed reservations about Mechau's picture before *Time* reproduced it. For one thing, the postal theme was sustained solely by letters concealed in stagecoaches and covered wagons; the actual topic was the wholesale massacre of pioneers by a methodically efficient band of Indian butchers. For another, the Indians were taking special delight in scalping two naked women crawling on their hands and knees across the foreground of the scene and across their own carefully discarded bonnets and calicoes, while a third woman, also nude, was being strangled with exquisite deliberation by no fewer than two savages, who dominated the corner of the composition. May M. Harlow, of the Women's Hotel in Los Angeles, may not have recalled the 1921 ruling by the Kansas board of film review which mandated that a screen kiss could last no longer than thirty feet of film, but she knew salacious monkeyshines when she saw them in *Time*. The Kansas ruling had led to the movie industry's first attempt to censor itself before the rest of the Bible Belt jumped on the bandwagon of public purity; the Famous Players-Lasky Fourteen Points of 1921 forbad nakedness, "prolonged passionate love scenes," inciting dances, white slavery, and any expression of "sexual attraction in a suggestive or improper manner."[13] Mrs. Harlow's letter to the Treasury Department made it plain that the Section needed a Will Hays of its own and a stiff Production Code to make federal murals at least as hygienic as the movies:

Surely our American women will not be so blatantly insulted as to have your Department, the very heart of our Government, permit . . . the hanging of

"Dangers of the Mail" . . . in the Washington Post Office building. So many millions have already been spent by Americans to clean the motion pictures of some of the sordid pictures capitalizing on our American womanhood, that this seems just another slap in the face [by] a male personnel who are not aware of the "Invisible" means subtly undermining our best traditions and decencies. We are too high and clean a nation to overlook so much. . . . I add my plea to the thousands, that our Government not allow further improper and indecent showings of pictures, views and illustrations, many of which have been carried thru our cities on trucks, showing motherhood's most sacred ties, that our hearts might be broken further. . . . [It] is vital now that this part of our National Bulwark be carefully and sacredly respected.[14]

The language of Mrs. Harlow's critique is exceedingly delicate. Those awful mobile images "showing motherhood's most sacred ties," for instance: did she mean busty billboards for Paramount's *The Last Days of Pompeii* rolling through the streets of Los Angeles in 1935, bound for a premiere of that violent and diaphanous epic? She did regard fully clothed American womanhood as a bulwark against the Depression and "waning pride in citizenship." Her ladylike circumlocutions do not conceal her horror at Mechau's pioneer vamps of the decadence, symbols of a moral abandon particularly dangerous in troubled times. She hinted, too, at an "Invisible" conspiracy against the national character, and for several months it seemed as though the guilty silence that prevailed among critics and bureaucrats would confirm her theory. Mechau's very noticeable nudes became invisible by virtue of a refined, indeed prudish, disinclination to take up the topic of naked ladies.

The first expressions of shock at *Dangers of the Mail* came following announcement of the commission in the Colorado Springs *Sunday Gazette and Telegraph*, Mechau's hometown paper.[15] A reproduction of his prizewinning cartoon elicited a sharp protest from Harry Galbraith, the United Press stringer for the Pike's Peak region, who had happened on the Colorado papers in the line of duty. In February of 1936 he sent the illustration to Postmaster General Farley and to Senator Hiram Johnson along with a forceful, "(probably futile)" objection to certain historical inaccuracies. The naked ladies he passed over in discreet silence:

There is no desire to deprive anyone of money in these tough times and the murals may be high art as the critics seem to agree, but as a perpetuation to posterity of an epoch and an epic in American history, the stuff is terrible. . . . As to the top panel, I assume that it is allegorical or symbolical or some such silly term used in modern art. Perhaps so, but even at that the Red Brother never

scalped his victim until after that victim was dead. A few scalpings have been recorded when the scalpee survived, but the scalping was done when the victim was unconscious—presumably dead. Yet here in this painting we see . . . a woman sitting calmly while the scalper does his stuff and another woman wandering around on her hands and knees while she gets a hair trim. On this point, never in history did a frontier man, woman or child take a scalping tamely. If unarmed, they fought desperately with hands and feet until they died.[16]

Accuracy was the bugbear of the young Section and the case for the great American return to the facts was being made, detail by hard-won detail, during the Federal Triangle interlude. It is small wonder, then, that the Section was terrified by Galbraith's remarks and by the potential enmity of the influential figures who had been apprised of factual deficiencies in the very murals which were to launch the new crusade. The official rejoinder to his faultfinding lamented Galbraith's "scant appreciation of the quality" of the art but welcomed his "valuable and legitimate suggestions in regard to historical accuracy." The Section was not prepared to tolerate mistakes and, as proof of its zeal, cited the actions of appointees already at work in the Post Office Building who, after judicious nudging from Rowan and Watson, "have gone to the greatest pains to have their work correct regarding such details as Mr. Galbraith has discussed." There is a certain irony in the mention of Rockwell Kent among the cooperative and docile apostles of deadpan fact. And the bureaucratic lambasting Reginald Marsh received while he struggled with the new aesthetic of hard evidence was passed over in the cheery assertion that "he was not himself satisfied until [the engineers] accepted all the mechanical details in his Post Office machinery as being correct."[17] Behind the scenes, Mechau was being raked over the coals with Rowan's customary thoroughness. The message from Washington was blunt: "Correct historical details."[18]

Mechau spoke to some of Galbraith's minor objections by citing Mark Twain's disquisition on saddles used in the West and left for San Francisco and Salt Lake to obtain copies of documents on scalping, so that "we will have factual data to present for every criticism."[19] Scalping weighed heavily on Rowan's mind in the spring of 1936, and from his vantage point, the gender and the dress or undress of the victims were minor matters. He had been expecting loud objections to Mechau's picture, although not historical ones from the public sector. Shortly after *Dangers of the Mail* was approved, the Washington rumor mill began to grind out word that the Section might

be removed from Treasury jurisdiction and transferred to the Interior Department. Rowan and his colleagues were ardently committed, therefore, to doing nothing to rile the cantankerous Secretary Ickes, who, he confided to Mechau, "is extremely particular about the presentation of the American Indian and does not condone the presentation of the Indian in any but the most friendly scenes."[20] From the outset, Rowan advised Mechau to finish his work with all deliberate speed and get it installed "without further delay" in case the stories were true. While watching the Bureau of Indian Affairs for signs of wrath, the Section had been hit in the blind side by Galbraith's letter and was bowled over entirely by the storm of indignation that swept into Washington following the exposure of pioneer womanhood in the pages of *Time*.

As Rowan attended a series of hastily arranged conferences with postal officials who took obscenity charges and invidious comparisons between their fifth-floor murals and a depraved Hollywood extravaganza seriously, it became apparent that he did not. Nudity was, at any rate, easier to deal with than scalping, since Rowan had the cumulative history of Western art behind him with which to neutralize opposition to chaste revelation of the female anatomy. And this was modern, uninhibited 1936! Just a year earlier, Robert and Helen Lynd, returning to *Middletown* for a second look, "got . . . a sense of sharp, free behavior between the sexes (patterned on the movies)," and they were talking about Indiana, no less.[21] *Fortune* surveyed the collegiate scene in 1936 and noted a nonchalant sophistication there, too: "As for sex, it is, of course, still with us. But the campus takes it more casually than it did ten years ago. And the fact that it is no longer news is news."[22] The Section was ready to take its lumps from the Interior Department and meddlesome history addicts. But yield to diehard Comstockery? Never!

On the morning of March 6, Rowan and Mechau were summoned to the Post Office Department, where the artist was closely "quizzed on every part of his design, including the nudes," and marched up Capitol Hill to repeat his explanations before Senator Lyons of Texas, a member of the joint legislative committee on postal affairs, whose constituents were up in arms about the girlie-show version of Western history featured in *Time*. At this juncture, Rowan unveiled the line of defense the Section was to follow throughout the controversy:

I explained . . . that these were in no way personal nudes and that the scale of the finished work in addition to their almost abstract conception keep them out of the field of the personal as far as the spectator was concerned.[23]

Spectators in the postal hierarchy, however, had no trouble at all detecting "two women entirely nude on their hands and knees evidently being scalped by Indians" and, in their memorandum on the meeting, continued to wonder "whether a painting containing these nude figures is entirely appropriate and whether there might not be considerable adverse reaction on the part of laymen to such a painting in one of the lobbies of the Post Office Department Building."[24] Laypeople in the Treasury were not sure that they had fully grasped the distinction between "personal" and "almost abstract" nudity, either, and called for some quotable elaboration on that thesis before the postal bigwigs were approached again. In essence, Rowan told them that if internal squabbles could be kept out of the papers, the nudity issue would probably blow over, because Mechau's murals were going to be very big and "in the finished work these figures will be no more than 3 feet high." And there was artistic freedom to consider:

Insisting that clothes be put on the women in the massacre scene will materially change and interfere with the artist's original conception. I can see where personal nudes would be objectionable in a Federal Building, and no such nudes have been accepted in any of the designs created under the Section of Painting and Sculpture. In this particular case, however, the nudes are utterly impersonal and must be regarded merely as symbolic motifs introduced into a larger design.

Painting clothes over the naked ladies might be feasible, but it would be "next to impossible" to peel them off later. Why not follow the course of action already laid out to thwart the Bureau of Indian Affairs? Get the murals up fast and worry about them later: "Any letter of criticism could be answered with a statement that the murals are not installed; that the artist is working on them and that the suggestion of the critic is being taken under serious advisement."[25]

When Rowan delivered the Section's final verdict on the Mechau sketch to the postal authorities on March 25, he stressed tactical strategy to the virtual exclusion of the "naked" issue that had brought him to Farley's domain in the first place:

In view of the fact that these nudes are strictly impersonal in presentation, are but a small part of a much more important design . . . and that any instructions to the artist insisting that he clothe them would result in a wave of unde-

sireable publicity at this time, the Section recommends that the artist be allowed to proceed with the designs with the understanding that historical accuracy be stressed.[26]

Simultaneously, he counseled Mechau to find "some historical data showing that Indians actually tore the clothes from their victims" and told him to keep a low profile until the *Time* reproduction faded from public memory: "I suggest that no more publicity be given these works until such time as the final murals have been . . . installed."[27]

Official Washington hunkered down and held its breath until Mechau arrived to install his murals in September of 1937, lugging sacks of documentation on scalping techniques and Indian preferences in the matter of costuming appropriate for victims.[28] This was, Rowan told him, one of those "times when an artist can forego the pleasure of widespread publicity in the interest of a program which is designed to help all in the fairest possible way."[29] Mechau duly slipped into the building, worked in unobtrusive silence, and went home without a word to anyone. But as the public filed into the fifth-floor corridor to transact postal business, a second and far more vehement howl of protest arose from the very folks who were not supposed to notice those yard-tall nudes crawling down the hall at eye level. An older and wiser Rowan would have realized the futility of his gambit. The gimlet-eyed public never forgot a scandal and was rarely swayed by highfalutin jargon. In September of 1937, the Post Office Department also learned, too late, to beware of fast-talking aesthetes. What was an "impersonal" nude, anyway? The people massed in the hallway were taking these big nudes very personally indeed; they took them, in fact, for naked American females cavorting shamelessly in the altogether around the headquarters of the U. S. Postal Service, and that was pretty much what the ignorant laypeople in the Postmaster General's office thought they were, right from the first.

Rowan's case rested on style: there were nudes, and then there were nudes. Mechau's crawling women, for instance, have no facial features at all. Like store-window mannequins supporting spring hats, their faces are blank slates, eyeless, noseless, and mouthless. The bodies are clearly female, to be sure, thanks to volumetric mass, but no airbrushed *Esquire* pinup was more reticent about the existence of pubic hair, nipples, or the human navel. "Impersonal," then, meant an anonymous or generic approach to anatomy which made it difficult for the viewer to connect a Mechau nude with a specific, proto-

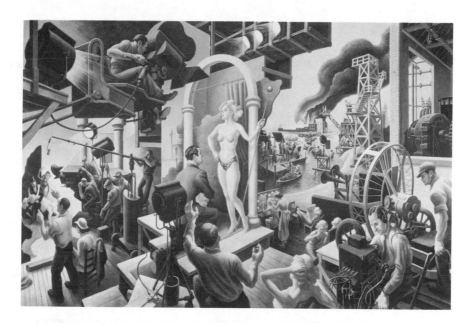

Thomas Hart Benton, *Hollywood*. 1937. Nelson Gallery-Atkins Museum, Kansas City, Missouri, Bequest of the Artist. (Photo: University of Minnesota, Photo Archive)

typical woman, of the "personal" variety. As Mechau was hanging his picture, with a minimum of fuss, Benton was showing America what a "personal" nude looked like and was making a great deal of noise about it. In 1937, Benton was in Hollywood on assignment for *Life*. He was dispatched to the Coast to prepare a set of forty drawings on the fancies and foibles of the movie colony.[30] His illustrations wound up in *Coronet* in 1940, however, because a "personal" sex goddess in a G-string who presided over a "large piece of canvas with a montage effect" proved so shocking to the public when he exhibited his studies that *Life* rejected the lot of them.[31]

The bottle blonde meant to symbolize "Hollywood" is not quite nude but is dangerously close to being naked.[32] She wears a hat, pink shoes, peek-a-boo spangles across her lush bosom, and a purple-sequined panty affair. Each provocative scrap of rainment, in best burlesque-queen fashion, calls attention to what it barely conceals, and this tootsie's anatomical endowments are amply and pneumatically modeled. Elevated on a stage, with cameras, directors, and spotlights riveted to her charms, she is the centerpiece of Benton's montage of backlot vignettes and is, of course, Hollywood personified, ruling the movie industry with hoydenish majesty. Benton gives the lie to the pious platitudes of the Production Code; his "Hollywood" is a bit

of a tart, garish, amoral, and possessed of the earthy vulgarity of Jean Harlow, the original blonde bombshell who died as Benton was making his studio tour. If "Hollywood" is not Benton's homage à Harlow, it is a double-edged tribute to the popular, trashy vitality of a medium that survived despite its own worst efforts at pseudore-spectability. And because Benton made it clear that he knew this empress was wearing as little as possible, and liked her all the better for her aplomb, the painting was stronger fare than *Life* cared to risk flaunting on its cover page. This "personal" almost-nude not only looked like a real woman but showed rakish pride in the power of her appeal to her fans in the audience.

By Benton's 1937 standards, Mechau's women are asexual, anemic statues, marmoreal dummies to which some toplofty symbolic significance must be conceded in the absence of a flesh-and-blood capacity to provoke a sympathetic response, to engage the emotions, or to do much but offer their tresses to Indian barbers like so many plaster wig stands in a hairdresser's display. Yet, perversely, these nudes are and were disconcerting in direct ratio to their unreality. Few of the figures in *Dangers of the Mail* are sharply characterized. With the exception of the women, however, all of them have faces and colorful modes of dress. Within the pictorial environment, therefore, the females stand out because they are uniquely unlike any bit of animate flesh depicted, with the possible exception of a pair of striken horses seesawing wildly behind two crawling women and reflecting their postures. As pure, "impersonal" flesh, existing solely to be preyed upon and maimed, Mechau's women are excessively noticeable and unpleasant to notice. Their lack of capacity to act in a "personal" manner—to resist their attackers, for example—makes them symbolic of victimization in a smarmy way. They are pornographic fantasies of the captive, passive female, featureless objects to which only a gross sexual identity pertains. In the context of a pulp magazine for adolescent males, this *Argosy* scenario was marginally acceptable; in a mural in the Federal Triangle, it was not.

Given the Section's negative attitude toward abstraction, it is fascinating that Rowan tried to defend Mechau's impersonal nudity by calling it an "almost abstract conception" that, as such, would never be read by the general public in terms of pulp fiction, Hollywood hootchy-kootchy, or any other concrete, sexually charged situation. It is equally interesting that the most articulate objections to the installation of the mural used the terms "abstraction" and

"modernism" as polite synonyms for the nasty, disgusting, and altogether unseemly sexual content that people readily discerned in the painting. The editorial denunciation of the Mechau mural published in the Washington *Evening Star* in September of 1937 adopted that viewpoint toward modern "Art At Its Worst." The diatribe began with a reference to a "recently published" and unnamed "murder mystery" dealing with a New England town enraged by a post-office mural "in the crude style lately affected by the surrealistic school." Scandalized beyond tolerance, the townspeople coated the offending "decoration" with red paint. "That," said the *Star* admiringly, "was the end of the mural" and a possible answer to the Section's postal folly, one of "the most brazen distortions ever perpetuated, in any of the so-called 'ages of art' ":

It represents an Indian raid upon a stage coach in the early pioneer days. . . . It has shocked all who have seen it and it will continue to shock those who come upon it, unaware of its presence. [The] indignation of the public described in the [novel] is . . . manifested by all who view these contributions to American art which, with rare exceptions, are far beneath the dignity of their emplacements and a shocking reflection upon the public taste. This new radicalism in art, which has been fostered by Government doles, is at variance from all the standards which have been taught during many generations. There can be no objection to the occasional display of such innovations and experiments in exhibitions. Indeed, they are to be tolerated as tokens of what is believed to be a passing phase of artistic aberration. But the painting of the walls of the Government's own structures, in a manner to indicate a degree of permanence, is just too much.[33]

Mechau's nudes are conspicuous by their absence from the editorial, although the *Star* was plainly not scaling the pinnacles of righteous indignation over the Western theme depicted. The subject of nudity is broached obliquely, through discussion of aberrant radicalism in art; it is tacitly assumed that the reader will equate avant-garde painting with scandalous breaches of propriety. Faceless, impersonal nudes are, as Rowan also assumed, abstract conceptions, but decadent abstraction is as loathsome as naked ladies in the Post Office Department Building. Trust a degenerate modernist in a beret to deflower American womanhood in a public place!

Beleaguered postal officials wasted no time sending clippings from the *Star* to the Section experts who had landed them in the soup.[34] If they expected a crystalline explanation of the impersonal nudes or an offer to expunge them, however, they were sadly disappointed on both counts. The official Section response to the complaints politely

told the postal authorities to shut up and lie low. Furthermore, although the letter sent out over the signature of the Director of Procurement aimed to laugh off the editorial slur, the line of rebuttal pursued actually reinforced the substance of the *Star*'s charges against the avant-garde and the abstract camp into which Rowan had consistently slotted the Mechau figures. The editorial was hopelessly "biased" and at variance with discerning, nonradical taste; Mechau's work, said the Treasury, had recently been praised to the skies by distinguished European visitors to the Post Office Building, including Raoul Dufy, "a member of the Legion of Honor," and Ferruccio Ferrazzi, "Director of the National Academy of Rome." A small replica of the disputed panel had been purchased from the artist by the Museum of Modern Art. Lest those testimonials be taken as proof of radical leanings, the letter pressed quickly on to undercut Rowan's unfortunate evocation of abstract principles with a list of the genuinely dangerous schools with which only "a person ignorant of art" would dare to associate Mechau:

In the editorial in question reference is made to the "sur-realistic school." Comparison with the work of the artists recognized as members of this school indicates clearly that Mr. Mechau's murals have no "sur-realistic" characteristics (compare Salvator Dali, Max Ernst, Georgia [sic] De Chirico and any of the leading surrealists). The editorial further employs the phrase: "This new radicalism in art". Authorities agree that the painting . . . encouraged by the Procurement Division is in no sense radical (compare the work of Marcel Duchamp, Pablo Picasso . . . and other recognized radicals). The criticism most generally made upon our work is that it is too objective to meet the ideals of radical art which, for the most part, are subjective rather than objective.[35]

And what could be more objective than an impersonal nude? There is pride in this acknowledgment of critical thunder from the lunatic fringe on the artistic left and an almost ghoulish delight in sounding the roll call of "recognized radicals" from whose perversities the Procurement Division recoiled in melodramatic horror. How one might tell a good foreigner from a bad one is somewhat clouded by citation of Dufy and the Italian academician, but the Ellis Island taint of the avant-garde pervades a document in which alien modernists seem strangely akin to painted Indians. For every noble brave praying over his cornfield, there are legions more who can be expected to massacre ladies in the post office without so much as a by-your-leave. A purchase by America's own Museum of Modern Art is a mark of honor, except in Kansas; to suggest that his mural smacks

of the "sur-real" or follows the canons of big-league European modernism is to brand Mechau with the mark of Cain.

This odd declaration of ideological purity was directed at the Post Office Department, where the manifesto could hardly have been expected to touch off sophisticated debate on the works of good old "Georgia" De Chirico. The intention was to razzle-dazzle the postal officials into silence with a litany of queer names and an exercise in stylistic hairsplitting, for the Section patently intended, for its part, to take no further action in the Mechau case. Down on Pennsylvania Avenue, the postal bureaucrats were left to grapple with public vituperation as best they could, by grasping at the few straws of common-sense logic the Section had deigned to provide. Thus when the mural made its scandalous debut in local newspapers from coast to coast, the caption information distributed by the Post Office Department boiled the issue down into lay terms and left readers as confused as the recipients of the Procurement Division's obfuscations. But Rowan's abstract nude came close to regaining her status as a naked lady:

[This is] "The Dangers of the Mail," painted by Frank Mechau, over which the controversy has arisen, since critics fail to understand the presence of the undraped figures in the painting. It depicts Indians scalping nude women after pillaging a stage coach and it adorns the office of Postmaster General Farley in Washington, D. C. The work is based upon historical fact, according to the artist.[36]

At the height of the Mechau controversy, folks in Faribault, Minnesota, shaking their heads in disbelief over the dirty picture so described in the *Daily News*, could turn to page four of their morning paper and find the story continued in Phoebe Atwood Taylor's serialized thriller *Octagon House*.[37] This was the novel to which the Washington *Evening Star* had alluded at the start of the furor. Via the Associated Press wires, it enjoyed a vast circulation at an early moment in Section history, when popular attitudes toward the mural renaissance were being formed and scandals over the repugnant stuff the government might smear on a wall erected with taxpayers' dollars were limited to breathless wire-service reports from the nation's capital, where Jim Farley sat trapped between Mechau's peepshow flesh-mongering and Kent's subversive sloganeering. *Octagon House* was no literary masterpiece. Subtitled "an Asey Mayo Mystery of Cape Cod," it was one of a series of entertaining page-turners pitting the

mother wit of a shrewd Yankee against the evil plots of suave tourists who were whisked in and out of "Quanomet," Massachusetts, to serve as foils for Asey's feats of cracker-barrel detection. Taylor's description of the public controversy over the Quanomet post-office mural, upon which the plot of the novel turns, is, nevertheless, a witty and prescient account of untold flaps to come on the hustings of Mural America. Because her hero is a plain-spoken rustic, the author can indulge in an ironic, folksy critique of ivory-tower painters with radical notions, taking the part of a bemused populace caught, like Postmaster General Farley, in the machinations of an artistic bureaucracy.

Quanomet neither needed nor wanted a big new post office. And neither did Congressman Eliot, who bore the brunt of the protests and anonymous threats. Eliot, a rock-ribbed Republican, cast the deciding vote in favor of a New Deal measure as a matter of conscience. Unbeknownst to him, the stock payoff for bipartisan cooperation was one deluxe federal building. He thought the Democrats were kidding when they asked where he wanted his prize delivered, and he joshed them right back: "The one town on the Cape that needed a luxurious post office was Quanomet."[38] Even without the mural that came with the package, the new edifice was controversial:

The building would have inspired unabashed awe in a good sized metropolis. In Quanomet it assumed an aura of complete unreality. For each individual member of the town's all year round population of eight hundred, Asey estimated that the post office provided an area of six square feet, apiece. For the most part the structure was red brick, but here and there whimsical areas of concrete had been introduced. The front pillars were dazzling chromium, the steps pink granite, the windows were strangely barred casements. A self-conscious placard announced that the architecture was Early Colonial modified. "Modification, my eye!" Asey murmured. "It's out an' out repeal. Wow!"[39]

Inside, half of New England was sitting on the marble parquet staring up at *The History and Customs of Cape Cod* in numb disbelief. The mural was the work of a local painter, Jack Lorne, who had stolen the commission from Peggy Boone, a popular commercial artist also resident in Quanomet. An uncle of his wife's lover was the Section official in charge of the competition for "the letting out of this painting. Lots of people tried for the job . . . an' they say that his wasn't anywhere near the best."[40] The murder of Marina Lorne, after her husband's "mocking burlesques" have been unveiled, gives Asey a job, and after a course of events as convoluted as a real Section mural controversy, he unmasks the killer by an art-historical ex-

amination of the mural cartoons. The disgruntled loser of Quanomet competition is the guilty party, but by the time she is brought to justice on page 295, that mystery has long since paled in comparison to the hysterical reactions of the townspeople, more horrified by art than by mayhem.

They behave so abnormally when lampooned in paint that the real mystery is why nobody killed the muralist. On aesthetic grounds alone, he richly deserves the tar-and-feather party proposed by half of Quanomet or the necktie party favored by the rest:

No living man could describe that mural, and if he could, no one would believe him. . . . Peace, her wings protruding from beach pajamas, was starting a side chancery on a clam digger, who resented it vigorously. Ignoring three heavily armed apes in gas masks who belabored her from virtually every angle, Peace beamed down at a stalwart youth whose full nelson on Capital was definitely getting results. Capital, Asey decided, was a mighty sick man. From the clam digger's left knee tottered a leering British Grenadier, and a priest hugging a mussed Red Cross nurse. Near her, two tired women stirred something steaming in a kettle. Out of the steam emerged a Model T Ford driven by a child who looked like Shirley Temple. Myles Standish sat in a cramped position on the spare tire, making faces at John Alden and a tubercular Indian.[41]

The side panels were worse. The Civil War was "a fat Aunt Jemima . . . frying pancakes. Grant is badly burned." Modern times featured the town playboy dandling two girls in teeny swimsuits on his lap and the town plumber, symbolizing "Industry Mending the Leaking Pipes of Civilization."[42] Most of the principal figures, in fact, were patent caricatures of local worthies. Jennings, the plumber, assaulted and spanked the artist, because his business had been maligned. The playboy came under suspicion of murder, because, in the mural, he ogled Peace, and that winged lady in the daring beach costume represented the victim. Apart from the mural theme itself and the hyperbolic treatment of the newspaper stories that turn Quanomet into a tourist mecca "with hot dog and tonic hawkers" and dancing girls, the most interesting and critical passages in the book deal with the painter's attitude toward his public and official reaction to local complaints. Washington will impose art on Quanomet whatever folks think of it; the artist thinks laypeople are insensitive ninnies.

Painter Jack Lorne is not a sympathetic character. Before Taylor even brings him onstage, his neighbors have already labeled him a fool: "The only way that fellow can think is with a paint brush in his hand, and then he isn't too bright." When Lorne is told of their complaints, he is stonily unmoved:

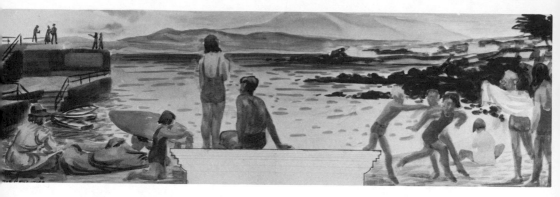

Victor Arnautoff, preliminary color sketch for USPO, Pacific Grove, California. 1939. National Archives.

They'll get over it. Some day they'll be proud, as I told the reporters. . . . I just told them they were too stupid to understand. They think a butcher's calendar is beautiful. . . . You hicks make me feel like vomiting! What do you know, anyway? What do you know about art? That's the trouble with this country, people like you.[43]

Artists were a nasty, prickly breed. Officialdom was stubborn. The mural was, after all, "gov'ment property, an' the gov'ment ain't had no sense a humor for a long time" about planned accidents to its possessions, even though the Quanomet taxpayers "never did want the post office [and] loathed the thought of the mural."[44] Washington rigged the commission, and Washington knew perfectly well what was going on in Quanomet. Folks threatened to chip a little of the picture off the wall every time they came in for the mail, the DAR passed a stern resolution, and Congressman Eliot yearned to cut through the red tape by subsidizing "a couple of good bums" to deface the mural, all to no avail. Quanomet seethed until the key to the post office was left lying around, the mural was discovered buried under a gooey coat of red paint (the plumber did it!), and the postmaster spent so much time facetiously decrying the vandalism that it was too late "to salvage that damned painting." G-men were expected, but restoration was out of the question:

Any sort of reclamation would be necessarily be a most expensive job, a burden on the taxpayers, already burdened—and so on. And after all, you can't expect the government to pour more money down the sewer—I mean down the pipe.[45]

"You don't figger there's any chance that they might, do ya?" the postmaster asked. No chance at all; in the realm of popular fiction, a plucky citizenry staved off wild-eyed modernists and truculent bureaucrats with the defiant spirit that made America great. On page

262

four of the hometown paper, stories had happy endings. In the news columns on page one, things were never that simple. Peace in a beach getup aroused Mural America, too, but it was no easy matter to thwart perfidious artists and foil insistent "gov-ment" agents.

After the Mechau dispute, however, the Section adopted a stringent review policy for designs that might prove controversial because of cheesecake content. The censor's pendulum, insofar as "personal" naked ladies were concerned, swung from an impervious disinterest in public response to a conviction than any woman wearing less than the full complement of street clothes was bound to cause a riot, unless sworn affidavits to the contrary could be produced. In the case of the Pacific Grove, California, post office, precautions were redoubled. The artist assigned to Pacific Grove was Victor Arnautoff, who had redeemed himself to a degree in the eyes of Washington following the political scandal at the Coit Tower, but was still a man to be watched in potentially ticklish situations.[46] Arnautoff began work on the Pacific Grove commission with a laudable willingness to oblige: he went there in the summer of 1939, looked up the postmaster, and "discussed the subject matter for the mural with him and some of the leading members of that community."[47] They settled on a view of *Lover's Point*, the local bathing beach, and Arnautoff prepared his preliminary watercolor on the spot.

To the right of the cornice over the postmaster's door, a group of children plays tag. To the left, a couple in sport clothes watches the activity on the pier at the end of the point. Above the door, a family group also turns away from the observer toward the water. The little girl builds a sand castle. The man and the woman at the apex of the composition gaze out to sea. He sits. She stands. His swimming trunks expose a large tanned back. She is a plump, maternal figure in a modest one-piece bathing suit, and she sent Rowan into a tizzy. Take care, he shot back, "with the standing figure of the bather above the door so that in the finished work she does not look too much like an advertisement of a bathing suit, or one of the bathing beauties."[48] To make absolutely certain that Arnautoff would take this admonition seriously, Rowan ordered him to execute a full-scale cartoon before proceeding further.

Bathing scenes were bound to be proposed for resort towns, whose beaches were the local industry and whose residents had seen women in bathing costumes. In 1939 the Section was coping with several other murals in which the fine line between wholesome fact and voy-

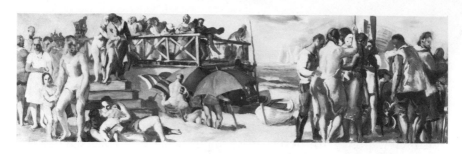

Jon Corbino, color cartoon for *The Pleasures of the Bathing Beach*, USPO,
Long Beach, New York. 1939. National Archives.

eurism seemed faint. Jon Corbino's *The Pleasures of the Bathing
Beach* showed the sandy shoreline of Long Beach, New York, that
community's principal claim to fame. The merest fragment of Long
Island real estate is visible amid the crowds of New Yorkers at play
beneath the lifeguard tower. The husky figures planted in matter-of-
fact poses do not correspond to contemporary standards of sugges-
tive allure; many still wear their city clothes, and the emphasis on
family recreation is marked in the beefy triad of father, mother, and
baby roughhousing in the left foreground. The bland domesticity of
the mural was a tolerable alternative to the breath of tabloid scandal
that hung over Long Beach after Starr Faithfull, a shady lady of easy
virtue, washed up on the bathing beach in 1931. Miss Faithfull was
full of drugs and quite dead, raped and drowned by parties unknown.[49]

Despite Corbino's unsensational resuscitation of Long Beach as the
working-class family's summer paradise, he, like Arnautoff, was re-
quired to work up life-size renderings of questionable details before
permission to install the mural was forthcoming. And Washington
was particularly agitated by the crowd at the right margin of the pic-
ture, drying themselves off and, in authentic Brooklyn style, chang-
ing their clothes behind the cover of beach towels. Within this nicely
observed slice of New York genre, the Section closely scrutinized a
rear view of a bulky woman still wearing the bottom of her bathing
suit and reaching toward her chubby infant. A balding man at her
side takes inordinate care to look in the other direction while hold-
ing up her towel for her, lest the impression be created that a painted
peeping tom is seeing something unfit for mass consumption.[50]

Atlantic City, New Jersey, was also safeguarded from incipient
scandal by a strong dose of Andy Hardy domesticity. One of Peppino
Mangravite's murals was called *Family Recreation*:

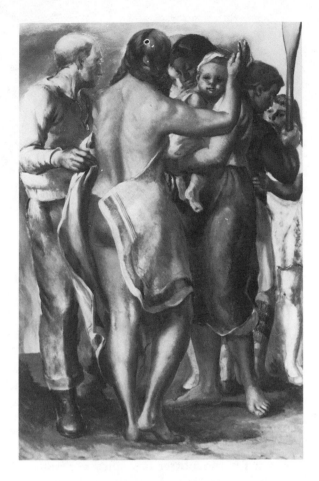

Jon Corbino, full-size
detail study for USPO,
Long Beach, New York.
1939. National Archives.
(Photo: Macbeth Gallery)

This composite design depicts children and their parents enjoying the recreation-
al activities of Atlantic City. Children are rolling hoops and riding ponies. In the
center background is a merry-go-round and in the foreground a family group re-
laxes peacefully. At the right children play a game of blind-man's-bluff while a
mother tends her young daughter and a husband adjusts the visor of a beach
chair for his wife. Adult groups enjoy the sun decks of the roofs and in the ma-
rine background are sailboats.[51]

That the man setting up the beach chair is lawfully wedded to the
woman for whom he performs that service is not apparent in the pic-
ture, but the Section's description reinforces the gingerly approach
to the theme that accounts for a puritanical dress code on this beach.
Female family members sit on the sand, under a broiling sun, muf-
fled to the teeth in frocks with sleeves and high necklines. Children
and a few fathers are permitted to wear shorts; the ladies are free to
remove their shoes, if they wish. Suggestive hanky-panky between

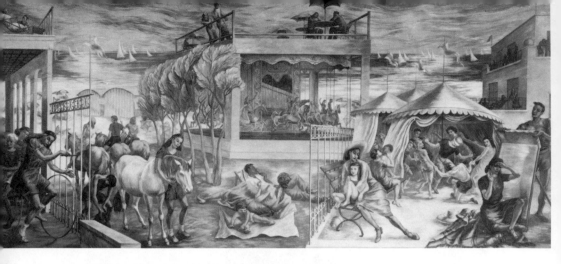

Peppino Mangravite, *Family Recreation*, USPO, Atlantic City, New Jersey. 1939. National Archives.

the sexes is not admitted, even in the second mural, which shows what teenagers do along the Boardwalk. Revealing attire for the young couples chastely spooning near the Steel Pier is limited to one serving of exposed midriff, shown from the back.

On the left a vendor sells flowers and fruit to sun bathers while others play handball. In the center foreground a chess game is in progress and behind this a pavilion with roller-skaters. On the wall of the building is a poster of "Miss America" and on the roof are shuffle-board players. To the right, on the terrace of a cafe, several couples are dancing a square dance while an orchestra plays on the roof above.[52]

The Miss America shown on the poster is a spicy contrast to all this hearty, overdressed activity. Indeed, it is only in the context of the picture of a poster, safely removed from real-life status and embedded in scenes of innocent, organized fun, that she is typologically acceptable. The mural presents her in quotation marks, as it were, holding her trophy in one hand and the American flag in the other, being crowned with the diadem of the fairest and wearing little else but the tiara, a broad smile, and a narrow bathing-beauty ribbon slung over her shoulder. At dead center, the poster pits her breathtaking cleavage against the minimal constraint provided by the skimpy bodice of a low-cut swimsuit. When Rowan warned Victor Arnautoff against "bathing beauties," he had this lush Miss America in mind.

By 1939, Atlantic City and its Miss America Pageant were emerging at last from the shadow of scandal. The show had been closed down between 1928 and 1933, while reporters had a field day with exposés of graft, jury rigging, professional showgirls masquerading

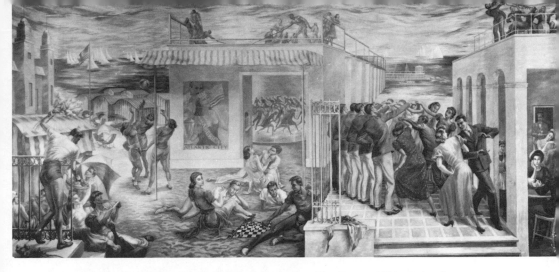

Peppino Mangravite, *Youth*, USPO, Atlantic City, New Jersey. 1939. National Archives.

as sweet coeds from Alaska, and dark hints of prostitution. The powerful Hotel Men's Association of Atlantic City worried that innuendo would drive their family clientele away: "There has been an epidemic recently of women who seek personal aggrandizement . . . by participating in various stunts and . . . that type of woman has been attracted to the Pageant in ever-increasing numbers. Many of the girls who come here turn out bad later and though it may happen in other cities, it reflects on Atlantic City."[53]

The Miss America poster in the post-office mural reflects favorably on Atlantic City, however, for in 1935 the chastened promoters hired Miss Lenora Slaughter to chaperone the proceedings and clean up the cheesecakery. The pageant was revived and enjoyed commercial success under a patina of respectability buffed by a much-touted talent competition that helped take the curse off the mammary fixation still manifest in Mangravite's facsimile poster. In the eyes of the jittery business community, fleshy displays were clothed in a new ambiance of propriety by supplemental credentials of a less obvious sort now expected of contestants. Like Mrs. Beil of Salina, Kansas, Miss America was cherished not only for her svelte 36-25-34 dimensions but also for her (usually limited) ability to sing, dance, play the piano, or recite a dramatic monologue. Patricia Donnelly, former Miss Michigan and Miss America of 1939, did not even place in the swimsuit segment of the pageant, and 1939 also marked the first time a nice, plain, good-natured girl won a special award for sheer "congeniality."[54] For Atlantic City, New Jersey, home of the bathing-beauty contest, the poster was an appropriate emblem of local prosperity and propriety, providing that a poster stood in for the

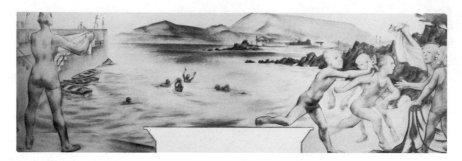

Victor Arnautoff, cartoon for *Lovers Point*, USPO, Pacific Grove, California. 1940. National Archives.

reigning lovely with the revealing outfit and enormous "talents," and providing that her picture was more than counterbalanced by family fun and a sanitized portrayal of adolescent mating rituals. As for Pacific Grove, California, the Section felt, upon inspection of the full-sized cartoon, "that the woman in the bathing suit on the left is distressingly insistent physically. It occurs to us that there might be some objection to this on the part of visitors to the Post Office."[55]

The mural cartoon sacrifices familial clutter for the sake of monumentality and simplicity of design. The beach is now occupied by the children on the right set off by one woman on the extreme left edge of the picture. Her stance is decisive and purposeful: with feet planted wide apart, she shakes out a beach towel. Her face is turned to the sea, and the musculature of the back of her body is pronounced beneath a tank suit which is neither revealing nor seductive in cut. Like the bathing costumes of the children, however, hers is an intrinsic part of the mass of the figure, coextensive with body contours and differentiated from muscle and sinew solely by indications of straps at the shoulders and the hem of the shorts passing below the buttocks. This is no Miss America daintily mincing down the runway in as brief a costume as Atlantic City's innkeepers will permit, and this is no simpering Mack Sennett "bathing beauty" flexing dimpled knees for the camera. Her scale, her posture, and her indifference to being observed contribute to a sense of density which verges on the "impersonal": Arnautoff's woman could be a piece of sculpture, a streamlined chromium hood ornament for a late-model convertible. Yet her firm, sleek derriere, glimpsed on the center line of the composition, touched off a cleavage crisis in reverse in Washington: "In view of the fact that you have such a delightful group of children on the right in bathing suits it is our feeling that the design would be more interesting if you substituted a young woman in street or sport

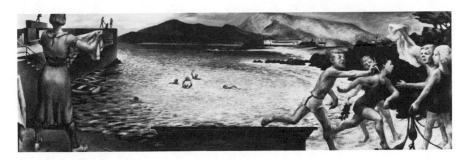

Victor Arnautoff, *Lover's Point*, USPO, Pacific Grove, California. 1940. National Archives.

clothes turned toward the children as though she were watching them at play." Surely the artist could discern the reason for caution, swaddled in the sexual innuendo of Rowan's remarks, which concluded with the "hope that the decision in this particular case will not be regarded as unduly stuffy by you."[56]

Had Arnautoff set out to titillate Pacific Grove by painting a pin-up leering back over her own shoulder to ensure the adoration of her own posterior, he might have reacted to being found out by the watchdogs of public morality. As it was, Rowan's verbal elbow in the ribs induced him to paint a sport costume over his bather without adjusting her pose or reducing her "insistent" solidity, and the Section was too red-faced to push its initial objections further.[57] Arnautoff installed the mural in April of 1940 and was pleased to report the postmaster's "complete satisfaction" with the subject, the color, and the execution of the work. But he did find it advisable to confess that official's objections to the topography of *Lover's Point*:

He seemed disappointed with the fact that there was no photographic likeness of the landscape in the mural; he said he could not recognize where I was standing while looking at the landscape. I explained to him [a] certain necessity of rearrangement of the natural landscape for the sake of the composition.[58]

For the moment, what his big lady was looking at had rendered the lady herself invisible.

She was also passed over in silence by the Pacific Grove *Tide*, which vented other objections to *Lover's Point* on the morning of April 5 under this headline: "That New Picture In the Post Office Worries Us." The *Tide* stated at the outset that the mural "promises to be the subject of considerable local argument," and, although why the townspeople were going to be up in arms over the painting was not made entirely clear, Arnautoff's cavalier treatment of the landscape never figured in the discussion. Editor Gould believed the

picture was a WPA make-work project and he approved of federal relief. "Certainly," he wrote, "unemployed artists have as much claim on the government as unemployed brick masons." Pacific Grove locals could endorse the value of project art, since the high-school murals installed by the FAP were much admired.[59] Nevertheless, there was a difference between those panels and the new post-office mural:

The editor of *Tide* doesn't profess to be learned in matters of art, but the high school project seems to us to be in good taste. The murals are a definite addition to the building and seem to fit well into their surroundings. The post office picture, on the other hand, seems to be entirely foreign to the general architectural style of the building and the rest of the lobby. It sticks out like a sore thumb. It is not [in] a place where it can be viewed properly or appreciated, and the general use of the post office lobby is not such as to promote proper appreciation of art.[60]

Most artists who had tried to paint a satisfactory mural for the cramped band of wall high above a postmaster's door could have seconded Gould's sentiments on the difficulties of appreciating artwork under adverse conditions. As a rule, post-office lobbies were tunnel-like affairs. A center entrance opened on a vestibule cage of glass and wood that gave in turn upon the bank of service windows cut into the long wall of the lobby. Short lateral partitions containing the door to the postmaster's office, bulletin boards, writing desks, and so on flanked the service area. A mural hung above the postmaster's door was hard to see from any position at floor level. If one stood between the vestibule and the door, the angle of vision was impossibly steep; when daylight from the windows between the entrance and the door flooded laterally across the surface of the picture, reflections reduced murals to a blur of color. On dark days, they disappeared into the murky shadows beneath the ceiling. Standing at dead center of the lobby, between the vestibule and the service windows, meant blocking traffic and trying to view the mural through a lattice of lighting fixtures dangling on chains from the ceiling. Given the vagaries of exterior light, the position of the vestibule, and the electric lamps blocking the sight line, the mural could not be seen at all from the far end of the lobby. The placement of *Lover's Point* was unfortunate, but an art lover bobbing and weaving to catch a glimpse of the painting could pity the artist without censuring his efforts. Poor visibility was not the reason the *Tide* anticipated "considerable local argument."

When Rowan took pen in hand to stifle the incipient uprising, he thought he had figured out what the fuss was really about. After the standard spiel on the difference between art patronage and relief for artists, he turned immediately to the possible disparity between the traditional style of the post office and the contemporary theme of the mural. Any failure to coordinate architecture and decoration was Pacific Grove's own fault: "Before beginning his designs . . . Mr. Arnautoff discussed the subject matter with the Postmaster and other interested citizens who desired, as he did, that the mural reflect contemporary life in Pacific Grove."[61] Although that aesthetic split had consumed the lion's share of the article at issue, Rowan's rejoinder did not mollify the *Tide*. A second editorial, printed beneath a photograph of *Lover's Point*, suggests that suave references to stylistic disunity had masked a more basic objection to a violation of social decorum:

[Here is the mural] for which the federal government expended a considerable sum of money. It is supposed to depict contemporary life in Pacific Grove. There are many people who do not like it. Principal objections are the distorted faces of the children and that the whole thing is out of place. What do you think?[62]

Apparently, nobody thought much that the *Tide* thought worth printing. Rowan readied himself for combat by soliciting a detailed report on the evolution of the iconography from Arnautoff, but the controversy melted away during the summer of 1940, as Californians headed toward the sunny beach at Lover's Point.[63] Had Gould marshaled angry partisans, it would have been a difficult revolt for the Section to quash, if only because the grounds for objection to the picture shifted at will, from landscape to architecture to placement to the "distorted" children that Rowan had found so "delightful."

And it is no exaggeration to state that the Pacific Grove mural bothered everyone who saw it: first, the Section; then, the postmaster; next, editor Gould; and finally, the "many people who do not like it." Yet each had a different explanation for why *Lover's Point* was bothersome, and every explanation was vague, partial, and inadequate. "The whole thing is out of place," the *Tide* insisted in the end, this time without bothering to dither on obscurely about architectural context or the configuration of the lobby wall. That the figural element was at issue is suggested by the sudden introduction of the "distorted" children. The boys and girls are caught up in their game and do not pause to flash the winning grins of the Campbell

Kids. At the same time, only a critic looking hard for a concise bon mot with which to dispatch a picture already deemed objectionable could use that deviation from greeting-card cuteness as a reasonable justification for despising what is merely a pleasant outdoor scene. Attaching a pejorative label to those figures neatly absolves the critic from having to verbalize an instinctual reaction to the only remaining figure in the picture, the invisible lady with the "insistent" backside that, although Rowan did not put it quite so crudely, "sticks out like a sore thumb."

Rowan phrased that insight with such lace-curtain delicacy that the artist missed it altogether. The postmaster took one look at the picture, slid his goggling eyes toward the fictitious hills in the distance, and kept them there. The *Tide* used just the right metaphor to express what everyone was thinking but promptly backed all the way around Robin Hood's barn in a high-toned effort to avoid a pratfall into the morass of pornographic revelations. Towns with fewer inhibitions about naming the anatomical affronts posed by bathing beauties fared better with their campaigns to get rid of stuff that stuck out "like a sore thumb." Prurient rhetoric had its uses.

The cryptic text of the placard mounted beneath the mural in the post office at Kennebunkport, Maine, for just over three stormy years contained no filthy words and hinted at the Section's prudent reluctance to call undue attention to the picture. The mural was entitled *Bathers*, and the complete description of the work consisted of a single declarative sentence: "A group of summer resorters relax on the sand at Goose Rock Beach."[64] Brevity was the soul of wisdom; Kennebunkport despised Elizabeth Tracy's painting, which was "repulsive" enough in its own right but doubly damnable when stacked up against a mural installed in nearby Kennebunk two years before.[65] Comparisons were inevitable, for the towns were fierce rivals. In 1939 Kennebunk gained an edge in the local game of one-upmanship by acquiring both a new post office and a ripsnorting historical mural featuring a "striking" rendition of an early stagecoach.[66] Kennebunk egos were further inflated by the Section's choice of Edith Barry to paint *Arrival of the First Letter in Kennebunk from Falmouth—June 14, 1775*. Edith Barry was a local girl.[67]

In the spring of 1941, Kennebunkport had reason to hope smug Kennebunk was about to get its comeuppance. Kennebunkport could boast of an even newer, fancier post office, and a mural was in the offing. As for the artist awarded the commission, Elizabeth

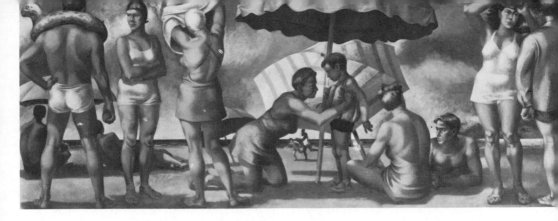

Elizabeth Tracy, *Bathers*, USPO, Kennebunkport, Maine. 1941. National Archives.

Montminy, nee Tracy, was not exactly a homegrown product, but she was a New Englander, schooled at Cambridge Latin and Radcliffe, and she had just been awarded a prestigious Guggenheim Fellowship. The Boston papers had it that she was a crackerjack history painter, too, with Section murals already to her credit depicting the pre-Revolutionary *Suffolk Resolves* and a Wild West railroad train.[68] Match that, Kennebunk!

Tracy went to Kennebunkport in May of 1941 and mailed her preliminary sketch to Washington from the post office, where she planned to set up a scaffold and begin work in July, with the eager townsfolk looking on and chortling with glee. "I have chosen a theme dealing with the town as a summer resort," she wrote. "I have talked with the Postmaster and he approves my suggestion of a bathing beach scene."[69] Rowan was understandably inclined toward circumspection in beach topics and inspected the drawing from the vantage point of an experienced devil's advocate:

In the case of the woman in the yellow bathing suit you [might] introduce a towel or cape over her arm which would in no way interfere with the line of the composition and would meet any criticism that might arise. I do wish to add, however, that you have handled the scene in a way that I should regard as above reproach.[70]

Rowan had been wrong before, of course, but the suitability of the beach scene received indirect confirmation from the local postmaster who requested a delay in the erection of the scaffolding "as Kennebunkport is a summer resort and as July and August are our busiest months."[71] That certainly sounded as if the post office were going to be jammed with ladies wearing yellow bathing suits and carrying capes or towels, and Washington was also reassured by signs of Tracy's apparent high standing in the community. She did arrive in

Maine at the height of the summer rush, but, far from sending her home, the postmaster relented instantly and let her start painting late in July.[72]

The minute Tracy picked up her brushes, the jig was up. Spectators in the post office knew that Kennebunk's nifty stagecoach was not going to be trounced by a pack of fat trollops. In fact, as word spread and scoffers from outlying points began to arrive to witness the desecration in progress, Kennebunkport was fast becoming the laughing stock of the State of Maine, because Kennebunk — Kennebunk, no less — was the site of the beach resort. Kennebunkport was a stodgy summer colony for writers and socialites and sedentary tycoons. Why, the nearest beach was a stony little cove some considerable distance beyond the municipal borders. By mid-August, the Section had been swamped in letters and petitions of protest. A prominent New York attorney who had previously enjoyed his retirement in Kennebunkport (N. B., not Kennebunk!) had second thoughts after he saw what was happening to the "beautiful post office building. It is being spoiled by a mural which is not only inappropriate but repulsive and disgusting. Nothing but indignation is expressed by the people."[73]

The first batch of denunciations fell into two categories: letters from folks who were ready to condemn any picture with a contemporary theme, and letters from people who kept that prevailing sentiment to themselves and confined their criticism to the five large female bathers in the mural, discounting five large male bathers and a little boy altogether. Historically minded citizens were not above taking a crack at the ladies either:

In this town of great historical interest from the earliest days, throughout the war of 1812, Indian fighting, great shipping interests, ship building, etc., etc. and not merely a summer resort it seems to us that a picture of bathers of beefy forms and ugly faces [is] quite out of place. It might do for Coney Island, but here it is an offense.[74]

Two petitions that circulated among the gentry began by enumerating the historical glories of the ship-building era in Kennebunkport, attested to the fact "that the district is wholly without a bathing beach," and concluded by calling the women in bathing suits "utterly grotesque and cheerless." The Postmaster General's office was shaken because "the petitions bear the signatures of Anne E. Morrow, Margaret Deland, and a number of other very prominent per-

sons, [and] it is the opinion here that the matter should receive very serious consideration."[75]

Perhaps the disappointment over the loss of a historical illustration colored the thinking of those who concentrated their wrath on the ladies, since they shared the opinion that Tracy's figures were tainted by aesthetic radicalism. A "Property Holder," for instance, demanded removal of "the disgusting, corpulent bathing figures," because the "offensive, repulsive mural abstract" was foreign to local standards of beauty.[76] This peculiar usage of the word "abstract" seems to imply a modernist plot and another Kennebunkport worthy thought female bulk was a sure sign of a Red conspiracy:

This summer a young woman appeared with a commission to paint a mural in a panel on the south wall of the building. The work is now practically completed, and her painting is of a number of highly colored grotesque figures on a miniature beach. The figures represent the Russian peasant type and the entire mural is most objectionable to those opposed to the kind of political philosophy which it undoubtedly represents.[77]

According to N. M. Martin, the assistant postmaster, the only plot afoot in Kennebunkport was the coordinated letter-writing campaign being organized directly beneath the scaffold, within earshot of that poor Miss Tracy:

There is absolutely nothing immoral nor indecent in the picture and I believe the public should allow Miss Tracy the privilege of completing her work before they should be allowed to criticise [sic] as any picture in an unfinished state does not look as the completed picture will be. If I may express a "confidential" opinion — I believe that a few who do not like the subject of the Mural have stirred up others who otherwise would not have expressed an opinion of disapproval. . . . [There] are many who do like the picture as well as objectors who will take the trouble to write to you.[78]

As Mr. Martin correctly surmised, Rowan had heard exclusively from the malcontents passing rude remarks in stage whispers while Tracy worked. He ordered her to prepare "a report on the reaction to your work so far. . . . In case it is true that bathing beaches are not suitable subjects for Kennebunkport, perhaps you made a mistake in selecting that subject matter."[79] That was all Tracy needed to hear. Her good judgment assailed by Washington, she ceased painting long enough to drum up expert opinion on her side of the question. Irene Morris, writing on the letterhead of the Fogg Museum at Harvard, identified herself as a "summer visitor" to Kennebunkport and gave the mural a ringing endorsement: "[In] my opinion both the subject

matter and execution of [the] work are excellent. I see no reason why a beach scene should not be regarded as typical of that section of Maine."[80] Edith Barry of Kennebunk reported Tracy near collapse. She did not say much about *Bathers*, except to note that the natives of rocky, beachless Kennebunkport had been pining for a "romantic, dramatic past of shipbuilding and sailing." She did, however, lay most of the blame for any error Tracy may have committed at the doorstep of the Section:

It seems to me that the arts department in Washington puts an artist in a most unfortunate position by accepting a subject sketch which is not appropriate to the place. . . . I do feel that it would help matters and create a more satisfactory relation of artist and public, if, before an artist begins work on a mural, a small committee of local townspeople could pass on the subject matter of a sketch, so that it would be acceptable to the community. As one person said, the artist is really paid by the town, and so the town should have the right to be satisfied. After the mural is finished, the tempest will probably blow over, as is generally the way when people get used to things.[81]

If Tracy hoped to convince Washington that she was an excellent and cooperative painter cruelly victimized by an innocent mistake, her counterplot misfired. An independent local witness, allied to no faction but connected socially with the First Family, came forward to tell all. Her story flattered neither the townspeople nor the artist.

The rambling, chatty letter that blew the lid off the Kennebunkport case was not written primarily for the Section's benefit. It was a thank-you note from Mildred Burrage to the president's uncle, Frederic A. Delano, Miss Burrage's courtesy "uncle" ever since she roomed with his daughter at Bryn Mawr. Burrage had taken an interest in the Kennebunkport mural from the first, because her collegiate major in fine arts included a stint on the scaffold and because she was profoundly skeptical of government mural patronage. A trip through the provincial museums of France during the palmy days of the Hoover regime exposed her to "the most terrible salon pictures, bought by the government, proving they had guessed wrong every time and never by any chance secured anything of lasting value." Art and politics, she concluded, probably ought not be mixed but what with this awful Depression and all, she tried to keep an open mind about Elizabeth Tracy and the nice New Deal post office in Kennebunkport:

The artist arrived one afternoon with her husband, also a painter. I asked her what she was going to do and she replied that she would not do anything histori-

cal or about shipbuilding—that Kennebunkport was a summer resort, and she was going to do a beach scene. She had never been to Kennebunkport before and her design had already been accepted by the Treasury Department. (She had been awarded the mural and it was not a competition). I asked her if anyone had told her that the beach was in Kennebunk . . . and that our coast is rocky. Since this town has been feuding with Kennebunk since before the Revolution I pointed out it was going to be just too bad if we got the wrong mural. . . . She immediately said that it did not make any difference to her, that it did not matter what the people here thought, and when I said that they might refuse to have it, and I thought she ought to be warned, her husband said, "Never mind! The Treasury will have to pay for it".

In Burrage's book, all this minx needed to complete her convincing imitation of Scarlett O'Hara was a toss of the curls and a "fiddle-dee-dee" for the postmaster. He and his deputy were in a lather of nervous anxiety after they saw Tracy's drawing:

The assistant reported that her sketch "looked just like a billboard of Old Orchard", our only Maine version of Coney Island. The postmaster explained that there was no local angle whatever to [the] mural. No one in town had any say about it and the design had already been accepted before the artist ever saw the place. However the next day the artist did return while I was away, and her husband said she was going to put in a local setting—while she said she could she could not see why she should! She came back in six weeks to paint the mural, and had decided she would paint the beach, no matter what I had said.

So much for the ruse of mailing the sketch from Maine and reporting the postmaster happy as a clam with the bathing picture. In retrospect, his last-minute attempt to protect his lobby from disturbance while the summer crowd was in residence seems to have been an effort to protect himself and the hard-bitten painter lady from what happened next:

She then embarked on the most frightful experience—painting a mural to an intensely hostile audience whose reactions were just what I had said they would be about the appropriateness of the subject, but were also to my surprise concerned with it both morally and technically. They worried about the lack of bathing suits while she was doing the figures and they did not like the fashionable hard red and yellow flesh tints, and very strong color, and they started writing to the Treasury and the Senators, and the Representatives, and when dreadful Mr. Oliver wrote suggesting a petition they started signing a petition! The acoustics of the P.O. were such that every breath of criticism was heard by the unhappy artist and she would get so mad she would cry with rage.

Looking back on this phase of the controversy, Burrage thought it had not been sporting of the locals to make a to-do before the naked ladies acquired their swimsuits. On the other hand, an artist

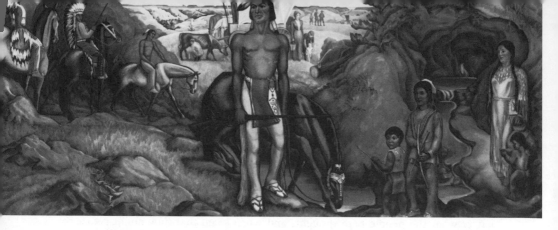

Edith Mahier, *Roman Nose Canyon* (unretouched), USPO, Watonga, Oklahoma. 1941. National Archives.

with a modicum of common sense, and one who already knew that her theme was not going to be lauded by the community, ought to have known better than to paint enormous ruddy women in their birthday suits on the post-office wall in broad daylight, at the height of the seasonal rush. But perhaps Tracy misjudged her audience. The gasping onlookers included such distinguished literary figures as Booth Tarkington and Kenneth Roberts, and a malicious trickster told Tracy that the literati were behind her. Instead, they thought her performance "incredible" and were the leading lights of the coterie which detected a conspiracy to sap the moral fiber of democracy in those lewd and hulking *Bathers* with modernistic complexions. When Tracy asked them to defend great art and sponsor a petition in her favor, they huffily declined:

The figures in the mural looked crosser and crosser and madder and madder, and then she included portraits of herself and her husband to leave with us as happy souvenirs. When she complained to me how terrible it had been, I said at least she had been warned, even if she had not believed me, and she replied she never imagined people could be so stupid.

In a classic instance of life imitating art, Phoebe Atwood Taylor's story of the Quanomet post-office mural, with its racy caricatures and its surly artist, was being reenacted in Kennebunkport, Maine in the summer of 1941. A murder and a bucket of red paint were the only missing ingredients, and Burrage felt certain that people were steamed enough to resort to the latter at the slightest fresh provocation. The Section deserved the worst, anyway; its slipshod methods were a scandal to art lovers everywhere:

If the government had one person who acted as a liaison officer between the town and the artist and the Treasury Dept. I think it would do more to popu-

larize Art than anything else, instead of everyone being sarcastic at poor Art's expense. Did you read about Chief Red Bird?[82]

"Uncle" Frederic had certainly heard of the chief. In the summer of 1941, the breakfast-time ritual of the American family centered on the Associated Press blow-by-blow coverage of the Indian picket line thrown up around the Watonga, Oklahoma, post office to protest a salacious and scurrilous depiction of Henry Roman Nose, legendary chieftain of the "Fighting Cheyenne."[83] His 71-year-old successor, Chief Red Bird, took up a vigil before the post office in June of 1941 and, speaking through Joe Yellow Eyes, his picturesque interpreter, claimed he would not budge from the spot until the honor of the tribe had been vindicated by substantial alterations to the mural by Edith Mahier. Red Bird was on the warpath because Roman Nose had been indecently exposed. "Breech-cloth too short," he muttered. "It makes him look like a Navajo jellybean and Red Bird doesn't like Navajos." The son and heir of Roman Nose looked like "a stumpy pig bloated on corn meal," too. Mahier, a recognized expert on Indian costume who had designed a line of women's apparel using native motifs, responded cheerfully enough:

I think a mural should arouse the interest of the people. . . . It should do that above everything. I entered the competition mainly because few Oklahoma artists were participating and they were sending out this way eastern artists who were putting English saddles on Indian ponies. At least I didn't do that.[84]

The Indian uprising in Watonga was a nine-days' wonder. Reporters asked Red Bird if he were going to scalp the artist and solemnly took down his reply: "Bow-and-arrow, horse-and-buggy-day business no good. Cheyenne streamlined. We picket post office."[85] Mahier offered "to rectify an offending element such as the length of the loin cloth on the central figure."[86] When the Section took her up on her offer and the chief went home, the capitulation was headline news: "Cheyenne Call Off Warriors, Uncle Sam Promises He'll Do Something About Bare Limbs of Chief Roman Nose."[87] What did not hit the wires, however, was the fact that the protest had been an outrageous hoax. An Indian informant named "Ernie" slipped Mahier a note telling her not to worry about a thing. "It's a publicity stunt," he admitted, "and everybody knows it is a joke. In fact, it'll probably make you more famous than you already are."[88] Long after the war drums fell silent, Mahier found out that the fun-loving Watonga Chamber of Commerce had hired Red Bird, Joe Yellow Eyes, and

their retinue to drum up free publicity. The picket signs, with their movie-Indian monosyllables, had been printed in the office of the Watonga *Republican*, and a reporter called "Cowboy" had written Red Bird's ceremonial chant for the occasion. "Mural Stink!"[89]

The local luminaries complaining in audible tones under Tracy's scaffold in Maine were too well-bred to utter those words. Moreover, they were not paid shills but angry and, for the most part, wealthy taxpayers who were used to having their own way, touchily intent upon retaining the down-East charm of their holiday retreat, and skilled in the wicked ways of Washington. After Delano showed the Burrage letter to half of Washington, the Section's sympathy toward Tracy cooled. Rowan paid her off in November of 1941. He tendered perfunctory regrets over her "distressing time" but enclosed a copy of the fateful document that impugned her protestations of naive innocence.[90] And in a long overdue reply to the Postal Department's request for an explanation of the situation, delayed until he believed the case was closed, Rowan insisted that the Section was the inno cent party. Tracy said her design was acceptable to the community. The letter was in her file. He himself believed her.

Under these circumstances this office offered no objection to her proceeding with that theme. . . . It is evident that to this artist sandy or shorter character istic of many regions of Maine where thousands of the citizens of America spend at least part of the summer days on beaches, had a special appeal; it gave her an opportunity to base her very handsome design on a group of figures at play on the beach and it would seem to this office . . . unfair to condemn her for not selecting subject matter chosen by the petitioners."

Ascy Mayo called that kind of steam-winding humiliating a "good Maine-to-California hit," and since the commission was over done with, it satisfied the Post Office people.[92] America entered World War II a month later, and the Kennebunkport mural was gotten by officialdom. It was not forgotten by the summer col however. They trickled back to Maine in increasing numbers war wound down and in 1944 decided the time had come to patriotic thing and wage a war of liberation to free Maine Red menace, "Uncle Joe" Stalin's prominence in Allie notwithstanding. They met beneath Tracy's Bathers, pac and raised enough money to commission a mural from an old Section hand who had begun to make a name the Atlantic seaboard as an illustrator of marine subje intention to remove "government property," valued

larize Art than anything else, instead of everyone being sarcastic at poor Art's expense. Did you read about Chief Red Bird?[82]

"Uncle" Frederic had certainly heard of the chief. In the summer of 1941, the breakfast-time ritual of the American family centered on the Associated Press blow-by-blow coverage of the Indian picket line thrown up around the Watonga, Oklahoma, post office to protest a salacious and scurrilous depiction of Henry Roman Nose, legendary chieftain of the "Fighting Cheyenne."[83] His 71-year-old successor, Chief Red Bird, took up a vigil before the post office in June of 1941 and, speaking through Joe Yellow Eyes, his picturesque interpreter, claimed he would not budge from the spot until the honor of the tribe had been vindicated by substantial alterations to the mural by Edith Mahier. Red Bird was on the warpath because Roman Nose had been indecently exposed. "Breech-cloth too short," he muttered. "It makes him look like a Navajo jellybean and Red Bird doesn't like Navajos." The son and heir of Roman Nose looked like "a stumpy pig bloated on corn meal," too. Mahier, a recognized expert on Indian costume who had designed a line of women's apparel using native motifs, responded cheerfully enough:

I think a mural should arouse the interest of the people. . . . It should do that above everything. I entered the competition mainly because few Oklahoma artists were participating and they were sending out this way eastern artists who were putting English saddles on Indian ponies. At least I didn't do that.[84]

The Indian uprising in Watonga was a nine-days' wonder. Reporters asked Red Bird if he were going to scalp the artist and solemnly took down his reply: "Bow-and-arrow, horse-and-buggy-day business no good. Cheyenne streamlined. We picket post office."[85] Mahier offered "to rectify an offending element such as the length of the loin cloth on the central figure."[86] When the Section took her up on her offer and the chief went home, the capitulation was headline news: "Cheyenne Call Off Warriors, Uncle Sam Promises He'll Do Something About Bare Limbs of Chief Roman Nose."[87] What did not hit the wires, however, was the fact that the protest had been an outrageous hoax. An Indian informant named "Ernie" slipped Mahier a note telling her not to worry about a thing. "It's a publicity stunt," he admitted, "and everybody knows it is a joke. In fact, it'll probably make you more famous than you already are."[88] Long after the war drums fell silent, Mahier found out that the fun-loving Watonga Chamber of Commerce had hired Red Bird, Joe Yellow Eyes, and

their retinue to drum up free publicity. The picket signs, with their movie-Indian monosyllables, had been printed in the office of the Watonga *Republican*, and a reporter called "Cowboy" had written Red Bird's ceremonial chant for the occasion: "Mural Stink!"[89]

The local luminaries complaining in audible tones under Tracy's scaffold in Maine were too well-bred to utter those words. Moreover, they were not paid shills but angry and, for the most part, wealthy taxpayers who were used to having their own way, touchily intent upon retaining the down-East charm of their holiday retreat, and skilled in the wicked ways of Washington. After Delano showed the Burrage letter to half of Washington, the Section's sympathy toward Tracy cooled. Rowan paid her off in November of 1941. He tendered perfunctory regrets over her "distressing time" but enclosed a copy of the fateful document that impugned her protestations of naive innocence.[90] And in a long-overdue reply to the Postal Department's request for an explanation of the situation, delayed until he believed the case was closed, Rowan insisted that the Section was the innocent party. Tracy said her design was acceptable to the community. The letter was in her file. The Section believed her:

Under these circumstances this office offered no objection to her proceeding with that theme. . . . It is evident that to this artist subject matter characteristic of many regions of Maine, where thousands of the citizens of America spend at least part of the summer days on beaches, had a special appeal. It gave her an opportunity to base her very handsome design on a group of figures at play on the beach and it would seem to this office . . . unfair to condemn her for not selecting subject matter chosen by the petitioners.[91]

Asey Mayo called that kind of stem-winding bloviating a "good Maine-to-California bit," and since the commission was over and done with, it satisfied the Post Office people.[92] America entered World War II a month later, and the Kennebunkport mural was forgotten by officialdom. It was not forgotten by the summer colonists, however. They trickled back to Maine in increasing numbers as the war wound down and in 1944 decided the time had come to do the patriotic thing and wage a war of liberation to free Maine from the Red menace, "Uncle Joe" Stalin's prominence in Allied councils notwithstanding. They met beneath Tracy's *Bathers*, passed the hat, and raised enough money to commission a mural from Gordon Grant, an old Section hand who had begun to make a name for himself on the Atlantic seaboard as an illustrator of marine subjects. It was their intention to remove "government property, valued at $700.00, at the

risk of its ultimate damage" and to substitute Grant's picture of "the shipbuilding and seafaring activities" of historical Kennebunkport.[93] Congressman Robert Hale suggested the swap to the Federal Works Agency in December of 1944 and received a wholly unsatisfactory counteroffer:

> You will readily understand . . . that permission to replace a decoration which some individuals regard as excellent cannot be approved. Nevertheless, this office has no objection to the inclusion in the Post Office of Mr. Grant's mural providing it is at no cost, whatsoever, to the government.[94]

Since the object of the exercise was to get rid of *Bathers*, the dissidents regrouped their forces and plotted a new strategy. In the spring of 1945 they persuaded Senate Minority Leader Wallace H. White, Jr. of Maine to carry the fight to the floor of Congress. A more devious ally could not have been recruited. White attached a special amendment authorizing removal of Tracy's picture to a vital $3,150,000,000 appropriations bill and pledged to keep talking until he had pushed the measure through the Senate on gales of perfervid oratory that delighted the Washington press corps:

> "The mural is a picture which, to speak frankly, depicts a group of fat women, scantily clad, disporting themselves on a beach". . . . Asked whether it was the nudity or the obesity of the post office women to which objection was made White told reporters: "Oh, I don't think those gentlemen in Kennebunkport have any objection to nudity. It was the bulges, fore and aft, they objected to".[95]

Reporters set out to find the gentlemen and tracked Booth Tarkington down in his home in Indiana. He was all for the departure of "the undraped portly gals . . . because they are inartistic—New England Puritanism has nothing to do with it." And his every opinion, Tarkington said, was shared by his old pal Kenneth Roberts:

> Tarkington regarded White's description of "scantily clad" women as an understatement. The author, whose vision is badly impaired, said he had seen the mural many times before his sight began to fail. He described the picture vividly and said it contained both nude men and women. "But there is nothing indecent about those nudes", Tarkington asserted. "They are simply ultra modern art. I would call them a combination of Coney Island and Mexican realism".[96]

Tarkington cleverly contrived to leave the impression that the women were as naked as jaybirds and were carrying on with naked men, too, in best "ultra modern," pinko style. As the story spread, headlines in hometown papers far from Maine, chortling over Kennebunkport's "fat hussies" and "shameless maids," compounded the error.[97] The Senate yielded to the blushes of the distinguished mem-

ber from Maine and passed his bill unanimously. "No one thought to ask what would become of the scantily clad ladies," recorded on a U. S. Government Bill of Lading as "1 mural, 58 lbs., from Kennebunkport, Me. P.0. to Federal Works Agency, collect."[98]

Tracy read all about it in the Austin, Texas, papers, but by the time her wire caught up with Edward Rowan, it was too late.[99] The Senate had spoken, Rowan had no clout left, and he had no inclination to tilt at windmills as the champion of the scarlet ladies of Kennebunkport. In his capacity as Fine Arts Consultant to the Federal Works Agency, his last official duty was to file her telegram carefully in the yellowing folder marked "Maine, Kennebunkport Post Office." "Miss Tracy's mural has been carefully taken from the wall," he told the sole remaining supporter of the federal renaissance who troubled to inquire, "and it is in the safe custody of this office. It is my hope that I may find a suitable space for it in which its fine qualities are appreciated and where there is no question, whatsoever, relative to the appropriateness of the subject matter."[100] Alas, nobody in America wanted those fat, naked hussies. The office closed. The ladies vanished. The purity of the republic was preserved.

As he closed the books on Kennebunkport forever, was Rowan tempted to rue the day he first argued for nudity in the Washington Post Office on the basis of Mechau's abstract and impersonal treatment of the bare facts? Over the years, the connection between nudity and modern art had come back to haunt him again and again. Kennebunkport, in the end, saw nude figures where none existed, mirages on a wall sullied by the strong, hot colors of modernism. Lewdness and aesthetic radicalism had fused in the popular imagination. Despite his best efforts to disavow any such intrinsic relationship, one species of depravity always evoked the other. Two fuzzy terms had become synonymous. The more vigorously the Section censored sketches and cartoons and the more zealously Rowan guarded the citizenry against violations of prevailing standards of morality and good taste, it seemed, the more intently the public sniffed out the cloying stench of the avant-garde, which the Section itself despised. In March of 1937, for instance, the Section decided to take a big chance on Paul Cadmus.[101] Cadmus had acquired a poisonous reputation for painting dirty pictures in 1934, when a retired admiral caught sight of his PWAP drawing *The Fleet's In*, a genre study of several awesomely endowed sailors dallying and dickering with a crowd of loose women. The picture was withdrawn from public ex-

hibition at the Corcoran Gallery on the orders of the Secretary of the Navy and his Undersecretary, Harry Roosevelt. The brass branded it "disgraceful, sordid, disreputable" and worse, but the hookers, who were to all intents and purposes naked in spite of a frosting of sopping wet drapery, captured most of the attention. Such temptresses of the waterfront existed; in this man's Navy, however, it was "the rare exception to find a man who would stoop to such a disgraceful orgy."[102] Turning Cadmus loose in the Richmond, Virginia, Parcel Post Building was going to demand exceptional vigilance on Rowan's part, although it was hoped that splitting the job between Cadmus and Jared French, who had a blameless record so far, might restrain the Navy's nemesis from decorating that prim bastion of Southern gentility with harbor whores. And the historical subject matter suggested by the architects promised to put a brake on his libido as well.[103]

The Section faced a double-barreled dilemma in Richmond. There was Cadmus, who always bore watching, even though he had promised to behave. More crucial at the outset was finding a subject that would keep Cadmus away from displays of feminine pulchritude and keep the South from rising in rage again. One idea to which all parties were attracted was a panoramic treatment of the burning of Richmond in 1865 after Lee's withdrawal to Lynchburg. Southern advisers saw the proposed mural as a mere "reminder of what struggles the people of Richmond went through in arriving at their present happy state." Cadmus, therefore, produced a sketch that met with qualified local approval; the finished work could not depict any "expressions of horror, fear, etc.," or "refugees fleeing from the residential districts."[104] The Section had reservations about "sponsoring the glorification of war," but Rowan himself felt such stringent censorship of content made a meaningful exploration of the drama of the Civil War impossible and reluctantly asked Cadmus to start from scratch again. He felt sorry for him, though, and began to feel a bit more comfortable about his character. "In conclusion," he wrote in barely stifled amazement, "let me repeat that you have shown in this work that you have fulfilled your agreement to avoid the satirical."[105] When Cadmus phoned Washington and announced in honeyed tones that he had found a nice, romantic, inoffensive topic calculated to win the hearts of the natives, Section members fell all over themselves in their haste to give him the go-ahead.[106] His mural would show the meeting of Captain John Smith and Pocahontas! If

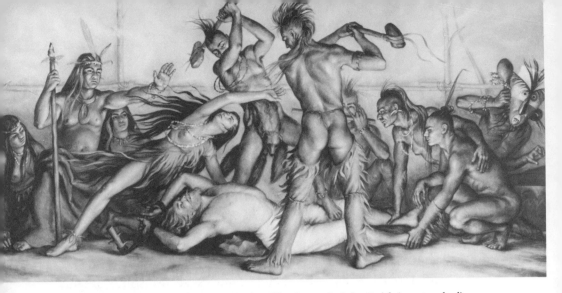

Paul Cadmus, *Pocahontas Saving the Life of Captain John Smith* (unretouched), Parcel Post Building, Richmond, Virginia. 1939. National Archives.

Rowan was agitated by a sketch of Pocahontas with one breast bared and one creamy leg canted across the foreground of the picture, he uttered nary a negative word. It could have been a whole lot worse.[107]

Meanwhile, Jared French thought his preliminary sketch had "lost a great deal of significance since the changing of Paul Cadmus' subject matter"; if Cadmus was doing Pocahontas flanked by the early governors of Virginia, he would cover the Civil War epoch with a picture of the climax of Jeb Stuart's ride around McClelland's army.[108] He paged through Robin's *Battles and Leaders of the Civil War* and J. W. Thomason's biography of Stuart and submitted a composition titled *Stuart's Raiders at the Swollen Ford*. Historical research proved that the daring maneuver by the Confederate cavalry had nearly been aborted at a raging river; their mission jeopardized, the desperate troops peeled off their uniforms and swam their horses to safety. In the design, the water is full of naked men. On the shore, the figure in the immediate foreground has already shucked his clothes while his fellow soldiers hesitate. Two chaps have taken off their shirts, and two others have removed their trousers. Companion portraits of Major John Pelham and J. E. B. Stuart in wings attached to either end of the scene stoop and peep into the central panel, as if they cannot believe they are seeing the flower of Confederate manhood posing in the buff.

Rowan was equally startled. A faux pas like that might have been expected from Cadmus. French was supposed to be the nice guy:

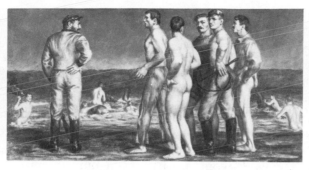

Jared French, preliminary sketch for Parcel Post Building, Richmond, Virginia. 1937. National Archives.

The source material as you say may be entirely authentic but you must realize that the design which you have submitted could not be considered for the decoration of a Federal building. There would be no offense to either the north or south as to sentiment but there unquestionably would be offense to the emphasis of the nudes. It is necessary for me to ask you in case you wish to use the subject matter of Stuart's Raiders to have them clothed. . . . You have painted enough nudes in your life so that the painting of several more or less should not matter in your artistic career. It is too obviously flying in the face of the public.[109]

In 1936 May Harlow had charged, in her protest against the female nudes in postal headquarters, that "male personnel" were insensitive to the implications of disrobing women in murals and movies. The crude, locker-room humor of Senator White's speechifying on the Kennebunkport *Bathers* proves her point, as does the Richmond episode. Whenever an undraped or scantily clad female was proposed for inclusion in a mural, the boys from the Section encountered greater resistance than the office anticipated. In light of his uncanny foresight in spotting sources of public rancor, some of them illusory,

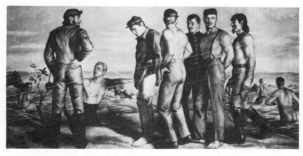

Jared French, *Cavalrymen Crossing a River*, Parcel Post Building, Richmond, Virginia. 1939. National Archives.

Rowan was quick to accept the principle that exposure of the female body was consistent with the natural order of things. He was reluctant to appear prudish, and he did develop some rough standards for how much costuming was necessary to set a woman "above reproach" and what types of women could safely flash a little cleavage. Nevertheless, his striken reaction to exposure of the male backside produced his most pungent and pointed sentences on the topic of nudity in general. The work would be disavowed and summarily rejected by the Section, he told French, unless "all the figures in the foreground" were covered up forthwith.[110] A little contemporary cheesecake was fine; historical beefcake was taboo.

The cavalry put their pants back on and hitched them up to their armpits. In the finished picture, bare toes and a strange pair of Confederate underdrawers strategically obscured by shirttails constitute battle dress for fast river crossings, and scandal seemed to have been averted once more. Rowan felt confident enough about the decorum of both panels to allow them to go on exhibit at Vassar College in Poughkeepsie, New York. Professor Agnes Rindge, who taught the course in modern art at the college, was an admirer of French and arranged the show, which opened in February of 1939.[111] Among the visitors was a Mrs. H. Van Buren Magonigle of Park Avenue. She returned from her afternoon on the Hudson, called a press conference, and denounced French's picture as a "direct insult to all Southern cavalrymen." She had nothing to say about the round bottoms so recently covered in buff and blue paint except to doubt if troopers built like French's could sit a pony. The mural showed "a group of forlorn looking men, not one of whom looks as if he had ever ridden a horse."[112] On February 7 the Richmond *News Leader* caught wind of Mrs. Magonigle's temper tantrum, although there was confusion in the city room about which panel she disliked and why. But one thing was certain: "Reports from New York are little less than sensational—not an uncommon adjective attributed to the works of Cadmus and French" and other Yankee modernists approved by the Vassar faculty.[113]

Rowan was vacationing in Puerto Rico, in merciful ignorance of the volatile situation brewing in Poughkeepsie. Once the grande dame of Park Avenue had said her piece, trainloads of gawkers, primed to find some indecent stain of modernist depravity, swooped down on the exhibition. French's panel struck them as hardly worth the trip; its scandal value was practically nil. But the Cadmus picture was

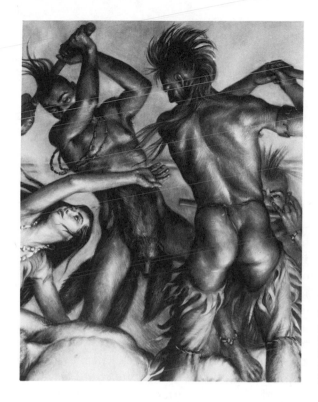

Paul Cadmus, unretouched detail of *Pocahontas Saving the Life of Captain John Smith*, Parcel Post Building, Richmond, Virginia. 1939. National Archives.

another story, rank with dreadful "immodesties in the scanty clothing on the Indians"—immodesties that Rowan had missed.[114] Like Rowan, the sightseers in the gallery did not turn a hair at the reckless dishabille of Pocahontas. As Edward Bruce told Cadmus, male modesty was the issue:

We have learned through sources that there are plans on hand to try to create some excitement about your picture especially having to do with the draping of the fox fur on the Indian and as you know we are anxious to avoid acrimonious discussions. Would you be good enough to paint over the fox skin and substitute for it the loin cloth which was indicated in the original pencil and two inch color sketch?[115]

The smutty prankster had struck again! In the middle of the mural stood two big Indians with clubs, preparing to dispose of Captain Smith, stretched out on the ground at their feet and shielded by the arm of Pocahontas. The Indian closest to the picture plane turns away from the viewer, toward Smith's quivering midsection, and this has the effect of putting his bronzed, naked, and manfully rippling buttocks at the precise center of the composition. Surprisingly enough, that detail offended nobody. Although in Richmond a different dress code might have pertained to Stuart's lily-white cavalry,

French must have recalled the fuss over his backsides with wry amusement, just as Rowan, racing back from his holiday, must have thanked his lucky stars that the Section still had time to avoid a grievous indiscretion. Had the murals been installed according to the wishes of the puckish painters, the Richmond Parcel Post lobby would have looked like a centerfold in a proctological manual!

The second warrior, poised behind Smith's body, faced his audience wearing a grimace, a string of beads, and a fur piece. The head of a skinned fox dangled between his splayed legs, and little imagination was required to notice that the animal's face looked exactly like—ahem—a penis. The voluminous correspondence that passed between Cadmus and the Section on the subject of the pelt shows that Cadmus had planned the placement of the fur maliciously and was enjoying his little joke no end. The purpose of his feigned confusion over what the matter could be and what he could do to redeem himself was also obvious: Cadmus wanted to make Bruce and Rowan say the unspeakable word—to use explicit anatomical terms instead of their usual prissy circumlocutions. He began by offering to paint out the fox face providing, of course, that he could leave the long tubular swatch of fur adjacent to it intact: "The swinging furs . . . help with the action of the composition."[116] Quite so. Yet the further Cadmus pushed his act, the starchier Rowan's language became. Finally, he told Cadmus flat out that if he expected to be paid, the fox would go, an "utterly unaccentuated part of the pelt" would be substituted, and that was that.[117] The game was over. Point and match to the Section.

When the most heavily retouched and scrupulously expurgated murals in Section history were installed in the fall of 1939, Richmond was properly scandalized nonetheless. But even the self-appointed committee of review from the United Daughters of the Confederacy could detect none of the lewdness promised by the newspapers. In fact, the ladies scarcely wasted a glance on the Cadmus Indians. They thought the "likenesses" were bad throughout, as was generally the case with this modern stuff, and especially disliked the cavalrymen in French's panel, because they "look like Yankees." Mrs. B. A. Blenner, president of the organization, delivered Richmond's official verdict on this federal art:

I think that the Confederate period should not be depicted unless the pictures are painted by Southern artists who know the spirit and traditions of the South.[118]

The delegation might have saved itself the trouble of touring the Parcel Post Building. They knew in advance they were going to hate murals painted by outlanders from New York, with all their queer ideas and scandalous ways paraded all over the front pages of the papers. The naked truth was this: modern art was scandalous, whatever it looked like.

NOTES

1. Ruth Lynch, President, and Helen M. Carlin, Sec'y, for the Trustees of the Salina Art Association, to Hon. Frank Carlson, September 25, 1942, 133 (Box 34).

2. Letter of September 29, 1942, quoted in Myers to Reynolds, October 2, 1942.

3. Unidentified clipping dated September 28, 1942.

4. Myers to Reynolds, October 2, 1942. The Rincon Postal Annex Competition, won by Anton Refregier, was the largest single award in Section history; see Jane Watson, "Woodstock to San Francisco," *Magazine of Art*, 34 (November, 1941), pp. 490 and 494.

5. Rowan to Congressman Frank Carlson, October 14, 1942.

6. Salina *Sun*, October 3, 1940. See also *PM*, August 2, 1940.

7. C. L. Schwartz to Rowan, December 2, 1940.

8. Topeka *State Journal*, April 15, 1939. It is worth noting that Regionalists were not immune from accusations of negativism. Curry's *John Brown* panel in Topeka was being criticized by the Kansas City *Times* as late as 1947 for calling undue attention to "storms, dust and soil erosion"; see Calder M. Pickett, "John Steuart Curry and the Topeka Mural Controversy," in *John Steuart Curry, A Retrospective Exhibition of his Work held in the Kansas State Capitol, Topeka, October 3-November 3, 1970* (Lawrence, Kansas: the University of Kansas Press for the University of Kansas Museum of Art, 1970), p. 38.

9. Schwartz to Rowan, December 2, 1940. The "what-not" is a dinner bell.

10. Quoted in Schwartz to Rowan, November 14, 1940.

11. Vincent Alvin Keesee, "Regionalism: the Book Illustrations of Benton, Curry and Wood," Ph.D. Dissertation (University of Georgia, 1972), pp. 89-90.

12. Julian Lewis Watkins, *The 100 Greatest Advertisements, Who Wrote Them and What They Did* (New York: Dover Publications, 1959), pp. 78-79.

13. Marjorie Rosen, *Popcorn Venus, Women, Movies and the American Dream* (New York: Avon Books, 1974), pp. 110-111.

14. May M. Harlow to Treasury Department, March 1, 1936, 133 (Box 124). The *Time* picture was published on March 2 and is mentioned in this letter.

15. Colorado Springs *Sunday Gazette and Telegraph*, February 16, 1936. Mechau signed his contract for $3000 on January 6, 1936, and was selected to do the work on December 10, 1935.

16. Harry Galbraith, United Press and Universal Service reporter, to James A. Farley, February 18, 1936, with copy to Senator Hiram W. Johnson.

17. Director of Procurement to S. W. Purdum, 4th Assistant Postmaster General, March 3, 1936.

18. Rowan to Mechau, March 4, 1936.

19. Two undated letters, Mechau to Rowan, ca. March, 1936.

20. Rowan to Mechau, December 31, 1936.

21. Robert S. Lynd and Helen Merrell Lynd, *Middletown in Transition, A Study in Cultural Conflicts* (New York: Harcourt, Brace & World, Inc./ Harvest Books, 1937), p. 170.

22. Quoted in Frederick Lewis Allen, *Since Yesterday, the Nineteen-Thirties in America* (New York: Bantam Books, 1965), p. 109.

23. Memo, Rowan to Section, March 6, 1936.

24. Purdum to C. J. Peoples, Director of Procurement, March 20, 1936.

25. Rowan to Director, *Re*: Nudes in Frank Mechau Design, March 24, 1936.

26. Rowan to Director of Procurement, *Re*: Designs for P.O. Dept. by Frank Mechau, March 27, 1936.

27. Rowan to Mechau, April 7, 1936.

28. See Assistant Director of Procurement to Mechau, September 13, 1937, approving payment for trip to Washington.

29. Rowan to Mechau, October 15, 1937.

30. Thomas Hart Benton, "A Chronology of My Life," in *Thomas Hart Benton, A Retrospective Exhibition* (Lawrence, Kansas: the University of Kansas Museum of Art, 1958), unpaginated entry for 1937-1938.

31. Thomas Hart Benton, "A Tour of Hollywood," *Coronet*, 7 (February, 1940), pp. 34-38.

32. "Hollywood" of 1937 was repainted late in Benton's life and is currently under conservation at the William Rockhill Nelson Gallery of Art in Kansas City, Missouri.

33. Washington *Evening Post*, September 16, 1937.

34. See Purdum to Peoples, September 18, 1937.

35. Acting Director of Procurement to Purdum, undated, ca. September 30, 1937.

36. See an unidentified group of clippings with uniform texts, which constitute the last entry in the Mechau file.

37. Phoebe Atwood Taylor, *Octagon House, An Asey Mayo Mystery of Cape Cod* (New York: W. W. Norton & Co., Inc., 1937) was serialized by the Associated Press in that year and supplied to subscriber papers in 1937 and 1938. The Faribault *Daily News* joined AP in April of 1938 and began running the excerpted novel on May 6, 1938. By the end of June, the mural discussed in the story had been vandalized and the series ended in July. I am grateful to Patricia M. Pearson for calling the circumstances surrounding serialization of this novel to my attention.

38. Taylor, *Octagon House*, p. 218.

39. Taylor, *Octagon House*, p. 8.

40. Taylor, *Octagon House*, p. 76.

41. Taylor, *Octagon House*, pp. 8-9.

42. Taylor, *Octagon House*, pp. 10, 99, 178, 277.

43. Taylor, *Octagon House*, pp. 196, 198, 200.

44. Taylor, *Octagon House*, pp. 13, 74.

45. Taylor, *Octagon House*, pp. 229-230.

46. Between the Coit Tower debacle under PWAP and the Pacific Grove commission, Arnautoff had done Section murals in College Station, Texas (1938), and Lindin, Texas (1939). He got the Pacific Grove job because of competent work in the Burbank, California, competition; see letter of appointment, May 2, 1939, 133 (Box 8).

47. Arnautoff to Maria Ealand, July 28, 1939.

48. Rowan to Arnautoff, undated, ca. August, 1939.

49. Morris Markey, "The Mysterious Death of Starr Faithfull," in Isabel Leighton, ed., *The Aspirin Age, 1919-1941* (New York: Simon and Schuster/Clarion Books, 1949), pp. 258-274.

50. Shapiro, ed., *Art for the People—New Deal Murals on Long Island*, pp. 13 and 58. A full-size photographic detail of this group, credited to the Macbeth Gallery, is in the Section files, Still Pictures Branch, Audio-Visual Records Division, National Archives, 150 (Box 10) GA.

51. "Descriptions" for Peppino Mangravite, Atlantic City, New Jersey, post office (1939), 135 (Box 203).

52. "Descriptions," Mangravite, Atlantic City (1939).

53. Frank Delford, *There She Is, The Life and Times of Miss America*, rev'd ed. (New York: Penguin Books, 1978), pp. 129-130.

54. Delford, *There She Is*, pp. 316, 330, and 337.

55. Rowan to Arnautoff, January 19, 1940, 133 (Box 8).

56. Rowan to Arnautoff, January 19, 1940.

57. Arnautoff to Rowan, February 2, 1940.

58. Arnautoff to Rowan, April 4, 1940.

59. This untitled cycle, painted in oil on composition board in 1937 by Burton S. Boundey, has since been destroyed; see Steven M. Gelber, "Guide to New Deal Art in California," in *New Deal Art: California* (Santa Clara, California: de Saisset Art Gallery and Museum, University of Santa Clara, 1976), pp. 82 and 87.

60. Pacific Grove *Tide*, April 5, 1940.

61. Rowan to William E. Gould, April 30, 1940.

62. *Tide*, May 17, 1940.

63. Arnautoff to Rowan, stamped as received January 19, 1946, and properly dated ca. June, 1940.

64. "Descriptions" for Elizabeth Tracy, Kennebunkport, Maine, post office (1941), 135 (Box 203).

65. Ida F. Austin to Section, August 14, 1941, 133 (Box 42).

66. G. H. Walker to Frank C. Walker, Postmaster General, September 23, 1941.

67. William D. Half, Postmaster, to Treasury, June 24, 1939.

68. Boston *Post*, July 31, 1941. Her two previous Section murals were *The Suffolk Resolves—Oppression and Revolt in the Colonies* in the Milton Postal Station, Boston, Massachusetts (1939), and *Chicago, Railroad Center of the Nation* in the Downer's Grove, Illinois, post office (1940). She received the Kennebunkport commission on the strength of designs submitted in the Social Security Building competition; see letter of appointment, April 11, 1941. According to the *Post*, she had done a history of Saugus mural for the Saugus, Massachusetts, Police Building Court Room under WPA auspices and a similar FAP cycle in the Medford, Massachusetts, City Hall.

69. Tracy to Rowan, May 7, 1941.

70. Rowan to Tracy, May 14, 1941.

71. Quoted in Rowan to Tracy, July 15, 1941.

72. Tracy to Rowan, July 22, 1941.

73. Herbert L. Luques to Section, August 14, 1941.

74. Frank W. Ober to FWA, August 16, 1941.

75. Undated petitions, circulated by Herbert Luques and Elizabeth Shannon, attached to Myers to Reynolds, September 16, 1941.

76. Ida F. Austin to Section, August 14, 1941.

77. G. H. Walker to Frank C. Walker, Postmaster General, September 23, 1941.

78. N. M. Martin to Rowan, August 27, 1941.

79. Rowan to Tracy, August 16, 1941.

80. Irene S. Morris to Rowan, September 1, 1941.

81. Edith C. Barry to Rowan, August 30, 1941.

82. Mildred Burrage to Frederic A. Delano, October 12, 1941.

83. Edith Mahier to Rowan, May 10, 1940, 133 (Box 88).

84. Special to Oklahoma City *Times*, June 14, 1941.

85. Baltimore *Evening Sun*, June 14, 1941.

86. Mahier to Postmaster Knoppenberger, June 25, 1941.

87. *Daily Oklahoman*, June 15, 1941; the retouch job is discussed in Mahier to Rowan, September 1, 1941.

88. "Ernie" to Mahier, undated.

89. Mahier to Rowan, August 15, 1941.

90. Rowan to Tracy, November 7, 1941, 133 (Box 42).

91. Rowan to Myers, November 10, 1941.

92. Taylor, *Octagon House*, p. 221.

93. Commissioner of Public Buildings to Rep. Robert Hale, December 4, 1944, and Rowan to Sara Tytell, Sec'y, Artists League of America, May 21, 1945. Grant had done Section murals in Alhambra, California (1938), and Brady, Texas (1939), and directed a TRAP mural team in the Venice, California, post office in 1937.

94. Commissioner of Public Buildings to Hale, December 4, 1944.

95. Washington *Post*, March 16, 1945.

96. Associated Press Dispatch from Indianapolis to Richmond *News Leader*, March 16, 1945.

97. Unidentified clippings, March 16, 1936, filed with Myers to Reynolds, March 20, 1945.

98. Washington *Herald*, March 17, 1945, and bill of lading, May 3, 1945.

99. Tracy to Rowan, March 21, 1945.

100. Rowan to Tytell, May 21, 1945.

101. Letter of appointment, March 3, 1937, 133 (Box 110).

102. McKinzie, *The New Deal for Artists*, pp. 29-30. McKinzie, pp. 70-71, also maintains that Cadmus pulled a similar stunt in the Port Washington, New York, post office, with a picture of a curvaceous girl popping out of skimpy shorts; in that case, Cadmus was forced to paint pajamas over his "hot stuff." The Port Washington project was a TRAP job finished in 1937 and the artist of record was Harry S. Lane; Cadmus was part of the team.

103. The theme is discussed in Rowan to Cadmus, April 29, 1937.

104. Marcellus Wright, architect, to Rowan, June 26, 1937.

105. Rowan to Cadmus, April 29, 1937, and Rowan to Cadmus, July 7, 1937.

106. Rowan to Cadmus, July 27, 1937, with memo of the phone call.

107. Rowan to Cadmus, July 31, 1937.

108. French to Rowan, September 29, 1937.

109. Rowan to French, April 13, 1938.

110. Rowan to French, May 7, 1938.

111. French to Rowan, January 30, 1939.

112. Richmond *Times Dispatch*, October 23, 1939.

113. Richmond *News Leader*, February 7, 1939.

114. Richmond *Times Dispatch*, October 23, 1939.

115. Bruce to Cadmus, February 8, 1939.

116. Cadmus to Bruce, February 20, 1939.

117. Rowan to Cadmus, April 17, 1939.

118. Richmond *News Leader*, October 31, 1939.

6

That Abstract Art Stuff
Ending at New London, Ohio

History has brought in a negative verdict on the post-office pictures of the '30s, Tracy's lumpish ladies included. They're awful murals! Poor art for poor people! When the long-awaited American renaissance finally burst upon the post-war world, it was the firebreathing anarchists who set off the aesthetic bomb. The modernists—the Abstract Expressionists and their numerous progeny—won the battle of styles. From the serene perspective of hindsight, Section art looks pretty dismal, and Section policies seem preposterously wrongheaded. Those hit lists of modernistic enemies and Rowan's prissy doubletalk about almost-abstract nudes are laughable and a little sad.

When bemoaning the tragic error of the bureaucrats, however, it is worth remembering that if people had demanded modern art with the same fervor they denounced it, the Section would undoubtedly have spared the premature New Deal renaissance the indignity of turning up in art-historical footnotes as an object lesson in institutionalized bad taste. The Section did, in fact, sponsor one abstract mural, so labeled in official publicity. They did so ungraciously and unwillingly, because the people of New London, Ohio, evinced a perverse fondness for Lloyd Ney and for his modernistic sketch, aptly called *New London Facets*. Then, too, Ney was the only artist in America to court a mural commission with a portfolio full of oddly faceted, garishly colored Cubist drawings, in complete confidence that Uncle Sam would defend the principle of democracy in art.

Prior to Lloyd Ney's startling emergence upon the mural scene

POSTMASTER

Lloyd Ney, *New London Facets*, USPO, New London, Ohio. 1940. National Archives.

during the course of the St. Louis Competition, Washington had never been faced with a doctrinaire modernist who owned up to an affiliation with the radical left. Prior to New London's show of interest in the anomalous Mr. Ney and his revolutionary plans for an Ohio post office, Washington had never been faced with a public clamor for modernism. Until the fall of 1939, the crusade against the radicals had been a squabble with a paper tiger: Cubists, Surrealists, and their ilk had not demanded walls. If large numbers of nonobjective painters were lurking ruefully on the fringes of the mural movement of the '30s, biding their time and anticipating their foreordained triumph over the factual reactionaries in the Treasury, they were an amazingly reticent multitude. Perhaps the modern throng waiting in the wings of history was deterred from entering Section competitions by those formidable lists of narrative topics. Perhaps they were content to fabricate legible pictures in return for Section paychecks. But if the avant-garde was out there en masse, seething with resentment, modern hordes had not been a force to be reckoned with on the Potomac.

Washington's fight against modernism had amounted to shadowboxing with a formless, popular specter of a lunatic artistic fringe made up of citified sophisticates with alien and probably scornful attitudes toward the common, ordinary, down-to-earth people of America. The peculiar story of the only abstract mural in America is instructive, therefore, in showing how and why the Section blundered into an aesthetic stance that time proved wrong. In their toe-to-toe confrontation with a self-confessed modernist, the New Deal bureaucrats were forced to map a path down the middle of the

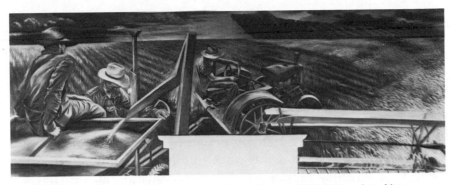

Joe Jones, *Turning a Corner*, USPO, Anthony, Kansas. 1939. National Archives.

stylistic road, a median line from which the rhetoric of the mural renaissance discouraged aimless wandering toward the academic right or the modernistic left.

In April of 1939 Lloyd Ney lost the St. Louis Competition.[1] The jury was composed of three stalwarts who understood the problems of making public art from a considerable backlog of experience as Section painters. Hence William Gropper, Howard Cook, and Ward Lockwood followed the Section's policy of avoiding blatant pictorial extremes and awarded the prize to a subdued rendering of the *Old Levee and Market at St. Louis*, a sketch which vaguely resembled an old tintype.[2] It was a conservative choice, based on the jurors' appraisal of the conservative taste of the community, and the decision enraged many competitors with no modernistic axes to grind. Joe Jones had submitted one of his agricultural scenes, for example, and resented being penalized for daring to explore a meaningful contemporary theme in a no-nonsense, realistic fashion. He was further miffed by Rowan's explanation of why the jury had chosen a bland historical illustration for this locale:

I don't know whether I'm supposed to take seriously your remarks about the subject matter of the Wellston post office job. But—between you and me, I ask you what is more abstruse, trite and generally unrelated to the lives of the people living in St. Louis (which is Wellston) than a covered wagon and smug southern gentlemen as an expression of postal activity under the heading of transportation. Your bulletin made an eloquent plea to present the idea of mail . . . on a human basis—even of great human significance. Your bulletin didn't want any more of the old crap that was usually thought to be appropriate. . . . Well, that's what you got and I wouldn't be writing this letter if you didn't regret my "lack of consideration in subject matter". Ed—you see I must defend my approach—I know it's a better one artistically, socially and intellectually;

architecturally [the winning design] will fit into any thousands of buildings. I know . . . it fits none without mediocrity—at best it will inspire awe among those who still think that a hand painted picture is expensive and rare.[3]

If Joe Jones's contemporary realism was too advanced for St. Louis, then Ney's Cubist sketches were out of the question. Yet the jurors found themselves strangely drawn to his heretical modernism. The longer they looked at his work, the more they questioned the validity of rejecting radical art of intrinsic quality out of hand lest the public eventually reject it to the embarrassment of the federal government. They appreciated the wisdom of an operational policy geared to the limits of popular tolerance and picked their winner accordingly. But by voting Ney a runner-up commission, this panel of Section painters also expressed reservations about a priori exclusions chiseled in stone on the façade of the Treasury Building. As Gropper reviewed the deliberations of the jury, recalling the way a conservative painting had been matched with a conservative community, he wondered why the Section could not find some place in America where a work of great merit and unconventional appearance might suit the social climate. The indignant Joe Jones had, after all, found an appreciative audience for his rejected St. Louis mural in rural Kansas:

I remember the jury was impressed by the pure brilliancy of [Ney's] color in contrast with other sketches of the somber note. It was suggested that if a Post Office in a summer resort, or a town with a Hollywood character could be assigned to Mr. Ney, that his work would fit in such surroundings, and add a note of freshness to the varied types of murals the Section of Fine Arts has sponsored. The jury also questioned the difficulty of placing such murals, but [it would be] worth the attempt in embracing all schools of art to encourage the growth and the development of American culture.[4]

Howard Cook took the opposite tack. Rather than suggesting that the Section scour the hinterlands for a whacky community receptive to newfangled novelties, he hinted that the artist could just as well restrain himself: "I honestly think . . . Mr. Ney has an idea and . . . if he can think it through possibly more carefully, he should do something rather fine."[5] In his defense of Ney, Ward Lockwood counseled neither pictorial revision nor exile into cloud cuckoo land. Instead, Lockwood dared to assail the basic premise which made modernism repugnant to the Section:

Possibly his color schemes are a bit "loud" for the conceptions that we usually feel appropriate for post offices, but perhaps we may be mistaken in our view-

point! Although his designs are on the abstract side, I believe that as far as artistic standards are concerned, they surpass some of the more realistic work that has been done.[6]

Lockwood was talking about an artistic standard premised on works of art. By that yardstick, Ney's sketch was meritorious; as a work of art, it was superior to other works of art. Style was irrelevant to this artistic standard. Ney's drawing was superior to works of a different, realistic character, and indeed comparable to Jones's. Lockwood did not spell out the innate qualities that led him to his positive assessment, although color was one key to Ney's appeal. Among fellow artists and his contemporaries, a rehearsal of the unspoken canon of painterly excellence was beside the point. Rowan and his painter-jurors, Lockwood assumed, knew how aesthetic judgments were customarily made. But in their arguments in favor of giving Ney a job, because his work met a tacit standard of aesthetic value, Gropper and Cook introduced a social standard very different from the first. That second standard governed the judgments of the Section. It was not the common property of the art world, and it frequently conflicted with accepted criteria for determining what constituted good painting in the '30s.

It was not, in fact, an artistic standard. Although Bruce and his colleagues would, more often than not, have found themselves in private agreement with aesthetic appraisals of works of art arrived at by applying Lockwood's standard, the Section knew that murals succeeded or failed according to a social paradigm. In Mural America, the artistic standard bowed to the social standard. Gropper invoked the social standard when he advised Washington to find Ney a town with a razzle-dazzle outlook. The people were the ultimate judges, and the people were not required to apply the artistic standard. Cook invoked the social standard when he hoped Ney would rethink his ideas. People were touchy, and the public was not required to subscribe to notions artists found intriguing. The jury's brief on Lloyd Ney exposes the controlling anomaly of the federal mural renaissance. Painters for post offices were chosen by one standard and pictures for post offices by another. Artists painted murals. But were murals works of art?

The Section's immediate question, in the wake of this shocking verdict, was how a Cubist could produce a mural. Before he informed Ney of his award, Rowan put a system of checks and balances into operation. He wrote to the postmaster of New London, telling him

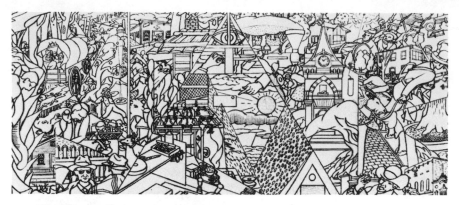

Lloyd Ney, preliminary sketch for USPO, New London, Ohio. 1939. National Archives.

to expect word from the painter and enclosing a press release about the St. Louis Competition which included mention of the jury's confidence in the man they were sending to New London. The testimonial was a precautionary measure. In case Ney showed up in New London and began raving incoherently about the integrity of the picture plane, the Section wanted it clearly understood that he was a bona fide artist in the government's employ. Postmaster O'Hara also learned that "Mr. Ney will be asked to get in touch with you by visit or letter relative to suitable subject matter for the decoration in question." No better brake on the mad impulses of artists had yet been devised than a small-town postmaster who had seized on a good solid topic for his mural and knew his rights in the selection process.[7] Two weeks afterward, when the instruments of containment had been set in place, Ney was invited to accept the New London commission.[8]

The artist's joy was boundless. His invitation arrived in New Hope, Pennsylvania, on the morning of September 27, and by nightfall he had already made plans to leave for Ohio in ten days' time. If Rowan had expected him to overlook the customary amenities performed in pursuit of the all-important story line, Ney's reply must have rattled him. In fervid, disjointed phrases, the painter pledged wholehearted compliance with the return to the facts: "Find out about historical happenings thru contact with people of the community—research thru Libraries—In Cleveland or capital of state!"[9] By mid-October he was home again, bursting with inspiration wrested from the soil of Ohio and sounding like the cooperative, socially motivated, citizen-artist of Rowan's dreams:

I had a very short stay in New London—being with Mr. O'Hara most of the time

—meeting people of the community—getting suggestions as to historical facts, etc. Have brought back Books from their Library and private individuals—Mr. O'Hara and I decided, of course with your approval, to reduce the dimensions. . . . The experience of seeing the Building—the town, and meeting some of their citizens, is invaluable to me—in my visualizing the material.[10]

In December, Ney submitted *New London Facets*. With his sketch came a two-page summary of every bit of factual data incorporated into his contrast of New London past and present, a bibliography of literary and pictorial sources consulted, and his correspondence with Mr. Thorn, retired editor of the New London newspaper, who had suggested and verified most of the historical details. The supporting documentation was awesome. Ney had done his homework with exemplary thoroughness and had ferreted out enough facts to stock several murals. Nor was it strange that Ney included some American Stuff of purely local interest. New London was proud of the trek which brought its settlers from New London, Connecticut, after the great fire of 1776; of Ohio's two U. S. presidents; of its own recovery from a devastating conflagration in 1872; of its booming mail-order uniform industry. But people were also proud of the fact that the "first Hippopotamus seen in America was seen in New London." They were fascinated by the fact that the two physicians who served New London at the end of the nineteenth century both wore shawls in preference to overcoats. They enjoyed the story of a local farmer of long ago who "carried a basket of apples to the schoolhouse every noon to try to stop" naughty boys from raiding his orchard. And there was "Lunatic Belle Fontaine (a character)," who used to wander through town in a daze, crying "How far is it to Belle Fontaine? How far is it to Scioto Valley?"

This was run-of-the-mill fare, but Ney's explanation of how he proposed to weld local facts, the tastes of the community, and his own ideas about art into an orthodox Section mural struck Rowan as demented. Surely this was the cry of a latter-day Lunatic Belle Fontaine:

A center triangle form expresses [the] spirit, content and activity of the building and what it stands for—a letter is isolated a trifle above the center of the triangle —the five letters in the triangle is the only white used in the panel as a whole to symbolize the mail. The literary content deals with local history, rich in human interest, highlights of colorful notes that every man, woman and child will be interested in; also a background of time and movement. I have itemized in other notes the subjects of motives (past and present). The presentation is decorative;

the panel in its various arrangements invents forms and colors to be a spot of decoration and [of] use to the community as only a part of the building as a whole[. T]he essence of a particular part of Ohio and New London specifically is known as Western Reserve or Fire Lands. Historic society and vigorous people keep alive that rich historic past burned out in Connecticut and [the] migration to the Fire Lands. My work is a composite picture and the idea was approved by eight of the leading citizens of New London. This phase is important to the extent [that] while I was in New London, I mentioned to a committee of citizens that I would do a composite canvas—many scenes in one. They seemed to be pleased with that idea.[11]

A decorative presentation? Invention of form and color? Symbolic triangles? And all of it painted "in brilliant reds and blues"?[12] That was hardly the art of factual accuracy! Why, the people of New London were going to take to the streets when they got a gander at a "time and space arrangement" in which a triangle stood for mail, a square for the post office, and a circle for the sun, these metaphysical shapes together summarizing "the spirit, content and activity" of New London.[13] The design would never do:

[It] is our feeling that you have not presented the material in such a way that it will be acceptable to the general public. First of all, the palette is so extremely vivid that it is our feeling the mural would not harmonize with the architecture of the post office, and secondly that the combination of the objective and the abstract would find very few supporters in the town. In our opinion it would be much better for you to work for some objective clarity. This opinion is strengthened in the reading of the many suggestions sent to you by local citizens relative to suitable subject matter. Your design seemed more fitting as a theatrical backdrop than as a mural decoration in a Federal Building. It is our feeling that it would have absolutely no meaning for the people.[14]

In this instance, the Section's voluminous records of philistine protests proved their worth; the charge that Ney had painted something fit only for a movie palace came straight out of the Towson, Maryland, file and taxpayer jibes at Cikovsky's transportation vignettes. Rowan's letter, one of the strongest rebukes ever addressed to an artist, sounds like a citizen protest throughout. He puts forward no arguments against the quality of the sketch per se. The artistic standard is not applied. Rather, the work is rejected solely on the strength of an informed prediction about the popular response to *New London Facets*. People will object, Rowan maintains. The "vivid" colors will clash with the traditional decor of the post-office building, and people will say so. A mixture of objective details and an abstract compositional framework will not wash; people who have eagerly collected topical data will not find pictorial transcriptions of that material legi-

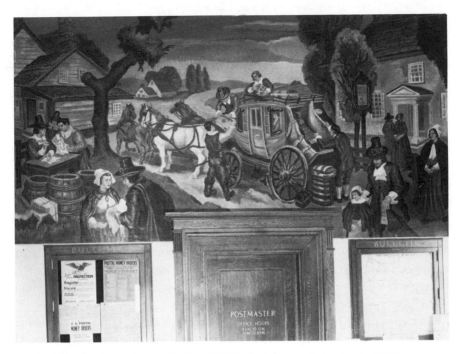

Bertram Goodman, *Quaker Settlers*, USPO, Quakertown, Pennsylvania. 1938.
National Archives.

ble and prominent enough to indicate that the artist paid attention
to the wishes of the community. Rowan could produce fresh docu-
mentation to bolster his forecast of storms over the New London
post office. The Towson file was still growing in 1939, and Rowan
said nothing about the New London sketch that had not already
been said, with more spite and scorn, in the Maryland newspapers.

Rowan heard the standard lay complaint against federal murals on
a daily basis. Pictures innocent of any trace of stylistic eccentricity
were routinely denounced because something depicted looked odd.
One such dispute had just petered out after months of rancorous cor-
respondence between Washington and Pennsylvania. Numerous ob-
jections had arisen to Bertram Goodman's 1938 mural in the Quaker-
town post office. The *Freepress* quibbled with historical inaccuracies
in *Quaker Settlers*: the Quakers, the paper charged, were wearing
"Puritan hats" and the neat, standardized bricks in the chimneys of
their painted houses could not have been manufactured in colonial
times.[15] But most of the irate townspeople who wrote to Washing-
ton could not make hide or hair of what was going on in the mural.

The artist had attempted to inject a touch of postal content into his work by showing a man opening a mail pouch and removing "an authentic scroll which I copied from an old print on manuscripts, letters, etc."[16] Only the end of the scroll showed, and local critics kibitzing in the post office swore they saw something else: "a man pulling a milk bottle out of a paper bag." That was "really a bit too much. If artist Goodman wished to portray real life in the good old days, and would have inquired locally, which . . . he was supposed to do, he would have learned that milk bottles and bags were . . . not dreamed of in this part of the country in the days he is depicting."[17] Thanks to Rowan's preemptive strike, the New London post office was already knee-deep in amateur historians with strong opinions on what Ohio looked like in "the good old days." If Quakertown could mistake a scroll for a milk bottle, in the context of a straightforward reportorial picture, what would New London make of a Cubist hippopotamus?

At this juncture, Rowan asked Gropper, Cook, and Lockwood to reconstruct the jury-room discussion that saddled the Section with Lloyd Ney. He could not believe Ney's work was "up to the standards which we are attempting to maintain."[18] By soliciting their comments, with the Section standard spelled out in block letters, Rowan was apparently trying to put some distance between the inevitable rejection of Ney's design and the Section's avowed hostility to modernism in general. If the jurors who chose Ney could be induced to concede the social shortcomings of bright color and symbolic triangles, then the Cubist aesthetic to which Ney was passionately committed would become a moot point. Ney could be denied his $800 contract without a wrangle over philosophic issues by citing the impartial verdict of a third-party panel of famous artists initially receptive to his work. The scheme backfired. The jurors elected to defend Ney. Worse yet, they rent the seamless fabric of "the standards which we are attempting to maintain" by saying, in effect, that the artistic standard took precedence over a social one. In the New London, Ohio, post office, the Section was obliged to reconcile the competing claims of art and society.

With the possible exception of Ward Lockwood, the St. Louis jurors believed in the social standard. They questioned whether the stylistic middle ground staked out in the name of Mural America was quite as cramped as Washington thought. Ney thought the social standard was a hypothetical delusion. He spurned criticism based

on what the public might or might not do and called Rowan's bluff in his rejoinder to the official dissection of *New London Facets*:

As to your assuming to know what the People of New London want or do not want—I would like to feel as I continue submitting proposals—that I eventually would be allowed—to have the Public of New London decide, which sketch they prefer. . . . I do not want to antagonize you—I am only Fighting to present a new Form of decorating—that is in tune with the Period we are living in. Please give it a chance? . . . Many people Feel you are using big illustrations in your Public Buildings. . . . You and Mr. Bruce know the difference between decoration and illustration—your department can open up a vast reservoir of stimulation to the artists of this country. . . . New London people have accepted my idea of doing a composite Picture. You state in your letter you feel that I have not presented the material in a way that will be acceptable to the General Public. Why not give the People a chance in New London to see my sketch and vote on it?[19]

Ney hit upon a sore point when he said that Rowan and Bruce knew "the difference between decoration and illustration." They did know the difference. What is more, they numbered illustrators chief among the academic enemies on the right wing of the factual mainstream of federal art and were frustrated to find the social standard a useless weapon in the battle to stem the conservative tide. Academic painters were a bad lot. For one thing, they were hellbent on denying that this was the 1930s, the epoch of the Depression and the New Deal locked in a mortal combat on which the survival of the republic hinged. The academicians fled from reality into the dim recesses of history. Their elegiac visions of a glorious past populated by make-believe nymphs clothed in Old Master flourishes of the brush repudiated the contemporary realism the Section championed. The worst of them, however, could be trusted to make scrolls look somewhat different from milk bottles—and, heaven knows, they painted a lot of scrolls.

What was shown in academic murals was often loathsome to the federal bureaucracy. Such traditional exercises as found their way into the Section's inventory of completed work did, nonetheless, show each deplorable detail with a clarity that qualified them for a toehold on the margin of the factual center. The public never complained about old-fashioned murals. Representational ambiguities were rare. And if a personage attired in virtue and a pair of wings chanced to appear, he or she was taken as an emissary from the noble parnassus of Art, never to be confused with the moral cesspool of real life. Hence the crusade to hold the academic menace at bay was

not bolstered by the social standard. The Section waged war on its own behalf and did so quietly, because, of course, artistic standards had no validity in the public sector. The several retrogressive set pieces that passed muster squeaked by because the artist had support from the public sector, or from a quarter thereof which Washington could not afford to ignore. And like modernism, with its cabals and factions, the academic manner was not monolithic. The disease exhibited a variety of symptoms. A mild case of updating selected masterpieces from the heritage of the past was greeted with somewhat less alarm than a terminal fever of copying colorplates from turn-of-the-century magazines.

Historical themes rendered in pseudohistorical styles were the hardest academic manifestations to fault, because members of the Section expressed open admiration for a golden age of social communication in art. According to Forbes Watson, the heyday of the popular mural began with Giotto and ended with Veronese, Tintoretto, and Rubens.[20] Given this thesis, masterworks cited to exemplify the dynamics of a healthy interaction between painter and public were easily mistaken for hard-and-fast stylistic models by eager competitors. Confusion between the social lessons to be derived from a usable artistic heritage and stylistic templates to be extracted from the pages of art history was rife in the mural studios of America as well. In 1926 Kenneth Hayes Miller inaugurated a popular course in mural painting at the Art Students' League of New York. Like Bruce and Watson after him, Miller excoriated the fictitious allegories painted in "poured water" approximations of classical drapery by the American decorators of the 1890s. But in his own studies of contemporary shoppers, Miller resorted to exact compositional quotations from the Old Masters that lent an aura of second-hand heroism to mundane American happenings.[21] Did a housewife waiting for a bus outside S. Klein's lack intrinsic dignity unless she reminded the viewer of a Renaissance madonna? Alert pupils—and Wendell Jones was one of them—learned to distinguish wholesome respect for the past from obsequious historicism, but few Section history painters had finished at the head of the Miller class. Painters of an academical disposition were prone to converting depictions of historical themes into stylistic tributes to the great pictures of the past. When those masterpieces also provided documentary evidence about a bygone episode, the temptation was irresistible.

Karl Free's *French Explorers and Indians in Florida* is a case in

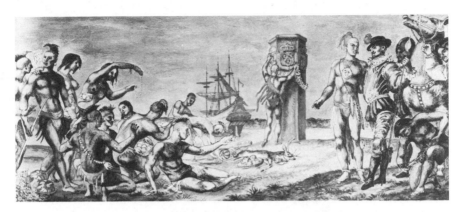

Karl Free, sketch for *French Explorers and Indians in Florida*, Post Office
Department Building, Washington, D.C. 1935. National Archives.

point. The mural, which hangs two floors above Mechau's "almost-abstract" nudes in the Washington Post Office, includes several al-most-nude tatooed Indians. At first blush, the Indians are the least objectionable feature of a work Section purists might have been ex-pected to condemn as the lowest form of academic palavering. To the casual observer, the Free mural seems tantalizingly familiar. It is, in fact, an overgrown, line-by-line replica of the famous 1564 Jacques Le Moyne gouache in the collection of the New York Public Library, showing Rene de Loudonniere meeting Chief Athore. In 1935 the Commission of Fine Arts turned the design down cold. Nudity was not mentioned. Neither was an unmistakable lack of originality; if the jurists recognized the source for Free's sketch, they kept that fact to themselves. The design was nixed because "the composition fails through the center."[22] The Treasury press release announcing the installation of the panel in 1938 praised the same composition, imperceptibly altered in the meantime, for its precise reenactment of a "picturesque legend."[23]

The Section also neglected to cite the obvious visual prototype. In-deed, the bureaucracy had gone to bat for the Free mural over the intervening years. The picture qualified for a place on the right edge of the factual center in 1938 in two respects. Known documentary facts had come to roost in the mural along with a veneer of sixteenth-century style. And the tendency to revive the look of history along with its stories and purported social ideals was itself a contemporary artistic phenomenon blighted by exclusive affinity with neither radi-cals nor troglodytes. A generic classicism, which took in most of the history of Western art, could be detected at every point on the aes-

thetic spectrum of the '30s. At the left were Picasso's Grecian maidens, thundering along the beach. At the center were Miller's Renaissance shoppers in modern Manhattan. At the right were the serried ranks of Baroque river gods, Rococo coquettes, and Mannerist cupids that cropped up in the works of almost any professed academic.

The Section also took care of its own. Weeding out the undesirables was supposed to happen before artists signed contracts, so that "acrimonious discussions" in the newspapers could be avoided. The New London situation notwithstanding, Bruce, Watson, and Rowan harbored few illusions about their ability to transform a painter's modus operandi by mail once a mural job was going full tilt. At the eleventh hour, details were negotiable, but basic predispositions were not. When the Section made a grave error, the Section learned to live with it, and Free was one such mistake. In 1938 Karl Free passed for a documentarist with leanings toward the art of the past. Historicism was not a hanging offense nor was it readily separable from Free's antiquarian approach to the particular theme of the Postal Department mural. Thus in 1939 Free was sent to Princeton, New Jersey, to execute his second and last Section mural. In *Columbia Under the Palm*, the difference between a sound historian and an academic reactionary disguised as an historian became clear at last. The work proved infinitely harder to swallow than the slavish copy of the Le Moyne rendering because Free's Princeton source material was not, in the strictest sense, documentary unless the art of the past had recorded the actual appearance of a race of alate beings who once fluttered about Italy and New Jersey.

The Princeton lunette was an indiscriminate pastiche of great moments from the Old Masters: a Mannerist putto floating here, a trumpeting Fame from the School of the Carracci hovering there, a colonial dame in the Rococo manner drooping about the foreground, and a clutch of Trumbull founding fathers parading across one corner. The scissors-and-paste job aside, the mural was exactly the kind of obscure allegorical muddle Bruce habitually ridiculed. To find "Columbia" in this art-historical stew, much less assign a gender and a tentative meaning to the creature answering to that name in 1939, would have taxed the sleuthing prowess of an Asey Mayo. Yet the Section had willingly given Free the job, and the artist had served up his reheated leftovers with the complicity of Charles Rufus Morey, Chairman of the Art and Archaeology Department at Princeton University, who was also chairman of the local, ad hoc citizens' ad-

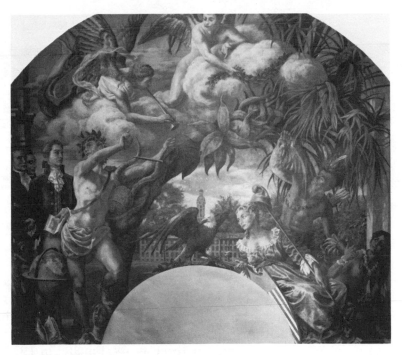

Karl Free, *Columbia Under the Palm*, USPO, Princeton, New Jersey. 1939. National Archives.

visory committee on the post-office mural.[24] Having taken Free on under the impression that he was, at heart, an attentive student of documentary fact, the Section felt honor bound to accept a picture limned with the fine Italian hand of an arch-conservative. Having given the local committee carte blanche to speak for the community, the Section was stuck with their favorable decision. The lunette certainly looked like Art, too; if the rest of Princeton hated *Columbia Under the Palm*, nobody came forward to say so. The Section's only viable recourse was to strike Karl Free's name from the list of candidates for further commissions.

Some artists the Section would have preferred to forget because of their notorious propensities toward Art in the grand old manner were too famous to ignore. The best juries could be deluded by the facile draftsmanship of an academic master, a rather more common gaffe than the mania that seized the St. Louis judges. Dean Cornwell was such a gray eminence in a velvet beret. A well-known magazine illustrator, he made a big name for himself as a muralist by placing first, second, and third in the 1927 competition for the decoration of the Los Angeles Public Library, one of the few contests

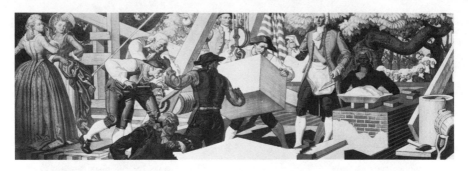

Dean Cornwell, *Laying of Cornerstone*, USPO, Chapel Hill, North Carolina.
1941. National Archives.

of that decade, with a roster of also-rans that glistened with the
names of academic warhorses previously listed among the deceased.[25]
Cornwell also attracted sufficient attention in the National Compe-
tition of 1935 to burden the Section with the obligation to hire him,
after a protracted spell of hemming and hawing. Washington man-
aged to postpone the inevitable for three years. Finally, in 1938, he
was shunted off to the wilds of Morgantown, North Carolina. There
whatever bombastic indiscretion he might see fit to commit in the
local post office could be forgotten or chalked up to defective South-
ern tastebuds.

The delay seemed justified when Rowan read a field report on the
mural, filed a year after the Section bit the bullet:

The Dean Cornwell mural illustrates what I think is one of the most important
truths which I have discovered in my survey which is, that a competent enlarged
illustration such as Dean Cornwell's "Sir Walter Raleigh" is cold and lacking in
appeal when compared with murals in which the artist tries to give a personal
interpretation of life or history as related to the community. In other words, a
painting which is a painting, a work of art, even if it is not top notch, has a cur-
ious animating quality which the best illustration lacks. . . . [But] the towns-
people admired Cornwell's illustration.[26]

That was the trouble. Even a staunch partisan of the Section's ambi-
tions to retool American art had to admit that the public adored
murals stamped with the musty trademark of the museum. When
masterpiece Art had been filtered through the flossy mesh of color
illustrations in *Good Housekeeping*, people liked it even better. The
expansive hand signals, the larger-than-life flailings of limbs, the
frozen expressions and the elegant, fashion-plate attire to which
Cornwell returned in his 1941 mural in Chapel Hill, North Carolina,
fared far better in the public arena than the contemporary artistic

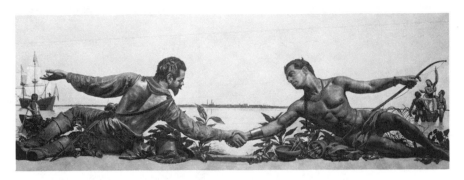

Edmund Archer, *Captain Eppes Making Friends with the Appomattox Indians,*
USPO, Hopewell, Virginia. 1939. National Archives.

vision "animating" the figure of Justice, who languished behind a
pair of velvet curtains in Aiken, South Carolina.[27]

Sad but true: the academic enemy knew how to make art that
looked for all the world like real Art. The man in the street preferred
Art to "a painting which is a painting" every time. When the Section
found an unreconstructed throwback to the age of the salons in its
employ, the public interest could scarcely be invoked to make the of-
fending party crawl back into his cave. In the drive to purge America
of academic art, the Section stood alone against the forces of con-
servatism. But the members of the Section stood united. In 1937
Bruce began assembling his troops for weekly staff meetings on
Tuesday afternoons. Pending designs were analyzed, and it was on
the basis of these skull sessions that operational policies were crystal-
ized and Rowan composed his directives to painters in the field. Ed-
mund Archer's design for the Hopewell, Virginia, post office was
taken up formally on March 5, 1937. According to the minutes kept
by Bruce's private secretary, the Section was struck collectively
dumb by *Captain Eppes Making Friends with the Appomattox In-
dians.*[28] Small wonder! The most stunning feature of the work was
Archer's implicit contention that Bernini was alive and well and
working in Virginia. And Tiepolo lived in the neighborhood, too.

The poses give the game away. Captain Eppes, kidnapped from a
Van Dyck portrait, and the Indian, who began life as a Dying Gaul
before he acquired the face of a brilliantined smoothie from a soap
billboard, recline awkwardly on the Atlantic shoreline. They attempt
to recline, anyway. Like a pair of beached Bernini river gods, they
rear up from their slouches and, holding their torsos erect with super-
human effort, fling out their arms in a valiant, gravity-defying stab at
explaining their predicament. In the center of the picture, their right

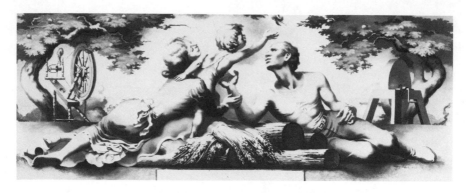

George Fisher, *Way of Life*, USPO, Chelsea, Michigan. 1938. National Archives.

arms join in a clinch that keeps them from toppling over. With his free hand, Eppes waves feebly toward his ship and its cargo of European settlers; with his, the Indian shakes his bow toward a fleet of canoes manned by his tribe. In ultimate effect, the composition falls midway between hauteur and hilarity. The melodramatic gestures and actions pictured might just as well pertain to two guys arm wrestling for beers, cheered on by their buddies from the bowling league. And wrestlers, spectators, and coastline are all about to plummet pell-mell into the lobby of the post office.

Archer surely meant to convey a sense of everlasting amity wreathed in clouds of symbolic grandeur. He cited lofty precedents. Tiepolo achieved just the mood Archer was after when he made Bernini's watery dieties into Indians reclining with stoic dignity on the edge of the ceiling cornice in the Royal Palace of Madrid. In the translation from the illusionistic ceiling of a throne room to a narrative picture on a wall in a U. S. post office, the convention suffered. Tiepolo's personifications of America never seemed pained, or in imminent danger of crashing to the floor. Postures and perspectives that worked for airy beings who never were looked distinctly odd when grafted onto the solid, factual types the Section insisted upon and odder yet when the characters struggling to hold those poses were average Americans, ca. 1938. George Fisher, for instance, used the same antigravitational trope for a contemporary family group perched atop a heap of timbers and wheatsheafs in the Chelsea, Michigan, post office. Fisher had timeless, emblematic glory in mind and failed to notice a conflict between eternal sublimity and the athletic prowess of Michigan moms and dads:

[The] artist writes, "The title, *Way of Life*, indicates the fundamentals of a system of living and thought which are correlated and which carry the possibilities of a great civilization and a strong and happy people. These fundamentals are symbolized by the harvest, the logs, the grindstone, the spinning wheel and the people themselves. Aside from symbol or prophecy, the mural is simply a picture of a family at rest, with work well done, enjoying the freedom, peace and love which [are] justly theirs".[29]

Whether members of an ordinary Michigan family on a picnic would sink naturally into such agonized poses—he miraculously flanked by grandpa's grindstone, she seconded by grandma's spinning wheel, balancing the baby between them—is open to debate. They were wearing ordinary American outfits, though, and the Section, having accepted this gaggle of symbolic lie-abouts in 1938, could hardly reject a second for Virginia in 1939. As it was, Washington temporized for two years before allowing that an eighteenth-century duo might have undergone the rigorous calesthenic rituals to which eighteenth-century painters subjected men of the heroic breed. Besides, Archer and Fisher had come by their contracts honestly. They could draw people who looked like people, and folks in Hopewell and Chelsea saw nothing peculiar about heroes and heroines enduring a little discomfort in the name of Art. There were worse follies possible in the New Deal renaissance than the spectacle of one of the Section's factual sea captains contorted by the allegorical rhetoric of yesterday, or a housewife tricked out as a nymph. Instead of real Art, the Hopewell post office could have been desecrated with that modern stuff, for instance. Why, Lloyd Ney or one of his crazy friends could have crept into Chelsea with a federal license to wreck the best new building in town!

Ney's letter to Rowan, coming as it did on the heels of several grudging capitulations to the academic right, promised to subject the weakened social standard to yet another challenge. Nothing in the Section's experience suggested Ney would win: townspeople had not been calling for more and better "isms," and John Q. Public and his congressman had refrained from picketing post offices on behalf of pure form. In fact, a growing number of protests directed against presumptive signs of radicalism showed that, in the public eye, modern art was not Art at all. At the same time, bad publicity seemed unavoidable. Ney was not going to give up the New London job and slink away; he spoke of his intention to "continue submitting proposals." He also spoke of "Fighting to present a new Form of decor-

ating." That phrase had the ring of a battle cry about it, and if the New London case degenerated into a pitched battle over artistic rights and standards and the minimal presence of modernism in the mural program, the Section was going to be in deep trouble. The St. Louis jury had refused to support Ney's dismissal on social grounds. The social standard had failed before, when pitted against the academicians. And Rowan realized, too, that whereas he had used the bludgeon of popular taste to bring artists into line with the factual demands of "painting Section," he had also begun to use qualitative language to combat popular taste, most notably in his ongoing struggle to prevent the destruction of Stefan Hirsch's mural in the Aiken Court House. Late in 1939 Ney was more than a nuisance. He had the power to force the bureaucracy to defend and explain a double standard that restrained artists in the name of the people and silenced the people in the name of art. The Section did understand "the difference between decoration and illustration." The Section knew the difference between illustration and "a painting which is a painting, a work of art." But in 1939 Washington had not decided where pictures in post offices stood in relationship to the illustrations of the academic right and the paintings of the modernistic left.

In the name of Mural America, the Section had staked out for the federal renaissance the factual, objective center of the aesthetic spectrum. The academic goddesses of yore were banished; divine beings were not facts in evidence. The nonobjective forms of the avantgarde went, too, under the same warrant and over the protests of modernists who claimed custody of the future to which a purified pictorial vocabulary provided title and key. The reformers at the Treasury planted themselves squarely in the middle of the stylistic road, ignoring the faint echoes of tradition and the clarion calls of prophecy. They took their stand on the firm ground of their own day and age. Behind the Section lay a moribund academic past. Up ahead glowered the vague shapes of things to come. But the bureaucracy refused to look back and did not presume to look forward. As New Deal pragmatists, they dealt with today, with a Depression culture caught between the shattered sureties of yesterday and the expectations tomorrow might also dash. In the unstable world of the '30s, fact was the only aesthetic and social certainty.

Elegy and prophecy were, in theory, equally reprehensible. In practice, however, the federal renaissance assumed the configuration of a vast mural triptych in a post office in Anyplace, USA. That big

wide panel in the middle was chock-full of accurately rendered mail chutes and recognizable portraits of historical worthies. In the overwhelming majority of Section murals, a legible, narrative theme shaped and subordinated the manner in which content achieved visual form. But as the eye crept toward the small appended wing at the right, fact gave way to *Columbia Under the Palm*. Academic murals were painted under Section auspices. Moving toward the pendant wing at the left, straightforward realism yielded by degrees to fragmented planes and swaths of exuberant chromatism. The Section's tally sheet also included modernistic murals. Of the two minority groups, the former was better represented. Academicians were hassled when they infused facts with the *sturm und drang* of the ages and when they presented humanoids nowhere in evidence in Depression America, but the sheer pictorial competence of a conservative gave him or her a fighting chance to beat the system. In George Fisher's case, wrapping an art-historical sprite in a housedress brought the picture back within the realm of the tolerable. In Edmund Archer's case, lacing a river god into the authentic costume of an historical character deodorized the academic aroma.

Academic painters who fell into the Section's clutches suffered for their Art: to practitioners of the grand manner, the philosophic implications of tossing out the geegaws and furbelows and reducing noble beings to dreary housewives were momentous. But in stylistic or purely technical terms, cosmetology could rectify most errors. However discordant the results, the movements of hand and eye demanded by the task of painting the folds of a Sears-and-Roebuck housedress were not dissimilar to the procedures required to drape a nymph in wet cheesecloth. Matching observation with replication sufficed for picture-making, regardless of the object pictured. Modernists were not so fortunate. Shapes, lines, and colors were not palatable substitutes for stage coaches, and a commitment to content at the expense of formal considerations provided entrée to the Section's client list. Nymphs, however pretty, were not factual housewives or pioneer mothers; a ravishing passage of green or blue was objectionable on the same grounds and far harder to rectify.

Painters to whom painting did not mean picturing were required, if they aspired to be Section muralists, to make fundamental adjustments in both the theory and the practice of their craft. Failing that, the Section was required to bend the rules to accommodate the ineptitude of modernists who had somehow penetrated the bulwark

Milton Avery, *Landscape*, USPO, Rockville, Indiana. 1939. National Archives.

of the jury system. In 1939, as the New London situation was beginning to heat up, Milton Avery's design for the Rockville, Indiana, post office presented Washington with such a Hobson's choice. Avery's *Landscape* was a planar surface subdivided by rounded green zones and dappled with complementary splotches of pigment. At a sufficient distance, these forms more or less resolved themselves into passable hills, and after squinting quizzically at the design for several weeks, Forbes Watson went to New York to try to coax Avery into a more enthusiastic compliance with the return to the facts. His memo to Rowan epitomizes the frustrations of a true believer contending with a personable and somewhat dense heretic:

I went to the studio of Milton Avery. I spent a very difficult two hours here because both [sic] the artist, his wife and his child were very much worried about whether the mural would be OK. They were very nice and seemed to be really hard up. While I should like to give a favorable opinion of the mural to save their distress, I feel that Mr. Avery has not understood the problem. He has painted a landscape with a single very badly drawn cow. The landscape is based on photographs which his wife collected of Indiana. . . . Mr. Avery has never been in Indiana and cannot afford to go there. He felt, from the photographs, that the country around Rockville resembled country which he knows well in Connecticut and he has created a landscape on that theory. Mr. Avery has a distinguished sense of color and a great fear of realism. The result is that he has painted a mural which, in spite of some fine passages, is rather soft and unconvincing. The ideal thing would be for him to go to Indiana but he cannot afford to do this. I questioned whether his mural landscape had sufficient local flavor to be acceptable in Rockville.[30]

The Watson memo is a revealing document insofar as it helps to define the character and the dimensions of the aesthetic center. For the creators of the federal renaissance, the social, narrative content at the core of the mural enterprise was something more than the end product demanded of artists under contract. The social center was

314

also the proper starting point for the creative act. Extremists who found their way into the Section fold had no choice but to consign control of the content of their murals to Washington. But murals from the left and right wings of the '30s look peculiar, because aesthetic outsiders steadfastly reserved the right to find their own paths to the canonical center from self-selected starting points. Academics en route to that neutral turf, for example, made pictures for the Section by cramming real characters from contemporary life and history into the rhetorical framework of the painterly tradition from which they set out. Conservatives did not begin with the facts at hand. As they neared the center, they gave the Section its pound of flesh in the form of Michigan housewives in cotton frocks, but the ladies continued to behave like goddesses in the grand manner. Conversely, modernists bound for a rendezvous with the middle ground of federal art made pictures by easing the painterly forms from which they began into tenuous visual parallels with the Section's cows and hills. From a vantage point at a social center conceived of as the origin and the terminus of the American renaissance, Watson justly thought Avery sick. Modernism was a disease, a wanton defection from the reportorial truth that constituted the wellspring of a wholesome social art.

Avery suffered from a debilitating phobia about the facts. It never occurred to Watson that Avery might not have premised his *Landscape* on the photographs his wife collected and that Avery was instead searching those snapshots for evidence of tangency between his independent color structures and the structures of nature in Indiana. Watson saw a nature study gone sour, distorted by a fixation on color values that diverted the artist's attention from blades of grass, land contours, and accurately rendered cows. He recognized Avery's "distinguished sense of color" yet could not see color as sufficient justification for painting the "unconvincing" entities Avery called *Landscape*. Watson wanted a *Rockville Landscape*, a status report on the topography of Indiana. The visual accounting of the present history of Rockville came first, according to the social standard. Color, however "distinguished," could be worked out later. Artistic quality came into play only after the social criterion had been met.

The conversation in the Avery studio must have been strained. Watson, for his part, was personally sympathetic to Avery, puzzled by "fine passages" of color squandered on a composition that barely a picture made, and officially convinced that a trip to Indiana would

cure the artist's modernistic illness. Avery, for his part, was desperately eager to please and baffled by how to make those same "fine passages" of painting turn themselves into the kind of picture Watson wanted. The Section fussed over Avery's cow more in sorrow than in anger, installed the mural, and hoped for the best. Those big green shapes looked something like hills. Avery's painting, when the light was right, looked something like a picture.

In December of 1939 Lloyd Ney sounded as desperately cooperative as Milton Avery when he told Rowan that "I do not want to antagonize you." But his letter posed a threat to the Section's tenuous hold on the middle ground between the artistic left and the artistic right, a center point which was, in fact, a strange, politically delineated no-man's-land between society and art. Ney claimed he could prove the social standard wrong; people could appreciate modern art. Whether he succeeded or failed on that fool's errand, Ney's militant espousal of a "new Form" of art invited an aesthetic debate, and debate spelled probable exposure of the Section's guilty secret. Federal art patronage was federal picture patronage. Pictures in post offices could be works of art, to be sure, but nobody among the ranks of the art czars at the Treasury was prepared to say what art was in 1939, much less debate the tacit and peripheral artistic standard. In a curious fashion, the Section's prerogatives as a New Deal agency were checked by the politics of consensus. The patronage of cultural artifacts was a legitimate governmental activity so long as the federal patron kept to the domain traditionally encompassed by political debate. The facts of life were out there, the common property of all parties to the social contract—patron, painter, and people. When painters hired by the government stuck to the facts, the rich variety of sights and memories always proved one supreme fact: this American society had met and surmounted challenges equal to the Depression. The recollections and hopes of Mural America, in all their pluralistic diversity, found a common avenue of expression at the factual center, here and now. Outside the center lay reaction and stagnation, revolution and chaos. As Roosevelt's electoral coalition held the center against the Huey Longs and the Earl Browders, so the mural movement clung to a center to which the social convictions of most people and most citizen-artists adhered.

That center was exceedingly capacious, but it was not quite ample enough to include matters extraneous to the American social con-

tract. Art, qua art, was profoundly irrelevant to the social mission of government and thus to the mural renaissance. At best, art was an instrument of social dialectic, a vehicle of an urgent national dialogue. Debate over the content of a muralistic speech was pertinent; wrangling over its grammar and vocabulary were not, unless the language garbled the message. The Section used art, but the Section was not deeply committed to making art. Official breastbeating about the artistic impoverishment of the masses and pledges of reform and rebirth disguised that truth in the '30s, and the bureaucracy that championed the New Deal renaissance would have denied the charge, even as they skuttled away from the debate on the artistic standard Ney wished to initiate. Since the '30s, the vogue for measuring the value of modern art according to the strength of its antisocial proclivities has further clouded the issue; art-historical criticism of the mural movement has merely bewailed a New Deal conspiracy against modernists like Avery who went on to become the great American artists of the '50s. Bruce, Watson, and Rowan were not implacable foes of abstraction so much as they were lukewarm allies of *any* art which asserted its independence from the political arena. Ney was a dangerous man because he wanted to talk about art. Cubism might, as he insisted, find a place in the social realm, but Ney was clearly prepared to press his claim for the innate legitimacy of his art, regardless. Art liberated from the bondage of instrumentality was useless trivia, a distraction from the task at hand.

Ney was also an awful pain in the neck. He was bound to stir up trouble in New London with his poll on Cubism. And when he learned that the members of the Section "were unable to detect the merits" of his design and that the St. Louis jury had been reconvened, Ney left for Key West to make life miserable for Edward Bruce, who was taking an extended winter vacation in Florida.[31] Ney had moved to Florida bag and baggage expressly to push his cause, and Rowan warned his boss to expect anything:

When you are in Key West you will no doubt be bombarded by one Lloyd Ney of 515 Fleming Street, Key West. For your information in order to help you be prepared, I attach photographs of the work which he submitted for the decoration of the New London, Ohio Post Office and which the Section was unable to accept. I have sent similar photographs to Howard Cook, Ward Lockwood and William Gropper asking for their comments and advice in a situation of this kind.[32]

Ney turned up on the chief's doorstep early in February of 1940 and thereafter, as Rowan had predicted, bombarded Bruce with impassioned pleas for justice and tolerance.

Ney's summary of their initial conversation demonstrates his awareness of the Section's social brief against abstraction and, amid a barrage of exclamation points, counters it with a socio-political argument of some ingenuity:

I feel you are turning down my work, presented to you [by the St. Louis jury] and wanted by the people of Ohio because it is an abstract approach to painting. . . . Mr. Bruce, you represent a medium! of serving the people. Mr. Bruce, there are two schools of thought concerning painting—you are using only one of the schools of thought! You are only using half of an idea! in what you are presenting to the people. [You] tell me you may be wrong with your point of view— but that you will have to stick to your ideas! Mr. Bruce, suppose Mr. Roosevelt hadn't realized his need for a more liberal interpretation in the supreme court to accomplish his ideas. Can't you see how he would have been handicapped, in putting over the big idea as a whole, without the liberal interpretation[?] If your visualization, of your Section of Fine Arts, serving the people as a whole, would combine all the creative forces in this country, combine modern art and conservative, you would combine a full force, you would combine a whole idea, not half an idea—to give to the people. Mr. Bruce, it isn't fair to Mr. Roosevelt! It isn't fair to the artists! . . . And it isn't fair to the people![33]

The analogy between art and court-packing introduces a novel definition of style. In Ney's view, style is a political component in the mural dialectic, not a passive medium through which social content is objectified. Like the Section, Ney approves of a public art situated midway between the stylistic extremes of the day. Unlike the Section, he would not clear the middle ground by pushing back the forces arrayed on either flank to leave a neutral field, a stylistic vacuum to be filled by social facts in evidence. Ney's middle ground is a creative battlefield for politicized styles. The conservative right of the illustrators and the progressive left of the abstractionists push on toward a collision at the midpoint. Public art—an art of consensus —arises from the fiery mixture of the two distinct and competing styles. At the point of balance between the competing philosophies of right and left, art mirrors the political process of the '30s. Modernism is liberalism, in Ney's book, the art of Hugo Black, if Ney's Supreme Court metaphor is taken seriously; pictorial art is conservatism, the art of Chief Justice Hughes.[34] A democratic synthesis between the first hippo seen in America and the formal arrangement that embodies it uniquely expresses "the big idea as a whole." The

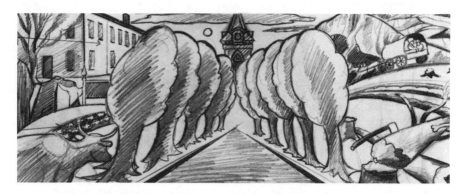

Lloyd Ney, explanatory diagram for USPO, New London, Ohio. 1940. National Archives.

public mural, like FDR, becomes the creative nexus in American public life, the mediating center. One need not be a liberal Democrat to paint a faceted hippo, of course, and Ney's singularly inappropriate reference to the political scheme that wrecked the Grand Coalition was not calculated to win the heart of a New Dealer. Yet Ney had a legitimate point to make about the character of the stylistic center. If Mural America was to be neutral territory, as the Section maintained, then abstraction belonged on the edge; Avery and Ney were lucky to have wedged a foot in the side door. But if Mural America was a hotbed of competing ideas, an arena for creative social action, then abstraction belonged there. Insofar as painting was a creative and a political act, Mural America was indeed the natural habitat of art.

Bruce was "quite unhappy about the situation" in Key West. He sent his own account of his meeting with Ney to Forbes Watson, requesting a full dress review of the case. By his own admission, Bruce "spent hours with [Ney] working on our point of view, without being able to make a dent." Nor did Ney's point of view make a visible dent on Bruce:

Ney is a very attractive, very poor and very sincere artist . . . and is thoroughly convinced that abstract art is the art of the future. It appears that New London, Ohio, is a little town which owes its existence mainly to a large mail order business. Ney went to New London when he got Ed's letter—talked with the local townspeople and apparently sold them, from letters which he has, on the idea that they should have an abstract picture, which as you know is rather unattractive in color, and has introduced into it everything from the kitchen sink down. Personally, I can't see anything attractive about it in the way that art appeals to me, but it does represent a lot of work and expense which Ney went

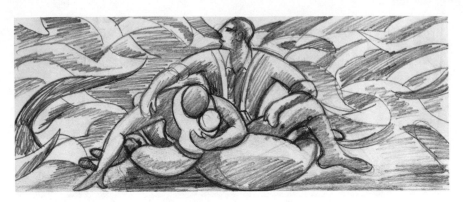

Lloyd Ney, explanatory diagram for USPO, New London, Ohio. 1940. National Archives.

to in perfectly good faith, and is exactly the kind of picture we had every reason to expect from his work. In other words, it is quite fair to invite an artist to submit a design for a commission, and as a result the artist goes to work in perfectly good faith, if in the first place we do not approve of his art?[35]

Art, abstraction, social content, and the aesthetic center get short shrift. Like Watson's report on Avery, Bruce's recollection of his verbal skirmish with Ney is marked by personal concern and tactical awareness of a problem to be solved but is devoid of interest in what makes Ney tick. The question of abstraction is dismissed in a phrase: "we do not approve of his art." Fair play toward a "poor fellow . . . on tenter hooks" precludes consideration of the larger issue.

Ney continued to pester Bruce. On February 22 alone he composed two more letters of clarification and entreaty. The first dared Bruce to prove his "claim to be working for the good of the artists and for the good of our country" by extending his benevolent protection to the "modern artists in our country"; by approving the New London design, he could make a symbolic gesture of reconciliation, injecting "new courage and new faith into all artists and especially into the modern artists of our time." His political ploy had apparently failed, so Ney unveiled a fresh, historical defense of his position. An appended chart, tracing the "History of Art" from ancient Egypt to the present, reiterated his contention that the New Deal mural program could go down in history as the flash point of explosive detente between tradition and experimentation:

Any great period of art expresses or reflects [the] spirit of the times it was created in. All great art of the past was a dynamic art—we salute the past. The great art of today and tomorrow will be an art of accented movement, reflecting the spirit of today. We borrow that nucleus from the past, *dynamic*! and by every possible means at our command, in an organic way we intensify into one explosion and establish the basis for a great new art period.[36]

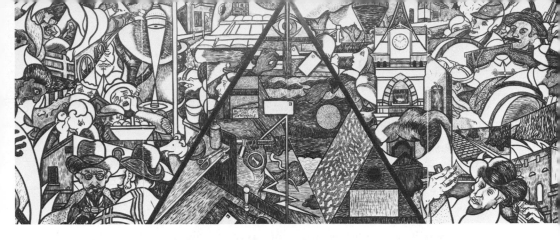

Lloyd Ney, cartoon for *New London Facets*, USPO, New London, Ohio. 1940.
National Archives.

His second letter of the day was an exasperated tirade. Ney sensed at last that his laboriously reasoned treatises were falling on deaf ears, and he had heard from Lockwood via artist Peter Blume, who had just arrived in Florida:

One lone soul in a wilderness! To embrace all schools of Art, to present to the people—that is the fearless structure which will encourage the growth and development of American Culture! [That is] the essence of what your St. Louis Jury will hand you, or has handed you, in case you don't know—since you are here in Key West on vacation—to embrace all schools of Art. The people of New London want my composite mural—the Jury and the People! . . . The Government and all its Departments are the People! Long live the People! Mr. Bruce, you are forcing me to appeal to our President, Mr. Roosevelt![37]

Bruce was not listening, or rather he was not listening to Ney. His reply made no mention of the elaborate chart or the substance of their previous conversation. Ney was, he felt, "intensely sincere" about his fanciful notions and Bruce was "sympathetic." But, as Ney had surmised, the jury's refusal to recant was uppermost in the chief's mind. "You have two very loyal rooters in Peter Bloom [sic] and Ward Lockwood, so you are not lacking in enthusiastic friends," Bruce noted dryly in conclusion.[38] For the moment, at least, Bruce was not among those friends.

Lockwood's endorsement, seconded by Gropper and Cook, boosted the fortunes of Lloyd Ney dramatically. The jury had voted for *New London Facets* and so, in all likelihood, would New London, Ohio. There was no accounting for taste! Caught between an artistic standard he would not legitimize by discussion and a social standard he could not repudiate, Bruce caved in. After a frantic call to Washington and another trying session with his nemesis in residence, Edward Bruce hoisted the white flag over Key West. Ney could paint

whatever crazy thing he liked; New London was going to be the site of the only abstract mural in America:

> I feel very certain that in doing this we are doing the right thing as the man is very sincere and I am convinced that had we . . . turned him down the man would have had some sort of a nervous crack-up. He had undoubtedly sold his idea to the little town of New London, Ohio, and on the whole perhaps it isn't a bad idea to have *one* experimental picture in the project, as this abstract art stuff is certainly getting a lot of attention these days. The town is small and it is not a very important project and as long as the people like it, "What the --!" Certainly I think we must take the position that if we invite an artist to make a design, it is on the basis that we accept the quality of his art, and that if he comes across to the best of his ability we should not turn him down on the theory that we don't like his art.[39]

To err about the never-to-be-defined "quality" of this "abstract art stuff" was human; to forgive an artist on the brink of a tizzy, especially when he was bound for a forgettable little burg in the boondocks, was the lot of a stalemated bureaucracy and a pretty darned open-minded thing to do.

In Ohio, meanwhile, a public referendum on "abstract art stuff" was in progress under the impartial supervision of the New London Rotary Club. The Rotary exhibited "the mural designed by Mr. Lloyd R. Ney . . . for the corridor of the United States Post Office," debated reactions to the design at a heavily attended meeting and drafted a resolution "favoring the Mural, with recommendation of its acceptance." This document was subsequently reviewed by nineteen community leaders gathered in plenary session and signed by every one of them. The president of the local power company, the mortician, the movie-theater manager, the superintendent of schools, the vice-president of the C. E. Ward uniform company, Postmaster O'Hara, and anybody who was anybody in New London demanded that Uncle Sam let Ney paint his funny picture.[40] From that moment onward, the New London mural became an errant stepchild of the federal renaissance. The Section washed its hands of all responsibility for what happened in the New London post office. Ney filed the usual progress reports: he submitted reference studies of details, a revised color sketch, a cartoon, and a last-minute plan to integrate the mural with the decor of the lobby by painting "abstract purple color areas around the bulletin boards." Rowan greeted each report with a stoic and wholly uncharacteristic indifference. That "abstract art stuff" was New London's business now. If the mortician and the superintendent of schools relished "abstract purple

color areas," they were welcome to them. Rowan had passed beyond the threshold of dumbfounded incredulity: "I will be interested in the reaction of the Postmaster and other prominent citizens who have championed your mural to any proposals you wish to submit."[41] And heaven help them all.

While the Section was actively ignoring the evolution of *New London Facets*, however, the agency was using the commission as a symbol of the democratic inclusiveness of the program. In August of 1940, for instance, Rowan wrote to Alfred Barr, Director of the Museum of Modern Art, and to Hilla Rebay of the Guggenheim Foundation, calling the New London project to the attention of a constituency with which Washington had not enjoyed cordial relations:

It was my great pleasure yesterday to visit the studio of Mr. Lloyd Ney in New Hope, Pennsylvania, and to see his most recent work. Mr. Ney has been working independently and with a great deal of intelligence and sincerity in the field of non-objective painting for a goodly number of years. I personally was deeply impressed at several examples of his achievement and it is because of this that I feel impelled to write to you.[42]

A cynic could detect skullduggery in this belated effort to conciliate the modern camp. In 1940 the Section was trying to found a Smithsonian Gallery of Art, a federal facility for the exhibition and promotion of contemporary American painting and sculpture that would ensure survival of the Section as its permanent custodial agency. Bruce was courting the Rockefeller and Guggenheim Foundations for private funding, without much success; kind words about a nonobjective painter served a useful purpose in approaching groups that had a record of supporting modernists with greater enthusiasm than the Section had heretofore demonstrated.[43] On the other hand, Rowan's remarks sound sincere enough to merit attention, and in the depths of bureaucratic despair over Ney's modernistic eccentricities, the Section never failed to believe in *his* "sincerity." But "achievement" rather than misguided sincerity is the principal reason for Rowan's sudden interest in Ney. "Personally," he has found something of merit in the New London mural and in nonobjective art.

Occurring as it does in a piece of quasi-official correspondence, Rowan's personal judgment, so designated, says a good deal about the case of the only abstract mural in America and the stubborn determination with which the Section held the artistic standard at arm's length. Artistic judgments were personal, private matters of opinion. Members of the Section held such opinions and were not

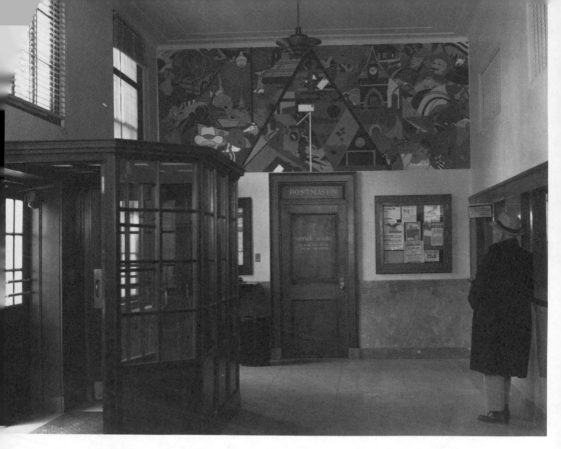

Lloyd Ney, *New London Facets*, USPO, New London, Ohio. 1940. National Archives.

above making them known; personal opinion played a role in choosing the jurors who chose the painters and in plucking runners-up from the lower reaches of the eligibility list. It also played a key role in scaring off those whom informed private judgment deemed dangerous to the program. Bruce despised modern art and did not revise his low opinion of Ney's modernistic mural. Between his abandonment of the New London project in the spring of 1940 and his discussion of a summertime visit to the artist's studio, Rowan changed his opinion. Neither his belated support nor Bruce's premature condemnation had much official impact on the New London mural, however, if Ney's bouts of personal elation and frustration are excepted. Official Section policy sacrificed private judgment to public taste, debatable sense to quantifiable sensibility, and the artistic standard to the social standard. As the plebiscite of the New London Rotary Club proved, the social standard was fact, and the ultimate measure of that elusive intangible called "quality." There was no room for the artistic standard in Mural America. Public art made in

the glare of the public arena with public funds defined merit by public consensus. The picture in the post office was officially exempted from the chancy domain of art. Mural America was, in both aesthetic and iconographic terms, the stable principality of fact.

By that preeminent factual standard, Ney's mural was a howling success. *New London Facets* was installed in November of 1940 with great pomp and ceremony. The New London *Record* treated the story—"$1000.00 Mural Is Placed In the Post Office"—as a triumph for the little guy, the forgotten man who took on Washington and won. Historical content, the battle to have the mural painted, and modernistic form intersect to proclaim the town's unique capacity to surmount obstacles. The mural project, therefore, symbolizes the triumphant odyssey of New London, past, present, and future:

The painting . . . is of the "abstract" type of painting, brilliant in color, bold in outline and depicting in three general phases the complete history and growth of the village. The brilliant coloring, and bold strokes, depict, in a vivid way, the gay, yet determined way in which the village and its people have taken hold of any matter that has presented itself and the determined manner in which adversity has been faced. This painting by Mr. Ney is the first of its kind to be installed in any Ohio post office, as well as being one of the very few [sic] in the entire United States. . . . The first plans, designs, etc., submitted were rejected by the government on the grounds of "being too bold in outline, and too flashy in color". However, Mr. Ney immediately communicated with interested persons here, and through the efforts of the local Rotary Club, the original designs were reconsidered and Mr. Ney was instructed to proceed with the work.[44]

What folks in Maine took for modernism symbolized the Red menace. New London attributed political significance of a different kind to abstraction. Cubism was a declaration of independence and will, as American as mom's apple pie. Espousal of modernism made the citizens of New London freedom fighters, ever at war against timidity, fear, and reaction. Modernism reasserted a historical commitment to progress. In an unbroken continuum of "determined" action, New London pressed on toward the challenges of tomorrow under the "brilliant" banner of Cubism. The symbolic value of modernism counterbalanced the distinctly peculiar appearance of the mural, too:

A consensus of opinion throughout the village express [sic] satisfaction in the mural as a whole. A cursory glance at the picture shows a jumble of lines and color but upon reading the small plaque accompanying it the visitor can see each part of the painting fall into place and can easily follow the story throughout.[45]

The "plaque," a rambling laundry list of pictorial details that challenges the visitor to find Connecticut, the wandering eccentric, the

doctors in their shawls, the apple man, a baseball team in locally made "gaudy uniforms" and, of course, the hippo, was supplied by Ney.[46] The story line, however, was supplied by New Londonites who knew the old stories, the legends, and the facts of home before they ventured into the post office to gaze in startled satisfaction at this emblem of their self-evident and intrepid courage.

As Ney began to paint his mural, he told Rowan why he had fought so long and so hard for the job. "I want to do a work that you will be proud of," he wrote, "a work that the people will have pride in having in the Post Office. I want to open the way for many other abstract painters."[47] Officially, the Section was proud of its liberality toward modernism when Ney was done. So were the people of New London, for whom modernism was a picture puzzle wrapped in a bold and brilliant tissue of local pride. The postmaster watched them peering owlishly at the plaque, stepping back, looking up, scratching their heads, and smiling suddenly:

[I] will say that I think [the mural] is very interesting and that it is one that you have to study to get the different views. It has caused a lot of people to say, well, it is interesting after you have studied same for a while. I myself appreciate it more every time I look [it] over and talk to someone about it. Trusting that the scheme of the mural will cause other Post Offices to try some, I remain, Sincerely yours, John L. O'Hara, U. S. Postmaster, New London, Ohio.[48]

O'Hara's trust in the appeal of abstract art was misplaced. Folks in Aiken and Salina and Kennebunkport had as little use for paintings as the citizens of New London who peered and looked and cogitated and broke into relieved smiles when they discovered that all was well. New London was really there, sort of.

In Mural America, people peered into pictures in post offices earnestly and purposefully and anxiously, looking for the courage to dream. The picture was a window on yesterday, showing the troubled people of Granville the dreams that their forebears once dared to dream. The picture was a mirror of today, showing the troubled people of Corning that the dreams of yesterday had indeed come true. And as they watched, that resonant picture of home began to sparkle with the promise of a serene and bountiful tomorrow. You couldn't see it clear and plain, but you knew it was there, at the corner of the window, at the edge of the mirror. The picture of Mural America showed the mighty dream that always came true.

NOTES

1. Rowan to Postmaster, New London, Ohio, September 13, 1939, 133 (Box 84).

2. See *Bulletin*, #19 (June, 1939), p. 2, 130 (Box 215). Lumen Winter completed *Old Levee and Market at St. Louis* in the Wellston Postal Station in 1939.

3. Joe Jones to Rowan, April 17, 1939, 133 (Box 32). Jones used the St. Louis sketch as the basis for his mural in Anthony, Kansas.

4. William Gropper to Rowan, February 3, 1940, 133 (Box 84).

5. Howard Cook to Rowan, February 7, 1940.

6. Ward Lockwood to Rowan, February 16, 1940.

7. Rowan to Postmaster, New London, Ohio, September 13, 1939.

8. Rowan to Ney, September 26, 1939.

9. Ney to Rowan, September 27, 1939.

10. Ney to Rowan, October 10, 1939.

11. Ney to Rowan, December 14, 1939.

12. Rowan to Gropper, Cook, and Lockwood, January 29, 1940.

13. Ney to Rowan, December 14, 1939.

14. Rowan to Ney, December 27, 1939.

15. Quakertown, Pennsylvania, *Freepress*, February 3, 1938.

16. Bertram Goodman to Rowan, March 23, 1938, 133 (Box 96).

17. P. A. Stonetaef, Quaker Advertising Company, to Farley, February 8, 1938.

18. Rowan to Gropper, Cook, and Lockwood, January 29, 1940, 133 (Box 84).

19. Ney to Rowan, January 2, 1940.

20. Bruce and Watson, *Art in Federal Buildings*, pp. 4-5.

21. See Marling, "Federal Patronage and the Woodstock Colony," pp. 347-350.

22. Charles Moore, Chairman, Commission of Fine Arts, to Rowan, November 26, 1935, 133 (Box 126).

23. Treasury Department press release, undated (1938), 133 (Box 124).

24. See, e.g., Leon Kroll to Bruce, January 30, 1938, 124 (Box 137).

25. Broder, *Dean Cornwell, Dean of Illustrators*, p. 25.

26. Helen Appleton Read, "January Report of Work Done in Connection with a Grant Received from the Carnegie Corporation to Study Art in Federal Buildings," 16 pp., February 16, 1939, 129 [Folder: Field Reports], p. 6.

27. *Bulletin*, #7 (December, 1935), p. 9, 130 (Box 214). The mural is entitled *Laying of Cornerstone*.

28. Memo, office meeting, March 5, 1937, 124 (Box 140).

29. "Descriptions" for George Fisher, Chelsea, Michigan, post office (1938), 135 (Box 203).

30. Memo, Watson to Rowan, April 3, 1939, 129 [Folder: Report on Trips].

31. Rowan to Ney, June 29, 1940, 133 (Box 84).

32. Rowan, Memo to Bruce, January 26, 1940, 124 (Box 140).

33. Ney to Bruce, February 12, 1940.

34. James MacGregor Burns, *Roosevelt: the Lion and the Fox* (New York: Harcourt, Brace & World, Inc./Harvest Books, 1956), pp. 291-315.

35. Bruce to Watson, February 19, 1940, 124 (Box 140).

36. Ney to Bruce, February 22, 1940, 2 pp., with appended chart.

37. Ney to Bruce, February 22, 1940.

38. Bruce to Ney, February 22, 1940.

39. Bruce to Watson, February 24, 1940.

40. John O'Hara to Simon, March 5, 1940, 133 (Box 84).

41. Rowan to Ney, April 4, 1940; see also Ney to Rowan, March 25, 1940, and Rowan to Ney, April 1, 1940.

42. Rowan to Barr and Rebay, August 6, 1940.

43. McKinzie, *The New Deal For Artists*, p. 46.

44. New London *Record*, November 28, 1940.

45. *Record*, November 28, 1940.

46. Ney to Rowan, November 28, 1940, 133 (Box 84). The *Record* story included lengthy extracts from Ney's description.

47. Ney to Rowan, undated, received August 17, 1940.

48. John L. O'Hara to Rowan, December 11, 1940.

A Note on Sources

This book is based in large measure on Record Group 121 in the National Archives (National Archives and Records Service, General Services Administration), Washington, D. C. Written records of the activities of the Section and the agencies that preceded it are contained, for the most part, in Inventory Entries 122 through 145 within Record Group 121, although some pertinent materials also turn up in Inventory Entries 104 through 121, dealing with the PWAP and TRAP. All these records are housed in the Natural Resources Division of the National Archives.

I know from a dozen years of painful experience that it is difficult for an interested reader, perusing a text larded with Record Group and Inventory Entry numbers, to visualize what these documents look like and how they might be used independently. By way of providing a bibliography, therefore, I can think of no more practical a research aid to supply than a brief description of how to use the National Archives, and how to move on from there to additional sources of information.

The first step is an examination of the descriptive inventory of Record Group 121: *Preliminary Inventory of the Records of the Public Building Service (Record Group 121)*, compiled by W. Lane Van Neste and Virgil E. Baugh (Washington, D. C.: The National Archives and Records Service, General Services Administration, 1958), pp. 28-41. This inventory has been reprinted in Francis V. O'Connor, *Federal Support for the Visual Arts: the New Deal and*

Now (Greenwich, Connecticut: New York Graphic Society, Ltd., 1969), pp. 131-143.

Each subheading, or Inventory Entry, contained in Record Group 121 is given a descriptive paragraph outlining, in a general way, the sorts of materials filed therein. The description of Inventory Entry 129, Record Group 121, for instance, reads as follows:

MISCELLANEOUS REPORTS: 1935-39 4 in.
Field inspection and progress reports. These are grouped by type of report and arranged thereunder chronologically.

This is the description of Inventory Entry 133:

CASE FILES CONCERNING EMBELLISHMENTS OF FEDERAL BUILDINGS. 1934-43 55 ft.
Correspondence, memoranda, and related records concerning the execution of works of art and their installation in Federal Buildings. Included are communications with consultants regarding selection of artists; correspondence with artists regarding submission of preliminary sketches, revision of work in progress, and administrative matters; correspondence with building custodians; and correspondence with the Director of Procurement regarding approvals of completed works and payments to artists. A few announcements of competitions and abstracts of contracts are also present. Arranged alphabetically by State, thereunder by building, with a separate section for buildings in the District of Columbia.

Hence Inventory Entry 129 is a small (4 inches) and homogeneous body of data; as I have noted elsewhere, on-site inspections were not a part of standard Section operating procedure. These few reports comprise four linear inches of stacked paper, and so they fit into one of the National Archives's green or grey document boxes. Entry 129 can easily be read in a morning. But, obviously, it is advantageous to know something about how the Section operated—what procedures it did and did not follow—before pinning one's hopes on the contents of this single box.

Inventory Entry 133 is more typical of the mixed lot of materials one is liable to encounter. It is a vast (55 feet) potpourri of letters, telegrams, clippings, canvas samples, rough sketches, forms, petitions, and other assorted scraps of paper, comprising over a hundred document boxes. Reading through Entry 133, at a good clip, kept me busy for several months. The Entry is subdivided geographically. If one wants to know something about the mural in the Corning, Iowa, post office, for example, one turns to Box 29, labeled "Iowa: Bloomfield to Emmetsburg" and extracts a large binder titled "Corning," held together by metal paper fasteners. The binder reads from back

to front. That is, all the wires, letters, carbon copies of letters, and so forth that the Section deemed pertinent to the Corning commission are stacked in chronological order, with the first form letter to the artist, dated October 16, 1939, appearing on the bottom of the pile and the last letter about local reaction to the mural from the postmaster of Corning, dated May 19, 1941, appearing on the top.

Entry 133 is, in my estimation, the key to all Section documentation. When one learns here that the Corning mural was painted by Marion Gilmore and that she worked on it from the date of the 48 States Competition, which she won in 1939, until her contract was paid off in 1941, it becomes possible to begin snaking one's way through the *Preliminary Inventory* once again, in an informed manner. Using Gilmore's name as a clue, for instance, one can turn to the biographical data in Entries 130, 135, 136, and 137 to discover if she painted other murals, and when, and where. Using her 48 States victory as a clue, one can turn to announcements of competitions (Entry 131) or to the *Bulletins* of the Section (Entry 130) for additional information on the early phases of the commission. Using the time framework as a clue, one knows where to look in chronologically arranged annual reports (Entry 128) or progress reports (Entry 129) for possible supporting materials.

Entry 133 also provides the most complete record of what the Section did on a day-to-day basis. Reading artists' biographies (Entry 136) or the card index of completed works of art (Entry 145) is useful only after Entry 133 has been consulted, for one notes omissions and missing documents constantly. Indeed, this is true of all the Inventory Entries which were not originally collected and filed with the intention of keeping track of the evolution of a specific commission. In effect, Entry 133 recreates the working files of the agency, and the remainder of the data fleshes out that story. The remainder is truly "miscellaneous."

A rough idea of the artists, commissions, dates, and places documented in Entry 133 can be obtained in one's local reference library, by consulting "Geographical Directory of Murals and Sculptures Commissioned by Section of Fine Arts, Public Buildings Administration, Federal Works Agency," *American Art Annual*, vol. 35, for the years 1938-41 (Washington, D. C.: American Federation of Arts, 1941), pp. 623-658. This directory does prove incomplete when compared with Entry 133 and the materials in the other entries to-

ward which Entry 133 points, and it does not distinguish between TRAP and Section commissions. Nonetheless, I have found it useful to keep a copy of the "Geographical Directory" at my elbow while using Entry 133. It is a flawed index, but it is an index.

And how, exactly, does one use Entry 133? After learning about the Section and studying the *Preliminary Inventory*, one presents oneself at the Pennsylvania Avenue entrance to the National Archives Building on Federal Triangle for a consultation with the screening staff in Room 200B. At this point, a research identification card is issued, and the researcher is introduced to the archivist of the Natural Resources Division who will direct document boxes from the storage stacks to a study desk in the Central Research Room, where they may be examined. Although this process is not time consuming, those on a tight schedule can speed matters up by writing or calling in advance to request access to specific entries and boxes. Of course, anyone planning a lengthy stay at the Archives should develop a research strategy, based on the *Preliminary Inventory*, beforehand.

Douglas Helms was the archivist who handled the research requests for this book, and my gratitude to him knows no bounds. He took the time to discuss my project in detail and was very helpful in modifying my research strategy and in calling promising materials, sketchily described in the *Preliminary Inventory*, to my attention. Archives have their quirks and researchers should be prepared to cope with them. With patience, materials temporarily withdrawn from boxes for photocopying can be turned up, along with the odd batch of papers nowhere recorded in the *Preliminary Inventory*. Trust the archivist!

Still and all, the arrangement of the documents has its drawbacks, particularly for the scholar who wishes to pursue a research program premised on the visual evidence of the murals themselves. Written records and photographic records are both included in Record Group 121. Both are listed in the *Preliminary Inventory*. But the written records and the photographs are not housed in the same location within the building. Record Group 121 photographs are available in the Still Pictures Branch of the Audiovisual Division, in a different part of the facility. Thus photographs of murals and written records about them cannot be consulted in tandem at one's study desk in the Central Research Room. A case file on a mural in Entry 133 *may* include a newspaper clipping with a murky reproduction of the work

in question. More often than not, however, no pictorial evidence is included.

If one grabs one's notes and rushes up to the Still Pictures Branch to take a look at the mural, it is possible to emerge sorely disappointed. The Section requested visual evidence from artists at several stages in their work, and what artists submitted makes up the holdings of the Still Pictures Branch. Artists had to submit a photograph of the finished mural to discharge a contract, for instance. Some hired professional photographers to record the work *in situ*; some had the mural photographed as it hung on stretchers in the studio; some took dreadful pictures with their Brownies. The quality and utility of these photographs vary widely. Verification was also mandated at intermediate stages in the work. Some artists shipped their cartoons to Washington, and the Section photographed them or forgot to do so; some sent snapshots of cartoons or sketches. The range of variables at all stages in the evolution of the photographic record is enormous. Rarely are good-quality images available showing the evolution of a given mural from the preliminary and revised sketch stage, through the intermediate phases, to the finished work, mounted in its permanent location, although this very process is the subject of most of the written documentation.

The Still Pictures Branch has a fragmentary card index of Section murals and artists, and periodically issues instruction sheets for researchers, directing attention to boxes of negatives and photographs that the index does not cover. Despite the best efforts of a helpful staff to instruct me in the vagaries of the index system, I continue to find this material extremely difficult to use in its present form. Thus I recommend allowing ample time for a visit to the Still Pictures Branch. Those interested in looking at photographs bearing on a specific mural or murals will have no trouble finding *a* photograph, although it may be much harder to find *the* photograph at issue, showing the sketch as opposed to the finished work, or the mural *in situ* as opposed to the cartoon. But a scholar dealing with the problem of style in Section murals should probably plan to begin work in the Still Pictures collection, by looking through every box of materials described in the *Preliminary Inventory* and moving on from there to the written documentation in the Natural Resources Division. Conversely, the iconographer might better reverse the process, beginning with Entries 133 and 135 and moving on from there

to the photographs in the Still Pictures Branch [Entry 135, the subjectival "Descriptions" of murals especially useful to the iconographer, is the exception to the split between Record Group 121 documents and photographs: one foot of Entry 135 is filed in the Natural Resources Division and the remainder is filed in the Still Pictures Branch].

When dealing with such a large corpus of material, obtaining reproductions of documents and photographs becomes especially crucial. It is not difficult to obtain copies, but patience and accurate notations about the nature of the copies requested are essential. Written documents in the Natural Resources Division may be photocopied in two ways. Fewer than ten pages per day may be photocopied at the main desk in the Central Research Room. For larger numbers of copies, the archivist will show the user how to mark document boxes and materials within boxes with paper strips. At busy times, it may take several weeks to obtain copies of marked materials and these may be mailed directly to one's home address. During slack times, copies may be delivered to the researcher in the Central Research Room within a day or two of placing an order. The archivist will provide a schedule of rates, and the National Archives will open deposit accounts for researchers who anticipate an ongoing program of copying material. Copies will be stamped on the reverse with a notation of the Record Group from which the original came, but it is the obligation of the researcher to keep good-enough written notes on the materials requested to be able to fill in the Inventory Entry number and the box number, without which it is impossible to cite the documents properly.

The Still Pictures Branch can provide prints and copy negatives in a variety of sizes; the archivist can provide current price lists and order forms. The numbering system used to identify prints is complicated. Some prints have a series of numbers and letters penciled in the margins, but in other cases an order number must be derived from the storage box or the file within a box. It is advisable to ask for assistance in filling out photo order forms and to fill them out before leaving Washington. If the Still Pictures Branch receives a mail request for a photograph without a proper order number, the staff must track down the photograph. Delays can occur, and one may not receive a photograph of the specific state of a given mural desired. One useful tool for doing research among the photographs is the excellent photo-copying facility located in that research room. The re-

searcher makes a dark but adequate copy of the photograph being used, writes the order number on both the copy and the photo order form, and uses the copy until the print can be made.

But why start at the National Archives? Why not make a copy of the "Geographical Directory" and go foraging about in Corning, Iowa? The problem, essentially, is one of precedence rather than merit. Black and white photographs, however excellent, cannot take the place of direct experience with the mural. Fortified by that conviction, I have visited over thirty of the sites described in detail in this book and about a hundred more that did not find a place in these pages. On the one hand, field research can serve to vivify aesthetic response and verify the continuing well-being of murals, which have begun to disappear at an alarming rate. Equally valuable are local and regional newspaper morgues, historical society files, postal records, and the recollections of town elders, all of which are hard for the deskbound researcher to tap.

On the other hand, it is no sure bet that Corning, Iowa, harbors a treasure trove of hidden documentation, nor is it likely that the researcher who has neglected to plow through Inventory Entry 133 will know how to coax latent riches out of hiding. References to defunct weekly newspapers and mention of specific names and dates and incidents jog memories in a way that general questions about the mural in the local post office cannot. The same generalization holds true for interviews with eyewitnesses to mural history. Those especially interested in the Section painter can find transcripts of recent interviews with many artists of the '30s, along with their papers, in the Archives of American Art (the Smithsonian Institution) in Washington, and in its regional offices; this data is clearly catalogued and indexed. But before setting up one's own interview with a muralist or charging off to Anyplace, USA, to buttonhole the natives, knowing what indeed happened and what one wants to know about that course of events is essential. Foreknowledge can turn vague reminiscences into pointed and pungent recreations of times past.

Detailed study of Section murals and New Deal patronage programs in general therefore hinges on an informed exploration of the National Archives, followed by even better informed follow-up research in other archival collections and in the field. The books and exhibition catalogs I have cited in my notes above provide one means of becoming a well-informed researcher. Insofar as the Section is concerned, three books in particular give solid introductions to the sub-

ject, augmented by substantial bibliographic suggestions for further digging. These are O'Connor's *Federal Support for the Visual Arts*; Richard D. McKinzie's *The New Deal for Artists* (Princeton, New Jersey: Princeton University Press, 1973); and Belisario R. Contreras's Ph.D. dissertation, "The New Deal Treasury Department Art Programs and the American Artist: 1933 to 1943" (American University, 1967), available from University Microfilms, Inc., Ann Arbor, Michigan (#67-12, 035).

O'Connor also edits an important newsletter, *Federal Art Patronage Notes*, available by subscription from 250 East 73rd Street, #11C, New York, New York, 10021. A three-page "Selected Bibliography" on the New Deal art projects, which appeared in *Federal Art Patronage Notes*, Vol. III, #3 (Summer 1979), pp. 1-3, gives an excellent descriptive listing of scholarly books, articles, dissertations, and catalogs published in the 1970s and thus serves to update the bibliographic information marshaled by McKinzie and O'Connor in the previous decade. Much of this new scholarship is contained in exhibition catalogs, which are, in contrast to the standard texts, adequately and often lavishly illustrated. I have frequently referred the reader to plates in recent catalogs in preference to reprinting those illustrations, reasoning that one key function of this book is to assemble a compendium of unfamiliar images, previously unavailable in published sources. In most instances, the recent catalogs I cite are still in print and may be ordered directly from the libraries, museums, and galleries that sponsored the exhibitions.

Whether one approaches the mural through the photographs in this volume, a sketch exhibited in a museum, a visit to a local post office, or a session in the National Archives, the experience is, I think, well worth having. If painted dreams have not always come true, they remain compelling and instructive.

INDEX

Index

(Mural titles appear in caps.)

Index

Index

Karal Ann Marling received her Ph.D. in art history
at Bryn Mawr College in 1971. She has taught
at Case Western Reserve University and Vassar College,
and is now associate professor of art history and American studies
at the University of Minnesota, where she also chairs
the art history department. Marling's articles
have appeared in *Portfolio*, *Prospects*,
and *Winterthur Portfolio*.